DESIGNER'S GUIDE TO FURNITURE STYLES

TREENA CROCHET

Wentworth Institute of Technology

PRENTICE HALL
Upper Saddle River, New Jersey 07458

Library of Congress Cataloging-in-Publication Data
Crochet, Treena
 Designer's guide to furniture styles / Treena Crochet.
 p. cm.
 Includes bibliographical references and index.
 ISBN 0-13-374695-X
 1. Furniture—Styles. I. Title.
NK2235.C76 1999
749—dc21 98-19923
 CIP

Acquisitions Editor: Elizabeth Sugg
Editorial Production Services: WordCrafters Editorial Services, Inc.
Managing Editor: Mary Carnis
Director of Production and Manufacturing: Bruce Johnson
Prepress Manufacturing Buyer: Ed O'Dougherty
Marketing Manager: Frank Mortimer, Jr.
Creative Director: Marianne Frasco
Cover Designer: Liz Nemeth
Interior Designer: Laura Cleveland

This book was typeset in Usherwood by Publishers' Design and Production Services, Inc., Sagamore Beach, Massachusetts, and was printed and bound by R.R. Donnelley & Sons, Inc. Crawfordsville, Indiana.

The Bodleian chair on the jacket was designed by Robert A. M. Stern. It was manufactured by HBF, P.O. Box 8, Hickory, North Carolina 28603; 1-800-423-9614. The photograph is reprinted courtesy of HBF.

Printed in the United States of America
10 9 8 7 6 5 4 3 2

ISBN 0-13-374695-X

Prentice-Hall International (UK) Limited, *London*
Prentice-Hall of Australia Pty. Limited, *Sydney*
Prentice-Hall Canada, Inc., *Toronto*
Prentice-Hall Hispanoamericana, *Mexico*
Prentice-Hall of India Private Limited, *New Delhi*
Prentice-Hall of Japan, *Tokyo*
Pearson Education Asia Pte. Ltd., *Singapore*
Editora Prentice-Hall do Brasil, Ltda., *Rio de Janeiro*

This book is dedicated to my mentor, Jan Parker, ASID, and in memory of Antonio F. Torrice, ASID. These two people made me realize that if you can dream it, you can do it!

CONTENTS

FOREWORD: THE CREATIVE PROCESS

Designers specialize in creating objects that fulfill both an aesthetic function and a practical solution. Historically, designers were merely creating to fulfill the wants and desires of their patron rather than following their own inspiration and need for artistic expression. Throughout most of ancient history, designers were looked upon as mere craftsworkers. Some examples from the past include the Egyptian pharaoh telling the architect what kind of tomb or palace he or she wanted; later, in the Middle Ages, Catholic Church Fathers regulating the design and decoration of cathedrals, and so forth. Often the craftsworkers executed these projects while getting little or no recognition, and in many cases, their ideas were ridiculed and rejected by the elite patrons who employed them. During such times designers had to also overcome obstacles of social class to be recognized and respected for their work.

Early in the twentieth century the 'modernists' designed products that reflected the progress of the machine age. They not only explored new methods of construction with this new machinery but also utilized new materials while searching to break from the past. The modernist felt that a historical perspective held back their creative development, and for a short time, styles of the past were ignored.

During the last thirty years we began to think of designers a little differently, perhaps as visionaries. Now, they are the creative people who forecast the kind of houses we will live in, the clothes we'll wear, or what type of car we will drive. The choices are entirely up to us, yet we are limited to what the designers have to offer us. They shape our basic wants and needs based on what we perceive as the latest trends in the design community, be it an ergonomically designed office chair, the slimmest cellular phone model, or perhaps the colors for new sports utility vehicles.

Today we are experiencing a melting pot of past and present cultures through creative research. No time has it been like the present where information and ideas are transmitted throughout the world so rapidly. This information age allows designers to continuously learn of new products thus generating new ideas for products of the past or new solutions to the problems of the future.

In short, designers have always learned to appreciate objects of beauty from their ancestors while creating functional and artistic objects. While adapting these objects to the changing cultural lifestyles, designers often perfected the technical processes and altered their designs.

Dalia Berlin, ASID
Florida Licensed Interior Designer

Treena Crochet, Allied Member, ASID
Assistant Professor, Wentworth Institute of Technology, Boston, Massachusetts

PREFACE

Inseparable from social, political, and economic influences, furniture design reflects the changing living conditions and lifestyles of developing civilizations from the Neolithic period to the present. Understanding the historical development of furniture is important since furniture was often designed apart from its need to function. The purpose of this book is to provide the reader with a comparative study of the evolution of furniture design viewed as an integral part of its unique cultural environment. Historical information is presented with emphasis placed on the cultural factors that set design trends and influenced individual preferences.

The focus of this book is on the fundamental integration of furniture into the built environment, including architectural setting, characteristic design motifs, and, to a certain extent, decorative accessories. *Designer's Guide to Furniture Styles* introduces the reader to a chronological examination of developing furniture styles placed in the context of its prevalent cultural milieu. As historians tend to use aesthetic categories in their analysis of art and architecture, the book is organized first by assessing the historical foundation, followed by a summary of the stylistic developments for each century. As history is not an exact science, the overlapping of stylistic developments between centuries is common since a new style introduced in the later part of one century often remained popular into the next. In this case, the development of the style is discussed through its period of popularity within its originating chapter. Photographs and illustrations along with explicatory text offer the reader visual reinforcement and explain by example the unification of the decorative arts.

In addition to historical information, a useful glossary and comprehensive timeline correlating key developments in furniture, art, architecture, and social history are included. To complete the understanding of furniture and the creative processes of design, a section of this book is devoted to technical processes. Accompanying photographs and illustrations introduce the reader to construction, joinery, upholstery methods and anthropometric and ergonomic considerations.

This book is intended to be used as a reference guide for readers interested in the study of the development of furniture styles—historically and as style evolved as an integral part of architectural and interior design. Every attempt has been made to present the material in a format that is interesting yet informative. Through supplementary research, every effort has been made to verify often conflicting and sometimes contradictory information through a variety of additional sources to ensure the accuracy of these facts. In most cases, information used for specific items discussed in the text was based on written documentation secured through each respective museum.

ACKNOWLEDGMENTS

Completing a project such as this has been the most rewarding experience of my life and I could not have done it without encouragement and support. To my Interior Design colleagues at Wentworth Institute of Technology, the Art Institutes of Dallas and Fort Lauderdale, Lynn University, and Palm Beach Community College, thank you for your reassurance in realizing that a comprehensive book on furniture styles was long overdue. Thanks are also due to Cynthia J. Parker of Northern Arizona University for her editorial comments. A sincere thank you to Judy Whitlock and Rachel Pike who opened their personal libraries to me for research, as well as the numerous assistants at The Museum of Fine Arts, Boston, and The Metropolitan Museum of Art who guided me through their photographic archives in my search for the best examples of period furnishings. My gratitude is extended to my parents, Robert and Elizabeth Vleck, and my partner, Brian Mackey, who never hesitated to offer their financial support throughout the duration of the research and writing of this book. To David Vleck, my considerably artistic and talented brother who endured laborious hours to complete the over 200 illustrations used in this book, I cannot express enough appreciation for the enrichment these drawings have added to the text. And, finally, I acknowledge my indebtedness to the people who believed in this project when it was only an outline and a few sample chapters, including Mark Cohen at Prentice Hall.

TIMELINE

PART I HISTORICAL DEVELOPMENTS

Paleolithic Period

30,000–25,000 B.C.	Neanderthal man dies out	Small statuaries depict female nude as fertility goddess
15,000–10,000 B.C.	Nomadic man finds shelter in caves	Prehistoric cave paintings record life of early Homo Sapiens

Mesolithic Period

8000–7000 B.C.	Man begins agrarian culture and practices animal husbandry	Settlement at Jericho shows development of architecture

Neolithic Period

6500–5700 B.C.	Man establishes permanent settlements	Settlement at Catal Huyuk documents use of tools, furniture
4000–3000 B.C.	Advanced settlements develop along the Nile River in Africa	Post and lintel architectural construction methods used

Preclassical Period

3000–2000 B.C.	Egypt	Unification of Upper and Lower Egypt by King Narmer, beginning of the Old Kingdom	Great Pyramids at Giza; evidence of elaborate furniture—designed with animal legs, paw feet, gilding, inlay
	Aegean	Early Minoans settle on the island of Crete	Cycladic idols; evidence of basic furniture items, stools, tables, chests
2000–1000 B.C.	Egypt	Middle and New Kingdoms thrive; Pharaohs Tutankhamun, Ramses I, II, III	Temples, palaces built using post and lintel construction methods
	Aegean	Middle and Late Minoan civilization	Palace of Knossos built with indoor plumbing
		Mycenaeans occupy mainland, defeat Trojans	Citadels flourish until 1200 B.C.; beehive tombs; cyclopean architecture
	Italy	Etruscans move into Italy	Trabeated architecture

Preclassical Period (continued)

1000–500 B.C.	Egypt	Ethiopian kings rule Egypt	
	Greece	Beginning of the Archaic Period	Stone replaces wood as architectural material; Doric, Ionic, Corinthian orders of architecture
	Italy	Founding of Rome	Establishment of Roman Republic, 510 B.C.

Classical

500 B.C.–0	Greece	Classical Period; Persian Wars, 5th century B.C.	Acropolis buildings; furniture designed with graceful proportions; saber legs; metal, marble, and wood used
		Hellenistic period; Alexander the Great conquers Egypt, 332 B.C.	
		Greece becomes a Roman Province, 146 B.C.	
	Italy	Assassination of Julius Caesar in 44 B.C.; Octavius (Augustus) establishes Roman Imperial Period	Development of concrete, arch, and dome; furniture imitates Greek designs incorporating disc turning, massive proportions
0–500 A.D.	Italy	Christian persecutions; Emperors Trajan, Hadrian	Tuscan, Composite orders of architecture; arcuated architecture, Colosseum, Pantheon
		Late Imperial Period, Diocletian divides Empire	
		Constantine legalizes Christianity through Edict of Milan, 313.	Construction of Christian churches
		Seat of Roman Empire moved to ancient site of Byzantium in Turkey; city renamed Constantinople	
		Sack of Rome, 410; end of Roman Empire in the West	

The Dark Ages

500–1000	Eastern Empire	Byzantine Empire flourishes under Emperor Justinian, 565	Byzantine architecture
	England	Egbert, King of Wessex, 828— first king to rule all of England	
	Spain	Moorish invasion, 711	Islamic architecture
	Italy	Formation of the Papal States, 756	

		The Dark Ages (continued)	
	Central Europe	Charlemagne, King of the Franks, is crowned Holy Roman Emperor of the West by Pope Leo III, 800	Basilican churches, monasteries
		The Franks develop the feudal system establishing hierarchy of kings, barons, noblemen, and serfs (peasants), 800	

The Middle Ages

1000–1500	Europe	Rise of towns and guilds The Crusades, 1096–1204	Development of the Romanesque Style, 1000
	England	Establishment of Cambridge University, 1209	
	France	Introduction of the Gothic style of architecture, 1150	Oak; tracery, wrought iron hinges, trefoil, quatrefoil, linenfold panels, pointed arches, bracket feet used on furniture
	Eastern Empire	The Byzantine Empire is overthrown by the Turks, 1453	
	North America	Leif Ericsson explores the continent, 1002	
		Christopher Columbus explores the West Indies, 1492	

PART II THE MODERN WORLD

Period	Style	Significant Rulers or Events	Furniture Characteristics
15th–16th centuries Italian Renaissance		Death of Leonardo da Vinci, 1519	Walnut, heavy carving, pietra dura, intarsia, classical motifs based on Roman design
16th century Spanish Renaissance		Philip II, 1556–1598	Decorative wrought iron work, geometric designs based on Mudéjar influences, enlarged nailheads, decorative front stretchers and crest rail
16th century French Renaissance	Francis I	François I, 1515–1547	Oak, strong Gothic influences, diamond-point patterns, bun feet, limited classical detailing

Period	Style	Significant Rulers or Events	Furniture Characteristics
	Henry II	Henry II, 1547–1559; marries Catherine de'Medici of Italy	Oak and walnut, heavy carving depicting classical motifs brought to France by Italian craftsworkers, Burgundian influences
16th–17th centuries English Renaissance	Tudor	Henry VII, 1509–1547	Oak, strong Gothic influences, Tudor arch, romayne work
	Elizabethan	Elizabeth, 1558–1603	Oak and walnut, carving, bulbous forms include cup and cover turning, intarsia, limited classical details
	Early Jacobean, Cromwellian	James I, 1603–1625 Charles I, 1625–1649 Commonwealth, 1649–1660	Oak and walnut, bead turning, limited classical details, baluster forms
17th–18th centuries French Baroque	Louise Treize	Louis XIII, 1610–1643	Walnut, Burgundian influenced heavy carving, bead and baluster turning, stretchers, Flemish "S" and "C" scrolls, transitional style
	Louis Quatorze	Louis XIV, 1643–1715	Walnut and some oak, heavy carving, gilt furniture, saltire stretchers, square pedestal legs, tall rectangular-backed chairs, ormolu, boulle work, classical motifs
17th–18th centuries English Baroque	Late Jacobean	Charles II, 1660–1685 James II, 1685–1689	Oak and walnut, heavy carving, cane seat and back, barley sugar twist turning, Flemish "S" and "C" scrolls
	William & Mary	William & Mary, 1689–1702	Age of walnut, strong Dutch influences, extensive veneering, oystering, seaweed marquetry, burl walnut, bell or inverted cup turning, trumpet turning, japanning, chinoiserie, Spanish or paintbrush foot, baluster forms
17th century American	Early Colonial 1640–1720	Jamestown founded, 1607 Plymouth founded, 1620	Local woods; oak, pine, maple, utility furniture, Puritan economy, resembles English Jacobean, William & Mary styles

Period	Style	Significant Rulers or Events	Furniture Characteristics
18th century French Rococo	Régence	Regent, 1715–1722	Tall rectangular-back chairs, cabriole leg, saltire stretchers, classical and foliate motifs, transitional style has both Louis Quatorze and emerging Louis Quinze characteristics
	Louis Quinze	Louis XV, 1722–1774	Mahogany, walnut, ebony; chairs have shorter backs in cartouche shape, more curves including bombé, serpentine; cabriole leg with scroll foot, no stretchers, anticlassical motifs, Oriental influences, chinoiserie, gilt furniture, ormolu
18th century English Rococo	Queen Anne	Queen Anne, 1702–1714	Walnut, spoon-back chair with vase or fiddle splat, cabriole leg, pad, club, or claw and ball foot, delicate proportions, bracket feet on case furniture, bonnet top, cockle shell motif
	Early Georgian	George I, 1714–1727	Mahogany and walnut, heavy proportions, heavy carving, cabriole leg with carved bracketed knee, hairy paw foot, designs of William Kent
	Chippendale	George II, 1727–1760	Mahogany; French, Chinese, and Gothic influences; pierced carving, fretwork, tracery; cabriole leg with claw and ball foot; Marlborough leg
18th century French Early Neoclassic	Louis Seize	Louis XVI, 1774–1792 Reign of Terror, 1792–1795	Walnut, beech wood, mahogany, satinwood; classical motifs based on Pompeii; geometrical designs, ovals, arcs, medallions, squares; reeded or fluted round tapered legs with thimble feet; painted finishes, ormolu, gilding
18th century English Early Neoclassic	Late Georgian	George III, 1760–1820	Furniture designs influenced by Adam, Hepplewhite, and Sheraton
	Adam		Satinwood, painted beech wood; graceful proportions and classical motifs based on Pompeian excavations, paterae, urn, swags, lyre; round tapered legs with thimble feet

Period	Style	Significant Rulers or Events	Furniture Characteristics
	Hepplewhite		Mahogany and rosewood; shield-oval-, heart-, wheel-shaped backs; quadrangular front legs with sabot or spade foot, saber-back legs; classical motifs, wheat, urns, swags, Prince of Wales Plume; oval panels
	Sheraton		Mahogany and satinwood, square-backed chairs with trellis, lattice work, urn splats; quadrangular front legs with spade or sabot foot, saber-back legs; bell flower motif on legs
18th century American	Late Colonial, 1720–1785	American Revolution, 1775–1783	Walnut and mahogany; refined craftsmanship, Queen Anne and Chippendale influences
	American Federal, 1785–1815	Presidencies of George Washington, 1789–1797 and Thomas Jefferson, 1801–1809	Mahogany, cherry, walnut, and maple; resembles styles of Hepplewhite and Sheraton; furniture designed by Duncan Phyfe includes lyre forms, cornucopias, and pedestal bases
18th–19th centuries French Late Neoclassic	Directoire	The First Republic, 1792–1804	Mahogany, painted beech wood; strong Greek and Roman influences using klismos forms, rolled crest rail, saber front and back legs
	Empire	Napoleon, 1804–1814	Mahogany and rosewood; strong Roman influences with Greek and Egyptian motifs; saber-back legs, term front legs with paw feet, rolled crest rail, ormolu ornamentation, limited carving
19th century English Late Neoclassic	Regency	Regent, 1811–1820	Mahogany and rosewood; heavy proportioned furnishings with strong Greek, Roman, and Egyptian influences; some gilding, limited carving
	Victorian	Victoria, 1837–1901	Eclectic forms including Greek, Gothic, Renaissance, and Rococo revival
	Arts & Crafts 1860–1900		Oak; simplistic forms with rustic appearance; large brass hinges, limited inlay

Period	Style	Significant Rulers or Events	Furniture Characteristics
19th century American	American Empire, 1815–1840	United States and Britain, War of 1812	Mahogany; based on French Empire styles having strong Greek influence, ormolu, some gilding
	Shaker, 1800–1850		Religious sect furniture characterized by sturdy construction; utilitarian chairs and tables; no ornamentation; pine and maple
	American Victorian, 1840–1900	United States Civil War, 1861–1865	Based on English Victorian; historical eclecticism
	Mission, 1895–1930	Spanish American War, 1898	American Arts & Crafts movement; oak; rustic, rectilinear forms

COLOR PLATES

Color Plate 1 The Minoan Palace of Knossos, built from 1600–1400 BC, was partially reconstructed by Sir Arthur Evans in the nineteenth century. Notice the distinctive tapered columns used to support the roof. The capital design prefigures the Greek Doric Order used on many Archaic and Classical temples.

Color Plate 2 This dolphin fresco was reconstructed from original fragments found in the Queen's hall at the Palace of Knossos. The overlapping of both spiral wave and rosette decorative borders indicates that the room had undergone redecoration over the centuries of Minoan occupation.

Color Plate 3 This lekythos illustrates a woman pulling woolen yarns from a wicker basket. She is seated on a klismos chair and on the wall behind her is a mirror with a volute handle. A cloth hangs in the distance, possibly used to close off the room in which she works. Notice how the artist has detailed the klismos chair in this rendering: the dowels attaching the uprights and saber legs to the seat rail are exposed; individual strands of the rush seat are visible; and a polka-dot-printed loose cushion is shown hanging over the edge of the seat. The Greek key ornamental borders that frame the scene give a clear indication of how utilitarian objects coordinated with the interior decoration of the home. (Frances Bartlett Fund. Courtesy, Museum of Fine Arts, Boston.)

Color Plate 4 The atrium view of a Pompeian insula shows the impluvium built into the floor to collect rainwater from an opening in the roof. A marble table supported by massive trestles with paw feet is placed at one end.

Color Plate 5 This cubiculum nocturnum, or bedroom, contains artifacts taken from ancient Roman excavations. The frescos date from the first century B.C. and were taken from the villa of P. Fannius Synistor at Pompeii, while the mosaic floor, lectus, and footstool come from villas of a later date. (The Metropolitan Museum of Art, Rogers Fund, 1903. Photograph by Schecter Lee. Photograph ©1986 The Metropolitan Museum of Art.)

Color Plate 6 The Cathedral in Milan was begun in 1386 in the High Gothic style emphasizing the vertical height of the structure. Richly decorative carving on all façades adds textural qualities to the exterior stonework while depicting characteristic motifs for the period such as tracery, pointed arches, and towering pinnacles.

Color Plate 7 This scene taken from the illuminated manuscript, *Book of Hours of Catherine of Cleaves*, dates from c. 1435. Aside from the manuscript's biblical nature, the artist's representation of the Holy Family at Supper carefully records the interior of a working-class home. In this scene, the Virgin Mary sits in a simple, rush-seated ladder-back chair while Joseph sits in a chair made from a converted barrel. Storage furniture is limited to the "cup board" shown with an array of pewter to the left of the hooded fireplace and the small wall cabinet to the right. The baskets visible just above Joseph's head provide additional storage for various other household goods. The architecture is crude with an exposed beam ceiling, open windows, cracked plaster, and tiled floors that lack ornamentation or embellishment except for the small floor cloth placed under the Virgin Mary's feet. (The Pierpont Morgan Library/Art Resource, NY.)

Color Plate 8 *The Annunciation,* painted by Rogier Van der Weyden in the first decades of the fifteenth century, documents the interior of a home belonging to a wealthy family. Notice the following architectural details and furnishings: the ceiling is held up by large beams, the walls seem to be made from plaster, and decorative tile covers the floor. A large hooded fireplace on the left side of the room has a small iron

bracket designed to hold a candle attached to its surface. This candle provides only incidental lighting since the larger, more ornate chandelier hanging from the ceiling provides greater illumination. Windows remain open allowing natural light to enter the room and provide adequate ventilation to the interior. Notice that small, diamond-shaped glass panes are only used in the window's transom area. When necessary, the windows are closed off by heavy, wooden shutters. The furniture shows superb craftsmanship as each piece has detailed decorative carving. The settle, with its large velvet cushions, is pushed against the fireplace during the summer months and faces the fireplace during winter. Near the rear window, a tall, wooden armchair is crowded between a small credence and the tester bed. The red velvet canopy of the tester bed is supported by ropes attached to the ceiling, the hood of the fireplace, and the inside jamb of the window located on the right side of the room. Drapes placed inside the canopy are pulled around the bed at night for warmth and privacy. Household inventories dating from the Medieval period place greater value on tester beds primarily because of the cost of the fabric. The last item of furniture shown in this painting is the prie-dieu, a small bench used for praying. In this setting, the Virgin Mary kneels in front of the carpet-covered bench with her Bible. (Louvre. ©Photo RMN—Jean.)

Color Plate 9 The long gallery in this museum in Copenhagen features large paintings, hardwood floors, and period furniture lining the walls. Long galleries like this hallway provided a protected environment for walks and children's playtime during inclement weather. (Image Bank, Co Rentmeester.)

Color Plate 10 This château dating from the French Renaissance period is framed on both sides by massive turrets, reflecting a strict adherence to characteristic Medieval styling. The steeply pitched mansard roof with projecting dormer windows is more notable of the French Renaissance style. (Photo courtesy Jennifer R. Mackey.)

Color Plate 11 The Palazzo Davanzati in Florence dates from the fourteenth century and is indicative of most palaces owned by wealthy Florentines of the period. The rough-hewn painted beam ceiling, painted biblical scenes, tiled floor, and wall designs shown in this bedroom are typical for the fourteenth century although the bed, chairs, cradle, and credenza date from the sixteenth century. (Erich Lessing /Art Resource, NY.)

Color Plate 12 Dutch painter Emanuel de Witte documents seventeenth-century interior design and furnishings in his painting, *Interior with a Woman, Playing the Clavichord*. Specific items such as the fabric-draped tester bed and the Turkish carpet on the floor beneath it, the brass chandeliers, the gold-framed mirror, and carved architectural details reflect the wealth of the homeowner. Compare the design of the three chairs in the room and the table next to the window with English styles of the same period. (The Netherlands Office for Fine Arts, The Hague, loan, Museum Boijmans Van Beuningen, Rotterdam.)

Color Plate 13 Furniture design and interior decoration of the early Baroque period retain several Renaissance characteristics. Here, the room is finished with wood paneled walls hung with richly colored tapestries, wood plank flooring, and a coffered wood ceiling. Exuberant carving on the furniture advances toward the evolving Louis XIV style. Chairs are designed with tall rectangular backs and incorporate turned legs, baluster uprights, and H-form stretchers. The ornately carved crest rail and visible nailheads on the upholstered chair, along with animal legs on the table, reflect Renaissance design characteristics. The interior furnishings and room design are clearly transitional. (The Image Bank, David W. Hamilton.)

Color Plate 14 The bedroom of King Louis XIV at Versailles is richly decorated from floor to ceiling with gilt decorative moldings reflective of Baroque opulence. The railing separates the king's private sleeping area and the more public receiving room. It was not uncommon for the king to receive his invited guests while still in bed. The fauteuils and tabourets shown here could easily be moved around the room as necessary. Notice the bust of the Sun King by the sculptor Coysevox on the fireplace mantel. (Giraudon/Art Resource, NY.)

Color Plate 15 English, late seventeenth-century chairs of this design, dubbed "sleeping chairs," were used for convalescing. The example shown here dates from between 1677 and 1679 and was taken from Ham House located in Petersham, Surrey. Distinctive side panels kept drafts away from the face while an adjustable ratcheted back enabled the occupant to comfortably recline. This chair has a carved and gilt wood frame and is upholstered in red brocade fabric. The iron rods used to secure the tilt of the back are visible just under the left armrest. (Courtesy of the Trustees of the V&A, V&A Picture Library.)

Color Plate 16 An English William and Mary-style bureau, circa 1700, made from mulberry with kingwood banding and pewter inlay has a slant front, fitted drawers, and ball feet. (Bonhams, London, UK/Bridgeman Art Library Int'l. Ltd., London/New York.)

Color Plate 17 This view of a room miniature reflects characteristic furnishings and architectural details of the French Rococo period. (Boudoir, French, 1740–60, period of Louis XV, great Rococo influence, Workshop of Mrs. James Ward Thorne, mixed media, c. 1930–40, 46.4 × 62.9 × 58.7 cm, Gift of Mrs. James Ward Thorne, 1941.1206, overall view. Photograph by Kathleen Culbert-Aguilar, Chicago. Photograph ©1997, The Art Institute of Chicago, All Rights Reserved.)

Color Plate 18 The 1769 oil on canvas painting, *Venus Securing Arms from Vulcan for Aeneas*, by the French painter, François Boucher captures the Rococo spirit through its idyllic portrayal of mythological themes and its soft, pastel color palette. Large scale paintings such as this one (measuring 107 3/4″ × 80 5/8″) were often used as cartoons from which tapestries or Aubusson rugs were woven. (Kimbell Art Museum, Fort Worth, Texas.)

Color Plate 19 This room, circa 1735 with later additions, was taken from the Hôtel de Varengeville in Paris and reflects a fully developed Rococo style with an emphasis on asymmetrical curvilinear designs and chinoiserie motifs. Paneling, textiles, and furniture reflect these characteristics and work to unify the Rococo period within the Louis XV style. The paneling shown in this room, commissioned from Nicolas Pineau by the Duchess de Villars, is carved, gilt, and painted oak. The panels are unified in their designs, although each panel is slightly different in its central motif. Furniture in the Louis XV style includes fauteuils, a commode, a lacquered bureau plat with chinoiserie panels, a desk chair with caning, and a tabouret. (The Metropolitan Museum of Art, Purchase, Mr. and Mrs. Charles Wrightsman Gift, 1963. Photograph ©1995 The Metropolitan Museum of Art.)

Color Plate 20 An English Queen Anne-style dressing mirror with lacquered finish and chinoiserie doubles as a writing desk. Notice the pull-out knobs used to support the fall-front writing surface. (Frank Partridge Ltd., London/Bridgeman Art Library International Ltd., London/New York.)

Color Plate 21 A black and gold lacquered bed from the workshop of Chippendale dates from around 1755. Massive in size, the bed's Chinese influenced design is elaborate with its pagoda top, dragon finials, and fretwork headboard. (Courtesy of the Trustees of the V&A, V&A Picture Library.)

Color Plate 22 The second floor chamber from the late seventeenth- early eighteenth-century home of John and Sarah Wentworth in New Hampshire reflects refinement in household furnishings for the period. American homes at this time were comparably smaller in scale than English counterparts. The low beamed ceiling, plaster walls, and wide plank flooring is typical of late seventeenth century interior architecture while the furnishings are characteristic of the American Late Colonial-style fashioned after the English Late Jacobean and William and Mary styles. Notice the wing chair in the foreground with its turned stretchers and front legs shaped in the manner of a cabriole form. Several chairs line the wall in the background, each showing a degree of heavy carving, turning, and caning. A highboy with bell turned legs is visible against the back wall and displays a collection of Chinese export porcelain. The gate leg table in the foreground with its turned legs and stretchers is covered with an Oriental carpet, a common

practice for the period since these textiles were considered too valuable to walk upon. The centerpiece is also Chinese export porcelain. (The Metropolitan Museum of Art, Sage Fund, 1926.)

Color Plate 23 This room setting shows reproduction Queen Anne-style furnishings, one of the more popular traditional styles adapted for the American home during the twentieth century. Note the height of the tea table is appropriately proportioned by eighteenth-century standards. (Courtesy, Kindel Furniture Company.)

Color Plate 24 This parlor room dates from the mid-eighteenth century and was taken from the second floor of Samuel Powell's Philadelphia residence. The room and its contents were greatly influenced by the Rococo style of design prevalent in Europe at this time. The furniture, all made in Philadelphia, represents designs adapted from Chippendale's *Director* and include a slant-front secretary and Chippendale-style chairs arranged around a pie-crust table. The wallpaper is of the period, but not original to the room. The cross-stitch wool carpet was made in England in 1764. (The Metropolitan Museum of Art, Rogers Fund, 1918. Photograph ©1995 The Metropolitan Museum of Art.)

Color Plate 25 The Reception room from the Hôtel de Tesse in Paris dates from around 1768–1772 and shows a fully developed Neoclassical style designed by the architect Pierre Noel Rousset. The curvilinearity of the Rococo style has been supplanted by a strict adherence to geometrical-based designs as seen here in the wall panels, mantelpiece, and furnishings. The woodwork was completed by Nicolas Huyot and the stucco relief over the doors are attributed to Pierre Fixon. Furniture in the room is of the Louis XVI style, and include a secretary, commode, and mechanical table made by Jean-Henri Riesener for Queen Marie Antoinette, along with a canapé, bergéres, fauteuils, and tabourets. (The Metropolitan Museum of Art, Gift of Mrs. Herbert N. Straus, 1942. Photograph ©1995 The Metropolitan Museum of Art.)

Color Plate 26 Monticello, Thomas Jefferson's home outside Charlottesville, Virginia, reflects his interest in the emerging Neoclassic style. With an emphasis on symmetry, the central dome and large portico anchor the projecting wings on either side.

Color Plate 27 This boudoir taken from the Hôtel de Crillon located on the Palace de la Concorde in Paris dates from around 1777–1780. Designed by Pierre Adrien Pâris for Louis Marie Augustin, duc d'Aumont, the room reflects a fully developed French Louis XVI interior style; wall panels are painted with classical themes and include sweeping arabesques, Roman sphinxes, and cupids. The painted and gilded oak lit à travers and bergére were made by Jean Baptiste Claude Sené in 1788 and reflect the Louis XVI style. Also visible in the room are a lady's work table, or table à ouvrage, and a mechanical table used as both a vanity and a writing table. (The Metropolitan Museum of Art, Gift of Susan Dwight Bliss, 1944. Photograph ©1995 The Metropolitan Museum of Art.)

Color Plate 28 Percier and Fontaine transformed Château de Malmaison into a domicile fit for the new ruler of France, Napoleon Bonaparte, who crowned himself "Emperor" in 1804. This view of the council room shows military-style decor with walls designed to look like tenting. The center table, fauteuils, and chaises reflect furniture styles derived from excavations at Pompeii, with subtle Egyptian themes. (Giraudon/Art Resource, NY.)

Color Plate 29 Red silk fabric with gold embroidery draped over the walls and ceiling resemble military-style tenting in Percier and Fontaine's design for Empress Josephine's bedroom at Château de Malmaison. There is an abundance of feminine grandeur with the elaborately draped and carved gilt bed bearing Josephine's monogram. Along with the fauteuils shown in this room are a pietra dura table, a lavabo, and a vanity. (Giraudon/Art Resource, NY.)

Color Plate 30 In this view of the Tapestry room from Croome Court, Worcestershire, England, hearty festoons and delicate swags, palmette and honeysuckle patterns, sweeping rinceau patterns, and pateraes appear in the design of the ceiling, carpet, and tapestries. All of these characteristics are consistent with the designs of the Neoclassi-

cal period and include works by Robert Adam, François Boucher, John Mayhew, and William Ince. The Robert Adam designed ceiling was executed by artisan Joseph Rose; the furniture was made by John Mayhew and William Ince; and the tapestries were designed in 1759–1767 by Francois Boucher, woven 1764–1777 in the workshop of Jacques Neilson at the Gobelins for George William, sixth earl of Coventry and are made from wool and silk. (The Metropolitan Museum of Art, Gift of the Samuel H. Kress Foundation, 1958. Photograph ©1995 The Metropolitan Museum of Art.)

Color Plate 31 This room shows a recreation of a formal front parlor in a fashionable New York City townhouse from around 1835. The suite of furniture in this room was made by Duncan Phyfe for New York lawyer, Samuel A. Foote. The meridienne and curule form stool is mahogany veneer. (The Metropolitan Museum of Art. Photograph ©The Metropolitan Museum of Art.)

Color Plate 32 A twentieth-century adaptation of the American Empire period. The Neoclassical chairs and sofa fit well within the modern traditional interior. What was once an accessory item in the nineteenth century, the Grecian urns have been translated into lamps, while a scaled-down tea table serves as a coffee table. (Courtesy Kindel Furniture Company.)

Color Plate 33 This exquisite Biedermeier mahogany sofa with gilt swans came from the workshop of Anton Kimbel in New York and dates from the mid-nineteenth century. Anton's father, Wilhelm Kimbel, was one of the leading Biedermeier cabinet makers of the period. (Courtesy Ritter-Antik, New York.)

Color Plate 34 Turned beech wood spindles and a rush seat are the basic components for this simple but functional arm chair created by Morris & Company around 1870. The chair is set against hand blocked wallpaper in the "Chrysanthemum" pattern designed by William Morris and printed by Sanderson. Sanderson has been printing Morris' wallpaper designs since 1864. (Courtesy Sanderson.)

Color Plate 35 This original Gustav Stickley chair made from quarter sawn white oak has a beautiful flaked-grain pattern. An aged patina was achieved by subjecting the wood to ammonia fumes while a hand-rubbed finish gave the piece its luster. The lamp and chair reflect an Arts and Crafts style known in America as the Mission style. (Courtesy The Mission Oak Shop, Putnam, Connecticut.)

Color Plate 36 A room in the Musée des Arts Decoratifs in Paris shows the exuberance of the French Art Nouveau style. The architectural woodwork and furniture date from 1900 when the Art Nouveau style was at its height in Paris. As seen throughout the development of furniture design, coordination between the architectural interior and furnishings were carefully planned. Notice how the vine patterns and botanical motifs seen in the woodwork are incorporated in the two chairs flanking the entrance. (Reproduced by permission from the Musée des Arts Decoratifs, Paris. Photo by Laurent-Sully JAULMES, All Rights Reserved.)

Color Plate 37 Charles Rennie Mackintosh designed the Argyle chair in 1897 for he and Margaret Macdonald's apartment in Glasgow. Made from oak, the chair has a black stain finish consistent with other Mackintosh chairs. The tall back and unadorned surface treatment attests to the Modern spirit in furniture design. 57 7/8″ H, 19″ W, 18 3/8″ D. (Courtesy Cassina.)

Color Plate 38 Frank Lloyd Wright designed this Prairie-style house located in Grand Rapids for the Meyer May family in 1908. Consistent with the characteristics found in Wright's other Prairie designs, low height walls and freestanding partitions act as dividers within an open-plan interior. The golden oak millwork stands out against a background of warm ochres as Wright's selective layering of contrasting colors and materials emphasizes the horizontal. All of the home's furnishings including the textiles, mural design, carpets, light fixtures, furniture, and stained glass windows, were carefully executed by artisans according to Wright's drawings and specifications. (Courtesy Steelcase Inc., Grand Rapids, Michigan.)

Color Plate 39 Piet Mondrian's *Composition No. 8*, an oil and canvas painting completed between 1939 and 1942, reflects the fully developed De Stijl movement. Mondrian's prominent use of black lines binds the white, two-dimensional flat plane measuring 29 1/2 inch × 26 3/4 inch to a grid of squares and rectangles accented only by the primary hues of red, yellow, and blue. (Photograph by Michael Bodycomb, Kimbell Art Museum, Fort Worth, Texas.)

Color Plate 40 Gerrit Rietveld designed the Red Blue chair in 1917 for the Schröeder House. Written accounts describing the interior of the Schröeder House explain how Rietveld created a three dimensional study of a Mondrian painting using the Red Blue chair. Placed on a black painted square section of the floor, the red, blue, and yellow planes appeared to float in space as the chair's black supporting framework visually blended in with the background. 34.6″ H, 26.2″ W, 32.6″ D. (Courtesy Cassina.)

Color Plate 41 The table designed by Rietveld for the Schröeder House complements the Red Blue chair in its use of primary hues, black and white. The interconnecting planes reflect the intensity of the exterior architecture. 23.6″ H, 20.3″ W, 19.6″ D. (Courtesy Cassina.)

Color Plate 42 Characteristic of the International style of architecture, LeCorbusier based his 1929 design for Villa Savoye on machine aesthetics instead of regional vernacular. The slender steel columns used to support the structure replaces the need for load bearing walls allowing for unobstructed interior spaces and more flexibility with window placement. (Anthony Scibilia/Art Resource, NY.)

Color Plate 43 The Mae West apartment in Teatro-Museo took Surrealism to the ultimate three dimensional realm of tromp l'oeil by creating a room with the apparition of Mae West's face. Here, Salvador Dali's painting documents the result: draped fabric used at the entry create the hair, steps leading into the room form the chin, a Jean Michel Frank designed sofa appropriately placed in the room form the lips, and a sculpted-nose-fireplace is placed between two landscape paintings that camouflage the eyes. (Salvador Dali, Spanish, 1904–1989, Mae West, gouache over photographic print, ©1934, 28.3 × 17.8 cm, Gift of Mrs. Gilbert W. Chapman in memory of Charles B. Goodspeed, 1949.517. Photograph ©1997, The Art Institute of Chicago, All Rights Reserved. ©1998 Demart Pro Arte®, Geneva/Artists Rights Society (ARS), New York.)

Color Plate 44 The original Lip sofa was made by Jean Michel Frank in 1936 after Salvador Dali's design for the *Mae West Room,* a Surrealist installation at the Teatro-Museo depicting movie legend Mae West as a furnished room. This reproduction is by Green & Abbott, a London furniture firm. In 1972, the lip sofa was reintroduced as the Marilyn sofa after Marilyn Monroe. (Royal Pavilion Libraries and Museums, Brighton.)

Color Plate 45 An Art Deco-style bed made of Macassar ebony. 48″ H, 72″ W, 84″ L, 34″ footboard height. (Photos courtesy Shapes Collection, Los Angeles.)

Color Plate 46 The San Francisco showroom for Knoll Associates, Inc., designed by Florence Knoll in 1956, captures the contemporary character of the California-style interior. Large expanses of space provide a backdrop for over-scaled artwork while furnishings by Knoll-represented designers Mies van der Rohe and Saarinen are grouped to define separate sitting areas. (Courtesy Knoll.)

Color Plate 47 The 1951 Eames Shell chair, molded fiberglass with aluminum supports on rockers. (Private Collection, Photo courtesy Laura Rafferty.)

Color Plate 48 The Tulip collection of chairs shown here with circular tables were designed by Saarinen and introduced through Knoll in 1957. Saarinen emphasized slender aluminum pedestals that appear to effortlessly support the mass of the structure in the design of both marble table and fiberglass-coated plastic shell chairs. Although pedestal tables date back to Egyptian times, Saarinen's Tulip chair was the first to utilize a pedestal base. (Courtesy Knoll.)

Color Plate 49 Scandinavian designer Arne Jacobsen exaggerates organic forms derived from nature to create interesting yet comfortable sculptural furnishings. His Egg

chair designed in 1958 has a molded fiberglass shell layered with foam and fabric and is supported by an aluminum base. (Showroom Collection, Citi Modern, Dallas.)

Color Plate 50 The Mezzadro stool, or tractor seat stool, was designed in 1957 by the Italian designer Castiglioni. Rereleased in 1971, the stool's design captures the spirit of the Pop art movement that endured for almost two decades. (Courtesy ICF.)

Color Plate 51 Designed by Ettore Sottsass, founder of the Memphis movement, the room divider shown here exemplifies the attitude of many Memphis designers with its playful design, reminiscent of the Pop art movement, and colorful use of plastic laminate. (Ettore Sottsass, Italian, b. 1917, Carlton Room divider, plastic laminate on wood, 1981, 194.3 cm × 190 cm × 40 cm. Restricted gift of the Antiquarian Society, 1984.1035. Photograph by Kathleen Culbert-Aguilar, Chicago, Photograph ©1997, The Art Institute of Chicago, All Rights Reserved.)

Color Plate 52 The Piazza d'Italia designed by Charles Moore for the City of New Orleans to commemorate its Italian ethnic population, exemplifies one aspect of early Postmodern architecture. Moore completed this project in 1980 when postmodernism was just beginning to emerge in the American vernacular. His approach to the modernization of historical elements in architecture includes highly stylized steel classical columns and capitals accentuated at night with bands of neon tubing.

Color Plate 53 Designed in 1982 by the Italian designer Paolo Deganello, the Torso lounge reflects the nostalgic 1950s with soft boomerang contours supported by slender stick legs. The collection also includes a chair and settee. 57″ W, 45.6″ H, 41.7″ D. (Courtesy Cassina.)

Color Plate 54. A bedroom dresser designed by Robert Kornstein in 1997 made from satinwood combines traditional craftsmanship and materials with artistic expression of form. 80″ L × 36″ H × 20″ D. (Photo courtesy Arkadia, Englewood, NJ 07631, 800.223. 3281.)

Color Plate 55 Philippe Starck combined the elegance of Deco 1930s styling with surprising interior details to create an interesting gathering place in the lobby of the Paramount hotel in New York. A stainless chaise lounge designed by Australian designer Mark Newson accentuates Starck's tapering staircase and angled glass handrail. (Courtesy Starck.)

Color Plate 56 Starck's contemporary furnishings are complemented by a fabric reproduction of the *Lace Maker* by Baroque artist Jan Vermeer in a room at the Paramount in New York City. The checkerboard carpet motif is maintained throughout the hotel's interior. (Courtesy Starck.)

Color Plate 57 The Bodleian chair, with its exaggerated volute arms, sweeping saber legs, and rolled back, takes a twentieth-century retrospective look at the Late Neoclassic Regency style. Designed by the architect Robert A. M. Stern. (Courtesy HBF.)

Color Plate 58 This contemporary secretary designed by Vicente de Moltó and made of yew offers a contemporary twist on the French Empire and Biedermeir styles of the nineteenth century. (Photo Courtesy Moltó, Geneva, Switzerland.)

Color Plate 59 The Elson commode by twentieth-century designer Scott Cunningham incorporates Baroque flair in a truly modern spirit with exaggerated Roman sphinxes and dynamic ormolu. (Courtesy, Scott Cunningham.)

Color Plate 60 These samples show the coloring and grain of the more common woods used in the construction of furniture. From left to right on the charts; plain sliced oak, walnut, mahogany, birdseye maple, ebony, and ash. (Samples courtesy of Ven Tec, Ltd.)

• PART I •

HISTORICAL DEVELOPMENTS

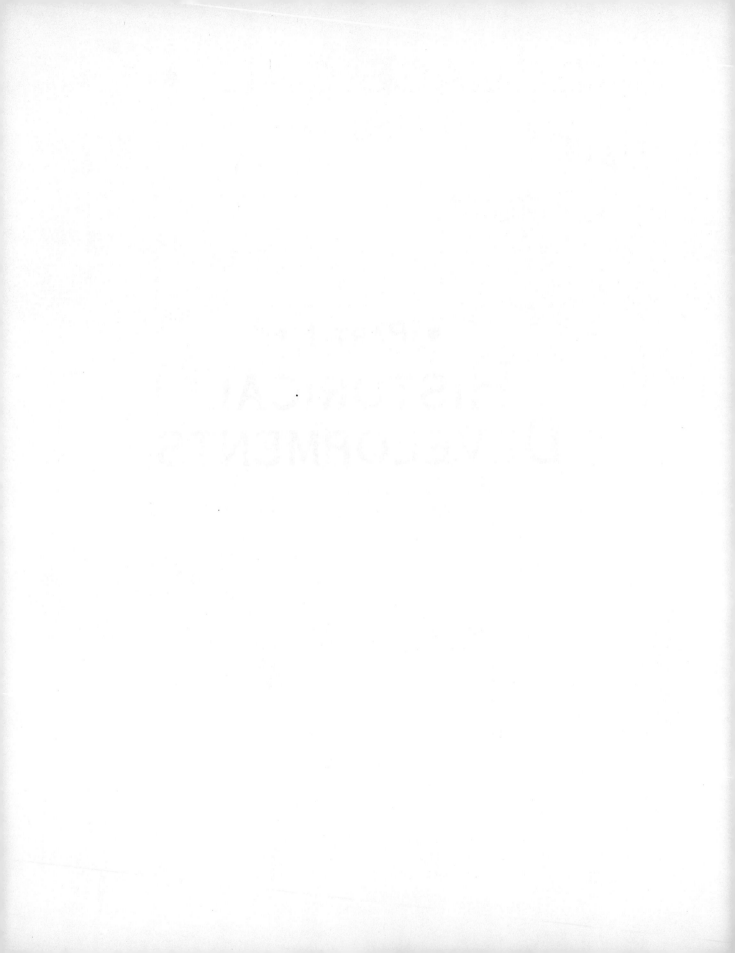

PRECLASSICAL • 1 •

NEOLITHIC CULTURE

As the human race became less dependent on hunted animals for their primary food source and began agricultural cultivation, permanent settlements followed. Since there is no recorded history before 3100 B.C., scholars such as archeologists, art historians, and anthropologists must reconstruct the lives of our primitive ancestors through thorough analysis of artifacts removed from excavated sites. Artwork, such as painting and sculpture, chronicles the lifestyles of early civilizations and provides these scholars with valuable visual references.

The study of the decorative arts is best understood by gaining insight into the lifestyles of the ancients. Scholars who analyze the remains of early settlements can trace the evolution of the creative process through painting and sculpture, architectural construction, or the production of utilitarian objects.

Since the prehistoric period was a time when no written form of communication existed, much speculation is based on scientific research. Archeologists, art historians, and anthropologists are educated to interpret the past through an examination of excavated artifacts, although it is difficult for them to know anything with absolute certainty.

The earliest known artifacts from prehistoric periods were made to fulfill a spiritual or practical purpose. As more advanced civilizations evolved, individuals instinctively brought beauty into their daily existence. We learn that personal possessions often reflected the power, authority, and wealth of an individual. Wealthier individuals lived in houses embellished with the finest materials and decorative furnishings. Throughout history, humans have surrounded themselves with beautiful objects that announced their wealth to others. This led to the refinement of the decorative arts as each generation attempted to live a better lifestyle than the previous one.

The earliest prehistoric settlement, Jericho, dates from around 8000–7000 B.C., during what historians classify as the Mesolithic period (Middle Stone Age). Excavations at Jericho reveal only fragmented information about its former residents. Unearthed from this location in the Jordan River valley were stone fortifications and houses made from

mud bricks. The houses had traces of decorative painting on the plastered floors and walls and contained small statues possibly used for religious or cult ceremonies. Because no pottery fragments or household furnishings were found, little is known about the lifestyle of these prehistoric dwellers.

A later settlement, far more developed than Jericho, was discovered in Turkey. Archeologists exposed the Neolithic (New Stone Age) city of Catal Huyuk dating from around 6500–5700 B.C. This excavated village contained more advanced examples of artwork including the earliest known landscape painting. Brightly colored decorative patterns, human figures, and animals were painted on the interior walls of houses and shrines. Although crude in artistic execution, these paintings offer a pictorial account of daily life and what was important to these early inhabitants.

Also found at Catal Huyuk were storage receptacles made of stone, wood, wicker, and pottery as well as textile fragments and woven floor mats. Even though most of the items discovered at this site were designed to fulfill a practical purpose, they were elaborately decorated. Remarkably, the textile fragments had traces of geometric patterns that corresponded to painted wall designs.

It is not known when the first human sat on a rock to rest his tired body. Whenever it occurred, it must have been an improvement over sitting on the ground since this unrecorded event eventually led to the evolution of furniture design and construction. Furniture items were found in Catal Huyuk, although scholars are not sure if these are the earliest examples. Inside the excavated homes were built-in reclining couches, or beds, made of plaster. Presumably, these couches were used for lounging, eating, or working; however, found buried in the floor beneath some couches were human skeletal remains. This discovery suggests that the couches may also have functioned as shrines for the ancestral dead.

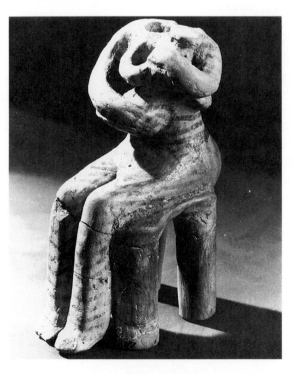

Figure 1 A clay idol from the Neolithic period shows a female deity seated on a simple stool.
National Archaeological Museum, Athens. Photo courtesy of the Hellenic Republic Ministry of Culture, Archaeological Receipts Fund.

Along with these couches, other examples of furniture were found at Catal Huyuk. Small clay statues recovered from grain bins depict female figures seated on stools. Although primitive in artistic technique, these sculptures clearly show another form of seating furniture used by this Neolithic culture. The findings at Catal Huyuk, along with other sculptures found in Europe that date from the fifth–fourth millennia, establish a precedent for furniture design and usage and document the advances of Neolithic culture.

In summary, an analysis of cultural development exposes the human desire to create beautiful objects and incorporate them into his or her environment. How each culture coordinates design characteristics in the built environment results in a unique stylization of furniture, textiles, architecture, and art. This is how we distinguish one cultural period from another and gain insight into our own sense of aesthetic awareness.

THE EGYPTIANS

In 3000 B.C., King Narmer of Upper Egypt defeated the ruler of Lower Egypt and established the first political dynasty to rule one unified country. Egypt's geographical location in northeastern Africa clearly separated the Egyptians from nearby Summerian and Mesopotamian cultures, although trade occurred frequently between the regions. The Nile River, flowing from the south to the north and into the Mediterranean Sea, supported economic growth and development along its banks. Egypt became a powerful nation and many Egyptians prospered throughout its lengthy history that survived through thirty dynasties.

Generally divided into three distinct cultural periods, the Old, Middle, and New Kingdoms of Egypt reflect a unique stylization of art, architecture, and decoration that separate them from earlier Summerian culture. The accomplishments of ancient Egyptian craftsmen influenced and inspired architects and designers all through history. Napoleon's campaigns into Egypt in the late eighteenth century contributed to the revival of Egyptian-based design motifs and characteristics seen in interior design of the period. More recently, early twentieth-century designers incorporated Egyptian design motifs into the Art Deco style prevalent in the 1920s and 1930s.

Egyptian Architectural Settings

In order to understand how furniture became an integral and inseparable part of interior architectural design, it is necessary to review specific types of structures built during the Egyptian Old, Middle, and New Kingdoms. During all Egyptian periods, architectural development consisted of tombs for burial, temples for religious practices, palaces or villas for the wealthy, and row houses for the general population.

Architectural design concepts borrowed from earlier Summerian and Mesopotamian civilizations enabled Egyptian builders to create distinctive pyramidal burial tombs during the Old Kingdom. Contributing to a dearth of available information about this culture were the Egyptian burial practices that

Figure 2 The Great Pyramids at Giza, built between 2570 and 2500 B.C. are monumental examples of burial tombs typically built during the Old Kingdom in Egypt. All three pyramids were covered with limestone after construction was completed. This gave the sides a smooth surface and reflected the intensity of the setting sun. The larger pyramid belonging to Cheops still has traces of the limestone.
Courtesy of the General Director of the Egyptian Museum, Cairo.

actually preserved many artifacts for nearly 5,000 years. Egyptians devoted themselves to preparing for the afterlife where the spirit, or "ka," would live for all eternity. During the Old Kingdom, pyramidal burial monuments like the Great Pyramids in Giza were built to honor the pharaohs. Located within the pyramid, a burial chamber provided a dwelling place for the spirit. Food, tools, clothing, jewelry, games, and furniture items were sealed in the chamber with the mummified body of the deceased. Egyptians believed that the spirit would enjoy all of these comforts in the hereafter.

Interior walls of the burial chamber were plastered and painted with scenes of Egyptian life, both carnal and spiritual. These paintings supply documentation of opulent lifestyles and provide accurate accounts of the type of furniture used by the Egyptians. The designs seen in tomb paintings incorporated the brightly colored geometrical designs on the floors and ceilings of the burial chamber, completing the overall interior decoration of the tomb.

The practice of burying the pharaoh with all of his worldly possessions continued through the Middle and New Kingdoms, although the types of burial monuments changed in design from pyramids to tombs. Such expensive burial accommodations were not affordable for the general population; therefore, the burial tombs discovered to date belonged only to wealthier Egyptians such as pharaohs and noblemen.

Vast architectural complexes used in religious practices for funerary purposes developed during the Middle Kingdom and continued to dominate New Kingdom architectural design. The temple became another significant accomplishment of Egyptian architectural design. Constructed to honor the gods, temples were intentionally built of hard stone rather than mud brick. Having to stand for all of eternity, these structures had to be more permanent. Made of limestone, sandstone, or granite, many temples, like burial tombs, still exist today either whole or in part. *Hieroglyphics* were inscribed into the plastered walls of the temple and carved in relief on the large column shafts that sup-

ported the roof in the *hypostyle* hall. Artists painted the hieroglyphics with bright colors so that the text could be easily read and interpreted.

Sophisticated town planning created a clear distinction between rank and social class by providing accommodations in separate sectors of the city. Within the main sector of town, merchant classes were housed in single-story row houses arranged back to back and in close quarters. By the New Kingdom, these dwellings rose to a height of two or three stories.

The layout of each house followed a similar plan; the living area was located near the entrance with a kitchen and open-air courtyard to the rear. A staircase accessed the second level leading to bedrooms, while the third level or rooftop served as a terrace or place for storing grains. For privacy, windows on the street side were shielded with palms or protected with *tracery*.

Made from sun-dried mud bricks, all that remain of these types of dwellings are their foundations, with some wall and floor fragments. Painstaking reconstruction of these fragments shows that the *façades* were brightly painted, with the door and window openings in contrasting colors. Artwork was considered a luxury; therefore, dwellings for the working classes lacked elaborate decoration since most residents could not afford to hire trained craftsmen.

While most could only afford to live in these modest quarters, wealthier priests and noblemen lived in large compounds. Palaces and villas proved to be much more luxurious than row houses and varied in size depending on the wealth and social status of the inhabitants. Most Egyptian palaces were located near the religious temples and were lived in by pharaohs or priests. Villas housed wealthier civil servants who could afford the plot of land required for a freestanding house. These estates had gardens, granaries, and outbuildings that allowed the residents of the villa to be self-sufficient. Built of fired brick, more examples of palaces and villas have been excavated, although none have survived completely intact. Foundation, wall, and ceiling fragments have been unearthed from sites in Amarna and Thebes that date from the New Kingdom.

Thorough analysis of wall and foundation fragments enable archeologists and art historians to reproduce these ancient structures in drawings or models.

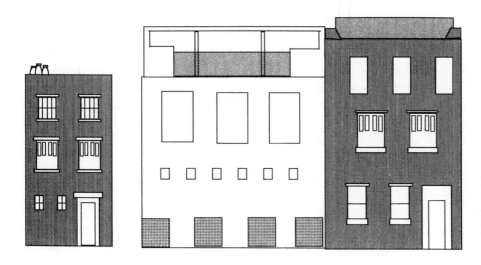

Figure 3 This drawing of a reconstructed street scene depicts typical multistoried housing for middle-class Egyptians living during the New Kingdom.

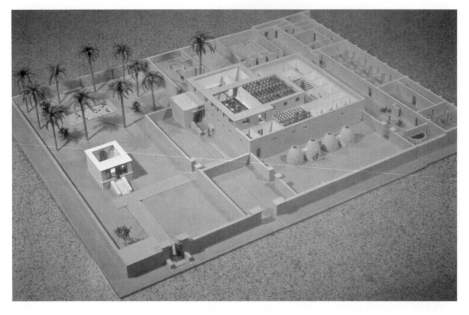

Figure 4 A model of a private villa and estate located in a suburb of Tell-Amana was based on an excavated site originally dating from 1350–1334 B.C. It is characteristic of architectural design afforded by wealthier Egyptians, typically of the noble class.
Courtesy The Oriental Institute of the University of Chicago.

Excavated fragments show that plaster was commonly used to cover the floors and interior walls, and in many examples, traces of decorative paintings remain. The geometrical patterns used around window and door openings were often accented with design motifs modeled after plant and animal forms. Along with these paintings, household inventories maintained by scribes in hieroglyphic-filled texts provide valuable references for researchers.

Egyptian Design Motifs

Motifs are stylized designs used to decorate architectural elements, furniture, decorative objects, and textiles. Plants and animals indigenous to the Nile inspired many Egyptian craftsworkers. Lotus and papyrus flowers used consistently throughout Egyptian design symbolized Upper and Lower Egypt, respectively. Consequently, when the two regions were unified by King Narmer, the intertwining of the lotus and papyrus was frequently used to represent a united Egypt.

Other motifs carried different types of symbolic associations. Animals often exemplified religious deities. The image of the hawk was associated with the sky god, Horus, while vultures and falcons with full wingspreads were protectors against evil or harm. During ancient times, supernatural powers were often attached to specific designs or fantastical figures. While griffins emanated protective powers, the ankh symbolized eternal life. Design motifs based on geometrical patterns and plant and animal forms continued to be used as ornamentation, although supernatural attachment lessens with each subsequent culture.

Egyptian Furniture

During ancient times, there was not an abundance of furniture items and most Egyptians, from both the lower and upper classes, had only basic pieces.

Lotus and papyrus borders

Spiral and rosette patterns

Fret Lotus bud

Chevron Checkerboard

Ankh Vulture Deities Griffin

Stools, chairs, chests, and tables were the most frequently used, and the craftsmanship varied depending on the owner's wealth. Most furniture items were constructed out of wood, although this material was relatively scarce in Egypt. Sycamore and palm were more available and used often by the Egyptian furniture maker. At great expense to the owner, woods were often imported—ebony was brought in from Nubia and cedar from Lebanon.

In most cases, household furnishings used by the residents of the row houses were minimal and strictly utilitarian. Furniture items consisted of wooden tables and folding stools with cloth seats, or three-legged stools (similar to a milking stool) with wooden or *rush* seats. Family members usually slept on straw-stuffed linen mattresses placed directly on the plastered floor. Occasionally, some residents had built-in plaster couches similar to ones found in the Neolithic city of Catal Huyuk.

Physical examples of furniture and household objects dating from the Old and Middle Kingdoms are limited; however, objects used during these periods can be seen in numerous wall paintings, relief carvings, and *sarcophagi* details. The best examples of Egyptian furniture and household articles come from burial tombs sealed during the New Kingdom. The tomb of King Tutankhamun, remaining virtually intact since the time it was sealed in 1325 B.C., provides some of the most exquisite specimens in construction, materials, and decoration. Furniture items removed from this tomb reveal intricate decorations using *gilding*, *inlay*, and *carving*. These objects were found among vases, baskets, lamps, and a multitude of both utilitarian and ceremonial artifacts.

The most basic furniture item found in the Egyptian home, whether row house or palace, was the stool. Generally, there were two types of stools: a folding type used mostly by men and a fixed type that varied in design and decoration. The folding stool had an X-form base designed to collapse. The

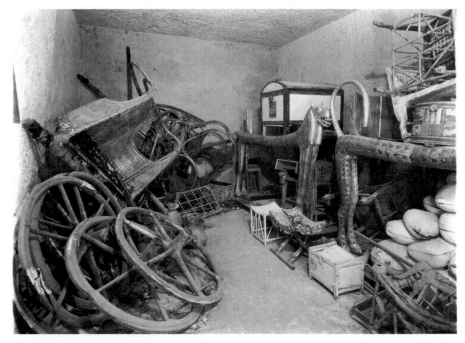

Figure 6 An interior view of the Tomb of King Tutankhamun, which was sealed during the Egyptian New Kingdom, 1325 B.C., and excavated in the 1920s, shows several furniture items. Many of the items placed in the tomb—specifically the two animal-form couches—were built by royal cabinetmakers for funerary purposes only. Notice how the items were placed in the tomb, not as if they were going to be used, but as if they were about to be taken on a journey.
Photography by Egyptian Expedition, The Metropolitan Museum of Art.

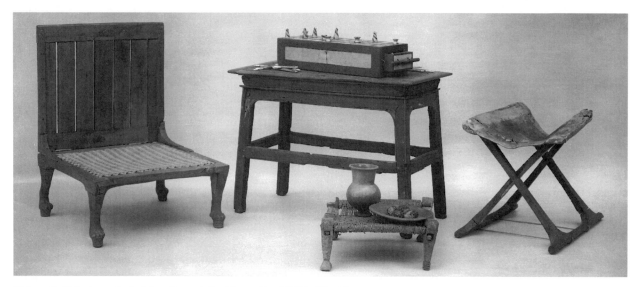

Figure 7 This grouping of furniture dating from the Middle Kingdom represents some of the most basic items found in an Egyptian household. The side chair has straw webbing that would have supported a loose cushion for added comfort. The table is designed with splayed legs and stretchers and is set with a game board for playing Senet. A small stool doubles as a low table, and the X-form stool, the most portable item, is designed to fold so it could be carried anywhere.
The Metropolitan Museum of Art, Gift of Egyptian Exploration Fund, 1901; Rogers Fund, 1912; Gift of Lord Carnavon, 1914.

construction of the X-form stool was simple. A bow saw was used to shape pieces of wood into rounded *spindles*. Artisans used *mortise and tenon* joints or *dowels* to secure the legs to the seat rail while the legs were secured with dowels. Linen cloth or leather was stretched over the seat rail and made collapsing the stool much easier. Folding allowed the stool to be moved easily from room to room or stored. This type of stool was favored by the pharaoh for use in private chambers as is often represented in tomb paintings. Hair grooming and the application of kohl around the eyes (aided by a handheld mirror imported from China) would be done as the pharaoh sat on a stool before a toiletry chest.

More refined fixed-type stools afforded by wealthier Egyptians were reserved for high officials of the palace court or important invited visitors. A stool found in King Tutankhamun's tomb imitated the folding type by using an X-form base with each leg carved into the delicately shaped head of a duck.

Additional types of fixed stools had four legs that extended straight down from the seat to the floor. Since stools were used most often in daily activities, side chairs or armchairs were reserved for special occasions; however, the basic design of fixed stools, side chairs, and armchairs was similar. Animal legs, either lions or panthers, terminated into a paw foot that rested on a block of tapering wood referred to as a *drum*.

Historians believe that the use of the drum dates back to a period before plaster floors were commonly used in Old Kingdom palaces. As previously mentioned, animals ei-

Figure 8 This ebony X-form folding stool was reproduced from original bronze and silver fittings recovered from a tomb at Meroe. The bronze ram's head finials extending from the seat rail symbolize the presence of Amun. Leather was most likely used for the seat. Height 40 cm, Width 50 cm, Depth 53 cm.
Courtesy Museum of Fine Arts, Boston.

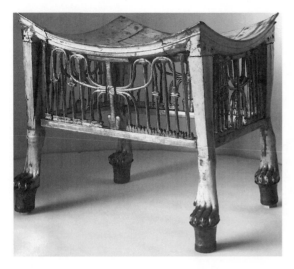

Figure 9 This fine example of a double-cove, fixed-seat stool was found in the burial tomb of King Tutankhamun. Made from acacia, a local wood, the furniture maker painted the surface of the stool with gesso then applied gilding to the decorative details. The ornamental grille work incorporates the symbol for unification—the intertwined lotus and papyrus stems—in its design. Notice the positioning of the animal legs that identify the front of the stool. Height 17^{11}/$_{16}$", Width 17^{11}/$_{16}$", Depth 16^{15}/$_{16}$".
Photography by Egyptian Expedition, The Metropolitan Museum of Art.

ther represented spiritual beings or were believed to possess supernatural powers. Egyptians hypothesized that these virtues were conveyed from the god or animal to the sitter. In this case, it was necessary to raise the paw above the straw-covered dirt floor, since the leg form symbolically transferred the power of the lion to the seated pharaoh. Even after more advanced floor covering methods developed, the drum remained at the base of the leg and foot as a design characteristic. Furniture designers from the Greek and Roman periods continued to use the animal leg as a symbol of power, but without the drum.

Egyptian craftsworkers reinforced the joinery by adding *stretchers*, *continuous stretchers*, or *runners* to the legs of stools and chairs. Occasionally, *struts* were also added between the stretcher and seat rail for extra stability and strength. Seats were made out of either rush or wood. Wooden seats were ergonomically shaped to follow the contour of the body, creating a *double cove*. Since upholstered furniture was not in use at this time, a loose cushion was placed on top of these dipped seats for greater comfort.

The Egyptian chair exemplifies another aspect of ergonomically designed furniture. Instead of a straight back positioned perpendicular to the seat, a slanted or *raking back* was added. The angled back was supported by three vertical *slats* extending from the *crest rail* to the seat rail. Motifs such as native plant forms, religious deities, and figures representing the owner were then painted, carved, or gilded on the backrests.

During important religious rituals or official coronations, armchairs would be used instead of side chairs. Considered the highest seat of honor, the armchair was reserved for the pharaoh and was richly decorated. An established hierarchy developed with the evolution of various seating units. Social prominence determined what piece of furniture the Egyptian sat upon. A stool was better than sitting on the floor, but a side chair had a back on it and was much

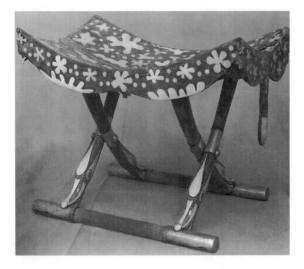

Figure 10 A stool found in King Tutankhamun's burial tomb imitates the X-form folding type typically used during the New Kingdom. The seat is made from ebony, although the furniture maker inlaid ivory to create the look of leopard skin. To imitate the appearance of animal hide, the furniture maker has added a carved tail. Height 13^{9}/$_{16}$", Width 18^{5}/$_{16}$", Depth 12^{3}/$_{8}$".
Photography by Egyptian Expedition, The Metropolitan Museum of Art.

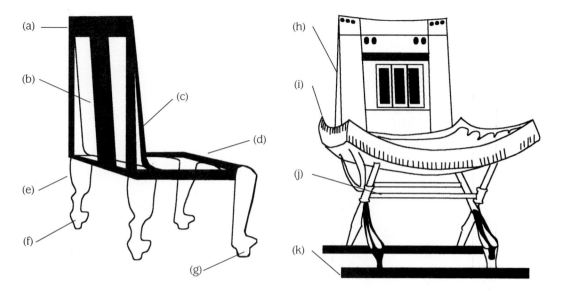

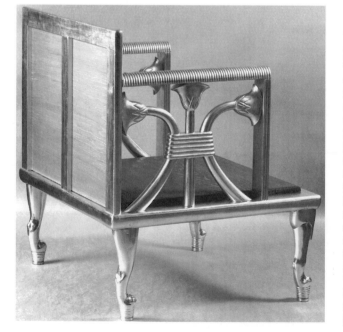

more comfortable. The highest ranking Egyptian would sit in an armchair since this type of chair had the comfort of both back and arm supports.

Moreover, the political hierarchy of seat furniture continued into the Greek and Roman periods with authoritatively designed throne chairs. The armchair was also a seat of prominence during the Medieval period. When receiving visitors to the manor, the lord sat in a massive armchair with the lady of the manor seated in a side chair. During banquets, the lord and lady sat side by side while their guests sat on benches, or stools, some of which were brought by the guests themselves. This hierarchy continues today in the formal dining

Figure 11 These drawings of Egyptian-style chairs illustrate technical terms applied to most seat furniture. (a) crest rail, (b) vertical slats, (c) raking or slant back, (d) seat rail, (e) animal leg, (f) paw foot, (g) drum, (h) uprights or stiles, (i) double cove seat or dipped seat, (j) stretchers, (k) runner.

Figure 12 Rare examples of Old Kingdom furniture were discovered in the burial chamber of Queen Hetepheres I at Giza dating from around 3000 B.C. The mother of Cheops, Queen Hetepheres was buried in an elaborate tomb near her son's pyramid. This reproduction was based on hammered gold shells recovered from her tomb that had covered the now decomposed wood frame of the chair. The furniture maker constructed the chair using mitered joints at the crest rail, with mortise and tenon joints and dowels attaching the legs to the seat rail. A wooden seat was dropped into place providing support for a loose cushion. Notice the papyrus motif, symbolic of lower Egypt, used on the armrest support. Although the backrest is perpendicular to the seat, the back legs are shorter than the front. This created a slight pitch in the seat which allowed the queen to sit in a less than erect position. Height 760 mm, Width 712 mm, Depth 656 mm, Front leg height 280 mm, Back leg height 258 mm.
Gift of Mrs. Charles Gaston Smith and a group of Friends. Courtesy Museum of Fine Arts, Boston.

13

Figure 13 This chest made from ebony and red cedar was found in King Tutankhamun's tomb. The furniture maker constructed the body of the chest and gabled lid using panel and frame construction. Its construction was secured with mortise and tenon joints and reinforced with dowels. Ivory and ebony strips bearing hieroglyphic inscriptions of funerary rituals were applied to the surface of the chest. Carrying poles were inserted through bronze rings attached to the underside of the chest for transport. Height 25″, Width 32¹¹/₁₆″, Depth 23¹³/₁₆″. Photography by Egyptian Expedition, The Metropolitan Museum of Art.

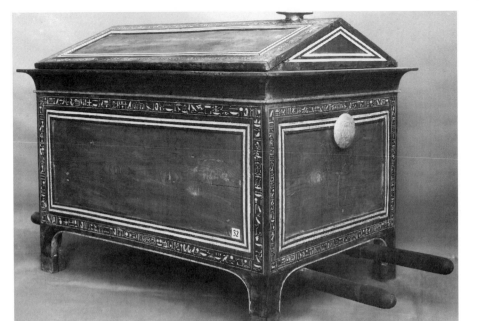

room. Armchairs are placed at each end of the table for the host and hostess, while guests sit in side chairs.

Perhaps the most universal furniture item used by all classes of society was the chest. Designed with removable lids, chests varied in size, construction techniques, and materials. Common ones were made out of woven papyrus reeds that were similar to wicker baskets. These types of chests were generally used by the lower classes for storage of household objects, although specimens of reeded chests were recovered from King Tutankhamun's burial tomb.

More complex chests were made of wood and differed in shape, size, and artistic expression depending on their contents. Many included panels of detailed narratives and had the same motifs that were used on stools and chairs. Nearly all the larger chests had straight or tapered legs and were designed to rest on the floor rather than on a table. One large chest taken from King Tutankhamun's tomb was of the portable type that had carrying poles attached to the underside, a *gabled* lid, and two knobs that worked as a fastener.

Figure 14 This casket came from a tomb found in the Valley of the Kings dating from the reign of Thutmose III. Although small, the construction was the epitome of cabinetmaking skills. The furniture maker used cleats on the lid to ensure a tight fit. Dovetail joints are used to hold cypress wood together, creating the body of the chest. The bottom is secured with two dowels while concave shoes are added for legs. Notice the two knobs on the lid and body. Height 13.5 cm, Length 19.7 cm. Gift of Theodore M. Davis. Courtesy Museum of Fine Arts, Boston.

Portable chests were not in general use; however, the practice of locking a chest was quite common. The procedure was

simple; one knob was attached to the body of the chest with another attached to the lid. To insure that the contents were not tampered with, a piece of twine was wrapped around the two knobs in a figure-eight style. The string was then secured with melted wax and embossed with an official seal bearing the emblem of the owner. As long as the seal remained intact, the contents were assumed to be safe.

Smaller chests called caskets were either made of wood or *alabaster*. Designed to hold toiletry items, jewelry, linen, and other valuables, caskets were also sealed with encrusted wax for security purposes.

Egyptian tables were designed for a variety of uses and most were small. Tablelike stands used to support alabaster vases or pottery containing precious *unguents*, or perfumes, were recovered from King Tutankhamun's burial tomb. Carved from alabaster, these stands usually had four *splayed* legs and continuous stretchers with struts.

Numerous tomb illustrations from the Old, Middle, and New Kingdoms show small pedestal-supported tables laden with food—presumably as offerings for the gods—or for feasting. Unlike dining habits today, Egyptians did not sit around a large table to eat. Guests sat on stools, chairs, or floor cushions

Figure 15 Tables are shown in a variety of heights and sizes in this offering scene from the sarcophagus of Prince Djehuty-nekht dating from the Middle Kingdom, c. 1870 B.C.
Harvard University–MFA Expedition, Courtesy Museum of Fine Arts, Boston.

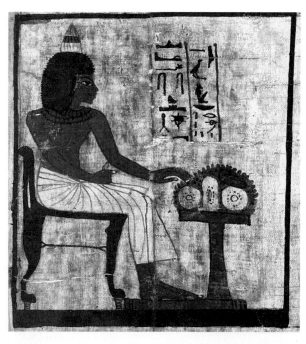

Figure 16 A painted coffin shroud from around 1300 B.C. depicts a seated figure reaching for an assortment of fruits and cakes laid on a pedestal table before him. Notice the proportional relationship between the table and the side chair.
William Stevenson Smith Fund. Courtesy Museum of Fine Arts, Boston.

Figure 17 This relief from an Egyptian tomb shows a figure seated in front of a pedestal table. Additional tables in the scene are laden with food offerings for the gods. Notice that the low-backed side chair has animal legs with hoof feet.
The Metropolitan Museum of Art, Rogers Fund, 1908.

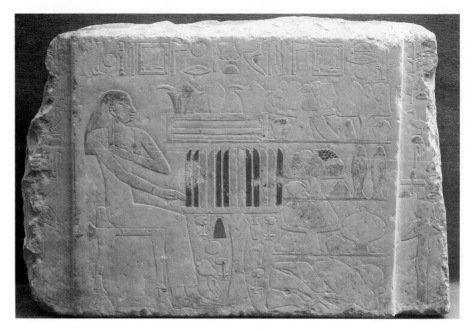

Figure 18 This is a reproduction of a bed typically used by wealthy Egyptians. The original bed dates from 1750–1550 B.C. and had laced rawhide webbing stretched around the side rails, providing a firm but tensile support for a linen mattress.
Director's Contingent Fund. Courtesy Museum of Fine Arts, Boston.

while attendants served food and wine from small tables placed in front of them. Greek and Roman cultures followed these dining practices with minor modifications.

Beds or reclining couches were rare since most people could not afford such luxuries. Several beds were discovered in King Tutankhamun's tomb and indicate how the wealthier classes lived. Most beds or couches were constructed from wood with stuffed linen mattresses supported by *webbing* material placed on top for added comfort.

Painted tomb illustrations reveal an unusual Egyptian sleeping habit; they slept with their heads elevated as a symbol of resurrection. A separate headrest called a yoke positioned at the base of the neck raised the head six to seven inches above the shoulders. This unnatural repose of the body necessitated the use of a footboard placed at the opposite end of the bed. What some mistakenly identify as the headboard on an Egyptian bed is actually the footboard.

Although most reclining couches were used for sleeping, scholars believe that two specific examples from King Tutankhamun's tomb were ceremonial in purpose. Carved out of wood and covered with gilt, one bed was in the shape of a lion and the other, a panther. Ceremonial beds similar to those found in King Tutankhamun's tomb are frequently seen in tomb painting illustrations.

Among the beds found in King Tutankhamun's tomb was one especially designed for traveling. Similar to a cot, these beds could be easily folded and taken from place to place. Most traveling beds were used by military personnel and continued to be used by the Roman army centuries later.

Egyptian Decorative Accessories

Numerous vases, chalices, and lamps were also recovered from Egyptian burial tombs. Several examples have decorations depicting religious themes while others display geometrical designs and plant motifs. Wealthy Egyptians could afford to have many of these essential articles made from molded glass, carved alabaster, hammered gold, or rare silver. Vases made to hold expensive perfumes and unguents resembled animal or plant forms in shape and design.

Figure 19 Certain African tribes still use the Egyptian yoke for sleeping. This example is made from carved wood and dates from the twentieth century.

Aesthetically designed yet practical, these objects show how craftsworkers coordinated each item with its architectural setting; motifs mimicked decorations that were painted on interior walls and seen on woven rugs or rush mats. The artists themselves were regarded as mere craftsmen. Utilitarian objects such as these were not intended to be works of art; they were necessary items designed to be functional. Every article had a purpose, whether spiritual or domestic.

Lamps provided illumination but were also decorative. The design of the triple lamp found in the tomb of King Tutankhamun exemplifies the craftsman's reverence for the plant life of the Nile, as well as harmony and elegance

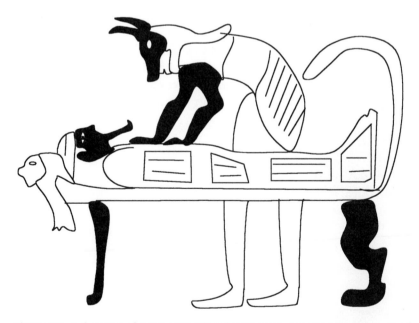

Figure 20 A drawing of a New Kingdom burial tomb painting illustrates the funerary god Anubis resuscitating the mummy of the deceased. Elaborately designed animal beds were made by royal furniture makers for funerary purposes and were not intended to be used on a daily basis.

Figure 21 These alabaster vases were found in King Tutankhamun's tomb and, although the residue left inside has not been positively identified, flasks like these usually contained expensive perfumes. Decorative lotus petal borders painted on the neck of each vase are also found on the interior walls of tombs.
Photography by Egyptian Expedition, The Metropolitan Museum of Art.

Figure 22 Taken from the tomb of King Tutankhamun, each cup on this alabaster lamp was carved into the shape of open lotus buds. Each cup held oil and a wick that was lit for illumination.
Photography by Egyptian Expedition, The Metropolitan Museum of Art.

in design. Carved from alabaster into the shape of three lotus flowers, this lamp contained linseed oil or a similar type of oil that burned with the aid of a wick made from twisted linen cloth. Often these most basic objects, although utilitarian in function, successfully integrated the more common Egyptian themes found in homes of the period.

• COMPARISONS •

Successive cultures borrow what they need from the previous one while developing their own unique interpretations. The lasting effects of Egyptian design can be seen in many furniture styles. Compare the Egyptian X-form stool to the examples shown in Figures 23–26.

What do these items have in common? Certainly the X-form base has been used consistently in each of these examples, but how did each designer reinterpret this design characteristic while supporting a variety of functions?

The Barcelona stool designed by Mies van der Rohe in 1929 reflects a twentieth-century modernist approach in its design and fabrication. The Egyptian X-form stool and the Barcelona stool both fulfill a practical purpose, are simple in design, and exemplify the materials and production methods prevalent during each period. Mies van der Rohe's version embodies the simplistic delicacy of the Egyptian's X-form base, while providing a modern rendition using stainless steel. The Egyptian example was used by the Pharaoh for nonritualistic purposes; however, Mies's stool was designed in conjunction with official ceremonies for the King and Queen of Spain.

Figure 23 Egyptian X-form folding stool with leather seat. Height 14″.
The Metropolitan Museum of Art, Rogers Fund, 1912.

Figure 24 This folding chair from the English Renaissance period of the sixteenth century derives its form and function from the Egyptian portable folding stool. Even during the Renaissance, furniture was scarce; therefore, many items were designed to be moved from room to room.
The Metropolitan Museum of Art, Rogers Fund, 1912.

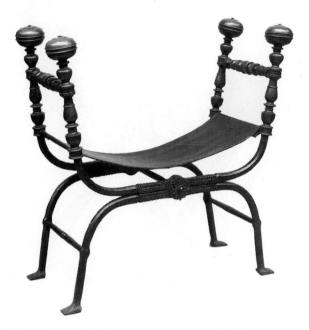

Figure 25 This Italian wrought iron stool with leather seat was made in the nineteenth century using retro-fitted sixteenth-century parts.
The Metropolitan Museum of Art, Gift of George Blumenthal, 1941.

Figure 26 The X-form base of this stool designed by Ludwig Mies van der Rohe for the 1929 World Exposition is manufactured from flat steel bars that require precise welding where the members intersect. Height 14.5″, Width 21.2″, Depth 23.2″.
The Mies van der Rohe Collection, Barcelona stool, courtesy of Knoll.

What we can determine from studying these examples is that each successive culture borrowed what it needed from the previous one. Different interpretations lead to new styles, each one unique. These are only a few examples of how the creativity of Egyptian craftsworker influenced designers from different cultures. Can you think of others?

CLASSICAL

• 2 •

AEGEAN CIVILIZATIONS

Between the Mediterranean and Aegean Seas, a mountainous mainland and several small islands comprise an area known today as Greece. Greek history can be traced back as early as 3000–2500 B.C. during the Bronze Age in Europe, and its culture developed through the intermingling of several ancient Aegean tribes that populated this region. The Peloponnesian mainland was occupied by a group of people known as Helladics, later called Mycenaeans, while to the south on the island of Crete lived the Minoans. The Cycladic Islands, which fell between these two regions, were inhabited by a primitive group who were thought to have traveled from Neolithic Anatolia.

The transformation of these Aegean civilizations into Greek culture evolved over several centuries and through specific occurrences. A volcanic eruption around 1500 B.C. on the island of Thera (now Santorini) sent tidal waves through the Cycladic Islands and into Crete. Earthquakes following the explosion destroyed Minoan settlements and weakened the defenses of the Cretans. Most scholars believe that Mycenaean armies invaded the islands at this time. A disbursement of Minoans to the mainland generated greater cultural exchange between the two cultures.

In 1150 B.C., Dorians from the north invaded the Peloponnesian mainland and suppressed the stronghold of the Mycenaeans. Following in 1100 B.C., Ionian tribes traveling from the east established colonies on the islands. By 776 B.C., the Dorians and Ionians merged and formed distinctive city-states extending from mainland Greece and the islands into Syria, Italy, and eventually into Egypt. These two tribes of people lived a much different lifestyle than the civilizations that preceded them—theirs was one that emphasized communal loyalty.

Aegean Architectural Settings

Artifacts from Minoan and Mycenaean sites—remains of architectural foundations, wall fragments, pottery shards, and funerary or religious objects—are prototypical of Greek design. The evolution of Greek design is apparent after studying excavated relics from these ancient Aegean settlers.

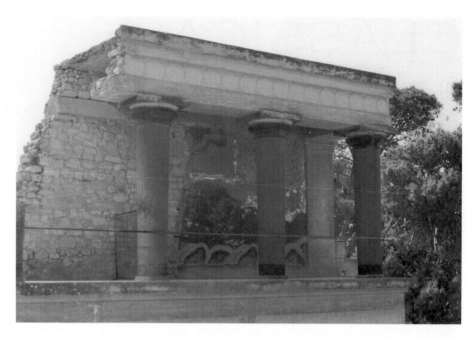

Figure 27 The Minoan Palace of Knossos was partially reconstructed by Sir Arthur Evans. Notice the distinctive tapered columns used to support the roof. The capital design prefigures the Greek Doric order used on many Arcahic and Classical temples.

The most significant discovery of Minoan architecture occurred in 1900 when the English archeologist Sir Arthur Evans resumed earlier nineteenth-century attempts to excavate the remains of a Cretan palace. Believed to have been built around 1600 B.C. for the legendary King Minos, the palace at Knossos contained more than 1,500 rooms spread over three stories. Highly sophisticated in plan and layout, light courts were built to provide illumination to all three levels.

Further advancement of Minoan engineering skills can be seen in a complex plumbing system concealed beneath the palace floor. Many of the rooms were supplied with running water that was channeled through a network of clay pipes. The most impressive discovery at the palace was the Queen's bathroom. Within this room, Evans found the original bathtub *in situ*, with private water closet facilities. These advances, the use of a light court along with underground plumbing, dominated Etruscan and Roman architectural design.

Evans rebuilt sections of the palace based on his findings. Support columns and door and window frames originally made from wood were replaced with plaster replicas, while the large stone walls were put back in place according to how they had fallen onto the foundations. Although Evans's work was criticized, a plethora of visual documentation of what life might have been like for the residents of the palace complex was brought to life through his accomplishments.

Along with reconstructing parts of the palace complex, under Evans's supervision teams of artists restored murals from numerous fresco fragments found in situ. Most of these murals depicted scenes from religious ceremonies and popular sporting events. Colored in bright blues, reds, greens, and golds that complemented the tranquil waters of the Aegean Sea, walls, floors, and ceilings within the complex were painted with lively animal and plant motifs contained within geometrical borders.

Unlike Egyptian painting techniques where the craftsman applied pigment to dry plaster, Minoan artisans painted directly onto prepared wet plaster. Since the plaster dried quickly, the artisan had to have an adept hand and be more spontaneous with the rendering of his or her subject. This resulted in a more durable surface finish since the pigment was indelible once the plaster dried. Consequently, this technique attributed to the quantity of fresco fragments that have survived for over three thousand years.

On the island of Crete, city planning was not practiced as the towns grew haphazardly from the center of the large palace complex. Recognized as the official seat of government, the complex provided living quarters for the royal family, housed the servants and guards, and functioned as a religious center. Public officials, noblemen, priests, and priestesses lived in the villas and country estates that surrounded the palace, while townhouses accommodated the merchants, mariners, and scribes of the town.

Lower classes lived in densely packed, single-family dwellings. Made out of fired bricks with wood framing around door and window openings, these houses rose to a height of two or three stories. Small faience plaques excavated from Knossos show examples of the decorative designs painted on the facades of these houses. Excavations of the town are incomplete; therefore, little is known about the interiors except that a storeroom was located on the ground floor with the living quarters above.

No Mycenaean palaces still exist in great splendor from the past. There are, however, traces of Mycenaean citadels. Under constant threat of marauding troops, the Mycenaeans built their palaces on high ground overlooking the surrounding region as a form of defense. This offered the most protection for the kings and princes who ruled from within the massive rough-cut stone walls of the palace complex.

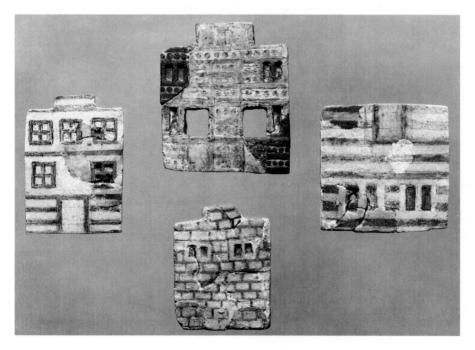

Figure 28 Excavated from Knossos, these faience plaques show Minoan houses. Notice how the façades for each house were decorated with both circular and linear patterns.
Heracleion Museum. Photo courtesy of the Hellenic Republic Ministry of Culture, Archaeological Receipts Fund.

Figure 29 Floor plan of Megaron, Tiryns. The entrance porch supported by two columns leads the visitor through an antechamber and into the inner sanctuary. Four columns supporting the ceiling frame the large central basin. An altar for offerings was located against one wall.

Excavations at Pylos, Tiryns, and Mycenae reveal much about the culture of the people that lived on the mainland. Similar to Knossos, the vast citadels of Mycenaean culture were self-sufficient. Running water was channeled in from a local source, and food supplies were kept in underground storehouses.

The plan for the Mycenaean citadel revolved around the *megaron*, a rectangular building accessed through a covered entrance porch. This entry often led to a stately throne room used for religious sacrifices and attending to the official business of the king. Reconstruction of wall fragments excavated from Pylos dating from around 1200 B.C. reveal ornate interior decorations including animal forms and geometrically designed borders.

Townspeople lived in small houses along the sloping hillside that led to the citadel, outside the protective walls of the compound. Houses were either circular or rectangular in plan and had flat roofs made from clay-covered thatch.

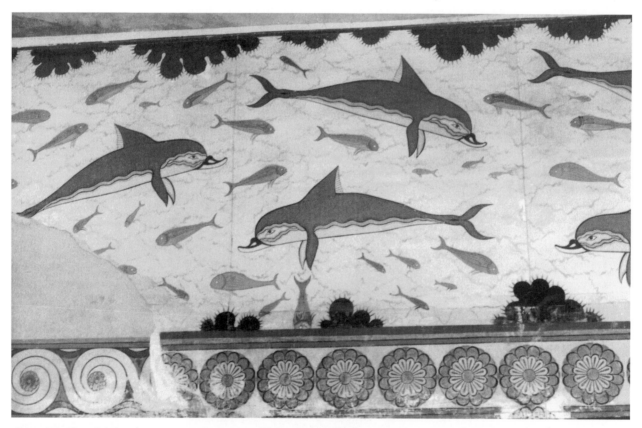

Figure 30 This dolphin fresco was reconstructed from original fragments found in the Queen's hall at the Palace of Knossos. The overlapping of both spiral wave and rosette decorative borders indicates that the room had undergone redecoration over the centuries of Minoan occupation.

Simple in construction and design, these houses provided modest living quarters for the craftsmen, merchants, and laborers of the town. Little else is known about these houses since there are few ruins left to study.

Aegean Design Motifs

Conventional plant forms and geometrically inspired designs filled the interiors of palaces, villas, and townhouses. Similar to the Egyptians, Aegeans used designs that often had symbolic or spiritual meaning. Animal forms, such as griffins and bulls, were used for specific purposes. The bull was considered a valuable offering to the gods; therefore, its representation is customarily found within murals depicting sacrificial rites. The image of the griffin yielded protective powers, as seen on the murals at Knossos in the throne room.

The Cretan artist created spectacular displays of color and movement with his designs. Many of the motifs introduced by the Minoans were used by the Mycenaean and Greek cultures with some modification and elaboration. Marine-based motifs that celebrated a life connected with the sea were mostly Minoan in origin. Dolphins appear as playful creatures, commonly swimming in opposite directions within the same composition.

More common motifs found in rooms excavated at the Palace of Knossos were rosettes, circles or *guilloche* patterns, frets, and spiral waves. These motifs appear as all-over decorations on floors and ceilings, or were contained within small bands bordering the perimeters of rooms, doors, and windows.

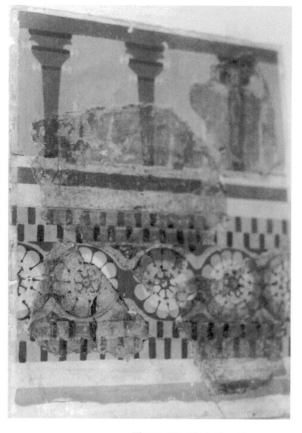

Figure 31 Sir Arthur Evans used fresco fragments like these as a visual guide in the rebuilding of the Palace of Knossos. The fragments document the type and color of the original columns used to support the palace walls. Notice the checkerboard and rosette borders.

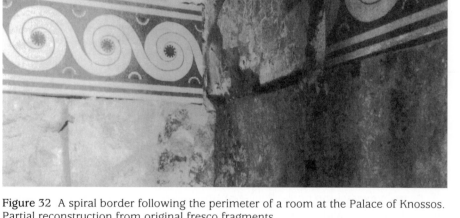

Figure 32 A spiral border following the perimeter of a room at the Palace of Knossos. Partial reconstruction from original fresco fragments.

Rosette border

Guilloche border

Fret work

All-over
geometric design

Marine plant

Mycenaen spiral border

Mycenaen ornament

Mycenaen button
design

Figure 33 Table of Minoan and Mycenaean motifs.

Mycenaen motifs were frequently derived from Minoan and Egyptian prototypes. Particularly Egyptian in nature, the lotus, zigzag, and rosette were found in Mycenaean interiors. Marine designs—cuttlefish, squid, and seaweed patterns—were adapted from Minoan examples and used on pottery and metalwork.

Aegean Furniture

The abundance of Egyptian furniture specimens in existence today is attributed to Egypt's hot and dry climate along with the air tightness of the tombs in which the items were sealed—ideal conditions for preserving artifacts. Greece, on the other hand, experiences extreme temperature changes with harsh winters and wet, humid summers. These climatic changes, along with the ancient Aegean burial practices, were not contributory to the preservation of artifacts. The Minoans practiced inhumation and did not believe it necessary to bury their dead with their worldly possessions. On the other hand, the Mycenaeans practiced cremation and placed the personal possessions of the deceased on the funeral pyre. These practices greatly reduced the quantity of furniture items in existence from this period.

Evans's excavation of the Palace of Knossos produced few physical examples of furniture. Within the throne room, an alabaster side chair was found

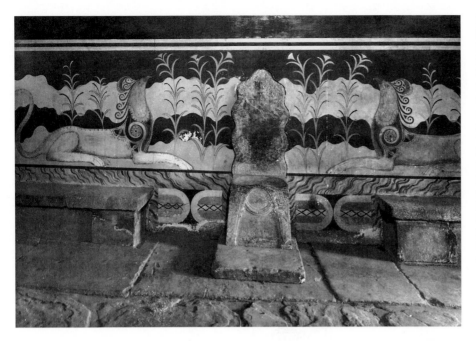

Figure 34 This alabaster chair from the Palace of Knossos indicates how Minoan chairs fashioned out of wood might have appeared. The back of the chair has scalloped edges with incised patterns repeated on the legs and front stretcher. This photo of the Throne Room reveals the hierarchical system of seat furniture; the tall-backed chair is reserved as the highest seat of honor, while officials of lesser status sit on the benches that line the walls.

Photo courtesy of the Hellenic Republic Ministry of Culture, Archaeological Receipts Fund.

placed against one wall resting on a raised platform or *dais*. Unlike Egyptian raking-back chairs, this chair had a tall back positioned perpendicular to the seat. The absence of the raking back on this chair indicates that it was intended to be placed against the wall at all times, affirming that it was designed for ceremony and not for comfort. Low plaster benches were built around the perimeter of this room and apparently established the same hierarchy of seat furniture practiced by the Egyptians.

In an antechamber to the throne room, Evans discovered charred wooden debris from another chair. Evans reconstructed this chair in wood using the alabaster chair as a reference and placed it in the antechamber during his excavation and rebuilding of the palace. It is uncertain that this copy is an accurate depiction of the original. Other examples of seat furniture recovered from Knossos were two stone specimens of X-form chairs designed with tall backs. The height of five inches suggests that these were used as some sort of shrine for a small statuette, although this is speculation.

Unlike Egyptian tomb paintings that showed the pharaoh surrounded by luxurious furnishings, fresco fragments excavated from the Minoan period rarely show furniture items. Only two illustrations recovered from Knossos depict furniture. In the "Camp Stool Fresco," Cretan men are shown seated on X-form folding stools similar to Egyptian prototypes. The discovery of this fresco clearly establishes the use of portable furniture within Minoan culture.

The second example of furniture illustrated in artwork from Knossos is seen painted on the H. Triadha Sarcophagus. Within the context of religious ceremony, a sacrificial bull is tied to a table as an offering to the gods. The artisan's depiction of the table reflects tapering *turned* legs mimicking the structural columns used in the construction of Knossos. From this illustration, it is difficult to know for sure if the table was supported by two pedestal-type supports or four turned legs.

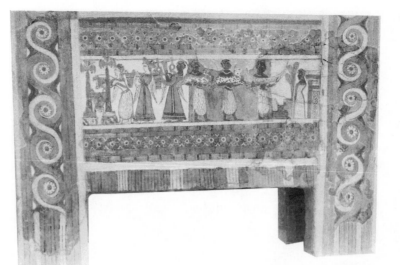

Figure 35 The front of the H. Triadha sarcophagus excavated from Knossos depicts a religious scene contained within checkerboard and rosette borders. Notice the spiral wave motifs running the length of each leg.

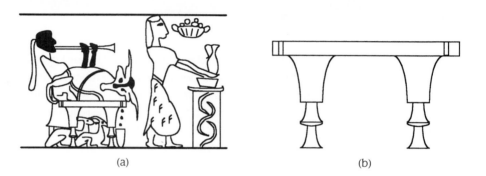

Figure 36 Drawings of details from the H. Triadha sarcophagus showing a table. (a) The legs are visible under the bull. (b) Reconstruction drawing of table.

(a) (b)

In establishing a precedent for Greek furniture design, apparently one Aegean culture built upon another. Most of what we know about Mycenaean furniture comes from an ancient form of writing. Used as a means of communication similar in concept to Egyptian hieroglyphics, the Mycenaeans inscribed clay tablets with ideograms or pictures that represented words or thoughts. These tablets, classified as Linear B texts, have been translated and provide written accounts of household inventories mentioning chairs, stools, tables, beds, footstools, and chests. Although Linear B texts do not give any reference to furniture size, some ideograms show chairs with footstools, indicating that the seats were quite high.

Furniture items made from ebony, sycamore, and yew are described in these texts as having decorative spiral patterns of inlaid silver, bone, and ivory. Chests are referred to frequently as repositories for jewelry and mention locking devices that are similar to the two-knob system used by the Egyptians. Only a few bronze hinges and looped handles recovered from Knossos remain as evidence of these

Figure 37 Ideograms from Linear B tablets: (a) folding stool; (b) chair with footstool.

(a) (b)

chests, while one rare example of a wooden jewelry box survived a Mycenaean funeral pyre.

There are no specific references to the sleeping habits of the Aegeans prior to Greek culture; however, plaster couches were found in the residential quarters at Knossos. Linear B texts make only one reference to a bed in household inventories and, to date, no visual representations exist from this period.

Aegean Decorative Accessories

The humble artistry of pottery making turned into a specialized art form after the introduction of the potter's wheel into Aegean culture. Firing the clay at high temperatures produced a vessel that would not break with normal use. Inexpensive to make, pottery was used by all classes of society in everyday life for utilitarian purposes.

Many examples of Aegean pottery display decorative patterns inspired by architecture. There was a deliberate effort by the craftworkers to ornament the vessel with spiral patterns, plant forms, and sea creatures in all-over designs that mimicked the interior decor. It was customary for two craftsworkers to combine their talents on one piece of pottery. Usually, one artist created the vessel on the wheel and another artist painted intricate decorations on the vessel's surface.

Candle stands and lamps were also widely used within the Aegean household. These objects were shaped into columnlike pillars and either molded from clay or carved from limestone. Designs were then painted or carved along the length of the shaft. Several examples of Minoan-designed lamps

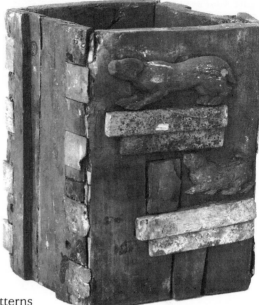

Figure 38 Notice the rudimentary dovetail joints the craftsworker used to connect the sides of this Mycenaean wooden jewelry box dating from around 1550 B.C. National Archaeological Museum, Athens. Photo courtesy of the Hellenic Republic Ministry of Culture, Archaeological Receipts Fund.

Figure 39 Giant pithoi from the storerooms at the Palace of Knossos. The designs were added in relief to the surface of the clay then fired.

Figure 40 Pithoi excavated from the city of Akrotiri on the island of Thera reveal typical Minoan design motifs. The vessels were decorated in relief with concentric bands on the potter's wheel, then circular and spiral designs were painted on the surface of the clay before firing.

were found all over the Aegean region, suggesting that Cretan artists produced these accessory items for export.

THE GREEKS

There are four distinct stylistic periods that shape Greek history: the Geometric (900–700 B.C.), Archaic (700–500 B.C.), Classical (500–300 B.C.), and Hellenistic (300–100 B.C.). Antithetical to Egyptian, Minoan, or Mycenaean forms of government, Greek government during the Geometric period emphasized the individual as a citizen, not as a subject. Property was owned by all citizens and there was a more equalized distribution of social rank and class. Religion was administered by all people; hence, the order of the high priest or priestess was dislodged.

During the Archaic period, land was divided among members of a territorial aristocracy who forced the artisans and merchants to rent property or to move to the suburbs. At this time, Greece came under heavy attack from neighboring regions that threatened their autonomy. Finally, the invading Persians were defeated in the fifth century B.C., and Pericles of Athens established a form of government ruled by the people. He instituted democratically governed city-states and undertook ambitious building projects. The dawn of the Classical period boasted the greatness of Athens as a port city that also had the largest population in the region.

The Hellenistic period to follow was dominated by the military strength of the Greeks. Alexander the Great of Macedonia set out to rid Egypt of Persian dominance, and by the second century B.C., Alexandria became a key port city within the Greek city-states. Short-lived was the power of the Greek Empire, when in 146 B.C., it succumbed to the dominance of the Roman Empire.

Figure 41 A drawing of a pedestal lamp, dating from around 1450 B.C., found at the Palace of Knossos. Made from limestone, lamps such as this were exported from Crete to neighboring colonies.

The Romans adopted much of the Greek way of life, including its religion, architectural design, artwork, and furniture. The synthesis of Greek and Roman culture established a design tradition seen throughout the history of Western decorative arts. The resulting Greco-Roman style of design can be considered one of the most enduring of all. Its design characteristics have been assimilated by hundreds of artists and craftsworkers over the centuries and continues to influence designers in our modern age.

Greek Architectural Settings

The Greeks instituted a systematic approach to city planning that considered the natural topography of each town. Sectors of the city were delineated for sacred, public, and private buildings. Sacred buildings were large temples made of durable stone, primarily marble. The plan and design of the Greek temple were based on the Mycenaen megaron, although modified for differences in religious practices.

Public buildings were less monumental and provided space for market centers, assemblies, and cultural events. Careful arrangement of streets laid out on north-south, east-west grid patterns allowed property owners to maintain freestanding houses that demonstrated their social prominence. Many of the middle-class merchants and artisans rented from the aristocratic town dwellers or moved out to newer developing colonies in the suburbs.

Common Greek houses were usually two to four stories in height and constructed from mud brick. Interior walls, in rare cases, would be adorned with paintings. Floors were covered with plaster and some were decorated with geometrical patterned *mosaics* using black, white, and red *tesserae*. The floor pattern usually accentuated the perimeter of the room and outlined the position of important furniture. Homer, who lived during the Greek Geometric period, wrote about "lovely dwellings full of precious things." Unfortunately, severe winters and humid summers deteriorated most of the mud brick houses as well as the interior furnishings.

The Greeks living during this time did not escape the frequent earthquakes that devastated Minoan culture. Most of the stone buildings dating from the Archaic, Classical, and Hellenistic periods collapsed long ago from the shaking earth. Of the temples still standing today, several are missing the roof and walls as these were the first to collapse, weakened by the force of quakes and tremors.

Much of Greek architecture evolved from a synthesis of Egyptian, Minoan, and Mycenaean prototypes. It is important to keep in mind these influences on the stylistic development of Greek design. Like earlier structures, Greek buildings used a *trabeated* architectural system. A post, or column, upheld an entablature that supported a gabled roof. Specific types of columns are identified by their component parts based on the decorative treatment of the capital. A simple disk denotes the Doric order, a carved volute decorates the Ionic, and scrolled acanthus leaves adorn the Corinthian order. *Fluted* grooves cut into the length of the shaft are the only unifying characteristic of the three orders.

The use of the Doric, Ionic, and Corinthian orders of architecture developed at various time periods within Greek history. The Doric order, the oldest

Figure 42 The three Greek orders of architecture are Doric, Ionic, and Corinthian. The Ionic order is recognized through its use of the volute capital, while the Corinthian order emphasizes an acanthus leaf capital. All three column shafts are fluted; however, the base is used only on the Ionic and Corinthian orders. All columns support the entablature, which in turn supports a gabled roof or pediment. Greek artisans carved decorative borders and patterns, such as the dentil molding, egg and dart, anthemion, and honeysuckle, into the frieze areas of the marble entablature.

Doric order

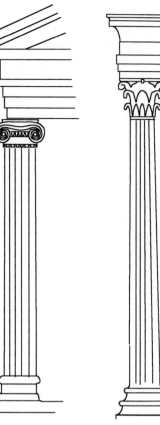

Ionic order Corinthian order

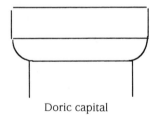

Doric capital

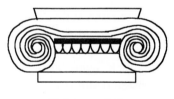

Volute capital

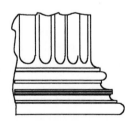

Fluted base

Acanthus leaf capital

Figure 42 Continued

Pediment

Cornice ——————

Frieze ——————

Architrave ——————

Entablature

Frieze Detail

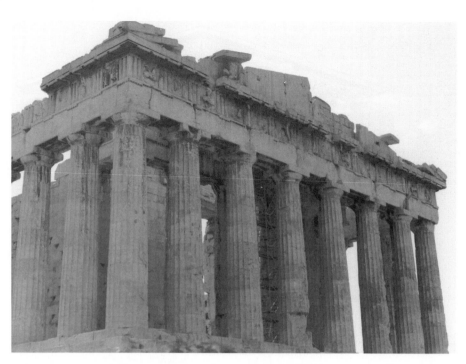

Figure 43 The Parthenon in Athens built in the fifth century B.C. exemplifies Greek temple design. The triangular pediment and supporting entablature will influence the design of many furniture case pieces.

Figure 44 This caryatid from the Erectheum at the Acropolis in Athens was originally painted with realistic color. First used as an architectural support column, this vertically erect figure became the source of inspiration for decorative items used on case goods during and after the Renaissance.

of the three, was used on the earliest surviving Archaic temples, while the Ionic order appeared on many Classical and Hellenistic buildings. The Corinthian order was usually used as an interior support column; however, greater use of this order is seen on Roman buildings. This style of Greek architecture established a precedent for the history of architecture and contributed to the design of furniture *case goods* developed during the Middle Ages.

Greek Design Motifs

Like the Aegeans, the Greeks favored elaborate detail and ornamentation; however, Greek design motifs were detached from symbolic representation or interpretation. Design motifs used by Greek craftsmen reflected four distinctive themes: geometric (fret, guilloche, spiral wave), natural (anthemion, antefix, palmette, rinceau, honeysuckle, rosette), animal (masks, human heads, paws, wings, griffins), and architectural (egg and dart, dentil, fluting, bead and reel). Many of these motifs were adapted from Egyptian or Aegean designs; for example, the spiral wave evolved from fret borders, while the anthemion developed from the lotus.

While Egyptian craftsworkers incised design motifs directly into plaster, the Greeks sculpted theirs out of marble. Greek ornamentation was primarily used as architectural embellishment on the entablature areas of temples and civic buildings. The motifs were painted with brilliant reds, blues,

Vine patterns

Figure 45 This table shows motifs commonly used by Greek artisans to decorate architecture, furniture, pottery, and textiles.

Palmette and honeysuckle

Anthemion

Antefix

Rinceau

Lotus and palmette

Greek key or fret border

Spiral wave

Ram's head

Ram's head border

greens, and golds that gave the architectural details visual presence from street level. Often these decorative carvings were duplicated with paint on the interior walls of the temple. Unified interior and exterior design resulted as the artisans incorporated these motifs on furniture, pottery, wall hangings, and textiles.

Greek Furniture

Unlike the Egyptians, the Greeks cremated their dead instead of entombing them. Personal possessions of the deceased were placed along with the body on a funeral pyre. As a result, examples of furnishings from this period are scarce, and the only furniture that survives today from the Greek period was made from bronze or stone.

Greek furniture style was more graceful and delicate than that of the Egyptians or Minoans. Ornamentation was kept to a minimum as the designer emphasized the sweeping curves of chair backs and legs. The use of the stretcher is limited during the Greek period since the quality of furniture construction was so great that the legs did not need extra reinforcement.

Figure 46 This relief carving of a griffin used to embellish the entablature of a Greek temple was brightly painted so it could be seen from the ground.
Purchased by Contribution. Courtesy Museum of Fine Arts, Boston.

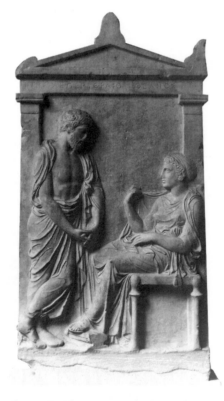

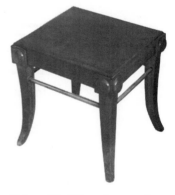

Figure 47 An interior view of a kylix from the Classical period shows a seated woman holding a lyre. The painting depicts a typical Greek-curule form stool, called a diphros okladias, supported by crossed animal legs and paw feet.

Figure 48 This grave stele dating from the Greek Classical period shows a woman seated on a stool designed with straight, disc-turned legs. Notice the separate footrest.
National Archaeological Museum, Athens. Photo courtesy of the Hellenic Republic Ministry of Culture, Archaeological Receipts Fund.

Figure 49 Although a modern reproduction, this stool represents a basic furniture item found in most Greek households. Notice the delicately carved saber legs.

Figure 50 Although worn with time, the distinctive shape of the klismos chair is still seen in these stone box seats from the stadium at Delphi.

Basic pieces of furniture used in the common home were stools, chairs, chests, reclining couches or beds, and tables. Most of these items had little or no gilding, limited carving, and rarely used inlay. Stools were still the most common piece of furniture because they are easily moved from room to room. One type resembled the Egyptian X-form folding stool in the Greek *curule* style; another was designed with four independent legs that extended from the seat rail.

The hierarchy attached to specific types of seat furniture was less significant to the Greeks, although the thronos was used for official state business. The *klismos* chair (see Color Plate 3) was used for unofficial activities and was common in most households. The klismos was delicate, well proportioned, and lacked ornamentation. Although this chair was favored and used by women, it was often reproduced in stone and incorporated into the reserved box seats for political officials at theaters and stadiums.

Beds were considered the most important piece of Greek furniture. As in the past, for the many people who could not afford to own them, a stuffed mattress was either placed on the floor or on a raised plaster platform.

Greek dining habits were similar to those of previous cultures: they ate their meals while reclining on a couch or bed. A *kline* was designed for this purpose. It was raised high off the ground and required the use of a step- or foot-stool. Mattresses and cushions made the kline more comfortable.

A table was placed in front of each kline where a servant placed trays of food and beverages. These tables were small in size and simple in construction. This allowed the servant

Figure 51 A youth sits on a cushion on the floor as he plays the lyre.
H. L. Pierce Fund. Courtesy Museum of Fine Arts, Boston.

Figure 52 The interior of this kylix from the early fifth century B.C. shows a guest reclining on a kline while being entertained by a flute player. The design of this particular kline resembles the klismos chair with a concave crest rail and saber legs. Notice the footstool placed alongside the kline. The guest raises his kylix for a toast, while holding a krater in his other hand.
H. L. Pierce Fund. Courtesy Museum of Fine Arts, Boston.

Figure 53 This interior view from a kylix depicts a youth in front of a laver. The design of the laver resembles a pedestal table, with a circular top supported by a single, fluted column. Notice the egg and dart molding around the neck of the pedestal.
H. L. Pierce Fund. Courtesy Museum of Fine Arts, Boston.

Figure 54 This relief detail from a votive, circa 340 B.C., shows a simple table with straight legs. The table is laden with food, possibly offerings to the gods, indicating that the table was used in the preparation of food, rather than for dining. Notice the proportional height of the table to the figures and small child.
Frederic Brown Fund. Courtesy Museum of Fine Arts, Boston.

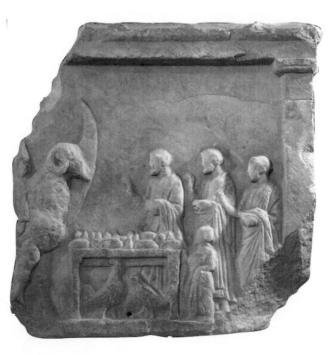

to slide the table under the kline after the meal. Entertainment by musicians and dancers followed as guests remained on the kline throughout the rest of the evening.

The Greeks typically used tables resembling small stands for serving wine. Tripod tables supported by three legs fashioned into the legs of a goat, lion, or dog were mounted to a *plinth* or base. Usually made from stone or bronze, these tables were more elaborate in decoration. Ornamentation often reflected animals native to the sea—geese and dolphin motifs were most common. Pedestal tables were also designed for occasional use and sized to suit a particular function.

Chests made of cedar were in great demand and were used as storage receptacles for clothing. Since wood was scarce in Greece, furniture made from this material indicated its owner's wealth. Homer refers to carved, gilt and inlayed chests containing fine cloth. The best indication of what these chests might have looked like may be determined by studying Roman stone sarcophagi.

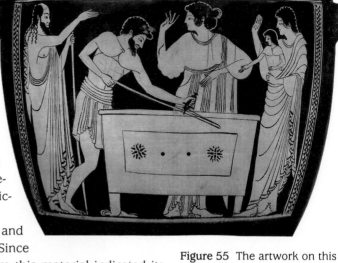

Figure 55 The artwork on this hydria dating from around 490 B.C. shows a craftsman working on a chest with carpentry tools. The front of the chest has an inset panel ornamented with rosettes, while the feet are fashioned into great paws.
Francis Bartlett Fund. Courtesy Museum of Fine Arts, Boston.

Greek Decorative Accessories

Greek accessories were comprised of functional objects necessary to daily life. Pottery was the most common item found in any home, regardless of wealth. The craft of Greek pottery making was very similar to that of Aegean pottery. Firing the clay at high temperatures produced a vessel that could withstand breakage through normal use. Pottery items in a variety of shapes and sizes were used by all Greeks. Various shapes were designed for specific purposes: an *amphora*, lekythos, and hydria contained liquids; a *kylix* was used as a drinking cup; and a *krater* was used for mixing.

Although Greek pottery was utilitarian in nature, the surface of the clay was lavishly decorated with motifs that corresponded to architectural embellishments. Many narrative scenes depicting religious themes, historical events, and

Two-handled vase

Krater

Lekythos

Amphora

Hydria

Figure 56 Drawings of various types of pottery vessels crafted by Greek artisans.

Figure 57 This glass vase dates from the fourth–third century B.C. and was probably made in Syria. The glass vase was made using the coil method with an applied thread-glass decoration.
H. L. Pierce Fund. Courtesy Museum of Fine Arts, Boston.

Figure 58 A small Greek candelabrum shows how functional but decorative accessories were designed in harmony with the furnishings of the period. The pedestal support for the lamp is fashioned into a simple baluster shape.
The Metropolitan Museum of Art, Purchase, 1901.

daily tasks were also painted and fired on the clay vessels. Like Egyptian tomb paintings, these pottery items reveal much about the life of this ancient culture.

The availability of glass objects was limited and they were often imported from the Phoenicians who excelled in glass-making techniques. Most glass objects were either molded or coiled into the desired shape until the end of the Hellenistic age, when glass-blowing techniques were introduced. Of course, glass was more delicate than pottery, so it was seldom used; and it was primarily enjoyed by the wealthier classes.

Most lamps were made of metal, usually bronze, and contained oil and a floating wick. Lighting elements varied from easy to carry handheld lamps to tall torchères used to illuminate entire rooms. Torchères were designed with high pedestal stands which allowed the light to filter down into the room for greater illumination.

Other decorative accessories that served functional purposes within the home were textiles used for making cushions, wall hangings, and draperies. Draperies were used to close off both doors and windows, since most interior rooms lacked actual doors. Based on descriptions from literature and representations seen on pottery items, geometrical designs were embroidered or woven into the textiles.

• COMPARISONS •

Disregarded for a short period of time during the Middle Ages, classically based design was reintroduced in Western Europe during the fifteenth and sixteenth centuries. This Renaissance, or rebirth of the golden age of Pericles, inspired everything from literature and philosophy to art and architecture. This classic tradition continued into the seventeenth century Baroque style in excessive proportions. By the late eighteenth and early nineteenth centuries, a purer, less elaborate use of classical design became characteristic of the Neoclassical period.

Compare the following furniture items:

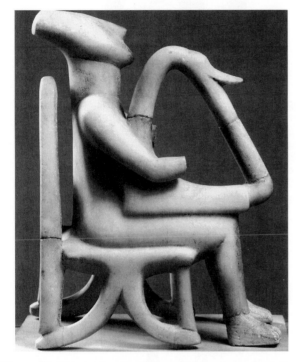

Figure 59 This sculpture of a seated lyre player from the Cycladic Islands dates from the early Bronze Age. Notice the gentle sweeping motion of the side stretchers, a precursor to saber leg forms favored by the ancient Greeks.

National Archaeological Museum, Athens. Photo courtesy of the Hellenic Republic Ministry of Culture, Archaeological Receipts Fund.

Figure 60 The front of this Greek funerary lekythos dating from the fourth century B.C. depicts a woman seated in a klismos chair. Although the chair is covered with a cloth drape, its unique design is still visible: saber front and back legs, a concave crest rail, and a slight rake of the back.

Courtesy Museum of Fine Arts, Boston. Gift of Mr. and Mrs. John J. Klejman.

Figure 61 This mahogany side chair designed by Duncan Phyfe between 1805 and 1815 in the American Federal style emphasizes classical styling. The lyre-form splat, saber-front and -back legs, and acanthus leaf carvings were synthesized from Greek and Roman examples.
The Metropolitan Museum of Art, Bequest of Maria P. James, 1911.

Figure 62 This chair from the modern period incorporates many features of the Greek klismos chair: saber legs, a concave crest rail, and a sweeping backrest. It is common for furniture designers working during the latter part of the twentieth century to create new works by blending elements from both the past and the present into their designs.
Courtesy John Stefanidis, London.

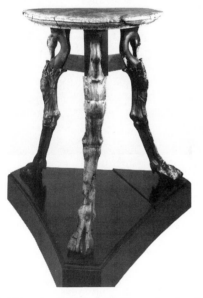

Figure 63 This tripod table dates from the Greek Hellenistic period circa second–third century B.C. Made from wood, the legs are carved into animal leg and paw foot designs modified from Ancient Egyptian prototypes with the introduction of duck heads and acanthus leaves. Standing 2 feet, 4½ inches high, small tables like this were usually used for serving wine.
Royal Museums of Art and History—Brussels. Inv. no. A 1857.

Figure 64 An eighteenth-century cherry candle stand in the American Late Colonial style modeled after designs by English cabinetmaker Thomas Chippendale is an adaptive form of the tripod table used by the Greeks and Romans. The table's pedestal support is carved to imitate a reeded column with Corinthian capital. Other decorative features include a laurel branch motif carved around the top rim and a carved talon motif on the feet.
The Metropolitan Museum of Art, Gift of Mrs. Alan W. Carrick, 1969.

The sets of chairs and tables have similar qualities and characteristics even though they were designed several hundred years apart. What similarities can be seen between those represented in the Cycladic sculpture of the seated lyre player and the Greek klismos chair? The Cycladic chair dating from 2000 B.C. has four straight legs extending from the seat rail with two sets of side stretchers. Could the design of these stretchers evolve into the delicate saber legs used on the Greek klismos chair dating from the fifth century B.C.?

Notice the similarities between the Greek klismos chair and the lyre-back chair from the nineteenth century. Did certain events lead to the reintroduction of Greek furniture design during the nineteenth century? If the furniture makers during the nineteenth century were influenced by Greek design, were they acting alone? Can we see the classical element in our current environment?

THE ROMANS

By the eighth century B.C., Greek settlements had expanded into southern Italy and the coast of Sicily. The area between the Tiber and Arno Rivers in northern Italy was settled by a tribe of people known as the Etruscans. The Greeks viewed the Etruscans, along with other cultures to the north, as barbarians—crude people with uncivilized ways, ignorant of the refinement of Greek customs and culture.

Originally from Asia Minor, the Etruscans did not share the language of the Greeks which, consequently, limited cultural exchange between the two civilizations. In fact, Etruscan writing has evaded translation by scholars to this day. Little is known about the Etruscan people since most of their cities were not abandoned, but were assimilated by encroaching Roman culture.

The establishment of Rome on the south bank of the Tiber River dates to 753 B.C. This area was first known as Latium from which the word *Latin* evolves. A myth based on religious beliefs developing years later credits the founding of Rome to Romulus and Remus, twin sons of Mars, the god of war.

Considered one of the greatest political nations in the Western world, the Roman Empire is categorized into three distinctive periods. The Republic period began in 510 B.C. when the first laws established the authority of the Empire. The newly formed Empire quickly became the dominant political force in Italy, subjugating the Etruscans and ultimately the Greeks. When the Greek city-states succumbed to Roman control during the second century B.C., the Romans quickly adopted the advanced Hellenistic knowledge of mathematics, science, and religion. Roman engineering, evolving from Greek architecture and urban planning, advanced through the extensive use of concrete. Highly developed sewer systems fed by aqueducts brought water into towns, and vast highway and bridge construction kept all outposts of the Empire within manageable traveling distance to Rome.

The Roman Empire reached its geographical and political zenith after the assassination of Julius Caesar in 44 B.C. The rise of the Imperial period (27 B.C.–A.D. 284) was led by Julius Caesar's great-nephew Octavius. By the end of the first century A.D., Roman conquests extended from the European continent into the British Isles, Egypt, Greece, and parts of Asia Minor. Political control

was enforced by a vast army and navy. The strength of the Empire resulted from autocratic political control maintained through a centralized government: the emperor and his consulates.

The last great period of the Empire, the Late Imperial period (A.D. 284–395) was threatened by constant invasion of northern tribes. Protective measures were taken over the course of several decades to protect the Empire from a coup d'état. The Empire was divided into Eastern and Western provinces, then promptly unified only to be divided again. Finally, in 410, the city of Rome fell to plundering Northern Goths. By 476, the Western Empire and last ruling emperor were eliminated and a bloody struggle for power ensued.

Roman Architectural Settings

After the Greeks fell to Roman control, artisans were taken into slavery and brought to Rome where they created great works of art for the Empire. Many of these Greek artisans trained Roman artists in the Classical and Hellenistic styles with Roman architectural design following the basic Greek temple in plan, elevation, and decoration.

The Romans introduced two new orders to architectural design: the Tuscan and Composite. The Tuscan order evolved out of Etruscan prototypes and resembled the Greek Doric. The Tuscan order, however, had a smooth shaft that rested on a base. The Composite order combined both volute and acanthus leaves for its capital. Advanced construction methods resulting from the Romans' perfection of poured concrete fabrication led to an arcuated support

Figure 65 The Pantheon in Rome, designed and built in A.D. 72–80 resembles a Greek temple from the façade with its overscaled portico. The circular plan of the structure, however, reflects Roman arcuated engineering skills made possible with poured concrete.

Figure 66 The Villa of the Mysteries, originally built in the third century B.C., is indicative of working estates owned by wealthy Roman citizens. Located on a terraced hillside overlooking the Bay of Naples, the interior of this domus was elaborately decorated with brightly colored frescoes and detailed mosaics.

system and domed architecture. The emphasis placed on arcaded structures influenced the decoration of furniture case goods during the Medieval period.

Roman culture can be studied first hand through continuing excavations in Pompeii and Herculaneum. These two cities located south of Naples were sealed in an airtight tomb when Mount Vesuvius erupted in A.D. 79. The force of the volcanic eruption sent poisonous gases, ash, and lava onto these doomed cities, encasing all under twenty-five feet of debris. Forgotten until an accidental rediscovery in the eighteenth century, excavations at these two sites reveal much about the daily existence of Roman citizens and their slaves.

This eighteenth-century discovery brought forth exquisite examples of architecture, furniture, frescos, and mosaics from this first-century town. Throughout two centuries of excavations at Pompeii, archeologists have been able to systematically remove and document these remains in an attempt to reconstruct the life of the Pompeians.

Not unlike other Roman towns, the city of Pompeii evolved over centuries. Long, narrow residential blocks were cross-accessed by busy traffic avenues leading to commercial districts and civic centers. Families of wealthy patricians could afford a villa with land apart from town. These homes were self-sufficient, many maintaining vineyards, livestock, and storehouses.

The Roman working class lived in town, often renting an apartment or owning a unit within an *insula*. Ranging in height from two to five stories, most insulas were designed with similar characteristics and layouts. Comparable to townhouses, the block of vertically arranged individual units allowed families privacy while sharing common walls. These long and narrow dwelling units had windows on the street side with an entry that led to a reception room. This

Figure 67 This floor plan represents the House of the Tragic Poet excavated from Pompeii. Typical of many homes belonging to wealthy Pompeians, the layout shows the proximity of the atrium to the street and the peristyle to the rear. (a) shops, (b) atrium, (c) bedrooms, (d) tablinum, and (e) peristyle.

Figure 68 The atrium view of a Pompeian insula shows the impluvium built into the floor to collect rainwater from an opening in the roof. A marble table supported by massive trestles with paw feet is placed at one end.

Figure 69 A fresco fragment from a first-century Pompeian home. The expansion of space was created by the artisan's use of linear perspective evident in the depiction of a coffered ceiling.
Richard Norton Memorial Fund. Courtesy Museum of Fine Arts, Boston.

room had an open-air atrium that allowed in both sun and rain. An *impluvium*, a recess built into the floor, collected rainwater and provided the tenant with a convenient water source separate from the public water supply.

Smaller rooms arranged around the atrium were used for a variety of purposes including sleeping. To the rear of the unit was a larger open-air courtyard or peristyle. The expansive airiness of the peristyle allowed for greater air circulation and made this the center of activity during the hot summer months.

Since the restrictive qualities of the insula limited windows to only the street side, the resourceful Roman artisan found a way to expand the sense of space within these dwellings. Along the walls running the length of the unit, artists painted trompe l'oeil landscape scenes providing windowlike views.

Furniture was minimal as the decoration of interiors did not depend on furnishings, but emphasized elaborate frescos and floor mosaics. Often, decorative mosaic borders delineated the placement of furniture while the repetition of motifs on floors and walls unified the interior design.

Roman Design Motifs

Roman design motifs assimilated and synthesized the Greek style of ornament. Most of the Roman motifs seen as architectural embellishments were taken directly from Greek sources, although the techniques of the artisans varied. The primary difference between Roman and Greek artisans rests in their execution of the design pattern. Greek artisans rendered their designs free hand and hand chiseled the stone, whereas Roman artisans used precisely fabricated templates and hand-powered drills.

Figure 70 This detail of an architectural entablature shows design motifs taken from Greek sources. Bead, dentil, and egg and dart moldings divide the surface into horizontal bands.
Charles Ames Cummings Fund. Courtesy Museum of Fine Arts, Boston.

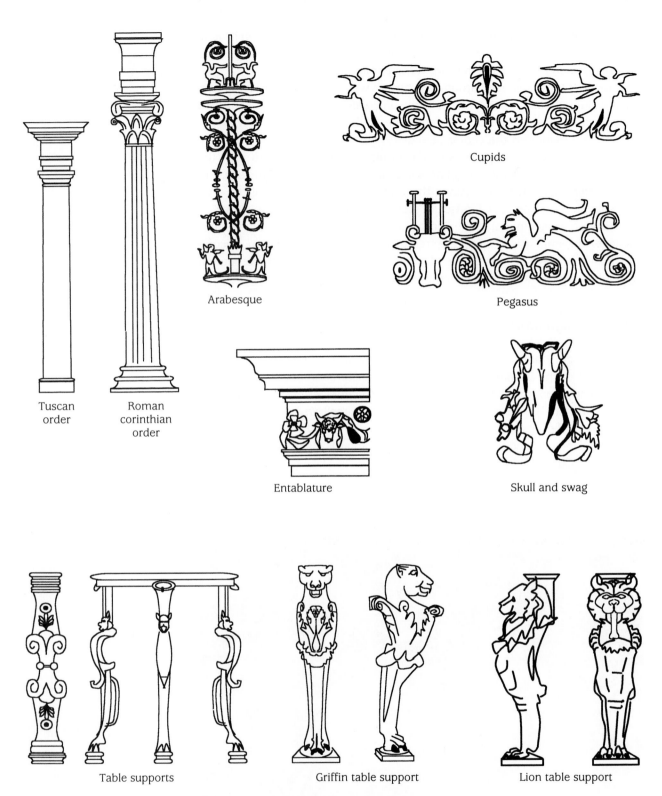

Tuscan order

Roman corinthian order

Arabesque

Cupids

Pegasus

Entablature

Skull and swag

Table supports

Griffin table support

Lion table support

Figure 71 Table of Roman design motifs and architectural and furniture details.

Roman Furniture

Pompeii provides us with the best examples of Roman furniture. This volcanic tomb, once excavated, revealed the routines of daily life. Furniture items made of bronze, and stone were found among both decorative and utilitarian objects. As in earlier periods, there was not an abundance of furniture and most was practical and utilitarian.

Roman furniture followed Greek examples—curule-form stools, small tables, and reclining couches. Although Greek and Roman furniture exhibit similar design characteristics such as saber and animal legs, Roman furniture lacked the delicate proportions perfected by classical Greek artisans. Although no wooden examples of furniture items have been found, bronze and stone specimens were excavated from Pompeii and Herculaneum.

The use of a lathe (introduced by the Greeks) enabled Roman artisans to turn rectangular blocks of wood into rounded forms much faster than they could by hand carving. Turned legs made in a variety of shapes adorned stools, chairs, and beds. The most popular turned form resembled a spindle of flattened discs.

The Roman sella curulis was a stool fashioned after the Greek diphros okladias; it was a curule-form with a folding mechanism. Easily transported, this piece of furniture varied in style and decoration and became a symbol of dignity used by patricians.

Many chairs were fashioned out of wood. The design of the crest rail and uprights often had *finials*, sometimes carved into the shapes of figures or animals. These chairs had loose cushions placed over the back and seat for added comfort. Draped fabric often concealed the frame and cushions, giving the appearance of a modern overstuffed chair. Since the chair seats were quite high, a footrest was added.

Identified by its characteristic encircling back, the wicker tub chair was the most economical chair to produce. Reed was inexpensive to obtain and easy to weave, making the tub chair a standard item in many homes. Its lightweight construction allowed the chair to be moved easily from room to room. Comfortable and practical, the tub chair was favored by women while nursing or attending to their toilette.

The Roman use of the Greek thronos was not common until the Imperial period when government control was placed in the hands of an emperor. The emperor and his consulates sat in armchairs when attending to official business. Occasionally, the solium or throne chair was placed on a dais elevating the sitter to a position higher than anyone else in the room, thus establishing his importance as ruler.

Figure 72 A small Roman cameo displaying the nuptials of Cupid and Psyche from 50 A.D. captures the design of a simple stool. The disc-turned legs are partially covered by a drape placed over the loose cushion seat.
H. L. Pierce Fund. Courtesy Museum of Fine Arts, Boston.

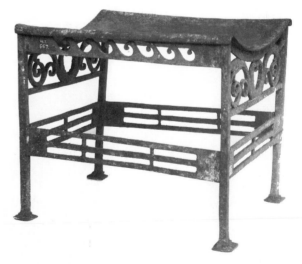

Figure 73 Motifs in the spiral wave pattern appear on the front and rear apron of this bronze stool from the Roman period. Side aprons reveal scrolled designs while the legs are connected with a continuous stretcher. The design of the dipped seat lacks the distinctive double-cove shape seen on earlier Egyptian examples. Height 18″.
©British Museum. Reproduced by courtesy of the Trustees of the British Museum.

Figure 74 This mourning scene depicted on a Roman sarcophagus frieze from the second century A.D. shows the everyday use of several furniture items. A woman seated in a high-backed chair covered with a cloth mourns the deceased in repose on cushion-covered lectus designed with disc-turned legs, high fulcrum arms, and a high back. The back is unusual for a Roman lectus at this time, and although it is not clear when the high back first appeared, it is apparent that the Roman lectus set the precedent for today's modern sofa. An additional mourner sits on an X-form folding stool. Notice the presence of the footstools.

Figure 75 In this architectural relief, a woman sits in a tub chair while her servants attend to her grooming. The artist's skillful rendering of the woven reed in stone gives a realistic depiction of the roman tub chair with its concave back, low arms, and high seat. (Notice the footstool.)

Roman chests, like Greek and Egyptian prototypes, came in a variety of sizes and were designed to store articles of clothing, cloth, and valuables such as jewelry and coins. These storage chests were often basic and simple in construction materials and methods; sophisticated locking devices were not developed until the Middle Ages.

The Romans also used a small table similar to the Greek tripod table. Satyr, goat, or lion legs rested on a plinth or base that stabilized the weight of the tabletop. Roman tripod tables incorporated a practical improvement over Greek designs; a raised edge or gallery followed the circumference of the top, preventing the wine-filled amphora from falling over the side.

Figure 76 This fifth-century mosaic depicts a man kneeling before a chest decorated with circular patterns. Although stylized, the artist gives a careful rendition of the chest's design and construction by detailing its panel and frame construction and mitered corners.
Courtesy The Bardo Collection, Musée National du Bardo, Tunisia.

Figure 77 Although there were many similarities between Greek and Roman furniture in both design and function, Roman furniture was typically much more decorative. This tripod table excavated from Pompeii and made from cast bronze shows several Roman decorative features: swags surround the table's gallery edge while Roman sphinxes resting on animal legs support its surface. Ornate stretchers connect the legs which are also stabilized by the plinth.
Courtesy Museo Naples.

Figure 78 This Roman marble table was reconstructed from many fragments found at Boscoreale dating from the first century A.D. The rectangular variegated marble top is trimmed with bronze and decorated with palmette and anthemion motifs in silver. A marble, baluster-shaped pedestal support connects to a bronze tripod base that rests on a marble plinth.
The Metropolitan Museum of Art, Rogers Fund, 1906.

Figure 79 A small round table used for dining is seen here in what used to be the triclinium of a Pompeian home. Three dining couches were placed around the table in "U" formation from which food and beverage were served.

Larger tables were used as a preparation area for meals, while smaller round tables called mensae were centered between dining couches. Marble tables were discovered at Pompeii in the outdoor peristyle area of the home where the Romans took their meals during the summer. Designed to withstand the weather, the marble table, or cartibulum, had either pedestal, *trestle*, or *pilaster* supports.

The Romans lounged on a dining couch while eating from a food-laden *mensa* placed within reach. As with most ancient cultures, eating was enjoyed while reclining rather than sitting as only children and slaves sat while they ate.

The Roman lectus replaced the Greek kline as a bed or resting couch. This piece of furniture provided comfort for eating, sleeping, or reclining and was made from wood, stone, or bronze depending on its location in the home.

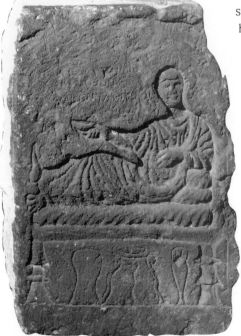

Figure 80 This relief carving from a second-century A.D. grave stele shows a male reclining on a lectus. The position of the body and presence of both eating utensil and tripod table reflects the formal dining customs of Romans. Notice the lectus has disc-turned legs, a stuffed mattress, and cushions that elevate the body on the left arm.

Gift of Paul Manheim. Courtesy Museum of Fine Arts, Boston.

Some of the houses excavated from Pompeii had built-in plaster couches used for sleeping that accommodated one person. These plaster couches were located in small cubiculums off the main atrium.

Like the kline, the height of the lectus from the floor required the use of a footstool. The lectus had a *fulcrum* at one end that provided support for the slightly elevated position of the body. The cyma recta-shaped fulcrum was made from the same material as the lectus. At some point, the Romans added two fulcrums, one at each end, thus providing the prototype for the sofa. Loose mattresses were then placed on top of the lectus and overlaid with coverlets and pillows (see Color Plate 5).

Roman Decorative Accessories

Accessories that coordinated with furnishings consisted of lamps, glass vases, and pottery. These objects were used to perform daily activities. Simply crafted bronze lamps were found during the excavations at Pompeii. Some were designed to be carried from room to room, while others were fixed onto tall pedestal supports and provided illumination similar to the modern floor lamp.

Glass-making techniques improved through the introduction of the iron blowpipe which enabled glass to be manufactured more economically than before. Shops set up along the avenues leading to the Colosseum sold souvenir glass. Decorations in the glass were made either by blowing molten glass or pressing soft glass into a patterned mold.

Cameo glass was also popular for decorative glassware. Artisans would first layer different colors of glass onto a mold. Once the glass cooled, the artist exposed the different layers and colors by cutting figures or patterns in relief. The most popular color combination showed white figures over a dark blue background.

Figure 81 The tall pedestal support on this bronze candelabrum dating from the fifth century B.C. Etruscan civilization enabled greater distribution of light from the top. The slender reeded column of the candelabrum is supported by a tripod base fashioned into animal leg and foot forms.
The Metropolitan Museum of Art, Purchase, 1896.

Figure 82 A glass bowl from the first century A.D. depicts a gentle swirling pattern created by impressing soft glass into a patterned mold.
Bequest of Charles B. Hoyt. Courtesy Museum of Fine Arts, Boston.

• COMPARISONS •

Throughout the ancient world, furniture design developed out of humankind's need for both ceremony and comfort. Furniture craftsworkers often synthesized many characteristics from artisans who lived centuries before as traditions were passed from one generation to another. Compare and contrast the Roman throne chair with the drawing of a sculpture of a goddess excavated from Catal Huyuk.

Although the leopards support the goddess as she prepares to give birth, could the presence of these animals bring a sense of importance to the figure? Why does the use of animals or animal legs on chair designs bring symbolic significance to the seated occupant?

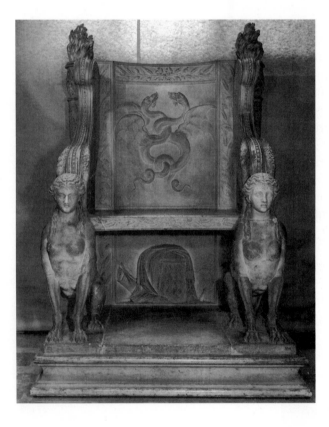

Figure 83 In this example of a Roman throne chair, the seat of power is supported on both sides by sphinxes. The wings of the sphinxes continue upward to create the arms of the chair and terminate at the height of the crest rail. Flanking the top of the wings are lit torchères, and across the crest and seat rails are carved laurel branches tied with ribbons. The chair has a built-in dais which elevates the sitter over others in the room, giving him more visual presence. The use of the raised platform continues into the Renaissance period of the sixteenth century. Spiritual empowerment given to animals or mythological creatures, which predates recorded history, is also seen in other cultures. Compare this Roman thronos to the drawing of a sculpture discovered at Catal Huyuk.
Louvre ©Photo RMN.

Figure 84 This drawing of a sculpture discovered in a grain bin in Catal Huyuk shows a woman giving birth while supported by a pair of lionesses. Believed to bring good luck in the harvest, fertility goddesses were an important part of the ritualistic practices of Neolithic culture. The significance of the lionesses is unknown; however, spiritual attributions given to animals and mythological creatures can be seen throughout prerecorded history.

Compare the following furniture items:

Figure 85 The Aldobandini Wedding fresco dating from the first century A.D. shows a cloth-covered lectus with mattress. A disc-turned leg is revealed along with part of the fulcrum. Notice the footstool and scale of the figures in relation to the furnishings.
Photograph, Biblioteca Vaticana, Vatican Library.

Figure 86 This sixteenth-century Florentine cassapanca resembles the design of the Roman lectus in form with its fulcrum-shaped arms and high back. The popularity of classical motifs during the Italian Renaissance period is seen through the use of reclining goddesses that form the pediment. Notice the shape of the arms formed to resemble the fulcrum design, while the unit itself is attached to a base which raises the piece above the ground similar in function to the dais. Made from walnut, the cassapanca would have been covered with loose cushions for added comfort. The seat lifts up for storage underneath.
The Metropolitan Museum of Art, Funds from various donors, 1958.

Figure 87 Made for Marie Antoinette by Jean Baptiste Claude Sené, this late eighteenth-century, Louis XVI-style lit de repos, or daybed, reflects strong classical influences. The walnut daybed has carved term figures, festoons, palmettes, and Ionic orders that are painted and gilt. The cylindrical pillows are strong characteristics of the eighteenth-century Neoclassical period. In general, daybeds came into popular use around the seventeenth century. Small in scale, the daybed allowed for napping in the afternoon without disrupting the already-made larger canopied beds. Height 36½″, Width 69″, Depth 31½″.
The Metropolitan Museum of Art, Gift of Ann Payne Blumenthal, 1941.

Figure 88 The Juno Bed with attached side table designed in 1982 by Zed. Notice the sweeping curvature of the headboard.
Courtesy Cassina.

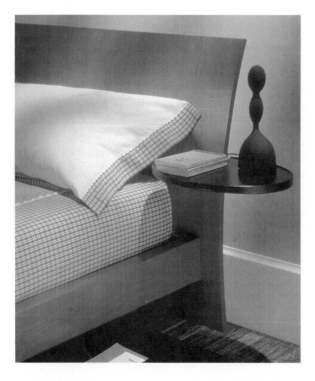

How does the lectus influence the design of the cassapanca that evolved nearly one thousand years later? What lifestyle changes developed that can be attributed to this evolution? How could the design of the sleigh bed be compared to the fulcrum form? Is there a cohesive functional use? What other characteristics do these items have in common?

PRE-RENAISSANCE

THE MEDIEVAL PERIOD

The Medieval period, or Middle Ages, is recognized by most scholars as the period between the fall of the Roman Empire and the beginning of the European Renaissance. Several developing factors took place during the fourth century that led to the establishment of this cultural period, and it is difficult to say with certainty that any one event took precedence over another. Changes in religious practice and political leadership, however, were important catalysts.

When Constantine the Great became emperor of Rome in the early fourth century, he legalized Christianity and authorized the construction of the first Christian church. This feat alone would not have merited great significance, as the practice of paganism continued through the early fifth century. More importantly, Constantine divided the Empire into eastern and western territories. In the west, weakening protection offered by Roman armies at the farthest outreaches of the Empire led to eventual deterioration of Roman dominance. Finally, the city of Rome itself was attacked in 410 A.D.

The Eastern Empire seated in Turkey aligned itself with the ancient city of Byzantium and continued to prosper until the fifteenth century. After the Roman Empire lost its political stronghold in Western Europe, territories were claimed by individuals who established their own laws and form of government. Eventually, the nobility became kings and queens, while their subjects lived with feudalism. These small kingdoms were the only unifying forces except for the Christian church.

The Medieval period is sometimes referred to as the Dark Ages since, at this time, church doctrine overruled individual thinking and progress deteriorated. A sequestering of pagan Roman culture in church libraries put an end to classical ideology that would not be revived again until the fifteenth century. Because the church controlled the education of the masses, pious individuals believed that hell and damnation were the fate of those who went against the teachings of the church. Strict church doctrine controlled social mores and acceptance of what was appropriate.

There are several reasons for the demise of the Medieval period in the mid-fifteenth century. The weakening authority

of the church was a key factor, along with a renewed interest in science and geographical exploration.

Medieval Architectural Settings

Churches or castles housing wealthy rulers or gentry comprised most of the construction taking place during the Medieval period. It is not the purpose of this book to introduce the reader to ecclesiastical design except as it influences the residential interior. Taste and style were dictated by the design of church buildings, exemplified in the twelfth-century Gothic cathedral. The cathedral became the most prominent structure in a town as many were visible for miles before the city could be seen.

Many engineering advancements made by Roman architects, such as an extensive use of concrete and indoor plumbing, were abandoned by the Medieval builder. Attempts by the church fathers to eradicate idolatry and paganism led to the ultimate destruction of Roman architecture as new churches replaced Roman temples. Vast cathedral-building projects often drained the money supply of townspeople and local parishes since everyone was taxed in order to pay for the construction. This left most individuals without money to build anything greater than modest shelter from the weather.

The general population lived in mud or timber structures with thatched roofs and beaten earth floors. Their lifestyle was subsistence based and only the most necessary household items were found inside these dwellings. Merchant-class families, although a smaller percentage of the population, had better living conditions in town. Townhouses made of stucco and timber usually had workshops or stores on the ground level with living quarters above.

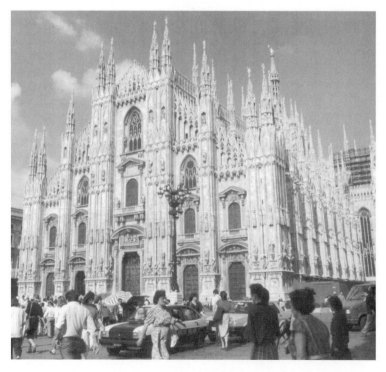

Figure 89 The Cathedral in Milan was begun in 1386 in the High Gothic style emphasizing the vertical height of the structure. Rich, decorative carving on all façades adds textural qualities to the exterior stonework while depicting characteristic motifs for the period such as tracery, pointed arches, and towering pinnacles.

Figure 90 This house, circa 1490 and taken from Somersetshire, England, reflects Tudor-style architecture with its heavy timber post-and-beam construction and plaster walls. Gothic styling can be seen in the pointed arch windows of leaded glass.
Courtesy Museum of Fine Arts, Boston.

Figure 91 High above the Rhine River in Germany, this castle typifies the Medieval fortification necessary to protect a landowner from his enemies. Its elevated location and tall lookout towers enabled guards to see marauding troops while still miles away. The surrounding walls exceeded 40 feet in height and offered additional protection as armed guards waged a successful counterattack from the crenelated turrets above.

Although the claiming of land established a hierarchy of kings over gentry, the ability to maintain possession of the land ensured a forceful reign. Authority was upheld by powerful paid armies and the protection offered by a system of fortification. Large castles with enveloping walls distinguished the political control of one landowner from another. During Medieval times, the castles had to be large enough to house the paid mercenaries and were used to entice favors from royalty. Visiting noblemen often brought their more important servants, including personal maids or valets, with them for extended periods. The total number of guests could exceed a hundred people at one time.

The castle was a vast stone and timber building that evolved from one large room, the great hall. Until the introduction of the fireplace in the fourteenth century, fires were made on the stone floor with an open window providing ventilation. To safeguard against the risk of fire, ceiling heights exceeded twenty feet, a characteristic that endures as a symbol of greatness and wealth.

The lord and lady of the castle greeted guests and attended to the official business of the manor while seated in large chairs placed at one end of the great hall. As the

Figure 92 This massive oak door on Heidelburg castle in Germany was closed and bolted at sunset to protect the inner sanctions of the castle compound. An additional door cut into the lower right corner allowed late arrivers to gain access to the complex as long as they could fit through the small opening. Oversized iron hinges and locking devices were also used on Medieval chests and other case goods for protection of stored valuables.

kingdom grew, so did the size of the castle and, eventually, separate rooms developed for different functions. Soon, the great hall became the dining or banquet room where guests were entertained by minstrels who performed from a gallery above.

As the lord's domain became more prosperous, the interior decoration of the castle became more promising. Wall hangings made from woven *tapestry* or linen cloth kept more warmth in the room and, in some regions, wood paneling carved to simulate folded linen panels was used. In homes of lesser wealth, wall paintings imitated these designs. Rugs were rare at this time and most floors were either stone or brick (see Color Plate 7). Further advances in residential design did not take place until the Renaissance period.

Medieval Design Motifs

Most of the design motifs used during the Medieval period reflect the architectural achievements of the great cathedral projects. The ornamentation of the cathedral was orchestrated by the church fathers and many of the designs had spiritual significance.

Specific plant and animal motifs symbolically represented certain virtues or vices, while natural forms including the grape vine, grape leaf, and grape bunch had a special meaning associated with Christ. This motif, so far seen in the decoration of Egyptian tombs (for wine production) and Greek and Roman temples (connoting the gods of wine, Dionysus and Baccus, respectively) represented the symbolic nature of the Eucharist.

Figural and animal forms were used to illustrate biblical teachings. The pious quickly interpreted these illustrations with their correct associations. Natural forms also dominated the intricate carvings of capitals and *impost blocks* used to support massive vaulted ceilings within the church. These designs resemble the free-form patterns used by monks in decorating the pages of illuminated manuscripts (see Color Plate 7).

Tracery patterns, strapwork carvings, *trefoil* and *quatrefoil* patterns, *crockets*, *pendants*, and pointed arches can be seen on the Gothic cathedral in the intricate stone carvings on walls, *buttresses*, and windows. These designs, however, do not carry spiritual meaning and translate to secular architecture where they are used freely on mantel designs, interior wood paneling, and furniture.

Medieval Furniture

To gain a better understanding of Medieval furniture styles, secular items dating from the twelfth through fifteenth centuries discussed in this book repre-

Window designs with tracery

Rosettes

Crocket border

Crocket finials

Linen fold panels

Diamond and oak
leaf carving

Strapwork
carving

Trefoil Quatrefoil

Figure 93 This table of design motifs exemplifies specific architectural elements incorporated into Medieval furniture design.

sent the essence of Gothic design and will influence many subsequent styles. Furnishings placed inside Medieval castles were designed proportionately to interior spaces. The high ceilings of the great hall demanded that larger-scaled furniture items be used. The introduction of tall case pieces and chairs with high backs was necessary to achieve a sense of balance within the interior. Furniture from the Medieval period is directly associated with architectural design and has many *architectonic* qualities.

The architectural significance of the Gothic cathedral cannot be emphasized enough when discussing interior design and furniture. In many cases, craftsworkers who worked on the construction of the cathedral also designed and crafted furniture. It was natural for them to translate architectural details into carved wood decoration. Workers belonged to specific craft-related guilds that set standards for quality craftsmanship. Guild membership was earned after serving lengthy apprenticeships.

Stools prevailed as the most practical piece of furniture. They were lightweight and often had built-in handles that made transporting them from room to room, or even castle to castle, much easier. It was common practice for individuals to bring their own stools when invited to dinner or a banquet. The stool was still viewed as the most functional type of seat furniture, although its hierarchal attachment diminishes.

Side chairs and armchairs were made in limited quantities. Massive in form and designed with tall backs, the heavy construction did not allow these chairs to be moved from room to room. Most were positioned within the great hall of the Medieval castle, where the lord and lady of the house received visitors and entertained guests. The chair had a straight back that kept the seated person in a formally erect position. Since the chairs were placed on a dais, the importance of the seated person was clearly established.

Medieval furniture was designed for economy as well as decorative value and function. Chairs often had a hollow space built beneath the seat that was used for storage. The iron hinge attached to the seat was hidden by a loose cushion. Furniture of this sort provided a practical solution to creating multifunctional furniture.

The Roman lectus was transformed into a piece of furniture used for sitting rather than reclining by the addition of two fulcrums. This innovation became the prototype for a new type of seat furniture introduced during the Medieval period. By adding a back and arms, the settle replaced the long bench and resembled a church pew; however, the settle was not used in the church since at this time, the congregation stood during services. Made from wood and following the design of carved chairs, some settles were enclosed at the bottom and had a hinged seat that provided access to the storage space.

A chest was considered to be the most important piece of furniture in the castle. Strength in construction insured the safety of valuables, and earlier chests from this period were made from hollowed-out logs. Iron reinforcements were translated into beautiful designs, and advancements in metallurgy enabled more sophisticated locking devices fitted with keys to be used.

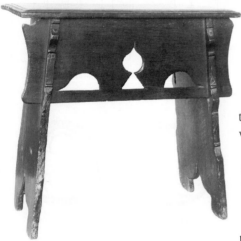

Figure 94 An oak stool with splayed trestle supports is constructed for maximum portability. Stretchers slide into slots on each trestle support. (Notice that the rear stretcher is missing.) The seat then fits over the projecting stretchers thus securing the sides.
Courtesy of the Board of Trustees of the V&A.

Clothing, tapestries, and household objects were stowed in a chest unless the household could afford additional furniture items providing more suitable storage, such as cupboards, armoires, chests of drawers, and *dressoirs*.

The cupboard became another frequently used piece of furniture in the Medieval castle. Prior to the development of the cupboard as a unit of furniture, eating utensils were usually placed on a narrow plank of wood attached to the wall with brackets and called a cup board. Other items were stored in a cupboard as well: a sacristy cupboard contained sacred books, a livery cupboard stored food, and an *ambry* held household objects.

The livery cupboard was designed as a short, wide case piece that allowed easier access to all of the fitted shelves. Doors were designed with pierced tracery panels that allowed the food vapors to escape from the interior. The concept of the livery cupboard can be seen in the modern version of a pie safe.

Figure 95 This French box-form armchair dates from around the late fifteenth or early sixteenth centuries. Massive in size, the chair would have been used by gentry for dining or receiving guests while attending to business at the manor. Decorative details include a crest rail of pierced tracery, crocket-carved finials, flamboyant tracery on the back, and linen-fold panels on the sides and lower front. Notice the key-hole just below the seat. The seat is hinged and raises to reveal a compartment below used to store valuable items. Multifunctional furniture items like this maximize both the cost and use of furniture which is still scarce at this time. Height 75″, Width 29½″.
The Metropolitan Museum of Art, Rogers Fund, 1907.

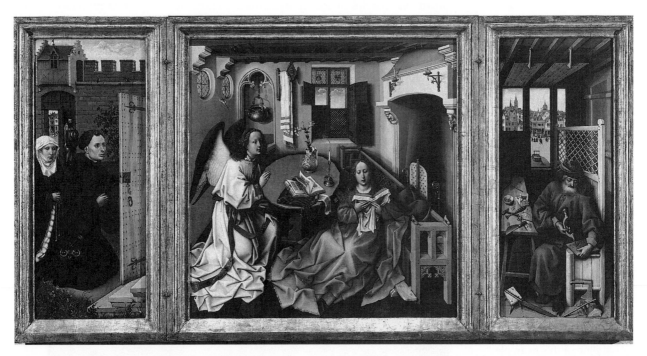

Figure 96 Netherlands painter Robert Campin captures the interior of the home of a wealthy owner during the fifteenth century in this triptych of the Annunciation. Architectural details visible in the central panel—such as the leaded glass windows, arched niche, and hooded fireplace, along with the interior furnishings—indicate the wealth of the owner. The settle has carved pointed arches with crockets (its placement against the fireplace indicates it is the summer season) and a round table has a shaped base. The right panel reveals the inside of a carpenter's workshop; tools are arranged on rectangular table with splayed legs while Joseph sits on a bench with open lattice work.
The Metropolitan Museum of Art, The Cloisters Collection, 1956.

Figure 97 This fifteenth-century French chest with flamboyant tracery front panels is characteristic of the Gothic style. French designs were more elaborate in decoration than English and Italian pieces of the same period. Height 31″, Length 63½″.
The Metropolitan Museum of Art, Rogers Fund, 1905.

Cupboards originally designed to store military armor developed into the *armoire*. Eventually, the armoire became fitted with interior wooden pegs and shelves and was used to store articles of clothing, along with another new piece of furniture, the chest of drawers.

As the great hall became the dining room and banquet hall of the castle, a few more furniture items were introduced at this time. No longer reclining to eat, people during the Middle Ages sat at a long and narrow trestle table for their meals. Guests sat along one side of the trestle table on either a long bench or stools. Servants brought in food from the kitchen and served from the open side of the table. At this time, it was uncommon for servants to walk behind the seated guests as constant fear of assassination cautioned people to protect their backs.

The design of the trestle table suggests its transitory nature: The top of the table was made from long planks of wood supported at each end by trestles. Since the top was not permanently attached to these supports, the table could be quickly disassembled after dinner. The planks were placed against a wall with trestle ends in front, clearing the room for entertainers or dancing.

Figure 98 This fifteenth-century French Gothic-style bench doubles as a chest. During Medieval times, furniture was so scarce that many items served dual functions. The styling of this example shows characteristic linen-fold panels on the front and a crude locking device. Notice the armrests.
The Metropolitan Museum of Art, Bequest of George Blumenthal, 1941.

Other new items of furniture, the dressoir and credenza, were also designed for inclusion in the great hall and were associated with dining. The dressoir was a large case piece used to store table linens and display eating implements made from pewter. The vertical height and massive construction of the dressoir incorporated the design motifs and elaborate ornamentation seen on the Gothic cathedral. Flamboyant tracery, pendants, linen-fold panels, finials, and pierced tracery were used as exterior embellishment, giving the piece its architectonic style.

The credenza was a small table with a square top placed next to the host in the dining hall. A servant, called a credence, placed food on this table before it was served to guests. It was the duty of the credence to taste the food to make sure that it was not poisoned, proving to everyone that it was safe to eat. This piece was eventually enlarged into the size of a cabinet or sideboard.

Before separate bedrooms were added to the design of the castle, everyone in the household—from servants to gentry—slept in the great hall. Unlike the Romans who preferred to sleep singly, the idea of a full-sized bed originated during the Middle Ages. While the servants slept on the floor on loose straw or stuffed mattresses called beds, gentry slept in a large canopied bedstead fitted with drapes that could be closed for privacy and warmth. Drapes were attached to the canopy or tester

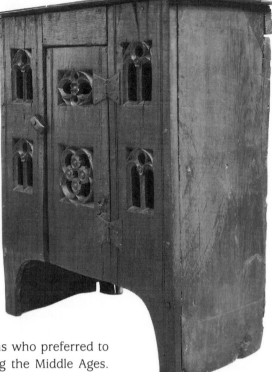

Figure 99 This English Gothic-style oak cupboard circa 1475 is fitted with shelves and was used for food storage. Often called livery cupboards, the pierced tracery allows for air circulation inside the cupboard.
The Metropolitan Museum of Art, Rogers Fund, 1910.

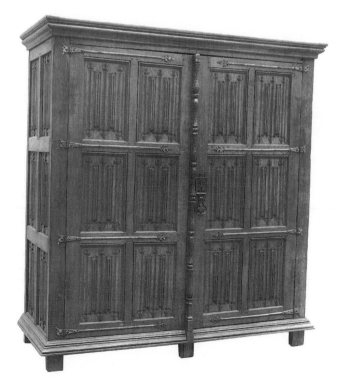

Figure 100 This fifteenth-century French Gothic-style cabinet is made from oak. Notice the linen-fold panels on the cabinet doors and side panels. Large wrought iron hinges were used on most furniture items dating from the Medieval period and are architectural derivatives. Consistent with French examples, this cabinet is more decorative with its application of split spindles, a trait more prominent in the Renaissance period that follows.
The Metropolitan Museum of Art, Gift of J. Pierpont Morgan, 1916.

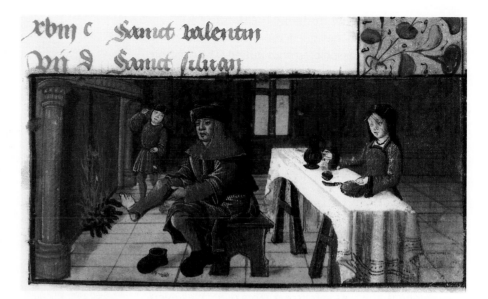

Figure 101 The scene depicted in this canon taken from a liturgical manuscript is set within the Great Hall of a Medieval castle or manor house. The great hall, a large, centrally located room, was used for eating, sleeping, and working until separate specific-purpose rooms were added. Here, a table is set for the next meal. During this period, tables were no more than boards placed on two sawhorse-like supports known as trestles. After the meal, the table was dismantled and the top boards were placed between the wall and the trestles for storage. A bench or stools were arranged along one side of the table for dining, with the opposite side left open for serving. In this scene, a traveler warms himself by the fire while seated on a long bench. Notice the size of the fireplace which heated the cold, drafty castle.
The Bodleian Library, Oxford, MS. Canon. Liturg. 99, fol. 6r.

Figure 102 By the fifteenth century, more sophisticated dining tables appeared but remained portable and adaptable. This French Gothic-style oak table has a hinged top enabling the size to double when unfolded. Notice the linen-fold paneled front, animal head stretchers, and pointed arch designs.
The Metropolitan Museum of Art, Gift of George Blumenthal, 1941.

that ran the length of the bed. A mattress was supported on a frame attached to the headboard, but not the footboard. This made it easier for the drapes to be completely pulled around the bed without obstruction, keeping the warmth inside (see Color Plate 8).

The amount of wood needed to construct the frame, headboard, footboard, and canopy, along with vast yardages of fabric, made the tester bed the most expensive piece of furniture listed in household inventories during the Medieval period. The tester bed was a luxury for most individuals. Even Medieval kings could not afford to furnish each room with a tester bed, let alone additional lodging places throughout the region. During a trip, it was common for the king to send the royal bed ahead of him to ensure comfortable sleeping accommodations on arrival.

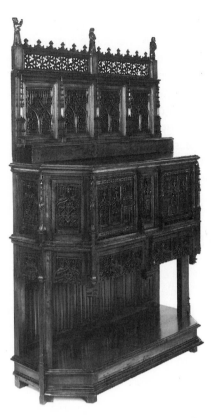

Figure 103 This French Gothic-style dressoir from around 1500 incorporates many design characteristics found on the great cathedrals; figural finials spaced between a row of crockets adorn the top gallery of pierced tracery, while flamboyant tracery decorates each panel on the front and sides of the piece. A lower display area is framed by pendants and columnar supports with linen-fold motifs appearing on the rear panels.
Reproduced by the trustees of The Wallace Collection, London.

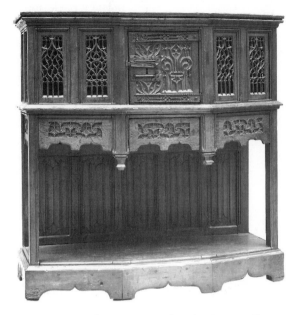

Figure 104 A credence was used in the Great Hall to store and serve food. This example from the late fifteenth century shows the craftsmanship of French joiners working in the Gothic style through its superb and high-styled designs. The cupboard is designed with elaborate pierced tracery, a finely carved apron with pendants, linen-fold panels, and a low shelf for display. Notice the shaped lower apron in the form of pointed arches.
The Metropolitan Museum of Art, Rogers Fund, 1907.

Medieval Decorative Accessories

A variety of decorative accessories was found in the Medieval castle, although their purpose was primarily functional. Most were household utensils fashioned out of pewter and displayed in the great hall on the massive dressoir.

Lighting or illumination was provided by iron candleholders attached to a large wheel suspended from the ceiling on chains. A pulley system raised and lowered the fixture so that each candle could be lit. The fixture was made from the same iron material used for hinges on doors and case furniture. In hallways and on exterior walls, torches were held in place by large iron rings mortared into the stonework or lanterns hung from iron brackets.

Figure 105 This wall bracket shows uses for wrought iron other than hinges. Brackets like these often held hanging lanterns, as the design of this bracket allows it to swing from side to side.
The Metropolitan Museum of Art, Gift of Henry Victor Burgy, 1901.

Although expensive, textiles were more plentiful after the fourteenth century. Tapestries hung on the stone walls of the castle insulated the rooms against drafts and dampness. Popular patterns included landscape designs embroidered in rich colors of crimson, ultramarine, and green.

Glassware was reintroduced to Europeans after twelfth-century crusaders brought back Roman glass-making techniques from the Eastern Empire. Owning glassware during the Medieval period reflected refinement of taste, and money, as the most exquisite examples came from Venetian glass makers.

Although stained glass was a predominant feature of the Gothic cathedral, it was still out of financial reach for many to have glass windows.

• COMPARISONS •

The Gothic style of design, popular at the end of the Medieval period, was gradually replaced by a renewed interest in classicism that spanned the next three centuries. The resulting Renaissance period embraced a newly developing style based on Greco-Roman examples, leaving the heavily proportioned Gothic style behind. As centuries passed, new stylistic directions developed, although the general characteristics of classicism could still be seen.

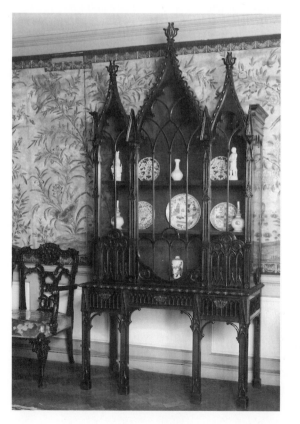

Figure 106 This finely carved mahogany china cabinet dates from the eighteenth century and is exemplary of the Chippendale style in the Gothic taste. Notice that the pointed arches on the display case are articulated with Gothic tracery.
Courtesy of the Board of Trustees of the V&A.

A brief attempt to revive Gothic architectural design occurred in the late eighteenth and early nineteenth centuries. Compare the three examples of furniture shown. What characteristics evoke the Gothic style? How did each furniture designer reinterpret the original concept, altering both design and function?

Several new styles of furniture developed as the Industrial Revolution in the late nineteenth century left many artists and craftsworkers fearful that machines would replace human aesthetics and craftsmanship. This resulted in a "back to basics" approach to design exemplified in the Arts and Crafts movement led by English architect and designer William Morris. How does the writing desk, designed by Morris's contemporary, reflect the traditions of Medieval craft guilds?

Figure 107 An American Gothic revival center table dating from around 1850 reveals a more literal interpretation of Gothic styling. Made from rosewood with rosewood veneer, this table has an apron of pointed arches and pendants, with trefoil tracery motifs appearing on the footing.
Courtesy Museum of Fine Arts, Boston. Edwin E. Jack Fund.

Figure 108 The Arts and Crafts movement of the mid-nineteenth century captured the essence of early Medieval design emphasizing quality craftsmanship and the use of oak. This oak writing desk by English craftsman Charles Voysey incorporates large, oversized hinges in the form of pointed arches into its design.
Courtesy of the Board of Trustees of the V&A.

• PART II •
THE MODERN WORLD

THE 15TH AND 16TH CENTURIES

THE RENAISSANCE

The word *renaissance* is derived from the French "renaitre," meaning to be born anew. The term is used to describe the cultural milieu of the fifteenth and sixteenth centuries which many scholars consider to be the origin of modernity. Significant cultural changes took place during the last two and a half centuries of the Medieval period that led to a rebirth of classic ideology that we call the European Renaissance.

Until the thirteenth century, only a small percentage of people had reading and writing skills. The majority of the population received a limited education, mostly through the church. Since the clergy was respected as great scholars and teachers, Christian monasteries became vast repositories of ancient classical texts that predated Christianity and professed paganism as the only religion. It is not difficult to understand why classical studies were not part of the educational process.

By the end of the thirteenth century, universities were established in England, France, and Italy. This allowed the sons of wealthy landowners to study subjects not covered in liturgical teaching. Improvements in education continued to develop. At the end of the fourteenth century, Greek philosophy was taught for the first time since antiquity. The establishment of Greek studies at Florence University prompted Italians to explore their heritage and rediscover the beauty of classicism that lay in ruins around them.

Other factors contributing to the demise of the Medieval period occurred in the mid-fifteenth century. The seat of the Eastern Roman Empire finally fell to Ottoman Turks in 1453. At this time, members of the clergy fled to Europe bringing with them ancient classical manuscripts from the libraries in Alexandria. In 1454, with the invention of moveable type and the printing press, these ancient texts were translated into Latin and mass produced.

An enlightenment soon followed as Western Europeans were introduced to the great philosophers, scientists, and mathematicians of Greece and Rome. Educated readers thirsting for knowledge embraced the classical teaching of humanism that encouraged them to become free thinkers and determine their own destiny. These events, coupled with greater independence from strict church doctrine, enabled people to experience knowledge at levels unequaled since before the fall of the Roman Empire.

Renaissance Architectural Settings

Ecclesiastical construction continued into the fifteenth century, although the mainstay of building projects emphasized residential development. With a boosted economy brought on by an increase in international trade, a wealthier merchant class enjoyed a more comfortable existence than middle-class families of the Medieval period. A compilation of writings by the first-century Roman architect Vitruvius was first published in 1486. As contemporary Italian architects experimented with Vitruvian theories, the heaviness of the Medieval style gave way to more unified proportions of classicism as expressed through the work of Andrea Palladio (1518–1580).

The architecture of the Italian villa resembled its Roman counterparts, but with modern modifications for changing lifestyles. Many villas were situated on

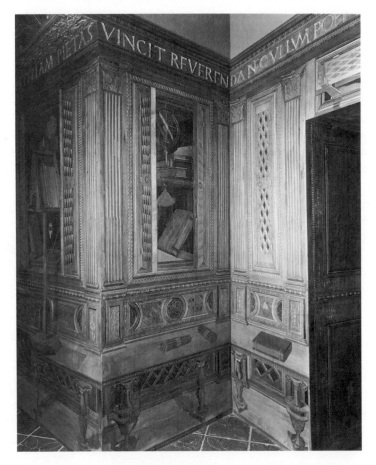

Figure 109 Intarsia panels attributed to fifteenth-century Italian Francesco de Giorgio of Siena and made for the Duke of Urbino shows the beautiful trompe l'oeil qualities of the craft created entirely from different colored woods. This side panel depicts a false bookcase complete with opened doors and a sphereoscope. Notice that a book appears to be resting on a shelf near the door.
The Metropolitan Museum of Art, Rogers Fund, 1939.

hills overlooking manicured gardens with rushing fountains. Italian Renaissance interiors had high ceilings with windows placed at the top, leaving walls open for decoration.

Intricately woven tapestries were hung against brick or stone walls to provide beautiful decoration and offer warmth. In many homes, walls were plastered, allowing skilled artists to execute elaborate frescos rivaling Roman examples. *Trompe l'oeil* scenery expanded the imagination through false representations of bookcases, landscapes, and simulated wood panel *wainscoting*.

By the sixteenth century, the Renaissance style reached Spain, Scandinavia, the Netherlands, France, and England (see Color Plate 9). Spain had been influenced by occupying Moorish culture throughout most of the Middle Ages and embraced the Renaissance manner more cautiously at first. A restrained style, much more simplistic than its Italian counterpart, exemplified Spanish elegance.

The Spanish casa was designed around a central patio created with wrought iron grille work resembling Medieval tracery. Emphasis on this iron grille work was repeated in the interior in the design of accessories and furniture. Most interior walls and floors exhibited ceramic tiles designed with intricate geometrical patterns—a definitive Moorish influence.

French design, on the other hand, remained engrossed in the heaviness of the Medieval style well into the sixteenth century (see Color Plate 10). When Leonardo da Vinci left Italy and went to France to become military advisor to King François I, he brought with him the spirit of the Renaissance. Chateau de Chambord, the king's palatial hunting lodge, introduced classical design mixed with Medieval fortification. It was not until François's successor King Henry II married Catherine de'Medici of Italy that French chateaux were transformed into Italian-inspired palaces.

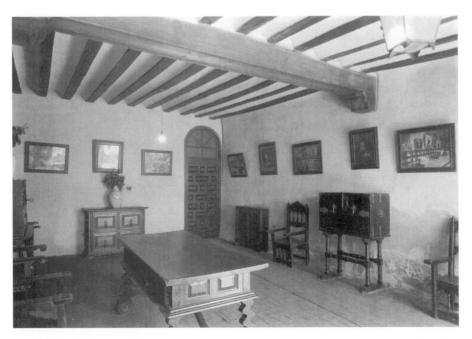

Figure 110 A room in the Casa de Cervantes, Valladolid, Spain, shows typical sixteenth-century household furnishings: a center table, a vargueno puente used for writing, a chest of drawers, and chairs. Throughout the Renaissance, furniture lined the walls to keep the center of the room as open as possible to accommodate the many activities taking place within the room.
Courtesy of The Hispanic Society of America.

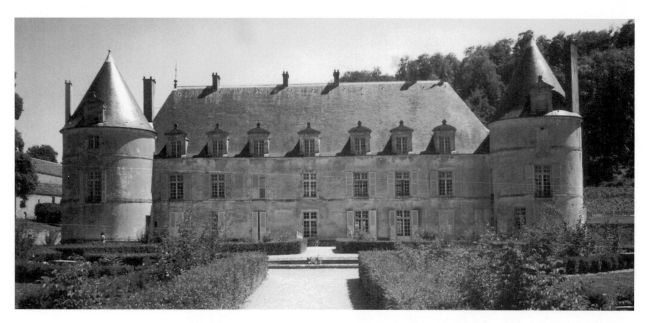

Figure 111 This chateau dating from the French Renaissance period is framed on both sides by massive turrets, reflecting a strict adherence to characteristic Medieval styling. The steeply pitched mansard roof with projecting dormer windows is more notable of the French Renaissance style.
Photo courtesy Jennifer R. Mackey.

Italian culture was virtually brought to France through Catherine's importation of Italian craftsmen and artists who transformed the French chateau from a ponderous Medieval castle into a refined Renaissance estate. Chateau de Chambord and Fontainebleau quickly became showplaces of French Renaissance styling executed by Italian wood carvers, painters, and plasterers.

Figure 112 This salon created for King Henry II in 1552–1556 at the Château Fontainebleau exemplifies France's indebtedness to the Italian Renaissance style of design. The focal point of the salon is the massive fireplace, with the prominent "H" carved into the mantel frieze, flanked by two columns. Geometric patterns appear on both parquet floor and coffered wood ceiling, with wood paneling on the base of the walls between each side arch. Remaining ornamentation relies heavily on gilt stucco relief and frescoes.
Giraudon/Art Resource, NY.

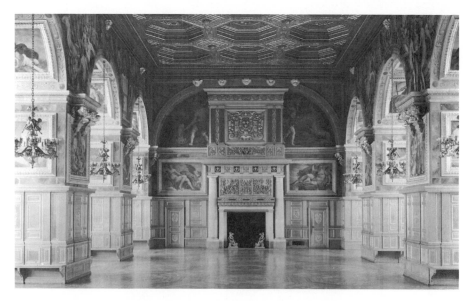

Figure 113 Hampton Court was originally built in 1515 as a residence for Cardinal Wolsey of England. Feeling immense political pressure from King Henry VIII, Wolsey bequeathed the property to the monarch in 1525, a move that undoubtedly spared his life. The west gatehouse shown here, with its large turrets flanking a pointed arch entry, a crenelated roof, and gothic-inspired tracery, reflects a strict adherence to Medieval styling.
RCHME, ©Crown Copyright.

Geographically, culturally, and spiritually separated from the rest of Europe, England developed its Renaissance style much later than the other countries. Hampton Court, home to the English monarchs beginning with the house of Tudor and King Henry VIII, was steeped in Medieval styling. Crenelated brick walls and turrets on the exterior concealed linen-fold paneled interior walls.

English country houses eventually advanced from the large fortified castles that were seats of power for feudal lords to refined estate houses. English design characteristics borrowed heavily from other countries, including Holland and Flanders in Northern Europe, as well as ecclesiastical models. The long gallery was an adaptation of the Medieval cloistered walkway. It was completely enclosed and usually located on the second level of the country manor. It served as a strolling room for long walks and an exercise and play area for children when England's typically inclement weather prohibited outdoor activities. Portraits of family members were hung high on the walls opposite the windowed wall. Oak paneling starting at the floor and extending to the ceiling was common in the English interior as ceiling heights were low by comparison to those in other countries. More elaborate decorations in the room emphasized *pargework* ceilings.

English designers did not adopt a true interpretation of the Renaissance style until the seventeenth century, after the architect Inigo Jones (1573–1652) returned from studying in Italy and introduced the style to King James I.

Renaissance Design Motifs

With a renewed interest in the aesthetic qualities of Roman and Greek culture, Italian Renaissance artisans only had to turn to the ruins of Rome for inspiration. Half buried by centuries of soil, fragmented entablatures and capitals lay on the ground. As excavations began and the new foundation was laid for the rebuilding of St. Peter's church in the early sixteenth century, a multitude of classical artifacts were unearthed that provided exquisite models.

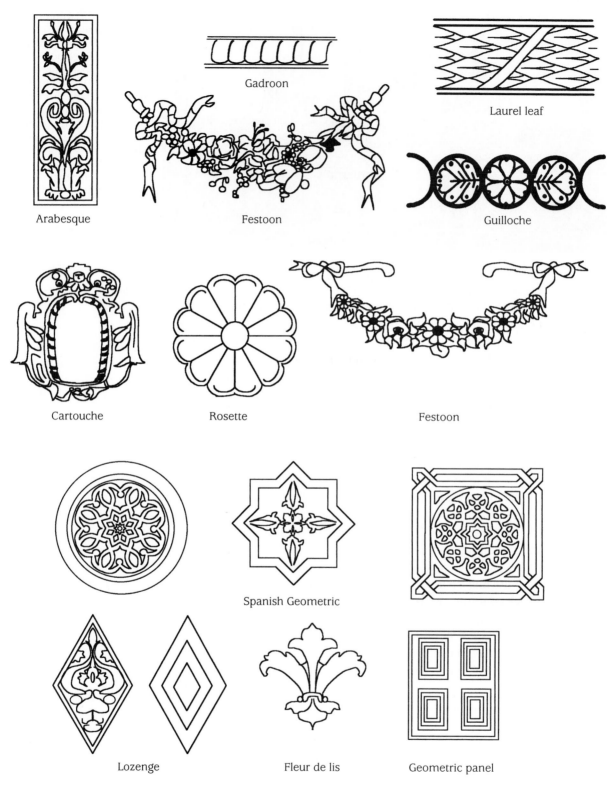

Gadroon

Laurel leaf

Arabesque

Festoon

Guilloche

Cartouche

Rosette

Festoon

Spanish Geometric

Lozenge

Fleur de lis

Geometric panel

French

Figure 114 Table of motifs characteristically used on furniture of the Italian, Spanish, French, and English Renaissance periods.

No longer were the great sculptures of Apollo and Venus idolized as gods; they became the source of inspiration for perfect beauty. Figures of gods and goddesses adorned architectural interiors and furniture as creatures from mythology, not as the powerful supreme beings who were once worshipped.

Spain, France, and England interpreted classical motifs in their own unique manner, with most still clinging to the conventional patterns from the Medieval period. Spaniards used classical ornament moderately and chose to emphasize Moorish-based geometrical designs in the *Mudéjar* style. France adopted classical arabesques and geometrical lozenge patterns, with more extensive use of classic details introduced after Henry II's marriage to Catherine de'Medici. In England, subtle use of the acanthus leaf, pediment, and volute were seen on furniture and architecture until further Renaissance architectural designs were introduced by Inigo Jones.

Renaissance Furniture

A rising middle-class economy enabled more people to possess finer household goods. However, there remains a disparity in construction quality and styling between furniture used by the working class and that owned by wealthier merchants. Typically, walnut replaced oak as the primary wood used in furniture construction, and carving prevailed as the most common decorative feature.

Turned *baluster* and urn shapes were used on chair and table legs, often made more decorative with carved motifs. Stretchers continued to be used and were designed in a variety of forms, usually imitating the shape of the legs. Feet were articulated with geometrical designs, although use of the lion paw appeared on classically enhanced pieces. Case goods were designed with more architectonic features accentuating entablatures or pediment tops.

A wide variety of chair designs was created during the fifteenth- and sixteenth-century Renaissance period, and each was used for a specific purpose. Since furniture was more plentiful at this time than in prior periods, the need to move items from room to room decreased. Greater emphasis was placed on luxury and comfort as the introduction of upholstered furniture made an improvement over the loose-cushion system. Horse hair padding was placed over the seat and sometimes the back of a chair, then covered with either fabric or leather. Held in place with nails or tacks, the stretched material gave the piece of furniture a tailored look.

ITALIAN FURNITURE

Since the Renaissance basically began in Italy, it is important to look at specific examples of furniture from this country first, as the Italian style sets the tone for that of other countries. Household inventories list two types of stools in plentiful quantities. The typical X-form folding design is still common, although a more comfortable type with a fixed back develops.

A *sgabello*, which evolved from these types of stools, has a small, triangular backrest attached to the trestle-supported seat. Although these chairs were

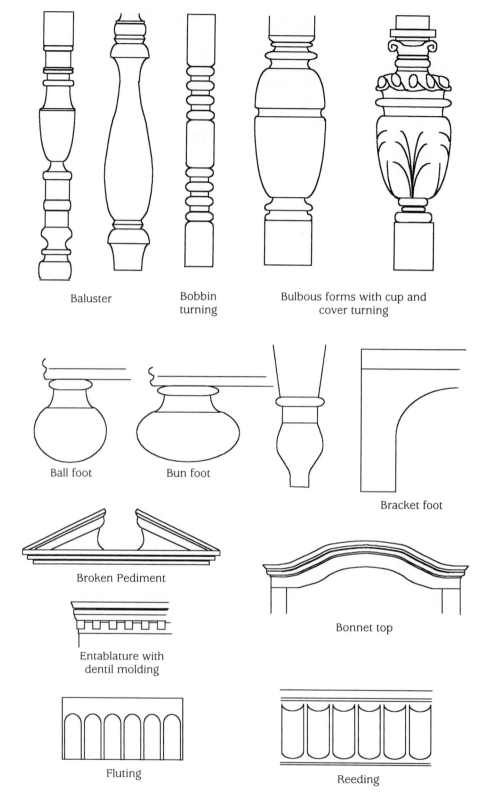

Baluster

Bobbin
turning

Bulbous forms with cup and
cover turning

Ball foot

Bun foot

Bracket foot

Broken Pediment

Entablature with
dentil molding

Bonnet top

Fluting

Reeding

Figure 115 Furniture forms characteristic of the Renaissance period.

quite uncomfortable, they were small enough to be moved from the bedroom into the dining hall when necessary. Women usually sat in these chairs since the absence of arms accommodated their cumbersome skirts. Many were fitted with a single drawer under the seat that was used for storing sewing yarns.

Chairs used for ceremony diminished as they were no longer necessary. The few examples that still existed reflect the proportions and scale of Medieval types; however, they are ornamented with classical carvings.

The box-form armchair called a *sedia* generally replaced these massively scaled ceremonial chairs. Sedias were upholstered and much smaller in size, although still rectangular in design. Finials carved into various shapes extended from the uprights, and bracket- or paw-footed squared legs were connected front to back with runners. This chair was used on a more formal basis in the *refectory*, or dining room. A sedia was positioned at each end of the table during the meal and placed against the wall while not in use.

Figure 116 Made from carved walnut and inlaid with multi-colored wood, this Italian chair, circa 1490, was taken from the Stozzi Palace in Florence and is characteristic of portable chairs of the period. The chair has a tapered back and its tripod base supports an octagonal seat. The top of the back has a scrolled pediment with small modillions on the uprights and an ornate medallion crest rail topped with an anthemion motif.
The Metropolitan Museum of Art, Fletcher Fund, 1930.

Figure 117 This Italian sgabello from the early sixteenth century shows a more advanced design evolving from the portable stool. Equipped with an exaggerated tapered back, the chair provided more comfort than a stool but could still be easily moved from room to room. This example shows delicate acanthus leaf carving on the trestlelike supports with egg and dart moldings and an ornately carved crest rail. Some sgabellos were fitted with small drawers to accommodate women's sewing implements.
The Metropolitan Museum of Art, Bequest of Annie C. Kane, 1926.

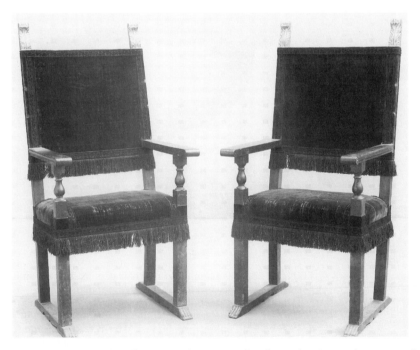

Figure 118 Italian box-form armchairs or sedias from the sixteenth century show the development of upholstery introduced during the Renaissance period. Here, velvet upholstery is attached to the frame with small nailheads. Fringe is applied to the bottom rail of the back and continues around the seat rail. Baluster armposts support flat arms which engage a slight scroll. Straight legs attach to runners with carvings of paw feet.
The Metropolitan Museum of Art, Rogers Fund, 1913.

Figure 119 This Italian arm-chair made during the second half of the sixteenth century is covered with patterned tan velvet upholstery and is slightly more decorative than the previous example. The walnut chair has allover carvings with decorative front and rear stretchers depicting a mythological scene of Leda and the Swan. Uprights are capped with decorative finials. On this example, scroll-shaped armrests supplant the straight armrest from the previous example and end in volutes. The turned armposts take the shape of balusters. This sedia is one of a pair.
The Metropolitan Museum of Art, Gift of George Blumenthal, 1941.

As chairs continued to be designed in smaller, more lightweight styles, upholstered armchairs and side chairs introduced in the later half of the sixteenth century utilized a shorter back and open frame. This style of chair was adopted by other European countries and is characteristic of more practical, less ostentatious designs.

Another popular upholstered chair, the *Dantesca*, was named for the Italian Renaissance poet Dante. This chair was designed with front and back staves and had a broad crest rail as a back support. The two staves were curule form and connected with runners that usually had paw feet. While some Dantescas had classical details carved on the frame, others were decorated with *intarsia* or *certosina*.

Named after an Italian Renaissance clergyman who was burned at the stake by political extremists, the *Savonarola* was a smaller version of the Dantesca. This chair was not upholstered and its curule

Figure 120 This sixteenth-century Italian folding chair, called a Dantesca, is identified by its low upholstered back, loose cushion seat, and X-form base. Decorative details vary on each example; this particular example shows intricate inlay patterns of certosina. The chair differs from another type of folding chair, the Savonarola, in its use of upholstery and its slightly larger scale.
The Metropolitan Museum of Art, Fletcher Fund, 1945.

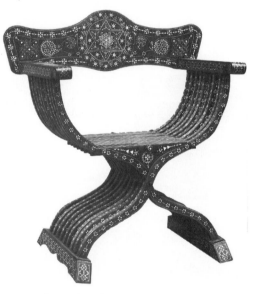

Figure 121 This Italian folding chair gets its name from sixteenth-century Fra Savonarola. Unpopular with the Florentines and the powerful Medici family, Savonarola was burned at the stake in 1498. The walnut chair is all wood with no upholstery, and its X-form base with multiple staves allows for easy folding. The crest rail is hinged on one side and clamps into place on the opposite side, maintaining the stability of the chair while opened. In a less decorative form, it was a popular chair among monks and friars. The association with monastic furnishings is probably why it is known to us as the Savonarola chair. Height 34", Width 30", Depth 20½".
The Metropolitan Museum of Art, Gift of William H. Riggs, 1913.

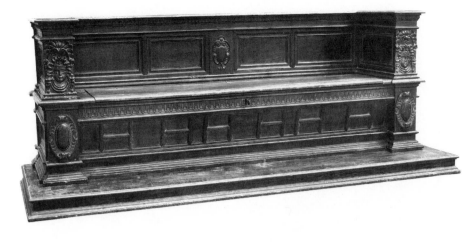

Figure 122 This walnut Florentine cassapanca from the sixteenth century is an example of bench seating used in the Renaissance period. Its flat top is not typical, as several cassapancas in existence indicate that a scrolled pediment was preferred. This piece shows carved mask and cartouche motifs, has a hinged seat allowing access to storage areas below, and is constructed on a dais. A loose cushion seat would have made the piece more comfortable. The Metropolitan Museum of Art, Rogers Fund, 1912.

Figure 123 An Italian cassone dating from around 1520 shows full classical detailing as the Renaissance period reaches its height in the sixteenth century. This example is made from carved cedar while gilding and paint enhance details such as the rosette border, classical figures, Roman sphinxes, and laurel branches. Notice the heavy paw feet. Courtesy of the Board of Trustees of the V&A.

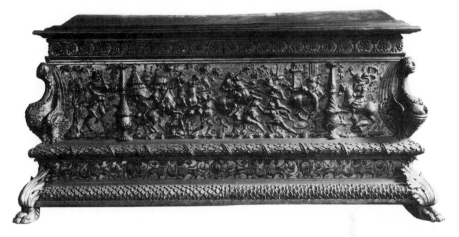

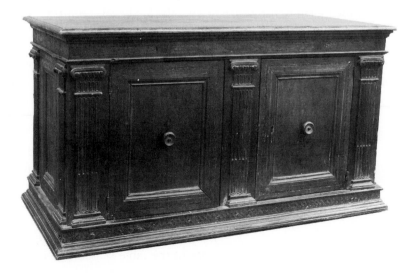

Figure 124 This Italian cupboard from the late fifteenth or early sixteenth century was used to store liturgical objects and is referred to as a sacristy cupboard. Perhaps due to its ecclesiastical use, this cupboard shows restraint in its decoration. Fluted Ionic pilasters flank both sides and the center panel of the cupboard while simple, carved medallion pulls ornament each door. Storage cupboards like this are proportionately larger than the Medieval credence which preceded it. Other types of credenzas stored a multitude of domestic objects and were located in either the refectory or bedroom. The Metropolitan Museum of Art, Rogers Fund, 1916.

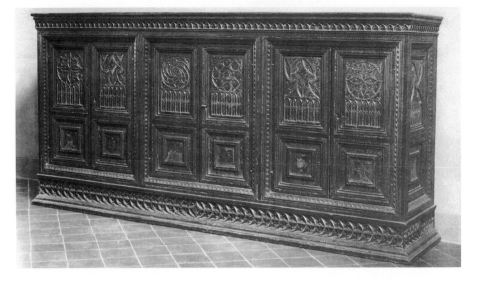

Figure 125 This Italian credenza dates from the early fifteenth century and shows much more decorative carving than the previous example. Cupboard doors are carved with circular motifs running above a row of pointed arches with geometric panels below. Opened doors would reveal shelves on which a variety of objects could be stored. Height 58″, Width 10′, Depth 25″.

The Metropolitan Museum of Art, The Cloisters Collection, 1953.

form allowed the chair to be folded. The crest rail, either hinged or separate from the uprights, could be removed, thus enabling the chair to collapse side to side or arm to arm. The popularity of this portable chair made it a common listing in household and monastic inventories.

Derived from both the Roman lectus with fulcrum arm rests and the Medieval box-form settle, the cassapanca became the prototype for our modern sofa. Made entirely from wood, the cassapanca was attached to its own dais, had arms on both ends, and had a hinged seat that could be raised to access a concealed storage compartment. This piece was not upholstered, but like the settle had loose cushions on both back and seat.

There still remained the need for a separate storage piece used to contain a wide variety of household goods, and the chest or cassone prevailed as the most important piece of furniture used in the home. Italian Renaissance versions resembled the Roman sarcophagus decorated with classical figures rather than the fortified chests of the Medieval period. Chests were often placed at the foot of the bed and stored family valuables as well as clothing.

By the Italian Renaissance period, the Medieval credenza developed into a larger type of storage cupboard. Placed in the refectory, this piece of furniture provided storage for eating implements. Designed with drawers in the frieze area and doors that opened to shelving below, this cupboard was ornamented with either carved, inlaid, or painted designs.

Figure 126 This Venetian walnut table dates from the sixteenth century and is exemplary of the development of refectory tables. No longer moveable, the table maintains its central location in the room and when in use, sedias, sgabellos, or bench seats were positioned along the sides. Notice the heavy paw feet, ornately carved stretcher and scrolled trestlelike supports. Height 34½″, Length 110″, Width 38¾″.

The Metropolitan Museum of Art, Bequest of Annie C. Kane, 1926.

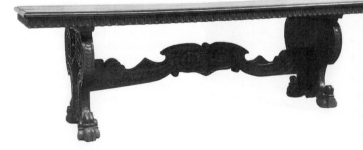

During the Renaissance period, dining took place in a room used exclusively for eating; therefore, a more permanent table was introduced. The refectory table was similar in design to the Medieval trestle table; however, the long and narrow top was securely attached to its supporting framework. As threat of assassination lessened, people were arranged around both sides of the table seated on either sedias, sga-

bellos, stools, or benches. When the table was not in use, the seat furniture was placed against the wall. In homes of the very wealthy, tapestries or Turkish carpets were often used as table covers.

In Italy, the winter temperatures were not as harsh as those in Northern Europe. Because of this, the tester bed was replaced by a four-poster canopy bed, highly decorative in design but without enclosing drapes. Bedrooms served as private chambers for individual members of the household. It was not unusual for people to visit with their guests in these quarters as many were furnished with chairs and tables. Some bedrooms had small dining tables set with chairs, allowing for meals to be taken in privacy (see Color Plate 11).

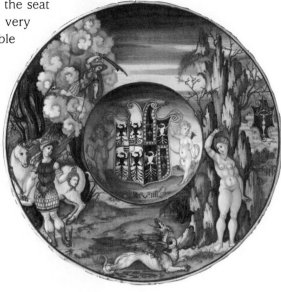

SPANISH FURNITURE

It has already been mentioned that the Italians set the stylistic direction for the Renaissance period, while other European countries adapted the style to fit their own unique culture. Although there are many consistencies in the type of furniture used, there are some distinctive stylistic differences. Furniture items presented in this section reflect some of these variances.

Figure 127 This Italian plate from the d'Este family table service was painted by Nicolo da Urbino circa 1525. The tin-glazed earthenware depicts two figures from Greek mythology, Perseus and Andronmeda, who surround the family crest. 10½″ Dia. Courtesy Museum of Fine Arts, Boston. Otis Norcross Fund.

Spanish furniture craftsmen introduced a new chair designed to benefit the working class. The Barcelona *ladder-back* was an economical chair to produce since the frame, uprights, legs, and stretchers were turned spindles held together with mortise and tenon joints. The rush seat provided a firm but comfortable foundation without the expense of upholstery fabric or leather.

Very similar in styling to the Italian sedia, the Spanish *frailero* was so commonly used by monks that the name itself is derivative of the word friar. The back legs were one continuous piece, extending upward to create the stiles or uprights of the chair. A wide, ornamental stretcher was placed between the front legs and typically mocked the design of the crest rail. This chair was usually padded and upholstered; nevertheless, folding types were quite common. A hinged frame covered with stretched tooled leather enabled the chair to collapse vertically. The craftsworker used nails with large heads to tack the upholstery fabric or leather to the seat rail and uprights, a characteristic of Spanish designs.

Comparable to the Italian Dantesca, although not as deep in the seat, the *sillón de caderas* or *sillón de tijera* (hip-joint) chair was of curule form and was upholstered on the seat and back. Occasionally, these chairs would be designed without a back so that they resembled

Figure 128 A sixteenth-century Spanish folding armchair made from walnut was designed to fold lengthwise as indicated by the hinge visible on the front stretcher. Other features of this chair include its original tooled leather upholstery, volute armrests, and shaped side stretchers. The Metropolitan Museum of Art, Gift of George Blumenthal, 1941.

Figure 129 Nineteenth-century examples of the Spanish Renaissance frailero are currently used in this Caribbean church. Simplistic in design and construction, the hide seat and back attach to the frame with nailheads.

stools except that the staves extended up from the front and back legs along the sides, enveloping the sitter at the hips.

Spanish Renaissance chests served the same purpose as other chests discussed so far in this text. Most were architectonic in design, with the differences between Spanish and Italian types determined through the style of ornamentation. Even though the Italian influence reached Spain through its eastern border, Moorish cultural styles remained popular. Moorish patterns of radiating geometric starbursts were created in *taracea*, an inlay of bone, woods, metal, or ivory on the paneled fronts and tops.

The *armario*, a taller case piece designed after the Medieval armoire, stored articles of clothing. Its arrangement resembles two chests placed one on top of the other, still featuring architectonic qualities and taracea work.

The great nomadic travelers of Spain carried their own writing desk, the *vargueño*. Designed to be portable, the unit had two carrying handles, one at each end. The inte-

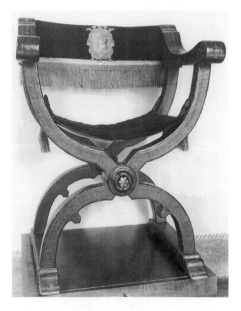

Figure 130 A Spanish sillón de cadera from the sixteenth century has an X-form base, short back, and high arms. These characteristics are shared with the Italian dantesca from the same century.
Instituto Amatller de Arte Hispânico.

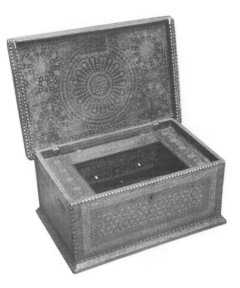

Figure 131 A small walnut Spanish chest from the sixteenth century, possibly from Seville or Andaluz, shows exuberant Moorish designs using inlaid ivory. Height 30.5 cm, Width 67 cm, Width at top 44 cm.
Courtesy The Hispanic Society of America.

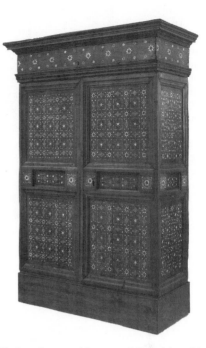

Figure 132 A walnut and boxwood Spanish cabinet or armario with taracea from the sixteenth century. Notice the architectonic features of the heavy cornice with frieze. Height 166 cm, Length 48 cm, Width 116 cm.
Courtesy The Hispanic Society of America.

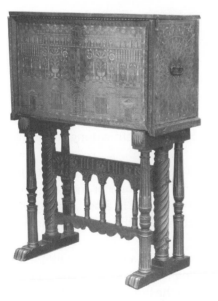

Figure 133 The Mudéjar styling on this Spanish writing desk reflects both classical detailing and Moorish-influenced geometric designs. The desk portion, known as the vargueño, has two handles on each side for carrying. Here, the vargueño is supported by an arcaded stand called a puente. The large carved shell designs on the puente connect to rods and extend to support the fall-front writing surface of the vargueño.
Courtesy The Hispanic Society of America.

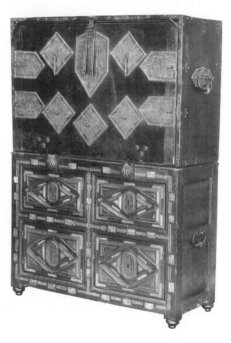

Figure 134 The fall-front panel on this sixteenth-century Spanish vargueño shows strong geometric panel designs that complement the diamond point patterns on the chest, or taquíllon, it rests on. Notice the carrying handles on each piece.
Courtesy The Hispanic Society of America.

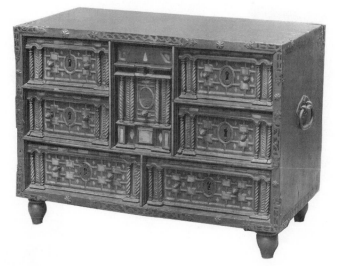

Figure 135 The Spanish papelera was a small portable cabinet used for storing important papers or legal documents. Notice in this example that each drawer has a keyhole for locking, and the frame is reinforced with metal brackets. Carved decorations include both geometric designs and classical columns.
Courtesy The Hispanic Society of America.

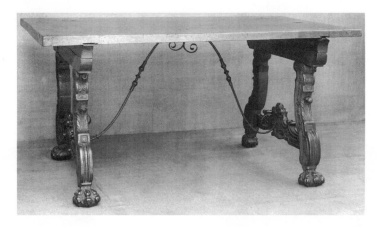

Figure 136 This sixteenth-century Spanish table has trestle ends carved with acanthus leaf modillions and paw feet. Decorative wrought iron underbraces extend from the tabletop to the stretchers located on the supporting trestles.
Courtesy The Hispanic Society of America.

rior was fitted with small drawers and pigeonholes concealed by a front panel. This front piece folded down to provide a smooth writing surface usually covered in leather.

In the home, the vargueño was placed on a small stand called *puente* or on a chest of drawers. Supporting the writing surface of the vargueño, two rods extended from the body of the stand to keep it in a horizontal position. Often the fronts of the vargueños were decorated with taracea or carved geometric diamond patterns.

A *papelera* (taken from *paper*) was used to store important papers. Like the vargueño, it was portable with carrying handles at each end, although the papelera did not have a writing surface. In the home, the papelera typically rested on a small tablelike stand.

Most tables were designed from the prototype trestle table and, like Italian versions, were not intended to be dismantled and stored. The trestle supports were splayed, often in the shape of a lyre, while wrought iron braces were incorporated into the underside of the table top. Bent into delicate "s" curves, these underbraces complemented the grille work commonly seen in the decoration of the Spanish Renaissance home.

FRENCH FURNITURE

French furniture at the time of François I was designed on a smaller scale and was more lightweight than the heavier Gothic style that preceded it. Most chairs were small enough to be arranged in the room according to need and function, although the most typical placement was still against the wall. Ornamentation emphasized carved techniques relying on subdued classical details, as many Gothic patterns were still fashionable.

The *caquetoire*, which emerged in the later half of the sixteenth century, could withstand mobility and was used as a conversation chair. *Caque* translated from French means "to chatter." Favored by both men and women, the chair was designed with a tall, slender back reminiscent of Gothic verticality.

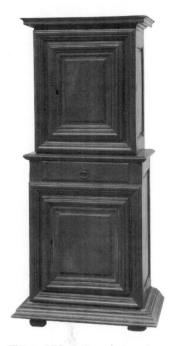

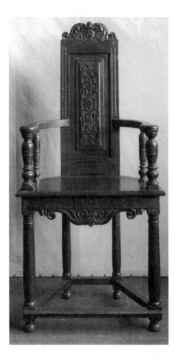

Figure 137 During the French Renaissance period in the sixteenth century, furniture was placed along the perimeter of the room rather than in centrally grouped conversation areas. A special conversation chair called a caquetoire was designed to facilitate communication with guests on either side of the occupant. The chair's broad seat and incurvate arms allowed guests to comfortably pivot from left to right as the focus of the conversation shifted in the room. This chair is designed with classically based motifs which include arabesque carving on the back, scrolled pediment baluster armposts, and a scrolled front apron.
Courtesy The Oslo Museum of Applied Art, ©Kunstindustrimuseet I Oslo.

Figure 138 A French Renaissance walnut cabinet circa 1500–1550 lacks distinctive classical carvings and is decorated with more simplified moldings indicative of the François I style. Notice the heavy cornices and bun feet.
The Metropolitan Museum of Art, Gift of J. Pierpont Morgan, 1916.

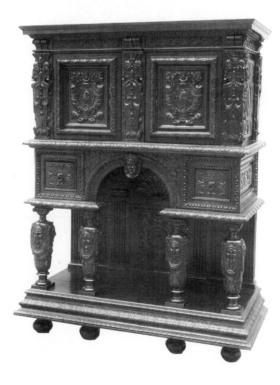

Figure 139 A French Renaissance carved walnut cabinet from the sixteenth century features ornate classical designs. Fluted pilasters, mythological figures, arabesques, egg and dart moldings, and voluted urns evoke strong Italian influences that dominated French furniture designs during the second half of the sixteenth century. High-relief carving and an emphasis on classical motifs are characteristic traits of the Burgundian School of designers popularized by Hugues Sambin, furniture designer and architect to Catherine de'Medici.
The Metropolitan Museum of Art, Bequest of Benjamin Altman, 1913.

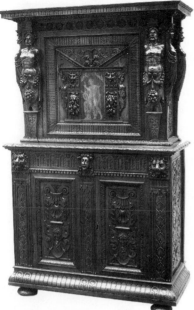

Figure 140 A French Renaissance armoire made during the second half of the sixteenth century in the Burgundian style reflects fully developed classical styling with mythological figures including grotesques and caryatids, roman and lion mask designs, and other classical motifs.

The Metropolitan Museum of Art, Bequest of Benjamin Altman, 1913.

The seat was trapezoidal with the broader side of the seat rail positioned at the front of the chair. Incurvate arms enabled the sitters to pivot left and right as they communicated with guests seated on either side. Ornamentation reflected more architectonic qualities with a scrolled pediment crest rail and baluster or columnar armposts and legs. The back panel often displayed carved barrel vaults or classical arabesque patterns.

A variety of cupboards and cabinets continued to be designed as storage case goods for household items as well as clothing and jewelry. Architectonic in structure, these case goods emphasized entablatures, moldings, and columns. Often, a combination of Gothic-inspired carvings and subtle references to classicism adorned the fronts and sides. After Henry II's marriage to Catherine de'Medici, surface carvings of classical figures, grotesques, garlands, and medallions became more elaborate.

The *armoire a deux corps*, a large case piece designed to store articles of clothing, was actually an armoire "of two bodies." The separate top and bottom pieces made it much easier for the cabinetmaker to transport the piece from his workshop to the chateau.

Tables were more plentiful and came in an array of sizes. The refectory table maintained the appearance of the trestle table, although it was stationary. To accommodate more seated guests, draw tables were made larger by pulling out the ends and extending the length of the table.

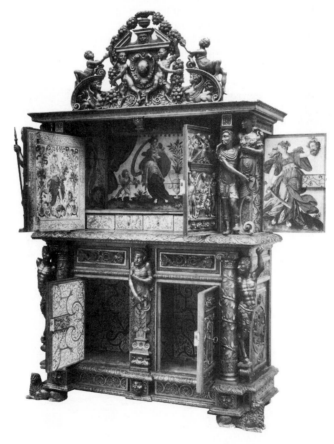

Figure 141 A painted and gilt carved walnut armoire from the French Renaissance period dates to 1552 and was given to King Henry II's daughter as a wedding gift. Opened doors reveal elaborate designs on the interior compartments and attest to the high quality and superb craftsmanship of the Burgundian School. Height 8'1".

The Metropolitan Museum of Art, Rogers Fund, 1925.

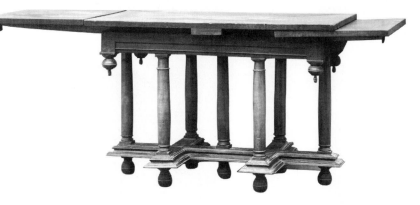

Figure 142 The walnut draw table shown here in various stages of extension was used as a dining table during the early seventeenth century French Renaissance period. Expandable tables originated in the sixteenth century and were designed with either a draw top like this one or drop leafs supported on hinged gate legs. The Louis XIII-style table has columnar legs and pendants along the four corners of the apron.
The Metropolitan Museum of Art, Gift of J. Pierpont Morgan, 1916.

ENGLISH FURNITURE

As previously mentioned, the geographical separation of England from other European countries kept artisans and furniture designers from experiencing the current stylistic trends developing in France and Italy. Only a few were able to travel to these areas and study the new Renaissance style. Elizabethan furniture of the sixteenth century made little advancement over Gothic form. It was sturdy and rugged but not as sophisticated as Italian or French examples. Stools usually were supported by splayed legs with baluster turning and were called joint stools since the components were held together with mortise and tenon construction.

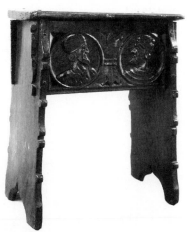

Figure 143 An English Renaissance, sixteenth-century oak stool with carved romaine medallions and trestle supports. Height 22¼″, Width 18″, Depth 10½″.
The Metropolitan Museum of Art, Rogers Fund, 1921.

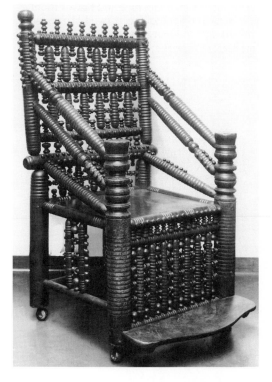

Figure 144 This oak chair from the Welsh countryside dates from the mid-sixteenth century and is a fine example of various turning styles. The complexity of the turned designs adds to its rarity and beauty, as well as the skill of the craftsworker.
Museum of Welsh Life, Cardiff.

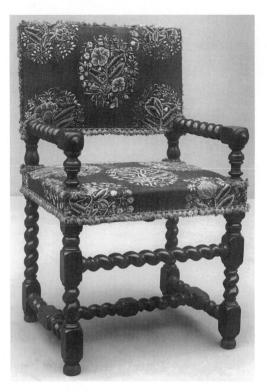

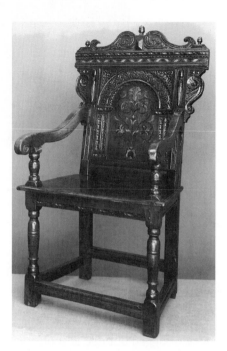

Figure 145 An English Charles II armchair of the Far-thingale type dates from circa 1669–1685. Designed with spiral turning on the arms, legs, and stretchers, a characteristic indicative of the transformation to the Late Jacobean style, the chair's upholstery is needlepoint attached with nailheads and fringe.
The Metropolitan Museum of Art, Rogers Fund, 1915.

Figure 146 An English wainscot chair circa 1640 is decorated with fine carvings of classical motifs, inlay using contrasting woods, and turning. The crest rail incorporates a scrolled pediment and extends over the uprights that support it. Modillions in carved scroll patterns make the transition between crest rail to uprights. The back incorporates an inlaid bird and flower motif framed by an arch in relief carving. Curved armrests slope downward and end in a tight scroll.
Courtesy of the Board of Trustees of the V&A.

Figure 147 A holly and bog-wood English chest dating from the late sixteenth century. Raised moldings and inlay of contrasting woods create an architectural scene of King Henry VIII's famed Nonesuch Castle.
Courtesy of the Board of Trustees of the V&A.

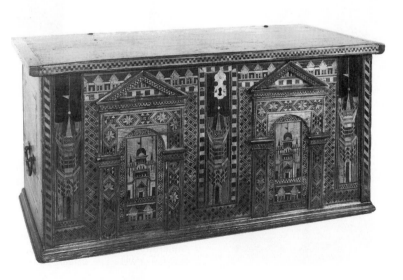

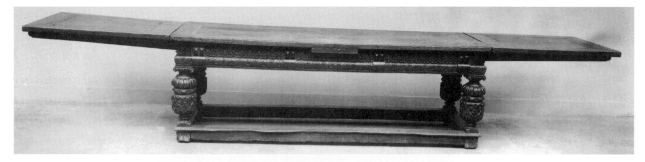

Figure 148 English draw-top tables like this one dating from the late sixteenth or early seventeenth century offered an adaptable solution to accommodating large parties at dinner. Shown here in full extension, this oak table has bulbous turning in the shape of the cup and cover design and strapwork carving in the frieze area. Height 34″, Depth 22¼″, Length fully extended 185¼″.
The Metropolitan Museum of Art, Fletcher Fund, 1923.

Most chair designs had turned legs, arms, and backs that made carved decoration unnecessary. These turned chairs were most common because they were easily produced and somewhat affordable.

Full skirts worn by women during this period hindered them from sitting in armchairs. The *Farthingale* chair was popularized by women's style of dress. Fully upholstered in *Turkey work* (large floral designs that looked like Oriental carpets), the chair had no arms, a raking crest rail back, and a shallow seat that enabled women to "perch" rather than sit. Gentlemen's versions were designed with arms.

Other chairs resembled the Italian Dantesca; they had uprights, raking backs, curule form legs, finials, nail heads, and fringe. Upholstered, this chair had thick cushions attached to the seat. The back was high with a broad crest rail.

The English *wainscot chair* was made popular through the placement of furniture tight against the wall. Its panel and frame design, taken from hay wagon construction methods, had a slightly raking solid wood back orna-

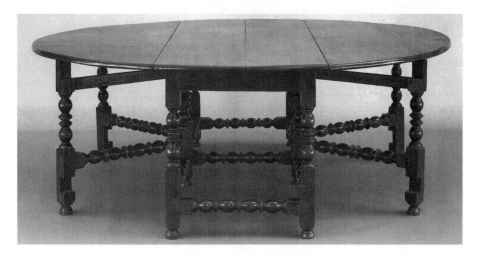

Figure 149 The surface area of this English table from the mid-seventeenth century doubles in size as its gate legs swing open to support the drop-leaf sides. This example, shown in an opened position, has a beveled edge and turned legs and stretchers. Height 31″, Diameter 84″ and 88″, Center section width 30¾″.
The Metropolitan Museum of Art, Gift of Mrs. George Whitney, 1960.

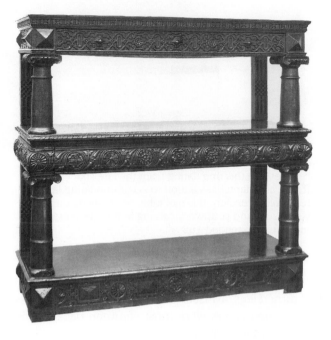

Figure 150 An English, early seventeenth-century court cupboard with open shelves functioned as a server in the refectory of the English home. The top shelf has strapwork carving in the frieze area with rosette medallion carving on the second and bottom shelves and ionic columnar supports.
Courtesy of the Board of Trustees of the V&A.

mented with a scrolled pediment crest rail, *modillions* on the sides of the uprights, and box stretchers. These chairs were not upholstered, but were made more comfortable with a loose cushion seat. The back panel was either carved, decorated with delicate inlay patterns, or both.

Chests were fashionable and varied in decoration from geometric diamond patterns to modestly decorated classical examples. Painted motifs, *Romayne* work, and family crests ornamented the surfaces. Panel and frame construction methods were common, but unlike the Medieval chest, English chests of

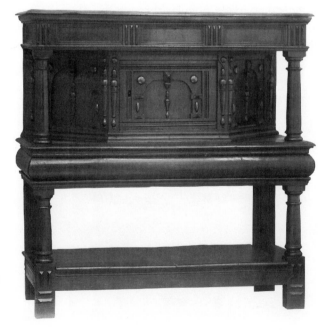

Figure 151 This English, seventeenth-century court cupboard with a closed top compartment was used to store eating utensils and serve food. Similar examples are sometimes identified as hall and parlor cupboards because of their location in the home. This oak example dating from 1650–1675 is designed with a canted cornered top cabinet with split spindle embellishments and a plain frieze divided into three sections by triglyphs. Tuscan columnar supports are used between the top cabinet and bottom shelf.
The Metropolitan Museum of Art, Gift of Mrs. Russel Sage, 1909.

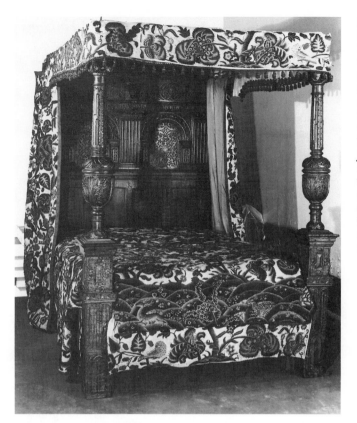

Figure 152 This English tester bed dating from around 1615–1620, with its crewel-work embroideries and detailed carvings, was an expensive piece of furniture to own due to the cost of the bed itself and the cost of the fabric used for bedding and drapery. Typical of Elizabethan and Jacobean styles, the posts include cup and cover turning with carved acanthus leaves and various other classical designs such as the arcaded headboard with pilasters and arabesque patterns. Museum of London.

the Renaissance period concealed the hardware to the inside of the piece, leaving the exterior surface free for decoration.

The English continued to use long tables in the refectory, or dining hall, while smaller, multifunctional tables were used in other rooms. A very practical and somewhat adaptable table was introduced in the sixteenth century that unfolded and expanded as needed. The top had hinged leaves that could be raised onto gate legs that swung open for support. This design offered the flexibility of having a larger table when necessary, with the convenience of a smaller table when not in use.

More refined dining practices led to a need for more formal furniture in the dining hall. The court cupboard, introduced in the sixteenth century, predates the sideboard or buffet that will accompany a suite of dining room furniture in the future. A tiered shelving unit was used to display the tableware when not in use and acted as a food server during meals. The cup and cover turned supports typify English Renaissance design and ornamentation. A variation of the court cupboard, the hall and parlor cupboard had an enclosed section with doors that concealed fitted drawers and shelves.

More ornate than previous Gothic examples, the English tester bed emphasized bulbous-form supports, usually cup and cover or melon turned, and extensive carving on the headboard. The tester bed was still the most expensive furniture item found within the home. The fabric canopy and side drapes, along with the quantity of wood and costly workmanship, reflected the wealth of its owner.

Compare and contrast the two sets of chairs shown. List the characteristics that are similar. How are they different?

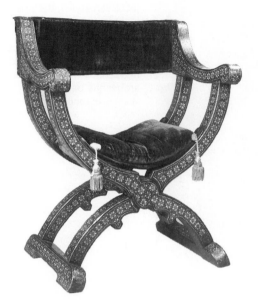

Figure 153 A sixteenth-century Italian Renaissance dantesca with short back, X-form base, and attached cushion seat.
The Metropolitan Museum of Art, Fletcher Fund, 1945.

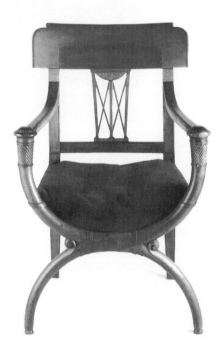

Figure 154 An eighteenth-century French Directoire-style armchair with broad crest rail, pierced back splat, and X-form base.
Reproduced by permission from the Musée des Arts Decoratifs, Paris. Photo by Laurent-Sully JAULMES, All Rights Reserved.

How does the French Directoire armchair from the late eighteenth century imitate the Italian Renaissance Dantesca from the sixteenth century? Considering that the Neoclassical movement was prompted by the rediscovery of Pompeii, why do you think the eighteenth-century furniture designer took his inspiration from the Renaissance period and not directly from Roman prototypes?

Figure 155 This sixteenth-century French Renaissance caquetoire has a tall slender back, incurvate arms, and a broad seat that narrows toward the back.
Courtesy The Oslo Museum of Applied Art, ©Kunstindustrimuseet I Oslo.

Figure 156 A modern, late twentieth-century "H" chair is designed with a tall slender back, incurvate arms, and a broad seat that narrows toward the back.
Courtesy Line International Inc., Coconut Grove, Florida.

Could the designer of the twentieth-century "H" chair have studied furniture design, appropriating the caquetoire's styling? Does this make the "H" chair any less valuable as a functional piece of furniture? Moreover, does its exaggerated reference to the caquetoire make it an art form—a piece of modern sculpture?

After analyzing your own comparisons, can we give credit to these designers for creating a new style of furniture?

THE 17TH CENTURY

THE BAROQUE MOVEMENT

The first use of the term *Baroque* appeared in late eighteenth- and early nine-teenth-century texts as writers attempted to chronicle significant cultural change taking place in post-Renaissance society. The cultural explosion of the Renaissance period was appropriately named; it embodied the rebirth of ex-panded learning in the arts and sciences suppressed since antiquity. The term *Baroque* literally translates from the French as "irregular." In an architectural sense, the term encapsulates a cultural movement emphasizing extreme or-namentation in architecture, lively patterns, and contrasting textures.

Intellectually, attitudes toward God, science, and human existence were more rational, which liberated humankind from spiritual dominance. By the mid-sixteenth century, significant changes developed in religion and politics. Prompted by the writings and actions of Martin Luther and John Calvin, a new Protestant religion formed that sought religious reform and freedom from the papacy. The ensuing wars, instigated by the Reformation in 1517 and the Counter-Reformation in 1560, finally ended around 1650. By then, most Eu-ropean countries were divided by religious alliances.

Europe saw merciless internal battles between countrymen. To compen-sate for these internal religious insurrections, respective monarchies at-tempted to create a profound sense of nationalism, promoting an allegiance to country rather than faith. The ruling monarchs strengthened absolutist con-trol and took protectionary measures to strengthen their political power. Ab-solutism brought greater economic opportunities to individuals as increased internal trading elevated more of the merchant classes to upper middle-class society.

Another important result of the religious wars and the quest for abso-lutism came with rising imperialism as the first permanent English colonies were established in North America. In 1607, John Smith and a small group of English adventurers seeking gold and religious freedom settled Jamestown, Virginia. Thirteen years later in 1620, the Mayflower set sail from Plymouth, England, and established the second settlement in Ply-mouth, Massachusetts.

Although the political power of the Catholic church diminished significantly, its religious strengths brought on by the victory of the Counter-Reformation and the endurance of the papal states—Italy, Spain, Portugal, and France—were made visible by church construction. In Italy, the Baroque period emerged as a more passionate and expressive extension of the sixteenth-century Italian High Renaissance style. New Catholic church designs emphasized the magnificence of size and scale, and exaggerated ostentatious decorative details replaced the simplicity of classical elegance used by Renaissance architects. Baroque architectural style became a highly articulated extension of Renaissance classicism; columns, pediments, pilasters, and arches were interpreted with a new vigor charged with emotion.

Baroque Architecture

The most celebrated artist and architect of the high Baroque style, Gianlorenzo Bernini (1598–1680), dazzled Italy with his work at St. Peter's in Rome. The *baldachin* he designed for the church interior forced the eyes to glance upwards toward Michelangelo's grand dome. The grandiose nature of St. Peter's and other ecclesiastical accomplishments prompted monarchs and aristocrats to adopt this new style in the construction of their own private estates and palaces.

First seen in the interior of the Italian Palazzo Farnese in Rome, the development of the Baroque style evolved in the gallery space designed by Annibale Carracci (1560–1609). His work on the gallery from 1597 to 1604 epitomizes the lavishness of the Baroque style: pilasters with gilt Corinthian capitals flank wall niches articulated with classical moldings and the upper walls and ceilings are covered with trompe l'oeil paintings compartmentalized by plaster moldings.

Early Baroque architects placed an importance on the coordination of architectural structure, painting, and sculpture into a single cohesive unit. Fresco painting and plaster relief works were used as backgrounds for exquisitely crafted furnishings. The skill of the Italian craftsman was celebrated throughout Europe. Traveling in almost all the papal states to meet the demands of aristocratic patrons, these Italian craftsworkers inspired architects in the seventeenth-century Baroque style, including many of the French.

Although Italy was the seat of the papal states, France had succeeded as a leading political force in Europe when five-year-old Louis XIV (r. 1643–1715) ascended the throne. Too young to actually rule, his mother acted as regent until 1661 when Louis XIV took control of the state. By this time, France was already the wealthiest and most populated country in Europe. As king, Louis made many progressive reforms including the implementation of a standardized money system and a consistent method of determining weights and measures. Trade was encouraged within the French borders as King Louis XIV viewed this as a means of building a greater tax-revenue base. An increase in local trade supported the growth of a wealthy middle class, the bourgeoisie, who exceeded the aristocrats in population.

Louis XIV took the initiative to develop art and culture in France and contributed greatly to its advancement. With an increase in revenue, he funded

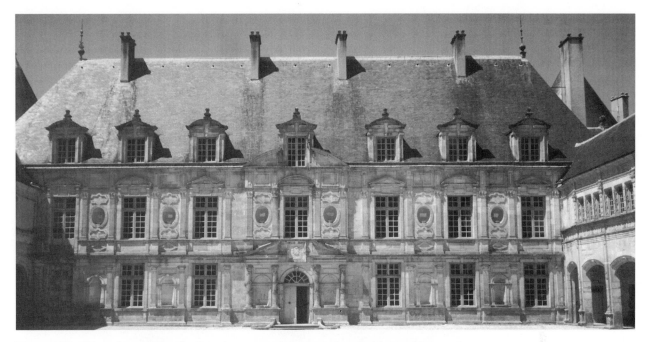

Figure 157 Although retaining the Renaissance-style mansard roof, this French château articulates the extensive use of ornamentation on the exterior which is more characteristic of the Baroque period. Classic details are emphasized through pediment windows flanked by pilasters, medallions, and niches.
Photo courtesy Jennifer R. Mackey.

public works projects in an attempt to create a French national style. In 1667, he organized the workshops at the Manufacture des Gobelins, (established in 1633 by Minister Colbert to provide furnishings for the royal palaces) under the leadership of Charles LeBrun (1619–1690). The following year, LeBrun found himself in charge of his most celebrated achievement: the interior decoration of a new palace for the French monarchy.

Located twenty miles southwest of Paris at Versailles, the 1624 château built for King Louis XIII (r. 1610–1643) was transformed into the new royal palace. In addition to LeBrun, Louis XIV assembled into his patronage the leading architects of the period—Louis LeVau (1612–1670), Jules Hardouin-Mansart (1646–1708), and André LeNôtre (1613–1700)—to design the palatial residence and gardens.

A garden façade setback designed by LeVau and enclosed by Mansart became the most impressive room within the palace. The Hall of Mirrors was designed with seventeen lunette windows overlooking the garden and equally sized mirrors hung opposite each window. This created a room bathed in sunlight. Each morning, the room served as the site of Louis XIV's awakening procession ceremony as his bedchamber directly connected to this hall. Just as the sun was at the center of the universe, Louis XIV considered himself to be at the center of the French state. He viewed himself as the "Sun King" and, unequivocally, Mansart's design had complemented the king's perception of himself.

Figure 158 In 1668, King Louis XIV of France commissioned the building of the Palace of Versailles. He assembled into his patronage leading architects and designers of the period, including Louis LeVau, Charles LeBrun, and later, Jules Hardouin-Mansart, to create the most grandiose chateau ever built. No expense was spared as seen in the famed Hall of Mirrors (designed by Mansart in 1677). Measuring 240 feet long and 34 feet wide with a ceiling height of 43 feet, the Hall of Mirrors was ornamented with green marble pilasters crowned with gilt Corinthian capitals. The length of the barrel-vaulted ceiling is covered with fine oil paintings surrounded by gilt putti and classical festoons. Lunette windows offer views to the formal gardens. Mirrors of similar size and shape placed opposite each lunette window reflect the light back into the hall with such an intensity that the room became the favorite of the Sun King.

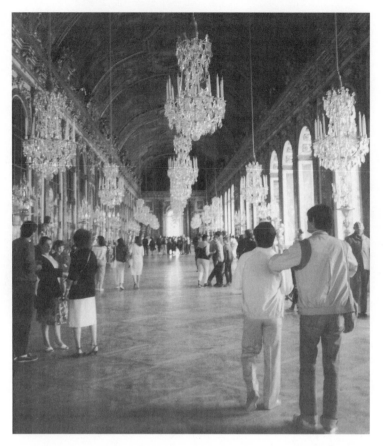

Figure 159 The entrance into the Hall of Mirrors reveals the same exuberance seen throughout the palace. The mirrors were necessary to help reflect light from the crystal chandeliers back into the room for nighttime activities.

LeBrun attended to the interior details. He directed teams of craftsmen in the design and execution of paintings, tapestries, furniture, and decorative accessories, thus achieving complete unity within the palace. Along with tapestries and velvets, gold and silver gilt furniture played an integral part of the interior scheme at Versailles.

Versailles became the envy of Europe for lavish social events. Celebrations and festivals lasted for days, while ballets and performances entertained numerous guests. Court life was poetic for everyone; it was carefree and leisurely. The completion of Versailles established France as the cultural leader in Europe during the seventeenth century. French was the fashionable language to speak and French court fashion provided a model for aristocrats and bourgeois alike.

England and the rest of the predominantly Protestant countries were not immediately influenced by the Baroque style of the papal states. Unlike the rest of Europe during the sixteenth century, England had not yet fully embraced the Renaissance style. As mentioned earlier, credit for bringing the Italian Renaissance style to England is given to the architect Inigo Jones. It is he who introduced Palladianism to King James I (r. 1603–1625) and all of England with his design for Banqueting House built in 1619. Palladian influences abound as its façade reiterates the unified proportions of Italian Renaissance architecture through the rhythmic placement of windows, engaged columns, and pilasters. Festooning delicately ornaments the architrave beneath the balustrade and cornice of the roof.

From the beginning of the seventeenth century until after 1666, there was an architectural lull as England experienced turbulent political change. Absolutism under James I was threatened when Parliament refused to support the king on matters of state. Further troubles followed under the kingship of James's son and successor to the throne, Charles I (r. 1625–1649). A bloody civil war led to the execution of Charles in 1649 and the dissolution of the monarchy. The following period of the Commonwealth was led by Oliver Cromwell and governed by Parliament. The regime lasted until 1660, when a newly elected Parliament reinstated the monarchy under Charles II (r.

Figure 160 The French landscape architect André LeNôtre was responsible for the design of the formal gardens at Versailles. Characteristic of French style, the shrubs and lawn are cut into well manicured shapes that reveal whimsical patterns when seen from inside the palace.

1660–1685) who had been in exile in Holland. This period of the Restoration established the balance of power between king and Parliament.

With the restoration of the monarchy, the second half of the seventeenth century ushered in new optimism for individual freedom and wealth exemplified by vast building projects undertaken by private patrons. England's introduction to the Baroque style occurred after the Great Fire in 1666 destroyed most of London. Charles II set out to rebuild London in grand style and appointed Christopher Wren (1632–1723) as surveyor to his court.

Wren had traveled to Paris in 1665 and returned to England with countless engravings depicting the ornate French Baroque style. The grandiose nature of the French Baroque style had impressed the king; however, it was ill-suited for London. Through Wren's achievements, an English national style was established and he was knighted for his architectural accomplishments. Wren's interpretation of the high Baroque style supplanted excessive ornamentalizing with classic Palladianism.

Grinling Gibbons (1648–1720), working under Wren's charge and independently, mastered the skill of wood carving and transformed the English interior. For both monarch and gentry, Gibbons's creations reflected an exuberance not typically seen before in English style. The staunch oak paneling and plaster pargework ceilings of the Renaissance were replaced with highly elaborate wood carving and detailed classical molding. Cupids, fruits and flowers, birds, and foliate patterns adorned paneled walls, door frames, mantels, and staircases. Gibbons's decorative carving, typical of Jacobean interiors, became less fashionable toward the end of the seventeenth century as

Figure 161 Woodwork at Cassiobury Park by the English carver Grinling Gibbons dates from between 1677 and 1680 and was carved from pine, ash, and oak. Classical details, such as rinceau patterns, oak leaf and holly designs, and pineapple carved finials add to the essence of Baroque exuberance. The two chairs, table, and desk in the stairwell hallway represent styles popular during the reigns of Charles II, James II, and William and Mary.
The Metropolitan Museum of Art, Rogers Fund, 1932.

Figure 162 The King's Apartments at Hampton Court Palace reflect Sir Christopher Wren's Baroque architectural styling near the end of the seventeenth century. Brocaded panels positioned under classically restrained moldings replace the dark paneled walls and heavier carvings of the Late Jacobean style. The furniture in this room maintains a strong Dutch and Flemish influence as seen in the use of "S" scroll legs on the stools and writing desk. Notice the reflection of the bedstead and day bed in the mirror hanging over the fireplace.
RCHME, ©Crown Copyright.

Figure 163 The influences of both Wren and Gibbons can be seen in this room at Hamilton Place, Scotland, dating from around 1690. Plasterwork ceiling, interior moldings, and the pilasters framing the fireplace all reflect Wren's style of classical detailing, while the woodwork follows the style of Gibbons.
Courtesy Museum of Fine Arts, Boston. Gift of Mrs. Harriet J. Bradbury in memory of George Robert White.

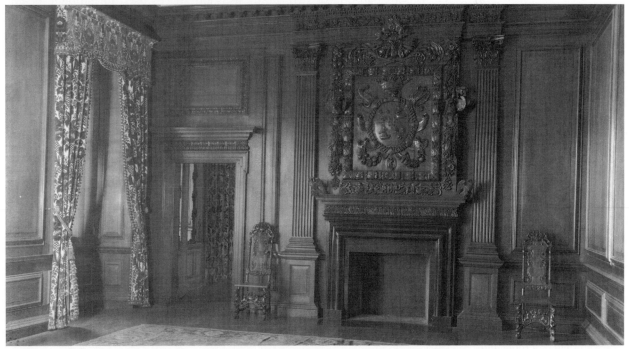

more simplistic classical motifs increased in popularity and ceiling paintings came into vogue.

Wren continued work under two additional monarchs: James II (r. 1685–1689) and husband-and-wife rulers, William of Orange (r. 1689–1702) and Mary (r. 1689–1694, daughter of James II). Unlike her predecessors, Queen Mary took a keen interest in architecture and the arts. The austere Hampton Court, under Wren's direction, was remodeled into a stately residence for the king and queen. Perhaps due to William's puritanical upbringing which defied luxury and excess, the interior of the transformed Hampton Court was more restrained in appearance and execution than the exuberantly carved Jacobean interiors (see Color Plate 12).

American Architecture

Seventeenth-century American architecture was quite different from the Baroque style expressed in European churches and villas. English ships sailed for America with a wide range of passengers aboard but with little provisions. Upon their arrival, the first settlers' primary concern was to build sufficient shelter from the weather and to cultivate the land. As each independent colony developed, the most fundamental methods of architectural construction were employed. Although some basic tools were brought with the settlers, other goods had to be imported from England on ships which were costly and took months to arrive. The small, but accommodating houses were made from wood planks that were felled, planed, and cut from the abundant supply of oak trees. The settlements resembled European medieval villages rather than sophisticated cities such as London and Paris.

Homes had one or two rooms with loft spaces used for storage. Beaten earth floors and daub and straw walls provided shelter from the elements but lacked aesthetic integrity. The interiors were furnished with strictly utilitarian items, most of which were made on the continent by joiners or brought over from England.

Shortly after the establishment of the Jamestown and Plymouth settlements, the Dutch, Spanish, and French came to the New World. By 1630,

Figure 164 This twentieth-century recreation of 1627 Plymouth, Massachusetts, accurately depicts the architecture of the first English settlers in America. Based on English examples, these houses were made from timber with thatched roofs and daub and straw walls.

Figure 165 The recreated interior shows the subsistence furniture items used by the settlers of Plymouth, Massachusetts. Barrels used for tables, a simple turned chair, and possibly a chest brought over from England containing the family's only possessions provide practical and modest comfort.

towns were established all along the eastern seaboard. A developing economy dependent upon cash crops such as tobacco and rice that were exported and sold in Europe brought wealth to the American colonists and towns continued to grow and prosper. By the end of the seventeenth century, the colonial home, which provided greater comfort to its inhabitants, dominated the urban landscape.

Figure 166 Toward the end of the seventeenth century, American colonists were able to build modest, but more comfortable homes like this New England house dating from 1687. Notice the lack of symmetry in the placement of the dormer windows. Symmetry in design is more prevalent in the American Federal style of architecture.

Baroque Design Motifs

Key design elements used consistently in architectural interiors and subsequently incorporated into furniture designs reflect the Baroque adherence to classic inspiration. Acanthus leaves, shell motifs, griffins, pilasters, classical arabesques, garlands, and cupidlike figures were supplemented with lively botanicals. Iris, lily, and tulip forms were used as architectural interior embellishment through plaster relief work and wood carving as already noted, but also were translated into delicate marquetry patterns used on tabletops, drawer and door fronts, and clock cases. The more ornate floral designs were introduced into France by the Dutch during the crusades that swept Europe in the 1600s. Even more influential are the specific characteristics that developed regionally on furniture as illustrated by leg and foot forms, entablatures, and hardware.

Figure 167 This chart shows typical leg, foot, and arm patterns used on French Baroque furniture.

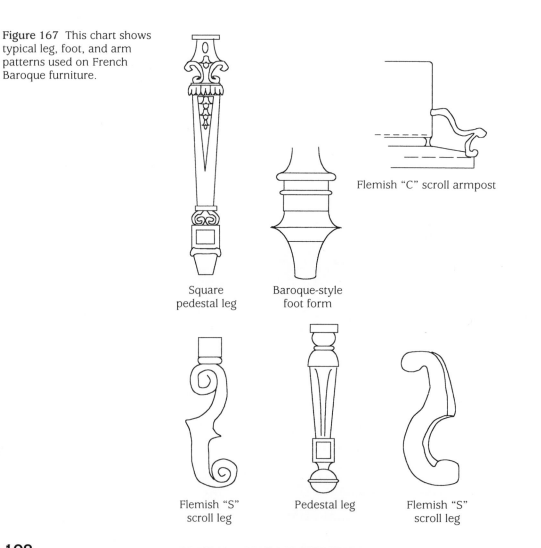

Flemish "C" scroll armpost

Square
pedestal leg

Baroque-style
foot form

Flemish "S"
scroll leg

Pedestal leg

Flemish "S"
scroll leg

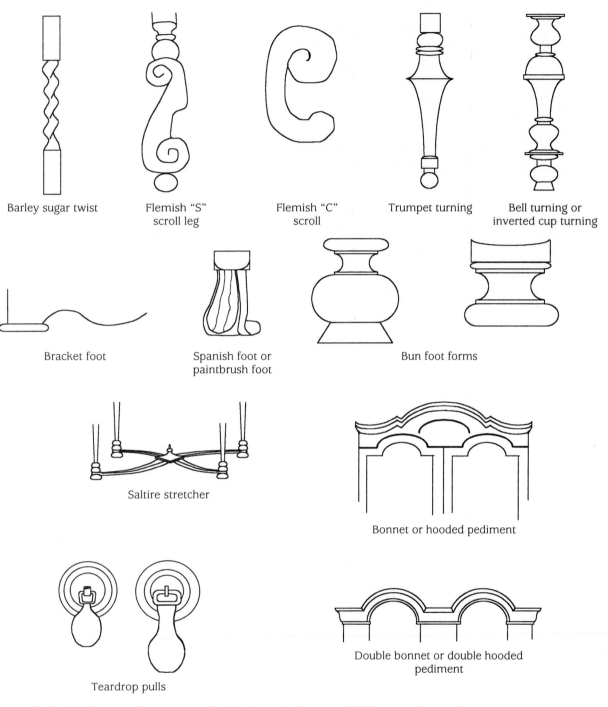

Barley sugar twist

Flemish "S" scroll leg

Flemish "C" scroll

Trumpet turning

Bell turning or inverted cup turning

Bracket foot

Spanish foot or paintbrush foot

Bun foot forms

Saltire stretcher

Bonnet or hooded pediment

Teardrop pulls

Double bonnet or double hooded pediment

Figure 168 English Baroque furniture details of the Late Jacobean and William and Mary style.

Baroque Furniture

An individual's wealth and social status in seventeenth-century Europe were shown equally by the size of his estate and the quantity and quality of furnishings within it. The large but sparsely decorated and furnished chateaux, country houses, and villas of the fifteenth and sixteenth centuries were now filled with matching suites of furniture produced for comfort and usefulness as well as decoration.

While each country adapted the Baroque style of architecture to suit its preferences, the furniture also reflected the disparity of style from one country to another. With the completion of Versailles, the French replaced the Italians in dictating the prevalent style of the period. While still highly decorative, furniture became less architectonic and more comfortable. The introduction of more specific-use furniture rather than multifunctional furniture revealed greater individual wealth as interiors provided satisfying accommodations to the inhabitants. New items introduced during the seventeenth century included a chest of drawers in an array of heights and sizes, the sleeping chair, cabinets, console tables, the sofa or settee, and bookcases with glazed panels.

The majority of country furniture was still made by joiners using the standard mortise-and-tenon method of construction. Toward the end of the seventeenth century, as the use of oak lessened and more walnut was used, the dovetail joint became a more suitable method of joining two pieces of wood. Also, the practice of veneering grew rapidly as furniture makers used walnut, known for its richness of color and grain, from France, Spain, or Virginia.

The skill of the cabinetmaker was reflected in the exuberant carvings and delicate inlay patterns that ornamented the furniture as marquetry became a popular surface treatment for cabinet doors, table tops, and drawer fronts. These better-made pieces were often signed by the cabinetmakers whose reputations were known through their "trademark" marquetry patterns. The variety of fruitwoods, imported ebony, mother of pearl, and ivory used for these inlays symbolized the wealth of the owner.

Pietra Dura—inlay using marble, granite, and other semiprecious stones—created beautiful mosaic botanical patterns on tabletops and cabinet doors. Tortoise shell, perhaps the most exotic new material used to ornament furniture, was heated then flattened and used as a veneer. Often, the shell was covered with a thin glaze of red paint to make it glow under a protective layer of *chased* metal.

By the 1680s, the Chinese export trade flourished, bringing Turkish and other Middle Eastern influences to Europe. Lacquered cabinets with *chinoiserie* patterns were quickly imitated by local cabinetmakers, offering their customers a less expensive alternative to veneer.

FRENCH FURNITURE

Furniture designed during the first half of the seventeenth century is usually categorized as Louis XIII style which was influenced by both Italian and Flemish Baroque styles (see Color Plate 13). Most scholars place the development of

a true French Baroque style with Louis XIV's reign and the completion of the palace at Versailles.

Charles LeBrun directed the completion of the palace interior, and the workshops of the Gobelins produced some of the finest examples of interior furnishings made during the seventeenth century in the Louis XIV, or Louis Quatorze, style. Since the scale of the palace was monumentally oversized, the furniture was proportioned accordingly. Louis XIV himself stood an astounding 6 feet 3 inches (unusually tall for the period), and since his comfort was a primary concern for LeBrun, chairs were adequately oversized and not scaled for normal stature.

A typical French Baroque armchair, or *fauteuil*, has a tall rectangular back framed by carved wooden arms. The back and seat were usually upholstered; however, some had cane backs. The arms placed lower toward the front of the chair than at the back allowed for a more relaxed positioning of the arm. Various leg forms were used; however, the square pedestal type was more common. Since some fauteuils weighed a hefty sixty pounds each, stretcher systems, either saltier or H-form, were necessary to support the massive carved legs and frames.

Although the frames for chairs and other furniture items made for Versailles were of carved wood, most were gilded with either gold or silver. Written accounts specifically refer to furnishings made exclusively of silver. Unfortunately, the solid silver items were melted down when France suffered extreme financial burdens late in the century.

The *bergère* was similar to the fauteuil, but was completely upholstered including the sides and the arms. Another popular type of chair developed during the Baroque period was the wing chair. This chair, designed with extensions that shielded the face from drafts, was referred to as a "confessional" (derived from ecclesiastical types) or a "sleeping chair" since the back also reclined.

Figure 169 An eighteenth-century French fauteuil in the style of Louis XIV has strong rectangular features carried through in the tall back and squared seat. The square pedestal legs and saltier stretcher are of carved and gilt wood. The patterned upholstery is cut and uncut velvet with fringe trim. Height 33½", Width 23¼".
The Metropolitan Museum of Art, Gift of J. Pierpont Morgan, 1907.

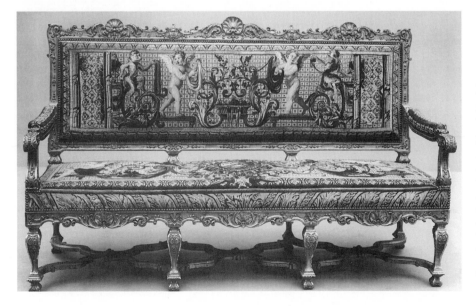

Figure 170 A French canapé from 1715–1723 in the Louis XIV style is designed with a rectangular back framed by carved and gilt wood, a squared seat with a carved decorative apron, and eight pedestal legs connected by saltier stretchers. Classical detailing can be seen in both carvings and the Beauvais tapestry upholstery. Height 48½", Width 77", Depth 26½".
The Metropolitan Museum of Art, Bequest of Benjamin Altman, 1913.

The number of fauteuils and bergères was limited at Versailles, but stools with either upholstered seats or removable cushions were in greater abundance. Louis XIV kept with traditional seating hierarchies by "permitting" guests to sit on stools, or *tabourets*, by his command. Placets or ployants were French X-form folding types. It was not unusual for people in the king's presence to be denied a place to sit.

The evolution of the settle into the settee occurred during the reign of Louis XIV. The French *canapé* is the first introduction to the formal couch or sofa. These early examples were usually upholstered and designed to match en suite with the fauteuils and tabourets. The uncomfortable upright back forced the sitter into an erect and formal position.

The Medieval or Renaissance chest was transformed into the more popular commode of the Baroque period. Commodes were often fitted with two horizontal drawers and used as storage pieces. André Charles Boulle (1642–1732) is credited with designing the first examples of this type of furniture for Versailles. Boulle's grandfather was furniture maker to King Louis XIII, and it was only natural for the younger Boulle to be appointed to the commission of Louis XIV in 1672. Original commodes designed for Louis XIV introduced Boulle's specialized trademark marquetry designs. His name sometimes is used generically; *Boulle work* indicates marquetry patterns that resemble his style.

The surface of the commode was covered with either ebony and tortoise shell or both. Thin sheets of brass, bronze, or pewter were then carefully cut into elaborate classical arabesque or other foliate patterns. Both positive and negative metal images were used to create impressive "matched" designs for the suite. Not only were two commodes perfectly paired in their design, but all the precious metal was used without waste. Boulle work marquetry appeared

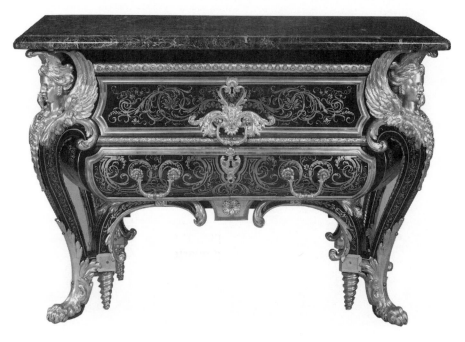

Figure 171 A French Louis XIV-style commode created by André-Charles Boulle around 1710–1732 for Versailles is made from ebony veneer on walnut with marquetry of engraved brass inlaid on a tortoise shell ground. Classical elements appear on the commode in the form of gilt-bronze Roman sphinx mounts, guilloche-patterned ormolu, and a green marble top. Height 34½″, Width 50½″, Depth 24¾″.

The Metropolitan Museum of Art, The Jack and Belle Linsky Collection, 1982.

on a variety of objects including commodes, cabinets, armoires, clock cases, and accessory items.

The commodes were finished with cast bronze mounts, and although highly decorative, served a practical function as well. When placed on corners, feet, and drawer edges of the piece, these mounts helped protect the surface from scratches, kicks, and bumps. The craftsmanship of these bronze appliqués, called ormolu, were usually executed by specialists trained in metallurgy rather than cabinetmaking.

Most French Baroque furniture was stately, formal, and richly decorated. Secondary storage units, such as the cabinet on a stand, were not simply functional but reflected the wealth of the owner. These cabinets were made from ebony and the cabinetmakers who specialized in this material became known as ébénistes. The cabinet doors displayed richly detailed pietra dura or intarsia botanical patterns. The stands were equally ornate, carved with classical figures, saltier stretchers, or *aprons*. Armoires continued to be used for clothes storage.

Tables were designed to suit a variety of functions; some were strictly decorative while others were quite practical. The console table developed during the Baroque period and had a carved wooden frame with legs and stretchers that matched those of the fauteuils. With aprons on three sides, these small tables were designed to be placed against the wall, usually in front of a large mirror. Although expensive, mirrors were necessary as they aided in reflecting light back into the room. Illumination came from richly decorated candelabras and sconces. A marble top protected the surface of the console table from dripping candle wax.

Other types of tables included those for dining, playing cards, dressing, and working. Writing tables were in greater use during the seventeenth century as both men and women of the court were highly educated and written correspondence was maintained on a daily basis. Some were simply tables fitted with a single center drawer, like the bureau plat, while desks were fitted with side drawers as well as tabletop compartments.

As in the past, furniture usually lined the perimeter walls, leaving the center of the room open. The arrangement of furniture within the room varied with purpose and function, and chairs and tables were relocated to the center as needed.

Within the larger French chateaux, people resided in small apartments or suites of rooms that became their living quarters. In many cases, the apartment was nothing more than a bedroom. At Versailles, the bed was placed against one wall separated from the rest of the room by a railing. The railing acted as the formal barrier between the public and private space as it was customary to receive visitors and dine in this room (see Color Plate 14).

Figure 172 A pair of French Baroque pedestals, circa 1780, are made from ebony veneer and have gilt bronze mounts and brass marquetry in the manner of Boulle. Notice that all of the chased metal is used in the application of both counter and direct marquetry.
The Metropolitan Museum of Art, Gift of Edouard Jonas, 1922.

Figure 173 A French, late seventeenth- or early eighteenth-century armoire in the style of Louis XIV made from carved walnut has a segmented pediment top and raised panel doors.
The Metropolitan Museum of Art, Gift of J. Pierpont Morgan, 1906.

Since the boudoir was both bedroom and primary living quarters, a new piece of furniture was introduced around 1625. The day bed, or chaise longue, was placed transversely at the foot of the canopied and draped four-poster bed and used for afternoon napping. This kept the linens on the lit à colonnes neat and orderly throughout the day.

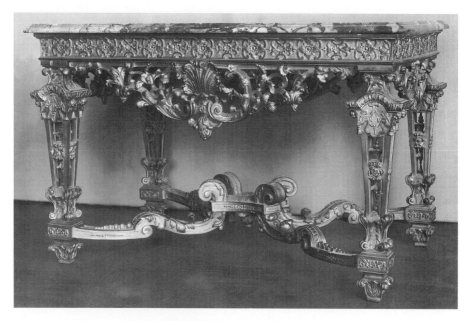

Figure 174 This French, seventeenth-century Louis XIV-style table made of carved and gilt wood has ornate aprons on all sides indicating this piece was placed in the center of the room, rather than against a wall. All four square pedestal legs and the saltier stretcher show detailed classical motifs such as acanthus leaf carvings and rosette and bell flower designs. Height 82 cm, Width 126 cm.
Reproduced by permission from the Musée des Arts Decoratifs, Paris, All Rights Reserved.

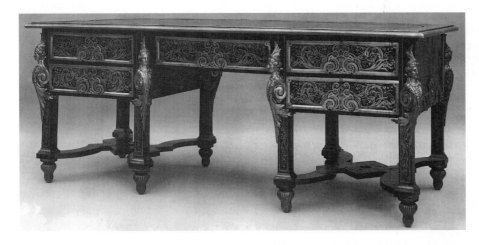

Figure 175 A French, late seventeenth-century Louis XIV-style desk made from ebony veneer with brass and tortoise shell inlay and gilt bronze mounts. This piece is attributed to the workshop of Boulle.

The Metropolitan Museum of Art, Bequest of Ogden Mills, 1937.

There is another side of French furniture not represented here but worthy of mention. Not everyone had the wealth of the aristocracy. In the villages, domestic homes contained tried and true examples of utilitarian furnishings including tables, chairs, stools, beds, and chests. Items created by local craftsmen were copied from previous styles perhaps with only slight modification.

In discussing any period of furniture history, the reader must realize that with the introduction of new styles, old ones still remained popular for quite some time. It was not uncommon for rooms to be decorated with a variety of different styles since furniture was still quite expensive to own.

ENGLISH FURNITURE

Typically, there are three prevalent English furniture styles of the seventeenth century: Early Jacobean, Late Jacobean, and William and Mary. In most examples, the style of Early Jacobean furniture followed the influences of the Elizabethan with little creative reinterpretation. After studying past styles and correlating the influences of architecture on the development of new furniture styles, English Baroque furniture followed the architectural achievements of Sir Christopher Wren and Grinling Gibbons.

A true English Baroque style is more evident in furniture designed after the Restoration and is thus referred to as Late Jacobean. Late Jacobean furniture is characterized by high relief carving and pierced carving imitating the complex patterns of Gibbons's work. Chair and table legs were fashioned into spiral turned columns called "barley sugar twists" with uprights, stretchers, and armposts equally ornate.

Most English Baroque furniture reflected a Dutch and Flemish influence due to England's close alliance with Holland even before William of Orange took the throne in 1689. The Flemish-influenced carved "S" and "C" scrolls were used frequently on Late Jacobean furnishings. After the Great Fire of 1666 that destroyed most of London, furniture makers were busy filling orders for inexpensive furniture, especially chairs. Consistent with Dutch and Flemish chairs of the period, the English adapted these tall and narrow-back chairs with

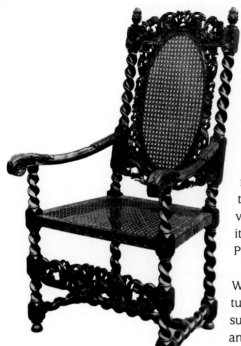

a heavily carved crest rail into their own version. Although not a new material, woven cane replaced the more traditional leather or upholstered seats and backs, providing a more cost-effective substitute.

Successful trading with the Far East and India encouraged an Oriental influence. As lacquered cabinets, tables, and small boxes made their way onto the continent, cabinetmakers were quick to imitate the colors, patterns, and high gloss finishes used. Since true Oriental lacquering processes were unknown to European cabinetmakers, they improvised by painting finished cabinets, armoires, and chairs in dark green, crimson, or black. The piece was then decorated with either inlayed or painted chinoiserie motifs and varnished. This technique was appropriately dubbed *japanning*, and its process was documented in a published treatise by Stalker and Parker in 1688.

The English Baroque period is often called the age of walnut. Walnut replaced oak during the second half of the seventeenth century as the prevalent cabinetmaking material. Various types of walnut such as black walnut or burl walnut were chosen for color and grain and veneered to less attractive woods; they were finished with a paste wax buffed to a high sheen. As the art of veneering improved with the development of better adhesives, new marquetry patterns were introduced. Characteristic seaweed marquetry and oystering patterns adorned tabletops, drawer and door fronts, and side panels. These new marquetry patterns were interspersed with typical French foliate patterns.

Wren's transformation of Hampton Court from an Elizabethan-Gothic palace to a more classically defined residence for England's new reigning monarchs, William and Mary, influenced changes in furniture design during the last

Figure 176 A combination of carved details and spiral turning decorate this English, Late Jacobean-style walnut armchair from 1680. Woven cane used for the seat and back offers resilient support and replaces costly upholstery techniques.
The Metropolitan Museum of Art, Fletcher Fund, 1923.

Figure 177 An English, late seventeenth-century Late Jacobean-style side table is decorated with spiral turned legs, ball feet, a saltier stretcher, and floral marquetry designs. The body of the table is pine with a walnut veneer; walnut, ebony, and fruitwood are used in the marquetry work on table top, drawer fronts, side panels, and the central crossing of the saltier stretcher. Notice the teardrop drawer pulls.
Courtesy of the Board of Trustees of the V&A.

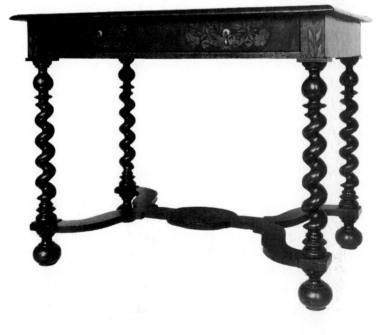

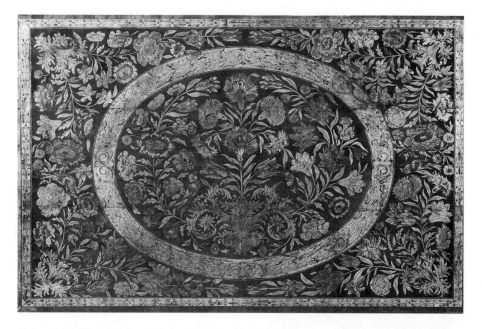

Figure 178 The skill level of the marquetry worker is revealed here in a detail of the top of Figure 177. Thin veneers of various woods chosen for either natural or stain-enhanced coloring were layered and held together with small tacks. A pattern for each part of the design was transferred onto the veneers and then carefully cut by hand with a fine blade saw. Edges of the cut pieces were then scorched in hot sand giving each piece the desired shading necessary for the modeling of the overall design. Pieces were then fit into a prepared background precisely cut to receive each pattern. In this example, intricate botanical designs, birds, and scroll patterns can be seen.
Courtesy of the Board of Trustees of the V&A.

two decades of the seventeenth century. The ornate carving on Late Jacobean furnishings no longer fit into a much simpler, classical interior. Queen Mary took an active role in the transformation of the palace. She was an avid collector of porcelains, and the new interior style relied greatly on Oriental accents.

The excessive carving seen on chairs of the Late Jacobean style was replaced by more subtle decorations. The periwig chair, a chair specifically designed with an elaborate crest rail that emphasized the fashionable wigs worn by both men and women, introduced gentle curves and scrolls rather than deep carving. Flemish "S" and "C" scroll legs terminating into Spanish or paintbrush feet were used less frequently as straighter tapering legs were introduced. Trumpet or inverted cup turned legs were more typical of the William and Mary style, and the use of the stretcher continued throughout the seventeenth century.

William III, not to be outdone by King Louis XIV and Versailles, continued to develop English high style even after Mary's death in 1694. The French Baroque style of furniture was favored by wealthy English gentry and fine examples of gilt items, including rare examples of silver-gilt furniture, survive today (see Color Plate 15). Instrumental in introducing the French style to

Figure 179 This English armchair in the William and Mary style, circa 1690–1710, is made from carved beech and uses cane instead of upholstery for the seat and back. Characteristic of chairs designed in this style, the back is tall and narrow and separated from the turned uprights along each side. The shape of the carved crest rail is repeated in the ornamental front stretcher, and the Flemish "S" scroll appears in the design of the front legs. After London was destroyed by the Great Fire of 1666, woven cane came into fashion as a substitute for upholstery since it was easier to produce and more cost efficient. Height 55⅝″, Width 26½″, Depth 20″.
The Metropolitan Museum of Art, Bequest of Cecile L. Mayer, 1962

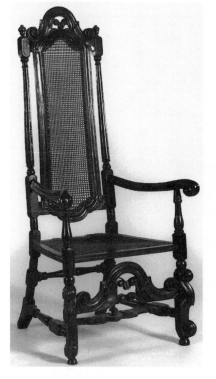

William III, the Paris-born architect Daniel Marot (c. 1666–1752) fled to Holland along with other French Huguenots during the 1685 persecutions. He came to England in 1694 and remained in the service of the court until 1698.

Cabinets on stands were used both for storage and for display of the owner's porcelain collection. Like their French counterparts, some cabinets were decorated with inlay of mother of pearl, ivory, or semiprecious stones; however, seaweed marquetry dominated the design of many English Baroque examples. Seaweed marquetry, appropriately named since the curvilinear cut slivers of colored wood resembled tangled seaweed, duplicated the intricate designs of Boulle work marquetry.

Unique to English and eventually American furniture are the highboy, lowboy, and tallboy. These replaced the low, horizontal chest and introduced a more practical means of storing clothing in drawers. A highboy was simply a chest of drawers raised off the floor on tall legs. The lowboy was a low table fitted

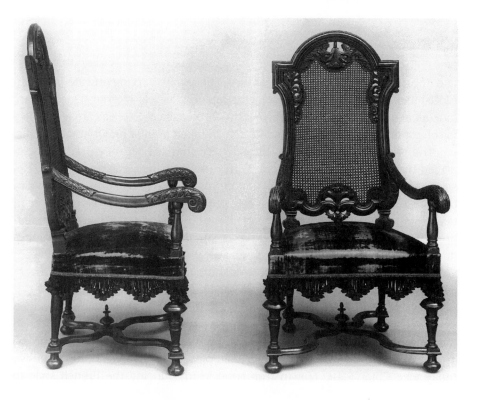

Figure 180 English, late seventeenth-century William and Mary-style walnut armchairs with upholstered seats and cane backs have baluster armposts, a saltier stretcher, and the developing inverted cup legs. Notice the acanthus leaf carving appearing on the armrests and crest rail.
The Metropolitan Museum of Art, Bequest of Benjamin Altman, 1913.

with a single drawer and used as a dressing table. Both highboy and lowboy were supported by columnar-type legs with trumpet or inverted cup turning more typical of the William and Mary style.

Flemish scroll legs were still used occasionally; however, these were flat and not turned or carved in a decorative fashion. All legs were joined with some type of stretcher system, usually a saltier. Like the Flemish scrolls, these were often flat and not carved. Only examples imitating the French Baroque style were ornately carved.

A tallboy, a name adopted by the Americans, was a chest on a chest. The base chest was supported by either bracket, bun, or ball feet. Most tallboys and highboys had a flat cornice top with a slightly bulging frieze called a pulvinar frieze. Teardrop pulls were the typical hardware used on William and Mary-style case

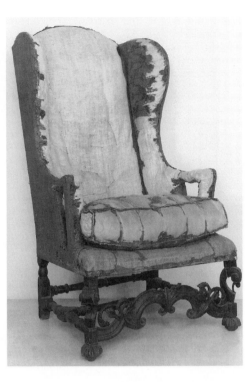

Figure 181 The side panels on this English wing chair from the late seventeenth or early eighteenth century shelter only the face of the occupant. Unlike the sleeping chair before it, it does not recline. Courtesy of the Board of Trustees of the V&A.

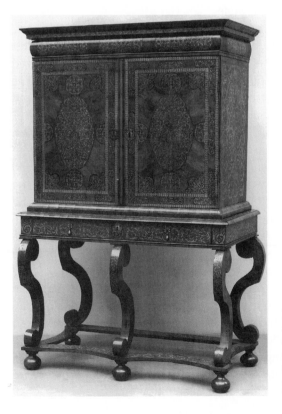

Figure 182 An English, seventeenth-century cabinet in the William and Mary style with seaweed marquetry panels rests on a tablelike stand fitted with drawers. The marquetry pattern is carried through on the design of the stand; it appears on the side rails, Flemish "S" scroll legs, and stretchers. Notice the bun feet, projecting cornice, and teardrop drawer pulls.
The Metropolitan Museum of Art, Bequest of Annie C. Kane, 1926.

Figure 183 This English William and Mary-style oak highboy, circa 1675–1700, is designed as a chest on a table-like stand. Both sections are fitted with drawers articulated by decorative moldings. Notice the teardrop pulls, shaped stretcher, inverted-bell-turned legs, and bun feet. The flat cornice is characteristic of seventeenth-century case pieces. Height 56¾", Width 38¾", Depth 22¼".
The Metropolitan Museum of Art, Gift of Mrs. Russell Sage, 1909.

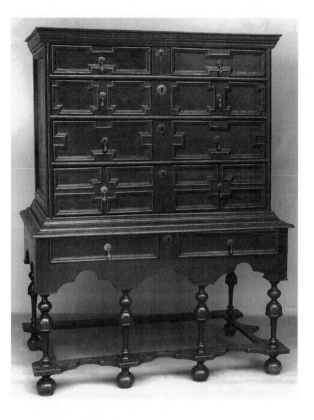

Figure 184 Features on this English William and Mary-style walnut card table from around 1690 include trumpet-turned legs, fitted drawers with teardrop pulls, and ball feet. Notice the sliding candle stands visible just above each of the side drawers. As the card table is opened, the hinged top unfolds and rests on the back pair of legs that swing open to support its weight.
Mallet & Son Antiques Ltd., London, UK/Bridgeman Art Library, London/New York.

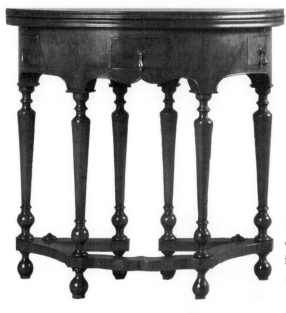

furniture. These small brass drops resembled a teardrop in appearance and are characteristic of the English Baroque style.

Gateleg tables were still quite popular and were used for dining purposes. Smaller side tables were introduced as tea tables, writing tables, work tables, and curio tables. A wide variety of styles and ornamentation individualized these tables to suit their specific functions, but all retained the characteristic trumpet or inverted cup turned legs and saltier stretcher.

Larger writing cabinets, or *secretaries*, also appeared in the last decades of the seventeenth century. Flat or slanted doors concealed drawers and paper slots and doubled as the writing surface when dropped onto supporting members. A smaller bureau designed with full drawers on either side of the kneehole space was also a new development (see Color Plate 16).

Accessory items completed the room design and ranged from pedestals used to display fine vases and sculptures to expertly crafted clock cases. Mirrors were more abundant during the seventeenth century and were placed above console tables, serving as necessary reflectors of candlelight.

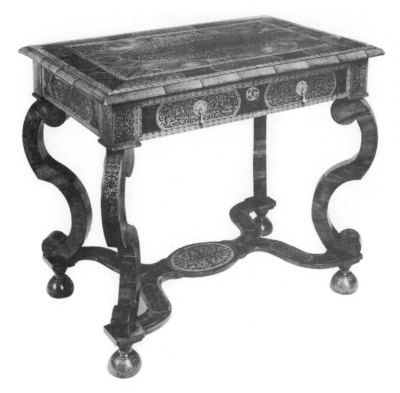

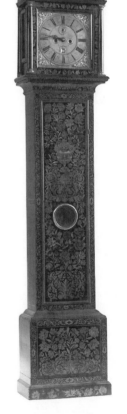

Figure 185 This English William and Mary-style side table with Flemish "S" scroll legs, a shaped stretcher with oval panel, and ball feet dates from circa 1690. The piece is made from walnut with walnut veneer and is decorated with seaweed marquetry. Notice the fitted drawers with teardrop pulls. Height 32³/₄", Width 49", Depth 21¹/₄".
The Metropolitan Museum of Art, Gift of Irwin Untermyer, 1964.

AMERICAN FURNITURE

Some of the earliest examples of American furniture to survive come from the New England and Chesapeake Bay regions where the first colonies were established in the early seventeenth century. Since the earliest settlers' first concern was to establish shelter and procure a food supply, furniture developed out of necessity and function rather than comfort or luxury. Most homes were furnished with stools or benches and perhaps a chair, a table, and a chest. Beds were usually straw-stuffed mattresses placed on a platform or bedstead.

In the early years of the settlements, furniture was made by immigrant joiners or turners who specialized in their craft. The style of furniture they made was fashioned after popular styles from their native countries and reflected those typically found in small European peasant villages. The furniture's unsophisticated, pioneer flavor resembled Early Jacobean and Elizabethan examples of the English Renaissance.

The furniture was sturdy but ruggedly made from an abundant supply of oak, maple, and pine timber. Crafted using the most simplistic methods, ornamentation was limited to turned pieces, scratch carvings, or painted designs. Chairs made during the seventeenth century were usually of the turned type. Two of the more common examples from this period are the Brewster and Carver chairs, named after their original owners. Both chairs were constructed out of spindles turned on a lathe and, although simple in their methods of construction and decoration, were reserved for the master of the house.

Figure 186 An excellent example of a late seventeenth-century English William and Mary-style walnut clock case, this piece emphasizes intricately detailed floral marquetry patterns on the front and side panels. The movement is by clockmaker John Ashbrooke.
The Metropolitan Museum of Art, Gift of Alexander Smith Cochran, 1911.

Figure 187 A bench placed outside a recreated seventeeth century dwelling at Plymouth Plantation in Plymouth, Massachusetts reflects the crude craftsmanship of early colonial furniture and emphasizes the extreme utility of such items made for necessity rather than luxury.

Most furniture lacked extensive carving and was decorated with painted motifs. If carving was employed, it was very shallow or low relief—often referred to as scratch carving. The Early American blanket chest was slightly taller than its English counterpart and was usually fitted with a low set of drawers. The height of the chest made it practical to use as a small table or bench, if necessary.

The press cupboard resembled an Elizabethan court cupboard and was one of the more elaborately decorated pieces of Early American furniture of the seventeenth century. A variety of bulbous turnings were used for supports, and separate pieces of wood shaped as split spindles or lozenges were added for ornamentation. Some cupboards incorporated low-relief carving in floral or arcade patterns and many were painted in bright colors.

Figure 188 This simple turned chair from southeastern Virginia dates from between 1700 and 1720 and is often referred to as a Carver chair, named after Governor Carver of Plymouth, Massachusetts, who owned one of this style. In northern varieties, it is uncommon for the armrests to extend over the armposts as seen in this example. The structural members and spindles are turned into a variety of shapes; on this chair, the baluster is more prominent. Seats were made from rush or woven splints and covered by a large cushion for added comfort. Height 37½", Width 21½", Depth 18". Collection of the Museum of Early Southern Decorative Arts; Winston-Salem, North Carolina.

Figure 189 This American Early Colonial-style, Brewster-type armchair is made out of turned hickory and ash and dates from around 1650. The design of the chair originated in Massachusetts and is similar to the Carver chair from the same period. This chair's design incorporates spindle turning on all members, including the areas beneath the armrest, a characteristic not usually typical of Carver chairs. Height 44¾", Width 32½", Depth 15¾".
The Metropolitan Museum of Art, Gift of Mrs. J. Insley Blair, 1951.

Throughout most of the seventeenth century, houses remained small. Adaptable, multifunctional furniture accommodated these modest quarters by their flexibility of use and size. The table-settle easily converted into a seating unit after the evening meal, while smaller ones converted into chairs. Most were fitted with a drawer or drawers that provided storage compartments for linens or utensils.

Figure 190 The blanket chest served multiple purposes during the American Colonial period. This eighteenth-century chest was also used for additional seating or, as seen here, a table. The chest is fitted with drawers, has bracket feet, and is decorated with scratch carving bearing the name of its owner. Most were made for young women and became part of their dowries or what was known as their hope chests.

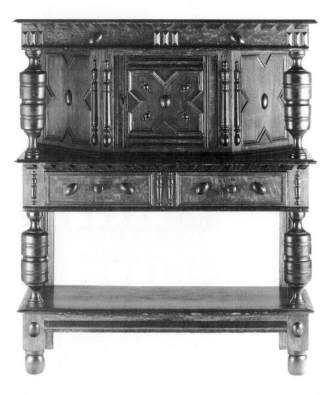

Figure 191 This American Colonial seventeenth-century press cupboard with canted corners is made from oak, pine, and maple—all native New England woods. The presence of bulbous forms, split spindles, and geometrical patterning reflects some of the more common characteristics found on Elizabethan-style English furniture. Height 53⅞″, Width 46⅝″, Depth 20⅛″.
Courtesy Winterthur Museum.

Figure 192 The table-settle offered both a table and a chair, allowing for more flexibility in American Colonial homes.

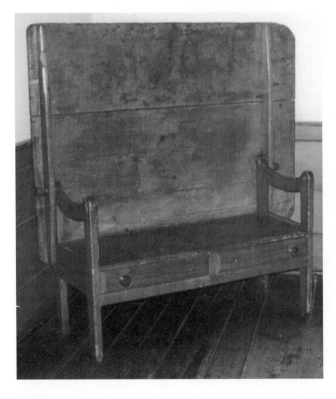

Other tables resembled the trestle type and were easily transportable. Smaller gateleg tables were in frequent use as they could be folded or expanded easily. These were fashioned after the English versions; however, the butterfly table is more uniquely American. When opened, the distinguishing support wings resembled those of a butterfly.

Toward the end of the seventeenth century, the colonists developed their own distinctive regional cultures and, with increased prosperity, homes were furnished with finer crafted goods either made locally or imported from England. At the close of the seventeenth century, Early American furniture began to keep pace with European styles largely due to an increase of imported furniture and widely circulated pattern books.

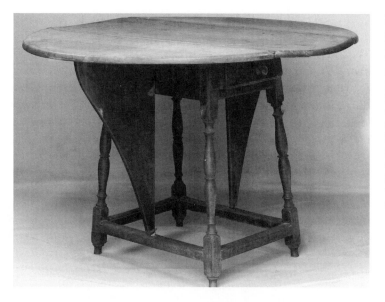

Figure 193 The American gate leg table was called a butterfly table because of the wing-shaped supports. This table has splayed legs made from turned maple shaped into balusters and is fitted with a drawer on the short end. As the gates are brought in and the leaves dropped, the table can be stored against the wall when not in use. Height 24″, Depth 24″.
The Metropolitan Museum of Art, Gift of Mrs. Russell Sage, 1909.

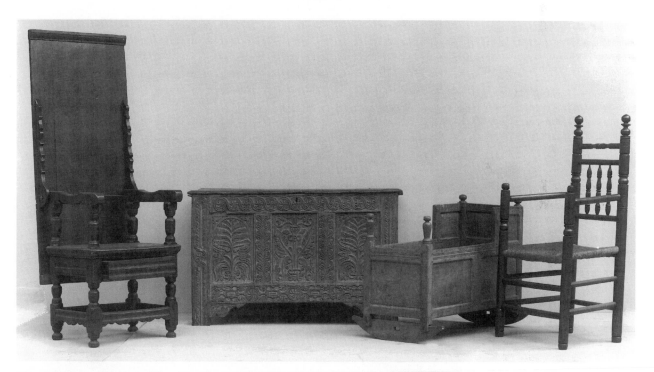

Figure 194 A collection of furniture from the Early American Colonial period contains the more basic pieces found in New England homes during the seventeenth century. Items include, from left to right, a chair-table, a chest with carved decoration, a cradle, and a Carver chair. Notice that the Carver chairs of the New England variety do not have spindles beneath the armrests.
The Metropolitan Museum of Art, Gift of Mrs. Russell Sage, 1909.

• COMPARISONS •

The Baroque period emphasized designs well suited for the grandiose scale of chateaux and country houses. Furniture of the period was used to impress and to reflect the wealth and lavishness of its owner. Compare the twentieth-century commode and console to seventeenth-century example by Boulle.

Figure 195 A French Louis XIV-style commode created by André-Charles Boulle around 1710–1732 for Versailles is made from ebony veneer on walnut with marquetry of engraved brass inlaid on a tortoise shell ground. Classical elements appear on the commode in the form of gilt-bronze Roman sphinx mounts, guilloche-patterned ormolu, and a green marble top. Height 34½″, Width 50½″, Depth 24¾″.
The Metropolitan Museum of Art, The Jack and Belle Linsky Collection, 1982.

Figure 196 The Elson Commode by twentieth-century designer Scott Cunningham incorporates Baroque flair in a truly modern spirit with exaggerated Roman sphinxes and dynamic ormolu.
Photo courtesy Scott Cunningham.

Figure 197 Console by twentieth-century designer Scott Cunningham.
Photo courtesy Scott Cunningham

How does the designer bring a sense of the Baroque spirit into the pieces? Which characteristics remain true to the Baroque period and which have been interpreted?

THE 18TH CENTURY

• 6 •

POLITICAL CONDITIONS

At the beginning of the eighteenth century, the Polish, Austrian, and Spanish successions wrought political havoc in Europe. As most of Europe plummeted into war over who would claim the thrones of these countries, England and France ushered in new monarchs without aggression. In England, Queen Anne (r. 1702–1714), the last reigning Stuart, took the throne in 1702 after the death of William III. In 1707, an Act of Union between Scotland and England formed Great Britain and combined the two parliaments into one unified government. Queen Anne was succeeded by George I (r. 1714–1727), elector of Hanover (Germany), followed by George II (r.1727–1760), then George III (r. 1760–1820).

In France, the Regent Duke of Orléans managed affairs of state for five-year-old Louis XV after the death of Louis XIV in 1715. By 1723, Louis XV had assumed power and militarily engaged France in the Polish succession of 1733 and the Austrian succession of 1740. In 1756, France entered into war with England over control of territories in North America and India. Also involved in the conflict were Austria, Russia, Sweden, Hanover, and Prussia. This struggle, known as the Seven Years' War, finally ended with the signing of the Peace of Paris in 1763. This treaty settled the dispute between countries and reorganized imperial control in North America. Britain gained Canada, the French gained Florida and territory east of the Mississippi, and Spain acquired Louisiana along with previously French held territory west of the Mississippi.

As the second half of the century progressed, political unrest in America and France led to revolutions in both countries. The American Revolution developed between American colonists and British Parliament as

restrictions on imports and heavy taxation caused colonists to rebel against such actions without representation in Parliament. With increased tensions between the Crown and the colonists, King George III used British troops to enforce colonial law and secure absolutism.

Such events as the Boston Massacre in 1770, which left five Bostonians dead by the muskets of British troops, and the Boston Tea Party of 1773 led the English Parliament to repress the American colonists even more by closing the harbor in Boston and rescinding the charter of the Massachusetts Bay Colony. Subsequently, in 1774, the First Continental Congress met in Philadelphia to organize a protest. The following year, American patriots fought against the British at Lexington. There on April 19, 1775, the first battle of the American Revolution took place.

France, by order of the new reigning monarch, King Louis XVI (r. 1774–1792), aided the Americans in their war against the British in 1778. Finally, in 1781 the British surrendered at Yorktown, Virginia, and the American Revolution ended with the signing of the Treaty of Paris in 1783. By the end of the decade, France would be involved in its own gruesome revolution.

By the time Louis XVI inherited the throne in 1774, problems leading to the French Revolution were irreversible even though the new monarch attempted unsuccessful reforms. The extravagant spending of the previous two monarchs carried on at the Palace of Versailles coupled with costly military campaigns left France near bankruptcy. Heavily in debt, France lived on borrowed time. The decadent and extravagant lifestyles of an aristocratic society along with constant controversies involving King Louis XVI's wife, Marie Antoinette, became targets of blame. These select few lived frivolously while peasants, who comprised the majority of the population, starved.

Increased taxation placed on the already overburdened commoners and peasants contributed to the growing resentment of aristocratic society. Inspired by the success of the Americans, the population reacted with violence and revolution. Seeking political, social, and economic reform, on July 14, 1789, crowds of peasants stormed the Bastille, killed the commander and his garrison, and paraded their heads on pikes through the streets of Paris. The capture of the Bastille stood for the fall of absolutism in the eyes of the French people.

Composed of French bourgeois representatives, the National Assembly quickly passed reform laws abolishing feudalism, but the fervor of revolution could not be stopped. With the aid of Austria and Prussia, Louis XVI attempted to maintain control but failed. Captured trying to flee France in 1791, both Louis XVI and Marie Antoinette were imprisoned, tried for treason against French citizens, and executed in 1793.

In 1794, the Reign of Terror ended with the execution of Maximilien Robespierre, and in 1795, political order was restored under a new constitution enforced by a Directoire of five men. Economic conditions worsened as reforms lacked cohesive leadership under the new Directoire, and in a coup d'état, a zealous Napoleon Bonaparte overthrew the Directoire and claimed power as consulate in 1799. By 1804, Napoleon seized absolute control as Emperor of France. For fifteen years, Napoleon established peace within French borders, administered economic prosperity through progressive reforms, and established political order.

In his attempts to imperialize the rest of Europe and establish France as the new world order, Napoleon led numerous military campaigns against Austria, Prussia, Naples, Egypt, Sweden, Spain, and Portugal. In 1812, after a costly defeat by the Russians, Napoleon abdicated and was exiled. In 1815, Napoleon returned to France, deposed the restored Bourbon monarch King Louis XVIII (eldest brother of King Louis XVI), and raised an army against the British. Defeated in the Battle of Waterloo, Napoleon was exiled once again. He died on the isle of St. Helena in 1821.

ROCOCO PERIOD

Architecture 1700–1750

Two stylistic periods developed during the eighteenth century as many new styles in both France and England were introduced. The first half of the century differed significantly from that of the second half with more obvious changes seen in interior design and decoration. An evolving Rococo style dominated interior design until 1750, thereafter replaced by Neoclassicism. The Neoclassical period emerged after the rediscovery of the ancient cities of Herculaneum in 1738 and Pompeii in 1748.

After the death of Louis XIV, a regent was appointed to monitor state affairs since the heir to the throne was only five years of age and obviously too young to rule. The regent, the Duke of Orléans, took Louis XV away from Versailles to Paris. As aristocrats followed, townhouses were commissioned to be built in Paris for their leisure. The regimented formality and opulence of Versailles was replaced by smaller, more intimate quarters resulting in a style of decor that took on a lighter appearance in both ornament and color palette. When Louis XV returned to Versailles, his appointed First Architect, Ange-Jacques Gabriel (1698–1782) was charged with the responsibility of creating smaller, more intimately scaled rooms within the palace.

Gentle curves and ornamentation based on natural forms led to the use of the term *Rococo*—derived from the French *rocaille*, meaning "shell"—to describe this new style of interior decoration. Shells, scrolls, delicate bouquets tied with ribbons, and exquisite ceiling frescoes depicting mythological figures adorned the interiors. Wainscoted walls painted creamy white embellished with gold accents framed the interior. More abundant in the eighteenth century than in the seventeenth, mirrors played an even greater role in completing the room design. Mirrors were strategically positioned to reflect and enhance illumination from hanging chandeliers. They were typically placed above the fireplace mantel extending toward the ceiling or inset into gilt frames above the wainscoting on wall panels and doors.

The earliest manifestation of the Rococo architectural style could be seen in France as early as the last decade of the seventeenth century. This transitional period incorporated both pilasters and columns in rigid classical formation with more free-form arabesque plaster work. As the eighteenth century progressed, the new modern taste replaced rectilinear classical symmetry with more natural asymmetrical curves. Grandiose Baroque-style rooms intended to

impress were exchanged for smaller-scale, more sophisticated interiors designed for comfort (see Color Plate 17).

Perhaps the most significant contributor to the development and refinement of a new French style was the mistress of King Louis XV, Madame de Pompadour (1721–1764). Like King Louis XIV before her, Pompadour took an active role in promoting artistic advancement at Versailles. A porcelain factory at Sèvres supplied cabinetmakers with soft paste plaques that adorned many furniture items produced during this century. Rose pompadour, the most popular color of porcelain created at Sèvres, was unique to this factory and influenced the lighter color palettes adopted by Rococo designers.

With the introduction of pastels, paintings of pastoral or idyllic scenes depicted rosy-fleshed goddesses and putti figures frolicking in lush green gardens. François Boucher (1703–1770) received numerous commissions from Madame de Pompadour to paint these idyllic scenes on large-scale canvases that complemented the interior decor. Many of his designs were used as *cartoons* for the production of tapestries and Savonnerie or Aubusson rugs. Over time, vegetable dyes used to color the yarns have faded leaving only a dull reminder of the original color palette. Viewing Boucher's original oil paintings reveals the soft, delicate pastel colors that once decorated the textiles (see Color Plate 18).

In England, architectural style developed exclusive of the trends favored by French aristocrats. English architects rejected the inherent Rococo style for Palladianism, which had been introduced a century before by Inigo Jones. The Neo-Palladian style of architecture flourished in England from 1715 onward, when Andrea Palladio's four books on architecture were translated into English in the eighteenth century. Interior design followed the classical program in every detail; columns, pilasters, and niches articulated rooms, recalling ancient Roman basilicas.

Chiswick House, built in 1725 and designed by owner Lord Burlington, reflected characteristics used in Villa Rotonda, which was built by Palladio in the sixteenth century. Like Villa Rotonda, Chiswick utilized a piano nobile and symmetry was uniformly expressed. Under the direction of William Kent

Figure 198 When the King of Poland's alchemist uncovered the secret of making hard-paste porcelain by identifying the key ingredient, kaolin, factories set up in Dresden and Meissen produced a multitude of three-dimensional decorative objects for wealthy collectors. The modeling capabilities of hard-paste porcelain led to the production of various animal and bird forms, along with figurines brought to life with brightly colored glazes. In addition to animal forms like the squirrels shown here, vases, snuff boxes, and dinner services were also produced during the eighteenth century. Height 10½″ with mounts.

The Metropolitan Museum of Art, Gift of R. Thornton Wilson, in memory of Caroline Astor Wilson, 1950.

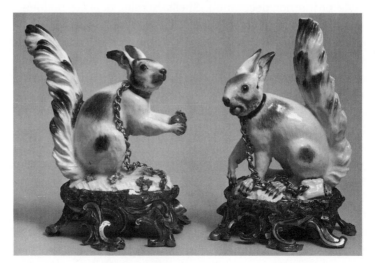

(1685–1748), the interior design of Chiswick combined architectural symmetry with an elaboration of Baroque-inspired classicism. Kent's furniture designs incorporated that of a Late Baroque influence more so than contemporary Rococo styling. Kent's furniture was heavy and massive and did not embody the spirited Rococo curvilinearity exemplified in prevalent French styles; however, an English Rococo furniture style does exist and will be discussed later in this chapter.

Figure 199 In 1787, Apprien-Julien de Choisy (1770–1812) designed a dinner service from which this saucer was taken. It is a fine example of French soft-paste porcelain produced at Sèvres and indicative of the Rococo spirit in its asymmetrically arranged floral designs.
The Metropolitan Museum of Art, Bequest of Emma Townsend Gary, 1937.

Rococo Design Motifs

Although France and England differed in their interpretation and use of the Rococo style, certain characteristics cohesively united the dec-

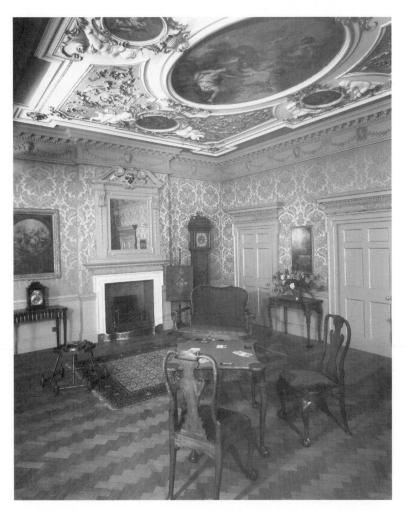

Figure 200 This view of an English Queen Anne-style room in the Victoria and Albert Museum in London shows a variety of early eighteenth-century interior furnishings. To the left of the fireplace is a game table shown in a closed position with a baby's walker placed in front. To the immediate right of the fireplace is a needlework firescreen and a tall clock case. Positioned between the doors is an additional gaming table with cabriole legs and claw and ball feet. In the center of the room, another gaming table flanked by two Queen Anne-style side chairs is set for card playing. The table and the two chairs have cabriole legs with claw and ball feet. Directly behind this table is a Queen Anne-style upholstered settee.
Courtesy of the Board of Trustees of the V&A.

orative arts in these two countries. Oriental designs introduced into the seventeenth-century interior through Chinese export porcelains continued to be popular during the eighteenth century. Chinese motifs, or chinoiserie, appeared in everything from textile designs to wall paneling and depicted images of dragons and bonsai landscapes with pagoda-topped tea houses inhabited by kimono-clad figures. *Singerie* depicted more frolicsome themes of monkeys at play and dominated textile patterns and ornamental relief work. Classical motifs diminished somewhat to the use of shells or scallops, garlands or festoons, spiral waves, and an occasional putti figure. Since an emphasis was placed on the free-flowing and asymmetrical forms of nature, bouquets tied with ribbons and vine patterns dominated fine marquetry work and architectural details.

Rococo Furniture

A variety of woods were used in the construction of furniture during the eighteenth century. Walnut, oak, and elm continued to be common; however, imported mahogany gained prominence especially in England. Fruitwoods chosen for their color and grain were used in marquetry work and veneering while beech wood was used for painted items.

Vernis martin, the name given to a type of shellac developed by four French brothers, the Martins, was used on a variety of case goods during the eighteenth century and imitated Japanese lacquerwork. The application of this varnish was similar to the japanning process practiced by the English a century before.

Seat furniture was made more comfortable than previous styles with the introduction of covered arm pads and thicker seat cushions. Upholstery fabrics in pastel colors emphasized foliate patterns either woven into the cloth as in *brocade* or *damask*, or printed onto the surface of the cloth as in English *chinz* or French *toile de jouy*. Heavy velvets, needlepoint, and tapestries used on upholstered furniture during the Baroque and Renaissance periods subsided as delicate silks and taffetas became more prevalent. Leather was still used to some extent, although it was dyed in a variety of colors, and caning continued to be used on a limited basis.

French Rococo Furniture 1715–1774

French Rococo period furniture is comprised of two related but distinctive styles: the Régence and Louis XV. The period of time between the death of King Louis XIV and the rule of Louis XV is known as the Régence and marks the transformation between staunch Baroque styling and the more fluid Rococo period. Considered the transition between the Baroque and Rococo periods, Régence styling reflects the heaviness of Louis XIV furniture but anticipates the more delicate style of Louis XV.

As aristocratic society began to live in the smaller hôtels of Paris, furniture design during the first half of the eighteenth century went through significant transformations. Chairs were designed with shorter backs and overall smaller proportions that fit nicely within the new, smaller-scaled rooms. Straight, symmetrical patterns were replaced with curving, asymmetrical shapes on every-

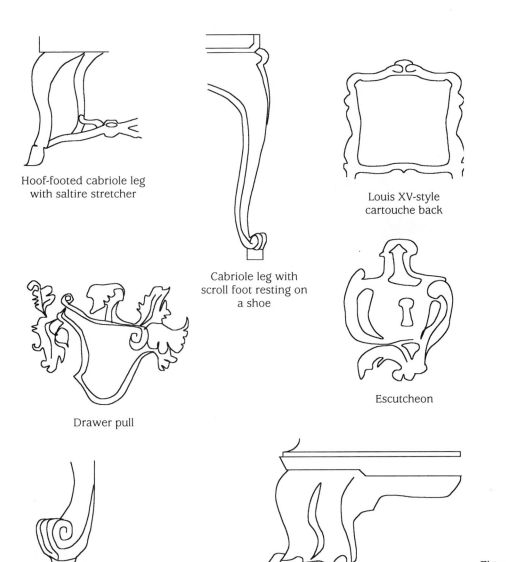

Hoof-footed cabriole leg
with saltire stretcher

Cabriole leg with
scroll foot resting on
a shoe

Louis XV-style
cartouche back

Drawer pull

Escutcheon

Scrolled foot forms

Figure 201 Furniture charac-
teristics of the French Rococo
period, Régence and Louis XV
styles.

thing from hardware to marquetry patterns and ormolu. Chair backs, seat rails, arms, and legs, along with drawer fronts, sides, and tops of tables and case goods incorporated serpentine curves into their design.

Rococo curvilinearity appears in the last quarter of the seventeenth century with the introduction of the *cabriole* leg. Its use is more typical of the Rococo period and, generally, Louis XIV and Régence-style cabriole legs terminate into either a hoof, paw, or a whorl foot, while Louis XV-style cabriole legs end in a small scroll. Régence-style chairs and tables continued to incorporate the characteristic saltier stretcher of the Louis XIV style only with more lateral curvature. The stretchers are completely eliminated on Louis XV-style furniture.

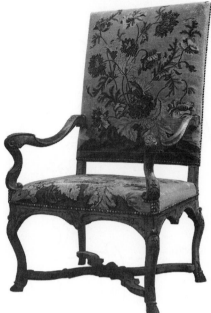

Figure 202 The Régence style, which developed in France at the end of the seventeenth century, marked the beginning of the Rococo period as fluid curves replaced the straight lines and heaviness of the Baroque period. This walnut fauteuil dating from the late seventeenth century maintains the characteristic tall rectangular back of the Louis XIV style; however, curves appear on the armrests, armposts, seat rail, legs, and stretchers. Cabriole legs, a common characteristic found on Louis XV-style furniture, are combined with hoof feet, and each leg is connected by a shaped saltier stretcher.
The Metropolitan Museum of Art, Gift of J. Pierpont Morgan, 1907.

Chair backs remained somewhat tall and rectangular with a slight curvature appearing in the crest rail; however, these proportions changed by 1720 with the full development of the Louis XV style. Scrolled or incurvate arm supports were set back from the front seat rail to accommodate the full skirts worn by ladies of the period. A small upholstered pad, or *manchette*, was added to the armrest in the early eighteenth century to relieve the pressure placed on the elbows and is indicative of a greater awareness of comfort in design.

Louis XV-style furniture exemplified the almost feminine quality of the era; powdered wigs, lace, and satin were worn equally by men and women who enjoyed a life of leisure centered around active social gatherings. As court life moved away from Versailles and into the Parisian hôtel or apartment, the new style emerged. The Louis XV style catered to newer, much smaller living quarters and emphasized graceful proportions and comfort over pretentiousness. Marquetry patterns of bouquets tied with ribbons, musical instruments, and intricate vines replaced carving as the predominant ornamentation on case goods and tables (see Color Plate 19).

Pieces of furniture that emphasized contemporary architectural spaces of the period were introduced into Rococo interiors. The window seat was intended to fit precisely within the windowed recessed arches of the interior and provided a more comfortable seat than a tabouret.

Figure 203 Compared to the previous example, the Régence-style fauteuil shown here from the late seventeenth or early eighteenth century incorporates more features of the French Rococo period in its design. A greater emphasis is placed on the curvature of the back, specifically the scrolled crest rail. In addition to the shaped apron, the front seat rail is slightly curved and foreshadows the serpentine seat rail characteristic of Louis XV-style chair designs. Overall, there is a reduction in the size and mass of the chair, evidenced here with the shorter back and cabriole legs. Notice in this example the delicate scroll on the foot of the cabriole and the presence of a saltier stretcher.
The Metropolitan Museum of Art, Gift of J. Pierpont Morgan, 1906.

Figure 204 A French window seat of carved fruitwood from the mid-eighteenth century shows the fully developed Louis XV style in its design. The cabriole legs are graceful and thin, ending with a scroll foot resting on a shoe. It has a serpentine seat rail and scrolled armrests. The frame has been recovered in an old silk from the period. Height 26½″, Width 46″, Depth 18½″.

The Metropolitan Museum of Art, Bequest of Catherine D. Wentworth, 1948.

Figure 205 Portable stools were still a common furniture item during the eighteenth century. This French tabouret in the Louis XV-style has an X-form base made from carved and gilt wood and a red velvet seat. Height 29½″, Width 18⅞″.

The Metropolitan Museum of Art, Gift of J. Pierpont Morgan, 1906.

Chairs of the Régence style were smaller-scaled with short backs carved into gentle cartouche shapes. Fauteuils and bergères were designed with dainty, carved cabriole legs ending in delicate scroll feet resting on *shoes*. While the seat rail and apron followed a serpentine shape, more curves were repeated on the crest rail and arm supports. Wood trim extending from the arm supports to the uprights and across the crest rail framed the shape of the all-upholstered cartouche back and sides, gracefully uniting the overall design.

The eighteenth-century wing chair, a derivative of the seventeenth-century sleeping chair, protected the face from drafty interiors with side panels placed near the head

Figure 206 A Louis XV-style chaise from the mid-eighteenth century, made by Jacques Jean-Baptiste Tilliard (1752–1797), captures the essence of the Rococo period with full attention to the delicate curves used in the design of the chair. The frame around a shorted back is cinched at the midpoint, giving shape to what is called a cartouche back. A full serpentine curve is given to the seat rail, and carved details include foliate patterns. This chaise is one of a pair. Height 34⅛″, Width 20½″, Depth 19″.

The Metropolitan Museum of Art, Bequest of Catherine D. Wentworth, 1948.

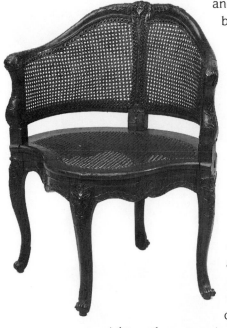

Figure 207 This fauteuil de bureau from the eighteenth century was specially designed with a center leg to accommodate a person seated at a desk or bureau. The chair has a woven cane seat and back and incorporates characteristics of the French Louis XV style in its design. Similar chairs appeared in England at this time and were called corner chairs.
The Metropolitan Museum of Art, Gift of J. Pierpont Morgan, 1906.

Figure 208 A French Louis XV-style bergère, circa 1760, has closed-in upholstered sides, manchettes, cabriole legs with scroll feet, and foliate carved designs on the oak frame.
The Metropolitan Museum of Art, Gift of J. Pierpont Morgan, 1906.

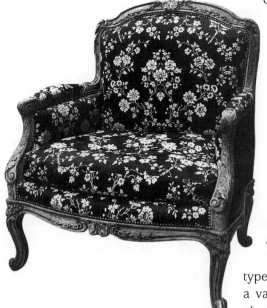

and extending perpendicular from the back. Some wing chairs were designed with mechanisms that allowed the back to recline; however, most remained stationary.

The lounging chair, or the chaise longue, was introduced as a type of daybed and consisted of either one, two, or three separate pieces of furniture although more common examples were designed in two pieces. One section, similar to a *bergère en gondole*, was fitted to a low-back bergère that had an extra-long seat. These pieces could be pushed together or separated as needed.

The formal settee of the seventeenth century evolved into a more comfortable seating unit referred to in eighteenth century inventories as a sofa. The French canapé was usually upholstered and designed en suite with either bergères or fauteuils or both. The length of the canapé varied but usually accommodated two or more people.

Case pieces increased in quantity and most were designed for specific purposes. Although the introduction of the commode in the seventeenth century was intended to raise the chest from the floor, trunks continued to be used for traveling and were easily portable. As the predominant piece of storage furniture in use throughout the eighteenth century, commodes, like chairs, were reduced in size to fit within smaller rooms. Designed with Rococo curvilinearity, commodes often had *bombé* sides and serpentine fronts. Magnificently decorated, commodes were placed against coordinating wall panels that incorporated similar floral or chinoiserie patterns.

Storage furniture increased in abundance with continued use of the armoire and the introduction of the *chiffonier*. While the armoire stored articles of clothing, the chiffonier was used by women to store needlework and other sewing items. Adapted from the chest of drawers, this piece of furniture is an example of items designed for a specific use during the eighteenth century and reflects the luxury of owning such objects.

Console tables continued to be used primarily for decoration within rooms and were used to display candelabras or other *objets d'art*. Since dining remained on a more intimate level, small drop-leaf tables proved satisfactory. Many other types of tables were introduced in the eighteenth century, each for a variety of uses including writing, game playing, sewing, and dressing.

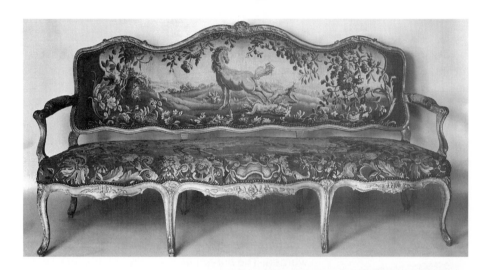

Figure 209 This French Louis XV-style chaise longue, circa 1725, made of carved walnut has an ornate crest rail, winged sides to keep drafts from the face, and heavily carved aprons running along the sides and front of the piece. Notice the cylindrical pillow and the asymmetrically balanced design motif appearing on the front apron. Height 48½″, Width 33½″, Length 69½″.

The Metropolitan Museum of Art, Rogers Fund, 1922.

Figure 210 This canapé in the French Louis XV style from the mid-eighteenth century is upholstered in an Aubusson tapestry designed with animal and botanical motifs. The fine quality of Aubusson rugs and tapestries is a direct result of the weaving process which uses both a high and low warp loom. Length 84″, Depth 30″.

The Metropolitan Museum of Art, Bequest of Catherine D. Wentworth, 1948.

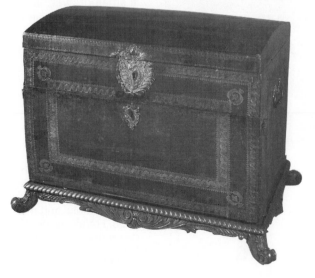

Figure 211 A red leather trunk with gold-tooled decoration from the second quarter of the eighteenth century has asymmetrically designed escutcheons on the front and bronze handles on the sides for carrying. The trunk is shown here on a modern reproduction carved and gilt wood stand. Height 33¾″, Width 38½″, Depth 23″.

The Metropolitan Museum of Art, Anonymous Gift, 1944.

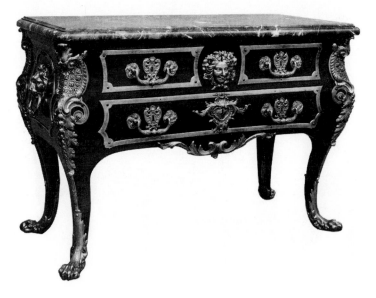

Figure 212 A Louis XV-style satinwood commode with ormolu mounts depicting lion and Roman mask motifs, acanthus leaves, and paw feet from around 1745–1749 was designed in the manner of Charles André Boulle II, son of the famed ebéniste who was employed in the court of Louis XIV. Height 33½″, Width 48″, Depth 23½″.
The Metropolitan Museum of Art, Fletcher Fund, 1925.

As the eighteenth century progressed, differentiation was made between furniture used by ladies and that used by gentlemen, leading to the introduction of more gender-specific furniture.

A variety of tables and desks introduced during the Rococo period were designed specifically to meet the needs of women. Small ladies' work tables, or the *table à ouvrage*, incorporated fitted drawers or recessed compartments for storage of sewing and needlework implements.

Tables for writing also increased in quantity and type as correspondence was maintained on a daily basis. Special desks designed for ladies and gentlemen often included secret storage compartments for the concealment of personal letters. The *secretaire*, *bonheur du jour*, *bureau à dos d'âne*, and *bureau à caissons latéraux* were types of desks commonly used by women. The *bureau plat*, a writing table fitted with a small drawer, and the *bureau à cylindre*, a roll-top desk, were much larger and preferred by men.

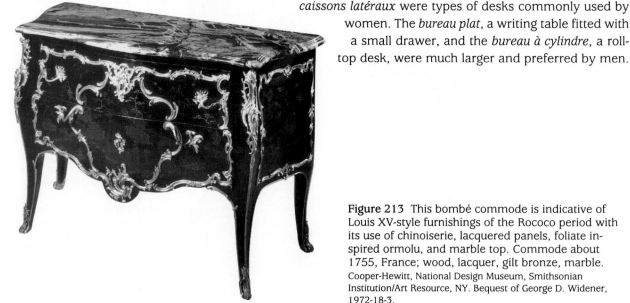

Figure 213 This bombé commode is indicative of Louis XV-style furnishings of the Rococo period with its use of chinoiserie, lacquered panels, foliate inspired ormolu, and marble top. Commode about 1755, France; wood, lacquer, gilt bronze, marble.
Cooper-Hewitt, National Design Museum, Smithsonian Institution/Art Resource, NY. Bequest of George D. Widener, 1972-18-3.

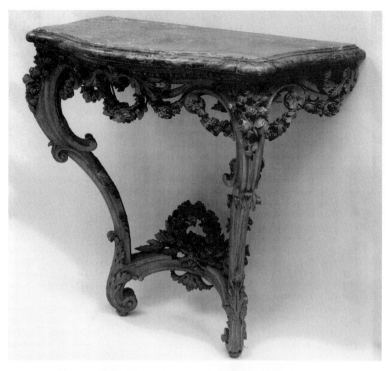

Figure 214 A console table of painted wood attaches to a wall for support. This table in the French Louis XV style dates from between 1760 and 1770 and incorporates a festoon design in the asymmetrically balanced apron. Notice the "C" scrolls on the table legs, inverse scrolled feet, and acanthus leaf carvings.

The Metropolitan Museum of Art, Rogers Fund, 1921.

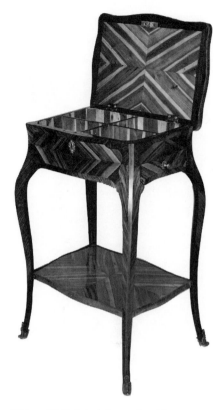

Figure 215 A lady's work table, or table à ouvrage, from the mid-eighteenth century in the French Louis XV style shown here with an open top to reveal the small compartments fitted to the inside. Notice the contrasting veneers in both diamond and reverse diamond match patterns, ormolu feet, and the small side drawer. Height 25½″, Width 17¼″, Depth 12¾″.

The Metropolitan Museum of Art, Bequest of Catherine D. Wentworth, 1948.

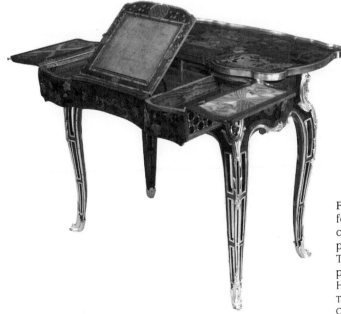

Figure 216 A writing table in the Louis XV style made for Madame de Pompadour by Jean-Francois Oeben circa 1761–1763 is embellished with floral marquetry patterns crafted from oak, mahogany, and other woods. The design includes gilt-bronze mounts, a sliding top panel, a raised writing surface, and side compartments. Height 27½″, Width 32¼″, Depth 18⅜″.

The Metropolitan Museum of Art, The Jack and Belle Linsky Collection, 1982.

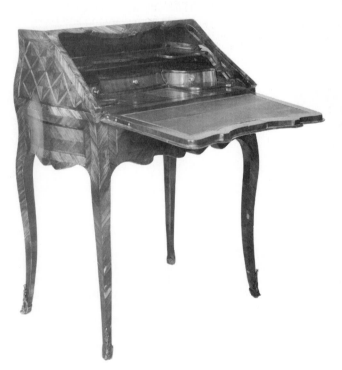

Figure 217 A tall, fall-front writing cabinet is called a secrétaire à abattant in French. This example from the mid-eighteenth century in the Louis XV style is designed with a marble top, lower cabinet, and fall-front writing surface. The opened position as shown here reveals shelves and fitted drawers for storage. The piece is decorated with floral marquetry and asymmetrically designed escutcheons and ormolu patterns. Height 50½", Width 26¼", Depth 12".
The Metropolitan Museum of Art, Gift of Susan Dwight Bliss, 1946.

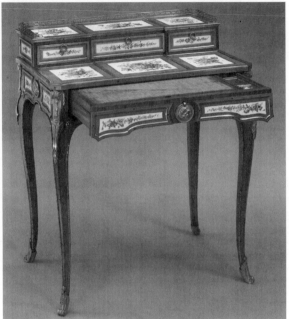

Figure 218 Made from oak, mahogany, tulip wood, purple wood, and harewood, this French Louis XV-style bonheur du jour is one of a pair. The bonheur du jour is a small writing desk used by women whose "good hour of the day" was spent on dutiful correspondence. This example, which dates from around 1775, has slender cabriole legs, a pull-out writing surface with storage compartments for an ink well and quills, and a cabinet top articulated by a pierced gallery and fitted with drawers. Height 31⅞", Width 25⅞", Depth 16".
The Metropolitan Museum of Art, Gift of Samuel H. Kress Foundation, 1958.

Figure 219 This small slant-front desk, or bureau à dos d'âne (literally, donkey-back desk, referring to the shape of the top compartment), is in the French Louis XV style from the mid-eighteenth century. The desk fall-front panel is mounted with reverse hinges that support the writing surface once lowered. The cabinet's interior has shelves and fitted drawers. Height 36", Width 25½", Depth 17".
The Metropolitan Museum of Art, Bequest of Catherine D. Wentworth, 1948.

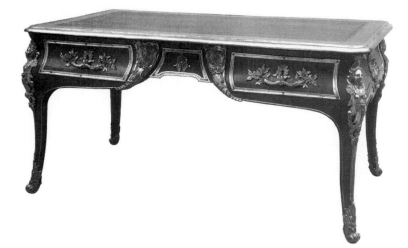

Figure 220 A Louis XV-style bureau plat made from mahogany with ormolu mounts and an inlaid leather panel is a French nineteenth-century reproduction piece yet maintains the characteristics of the original design.
The Metropolitan Museum of Art, Bequest of Benjamin Altman, 1913.

One of the most celebrated ébénistes of the period, Jean-François Oeben (1720–1763), produced a magnificent *bureau du roi* for King Louis XV decorated with trompe l'oeil marquetry and chased bronze. Although Oeben worked on the desk for three years, he did not live to see it completed. After Oeben's death, his apprentice and successor, Jean Henri Riesener (1734–1806) finished the desk and affixed his signature in 1769.

In the small suite of rooms or apartments taken as living quarters within the French hôtels or townhouses, the bedchamber often doubled as both sleeping room and salon. Lower ceilings made the larger tester beds and four poster types of earlier periods impractical. Beds designed with drapery that cascaded downward from large overhead canopies suspended from the headboard were more popular in the eighteenth century. Traversing the bed within an alcove became a popular French custom after 1755 and became increasingly popular throughout the remainder of the eighteenth century.

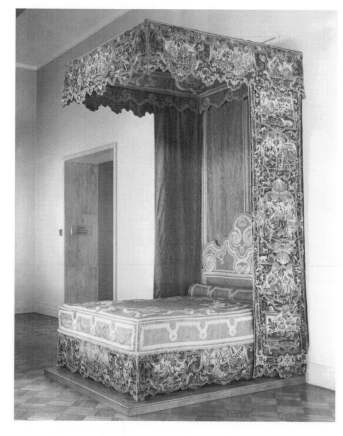

Figure 221 A state bed is shown with early eighteenth-century embroidered bed hangings. The valances, curtains, canopy, and coverlet are made from wool and silk. Height 94″, Width 65″, Length 81″.
The Metropolitan Museum of Art, Gift of Irwin Untermyer, 1953.

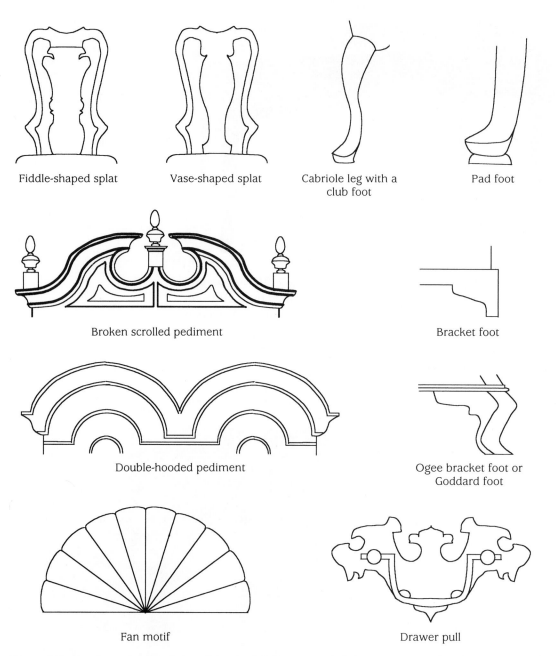

Fiddle-shaped splat

Vase-shaped splat

Cabriole leg with a club foot

Pad foot

Broken scrolled pediment

Bracket foot

Double-hooded pediment

Ogee bracket foot or Goddard foot

Fan motif

Drawer pull

Figure 222 Furniture characteristics of the English Rococo period, Queen Anne and Early Georgian styles.

English Rococo Furniture 1702–1760

Several distinctive styles of furniture developed during the English Rococo period. Specific characteristics that set one apart from another are subtle but noticeable as each subsequent style was greatly influenced by the previous. Queen Anne, Early Georgian, and Late-Georgian-style furniture share common characteristics that classify them as products of the Rococo period.

Queen Anne Furniture 1702–1720

The first true style of the English Rococo period is named after Queen Anne (r. 1702–1714). Unlike Queen Mary before her, Queen Anne thought little of the furniture styles of her age. It has already been discussed that England rejected the Rococo architectural style, favoring Neo-Palladianism instead. Rooms added onto Hampton Court and those redecorated during Queen Anne's reign adopted a more restrained interpretation of Rococo curvilinearity. Queen Anne-style furniture, however, reflects the characteristic delicate proportions and graceful curves brought on by the spirit of the Rococo movements in France and Austria.

Furniture designed during the English Rococo period adopted few influences from neighbors across the Channel. Typical of French Rococo trends in furniture design, eighteenth-century cabinetmakers preferred the carved leg over the turned leg. The cabriole leg, already popularized in France during the last decade of the seventeenth century, was used extensively, if not exclusively, on Queen Anne and Early Georgian-style chairs, settees, and tables.

The front legs of chairs were always cabriole, but the back legs varied from cabriole to saber leg forms. The typical English cabriole leg ended in either a pad or a club foot. The cabriole leg met the seat rail at the corners and a *bracketed knee* usually carved into the shape of a shell or acanthus leaf made the transition between leg and seat. Stretchers were eliminated around 1708

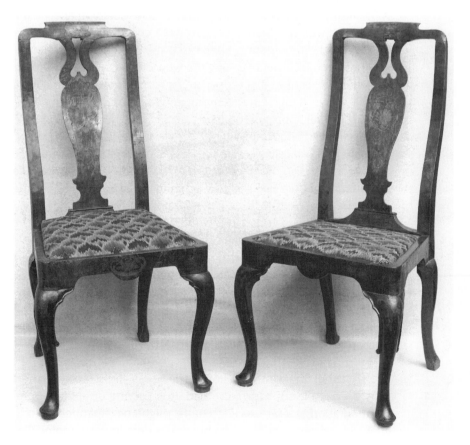

Figure 223 A pair of English, Queen Anne-style side chairs made from carved walnut has marquetry on the distinctive spoon-shape back splat and uprights, cabriole legs with bracketed knee, a shaped front seat rail, and pad feet. Notice the lack of stretchers. The Metropolitan Museum of Art, Rogers Fund, 1910.

Figure 224 This upholstered walnut armchair in the Queen Anne style dating from 1710 shows the graceful curves of the gooseneck arm.
Fitzwilliam Museum, Cambridge.

Figure 225 An English Queen Anne-style highboy circa 1715 is made from walnut veneer over an oak and pine body. This unusual piece has Corinthian columns flanking the sides of the top unit, with acanthus leaf carvings on the lower section and ivory inlay on the claw and ball feet.
Courtesy of the Board of Trustees of the V&A.

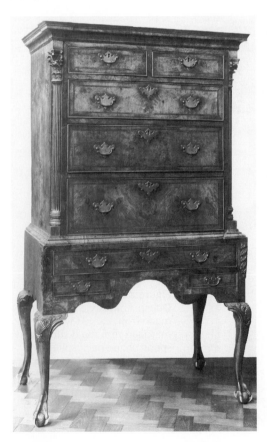

when improved craftsmanship no longer necessitated the need for this type of reinforcement.

While French furniture of the Louis XV style was redesigned to maximize comfort, the Queen Anne and Early Georgian *splat-back* or *spoon-back* chair offered more comfort to the sitter through shaped uprights and a back splat that followed the curvature of the spine. Sinuous uprights forming the spoon shape enclosed either a vase- or fiddle-shaped splat. The curvilinearity of both back and leg were carried through the design of the chair with the introduction of the *goose-neck arm*. Goose-neck arms were a common feature of Queen Anne-style armchairs and settees.

The splat-back chair, with or without arms, was frequently used for dining and remains a favorite style in present-day reproductions. These chairs incorporated a *slip seat* or *drop seat* that allowed for more flexibility in alternating textiles with the change of seasons. A cushioned seat was covered with fabric then dropped into the seat-rail frame and secured at the corners, leaving the wood of the seat rail exposed. Other types of seat pieces were usually fitted with slip covers that were changed in the spring and fall seasons.

The all-upholstered chair came in a variety of designs. A more basic upholstered type was designed with carved wood arms and cabriole legs. Unlike French examples from the same period, English-designed upholstered chairs connected at the juncture of the seat and back, limiting the exposed wood frame to the arms, legs, and stretchers if applicable.

The Queen Anne-style wing chair that evolved from the seventeenth-century sleeping chair is a more typical example of all-upholstered chairs used at this time. The wing chair has upholstery on the back, wings, arms, and seat. These chairs were placed in front of the fireplace, sheltering the face from drafts while a fire screen protected the sitter from the intense heat of the fire. It is also believed that fire screens kept the wax-based makeup worn by women of the period from melting.

Other than an occasional shell or acanthus motif, most Queen Anne-style furniture had little carving or applied ornamentation. In rare cases, chairs might be japanned in red, black, green, or gold, with chinoiserie detailing. Japanning was

used sparingly on most furniture types, occasionally appearing on cabinets or other case goods.

The delicate floral marquetry patterns characteristic of Louis XV-style furniture were not favored by furniture makers of the Queen Anne style. Furniture designers relied on the beauty of wood graining as their most decorative feature. Walnut or walnut veneer was favored by most cabinetmakers until 1725, when mahogany became more fashionable. Burl walnut, a more popular finish veneer, emphasized the marbleizing effect of the wood. As the tree grew, cuts were made into the bark that caused the tree to bruise. These produced irregularities in the grain as the tree continued to grow. Lighter woods appeared as *crossbanded* marquetry applied as a decorative border around drawer fronts, door fronts, and tabletops.

Highboys and tallboys continued in use for clothes storage. Most examples followed William and Mary types with flat tops; however, the cabriole leg replaced bell turning while the bracket or goddard foot replaced the ball or bun.

The soft curves of the Rococo period were incorporated into tall case furniture through the use of the hood or *bonnet top*. Door fronts mimicked the restrained arched shape, while escutcheons, aprons, and feet were fashioned into undulating curves.

Trading with the Far East increased during the eighteenth century, and the English fascination with Oriental design and customs continued to influence

Figure 226 This walnut tallboy in the English Queen Anne style has a pull-out writing surface on the lower section.
Mallet & Son Antiques Ltd., London/Bridgeman Art Library International Ltd., London/New York.

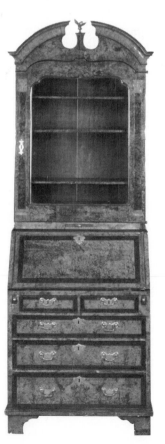

Figure 227 An English Queen Anne-style bureau cabinet circa 1700 made from mulberry and yew has an arched broken pediment bonnet, cross-banded panels on the slant-front writing unit and drawer panels, and bracket feet. The glass-front cabinet section, rare for the early eighteenth century, has adjustable shelves and is flanked by an inlaid pilaster design.
Private Collection/Bonhams, London, UK/Bridgeman Art Library International Ltd., London/New York.

furniture style and development. Tea drinking, introduced to Europeans in the seventeenth century, became increasingly popular with the English and Americans during the eighteenth century.

As export porcelains were being acquired at great expense, the china cabinet became a common unit of furniture used for the storage and display of these prized possessions.

Cabinets on stands were customarily ornate and modeled after French and Oriental examples. The stands depicted fine craftsmanship of elaborately carved legs and aprons, while the cabinets were often treated with fine japanning or burl walnut. The seventeenth-century writing cabinet developed into the ever popular secretary of the eighteenth century. Two basic types evolved: the fall front and the slant-front. Slant-front writing cabinets were tall case pieces usually ornamented with some type of pediment top.

Beds of the Queen Anne style remained virtually unchanged from the William and Mary style that preceded it. Four-poster types supporting draped fabric continued to be popular, although two-poster types were introduced with a half-tester.

Figure 228 A black and gold secretary in the English Queen Anne style, circa 1700–1715, shown in an open position reveals the inner components of this desk. No less decorative, the inside panels have chinoiserie, while fluted pilasters flank the central compartments. Notice the palmette design just below the broken pediment and running along the shaped apron of the lower body.
The Metropolitan Museum of Art, Bequest of Annie C. Kane, 1926.

Figure 229 This English Queen Anne-style fall-front secretary cabinet, circa 1705, is made from burr walnut.
Bonhams, London, UK.

Early Georgian Furniture 1720–1760

The death of Queen Anne in 1714 left no heir to the English throne other than a distant cousin, George, Elector of Hanover (r. 1714–1727). When he was crowned King George I of England, he was fifty-four years old, spoke no English, brought his three German mistresses, and had imprisoned his wife for thirty-two years. Although his reign was short, he was despised by his subjects. His son, George II (r. 1727–1760), was forty-five years old when he ascended the throne after his father's death and was more favorably regarded by his English subjects.

The Early Georgian style of furniture encompasses the reigns of these two monarchs. Although the actual rulers themselves took no part in the design process, the Queen Anne style appears to be more feminine in design with its delicate proportions, while the Early Georgian style is more masculine. The furniture created under the reign of these two rulers took on a masculine appearance through heavier proportions and had considerably more carving by comparison.

A shortened version of the cabriole leg was employed by Early Georgian furniture designers. These legs had more carving applied to them, particularly with a lion-mask motif incorporated into the bracketed knee. The claw and ball foot introduced in 1710 was used frequently on Early Georgian-style furniture; however, its transformation into a paw and ball foot was not uncommon, nor was the use of a hairy paw foot.

Seats were often wider than Queen Anne types, and stretchers were used more haphazardly. Heavy carving—emphasizing lion and other animal motifs, shells, and volutes—also appeared on armposts, armrests, and aprons. Although many furniture items were still made from walnut, mahogany became the wood of choice for most finely carved items.

Along with the corner chair introduced in the eighteenth century and widely present in furniture inventories, a reading and writing chair designed strictly for the male gender was gaining in popularity. The sitter straddled the chair, the back of which was fitted with a book rest or writing surface, while armrests extended from the uprights.

The clothespress, or wardrobe, became increasingly in demand during the Early Georgian period. Smaller in scale than an armoire, the clothespress was usually fitted with concealed drawers. The number of tea tables, toilet tables, game tables, and drop-leaf types increased during the eighteenth century. Designed to be portable, these tables were either small or expandable, allowing the piece of furniture to be placed in a corner or against the wall when not in use.

While most furniture designed in the Early Georgian style evolved from Queen Anne influences, the designer and architect William Kent took a different approach. Considered a master of design, Kent's specialty was furniture and interior decoration. After studying in Rome, Kent identified with Inigo Jones's use of the Palladian style; he transformed classical forms into exaggerated, almost Baroque-like interpretations. He incorporated ormolu and gilding processes onto pier tables, mirrors, and heavily carved settees that sparsely outfitted elaborately ornamented rooms.

Figure 230 Dating from around 1730, this side chair made from walnut and burl walnut veneer over beech typifies the delicate exuberance of the Early Georgian style in the English Rococo period. Ornamentation on the crest rail combines foliate patterns with a single shell motif, which is also used on the knee of the front cabriole legs. The front cabriole legs terminate in ball and claw feet, with pad feet to the rear. Height 42³/₄″, Seat Height 16¹/₄″, Width 20¹/₄″, Depth 20¹/₄″.
Colonial Williamsburg Foundation.

Figure 231 A gentleman's English reading chair in the Early Georgian style dates from around 1750 and is made from walnut, oak, and beechwood. The design of the chair requires its occupant to straddle the chair while using the back as either a book rest or writing surface. Arm supports include fitted drawers for storage of writing implements and candle stands. Typical of this period, gentlemen's chairs were often covered in leather attached with visible nailheads. Notice the unusual variation of the cabriole leg. Height 36¾".
The Metropolitan Museum of Art, Gift of William C. Jackson, 1968.

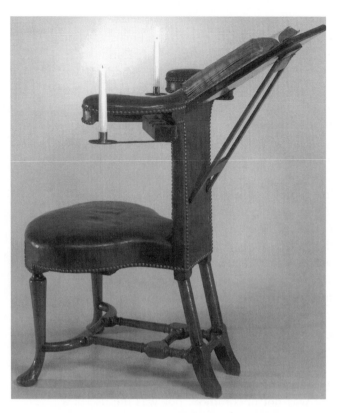

Figure 232 This clothes press is attributed to furniture maker Giles Grendey. It dates from around 1740 and is in the Early Georgian style. Made from mahogany, mahogany veneer, and oak, this case piece exhibits finely carved details around the top, door panels, apron, and knees of the cabriole legs. Some of these details include Vitruvian scrolls, egg and dart moldings, foliate designs, and modified shells. The interior of the upper section contains four adjustable trays and a permanently fixed shelf at the center. Height 65¼", Width 52½", Depth 27½".
Colonial Williamsburg Foundation.

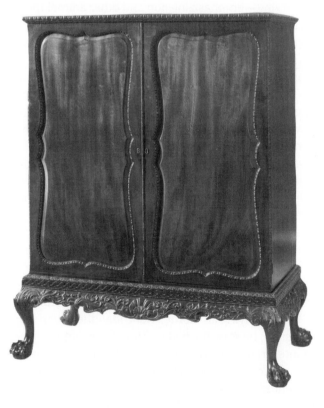

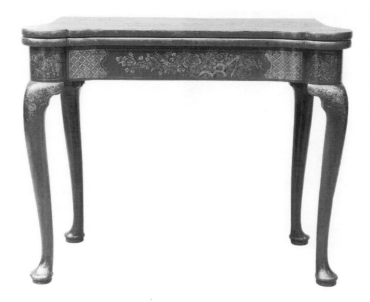

Figure 233 This English Early Georgian-style card table, shown here in a closed position, dates from circa 1730. Made by Giles Grendey, the painted beech finish (called japanning) imitates Chinese lacquer work. Height 29″.
The Metropolitan Museum of Art, Gift of Louis J. Boury, 1937.

Apart from the exuberant furnishings of country estates, there was yet another type of furniture that dominated the English countryside. Windsor furniture, popular in the early eighteenth century, became recognized as a style in its own right. Made by local craftsmen, the furniture was equally stylish and included complete ensembles of chairs, tables, chests, and hutches. Made entirely from wood, its handmade quality and durability proved practical for everyday use and was quite affordable.

Efficient and utilitarian in nature, chairs with spindle backs, wheel-carved splats, shaped saddle seats, and raking backs allowed for comfort without upholstery. Most chairs were made from birch wood, elm, or yew; branches were

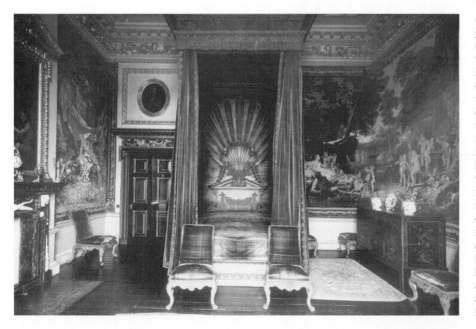

Figure 234 The state bedroom at Houghton Hall, from 1722–1732, built for Prime Minister Robert Walpole of England, shows exuberant Neo-Palladian furnishings designed by William Kent. The gilt furniture in this room is enhanced by the rich green velvet fabric used for upholstery and drapery. This view of the bed shows how Kent treats the design of the canopy like a classical entablature in conjunction with the room's gilt plaster work moldings. The triangular pediment headboard of the bedstead, with its modillions and ornamental swag, supports monumental shell motifs. Side chairs positioned around the room are designed with characteristic Rococo Georgian features: paw-footed cabriole legs, ornately carved knees, and scrolled aprons on front and side rails.
RCHME, ©Crown Copyright.

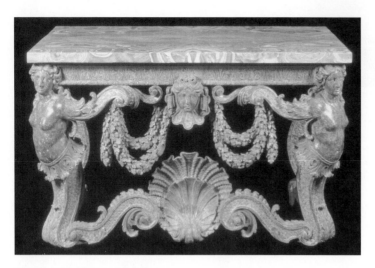

Figure 235 This carved gesso console table with alabaster top is attributed to William Kent and dates from around 1740. Clearly reflecting classically based themes of the Palladian influence, which Kent admired, the carvings on this table are executed with an exuberance more typically found on furniture of the Baroque period.

turned on a lathe to create slender spindles that fit into a bow-shaped back formed under steam and pressure. The saddle seat was carved out of a single piece of wood, and splayed spindle legs were stabilized with turned stretchers.

Variations in chair design incorporated cabriole legs and pierced splats, associating the piece with the more sophisticated Queen Anne or Early Georgian styles. Ornamentation was kept at a minimum and many furnishings were often painted in bright greens, reds, and yellows for added visual appeal. The Windsor style of furniture was also popular among the Americans during the pre-Revolution period.

The Gentleman and Cabinet-Maker's Director, published in 1754, set the direction for change in furniture styles for the remainder of the eighteenth century. Compiled by cabinetmaker Thomas Chippendale (1718–1779), *The Director* documented through measured line drawings the more popular styles and types of English Georgian furniture. All furniture, accessories, and architectural details included in this publication would become known as the "Chippendale" style.

Figure 236 Local artisans of the English countryside created a unique style of furniture that combined characteristics from the Queen Anne and Early Georgian styles with rustic ingenuity. The resulting Windsor style proved more suitable for provincial lifestyles. This Windsor chair from the mid-eighteenth century has front cabriole legs with bracketed knees, a pierced splat mixed with characteristic Windsor-style bow- or hoop-back, spindles, and a saddle seat.

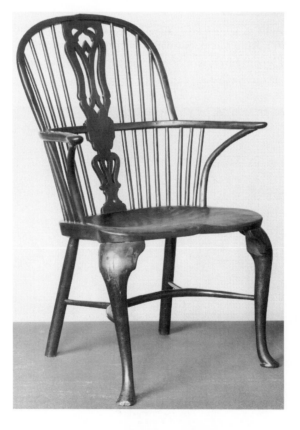

Chippendale's publication summarized the grammar of the classical orders and provided elaborately detailed and scaled drawings of furniture and coordinated decorative accessories. The collection of drawings reflected a growing interest in culture and architectural aesthetics by educated gentlemen. New pieces introduced in *The Director* included the camel-back sofa, the triple-chair-back settee, the *breakfront* china cabinet, pagoda-top canopied beds, tilt-top tables, dumb waiters, and Pembroke tables.

Chippendale included designs loosely based on the "modern" Queen Anne, Georgian, and Louis XV styles. He also introduced new styles based on romanticized representations of the Far East and the Gothic past. Interior furnishings incorporating distinctive Oriental influences such as pagodas, dragons, and fretwork became known as "Chinese Chippendale," while items with pierced tracery and trefoil arches reminiscent of Medieval cathedrals were considered "Gothic." Carving was an important decorative feature of all Chippendale styles, whether Rococo, Gothic, or Chinese influenced.

The Rococo-based designs utilized the cabriole leg, usually ending in a claw and ball, although sometimes a whorl foot was present. Bracketed knees were usually carved with an acanthus leaf or shell while the crest rail was formed into a yoke shape and the uprights enclosed a pierced splat of unusually rich decoration.

Gothic-style chairs retained the yoke back or had arched backs, but the splat was replaced by open tracery forming pointed arches. Legs generally were straight in the front, while extended uprights created gentle sweeping saber legs in the rear. The straighter legs often incorporated a stretcher system, although it was not necessary for strength and support.

The Chinese Chippendale style continued to incorporate a straight leg in the front with saber-back legs; however, the typical Marlborough leg was decorated with lattice- or fretwork. Yoke backs often reflected sweeping upward curves on the ends, imitating the effect of a pagoda top. Backs generally introduced either a pierced splat with small pagoda shapes or contained open fretwork.

Triple-chair-back settees followed in the form of side and armchairs. These settees had an upholstered seat, with wood backs, arms, and armposts. A more formal piece of furniture, the settee was not as comfortable as the camel-back sofa, a new introduction in the eighteenth century. Like the French canapé, the camel-back sofa was almost entirely upholstered at the seat, back, arms, and sides.

Storage items and other case pieces continued to dominate the interior scheme of a room with their immense size and exquisitely carved cornices. The popular writing cabinet, or slant-front secretary, was illustrated in Chippendale's *Director* in all three tastes—Rococo, Gothic, and Chinese. The more exuberant Chinese style often exhibited fretwork glazing with pierced, carved

Figure 237 Thomas Chippendale's pattern book, first introduced in 1754, went into three editions; the title page reproduced here is from the 1762 third edition. Included are engravings of furniture, architectural details, and decorative objects selected by Chippendale "to improve and refine the present taste, and suited to the fancy and circumstances of persons in all degrees of life."
Courtesy Dover Publications.

Yoke back with
ribbanding

Yoke back with
Chinese fretwork

Yoke back with
Gothic tracery

Cabriole leg with
claw and ball foot

Chinese
fretwork leg

Marlbourough
leg

Tapered or
quadrangular
leg with spade
foot

Drawer pull

Finial

Escutcheon

Swan neck pediment

Bracket foot

Claw and ball foot

Plinth base

Figure 238 English Rococo,
Chippendale-style furniture
forms.

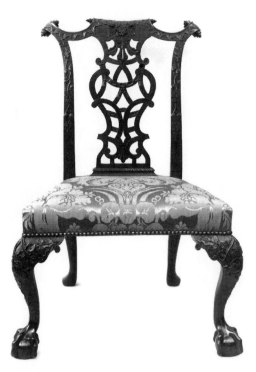

Figure 239 Fine carvings on this mahogany English Chippendale side chair, circa 1750, include an oak leaf and acorn motif along the crest rail, uprights, and cabriole legs; a waterfall motif carved where the pierced splat meets the silk upholstered seat, and claw and ball feet. Height 39⅝″, Width 26½″.
The Metropolitan Museum of Art, Gift of Irwin Untermyer, 1951.

Figure 240 This English Chippendale-style armchair in the Gothic taste has a back shaped into a series of pointed arches. Made from mahogany, circa 1750–1770, the straight legs appear severe compared to the curved forms of the armposts and armrests. Height 38¼″, Width 24¼″, Depth 18⅞″.
The Metropolitan Museum of Art, Bequest of John L. Cadwalader, 1914.

Figure 241 The Chinese taste was Chippendale's most exuberant style. This armchair, circa 1765, is made from beechwood with mahogany veneer. Its design includes lattice work back and sides, and front Marlbourough legs with bracketed fretwork design. The seat is upholstered in wool and silk tapestry. Height 39⅝″.
The Metropolitan Museum of Art, From the Marion E. and Leonard A. Cohen Collection, Gift of Marion E. Cohen, 1950.

Figure 242 This English Chippendale-style double chair back settee made from mahogany, beech, and oak dates from around 1760. Acanthus leaf carvings appear on the crest rail, along with a decorative pierced splat, gooseneck arms, and Marlbourough legs with Oriental-influenced bamboo carving. Height 36¾″, Width 60″, Depth 22¼″.
Courtesy Museum of Fine Arts, Boston. Bequest of Herbert Heidelberger in honor of Frederick and Minna Heidelberger.

pediments. Numerous glazed bookcases and china cabinets displayed interesting books and curios representative of a contemporary gentleman's intellect and wealth.

Highboys, tallboys, and armoires remained plentiful during the latter half of the eighteenth century as storage for wardrobe and linens. Chippendale styles incorporated fretwork, serpentine curves, and tracery, each reflective of its particular style—Chinese, Rococo, or Gothic.

Two other significant pieces of furniture introduced in Chippendale's *Director* were the dumb waiter and the tilt-top table with pie crust edge. The dumb waiter was a small circular table that had two or three tiers, each in decreasing size, one placed over the other. Food was placed on the tiers then brought into the dining room and placed next to the hostess for serving.

Much more popular was a type of tea table known as the pie crust table, or tilt-top table. This type of small table had a rounded top usually designed

Figure 243 This English Chippendale-style camel-back sofa, circa 1775–1800, has high, rolled arms, Marlbourough legs of carved mahogany, and casters, a novelty introduced in the late eighteenth century.
The Metropolitan Museum of Art, Rogers Fund, 1922.

Figure 244 When closed, this looks like a chest of drawers with a bookcase top. However, in this view false drawer fronts are lowered to reveal a writing surface and storage compartments, turning this piece into a secretary bookcase. Made in England around 1775, Rococo characteristics with Chippendale influences can be seen in the pierced scrolled pediment top with rosettes and glazed fretwork doors, although the emerging Neoclassical style appears in its rectilinear proportions.
Colonial Williamsburg Foundation.

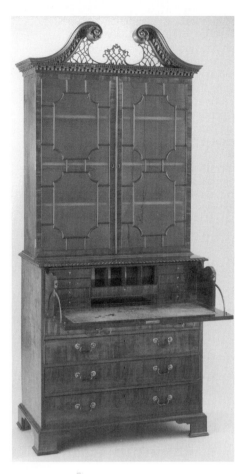

Figure 245 This bookcase breakfront is designed in three parts; the central projecting panel is flanked by two recessed wings and each section is then subdivided between bookcase above and cupboard below. Case furniture of this size was often made in sections making it easier to transport from the cabinetmaker's workshop. This particular bookcase, one of a pair, is believed to have been commissioned by Robert Adam for Sir Rowland Winn of Nostell Priory around 1762 and supplied by Thomas Chippendale. Notice the Chippendale styling in the Gothic taste; a double row of arcades appears on the bookcase, complete with spires, pendants, and waterfall carving. Instead of glazing, brass trellis-work hung with silk panels conceals the shelving for books. Height 9'1 1/2", Width 10'11 1/2", Depth 1'10 1/2".
Colonial Williamsburg Foundation.

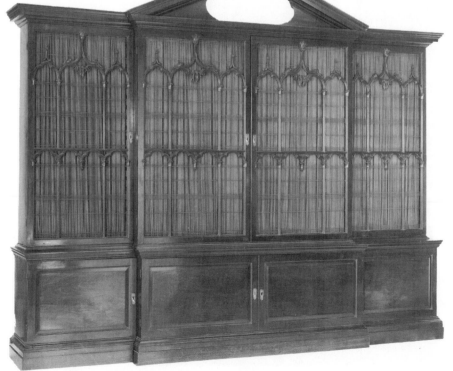

Figure 246 This eighteenth-century, Chippendale-style china cabinet in the Gothic taste designed to store and display Chinese export porcelains, has three pointed arches at the top, glazed doors with tracery mullions, and fitted shelves. Collecting Chinese export porcelain showed wealth and remained fashionable throughout most of the eighteenth century.
Courtesy of the Board of Trustees of the V&A.

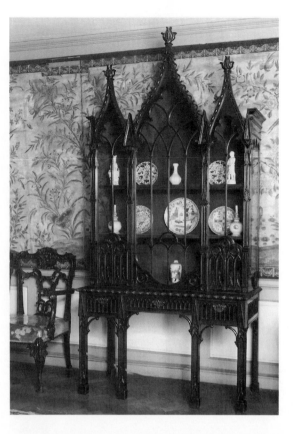

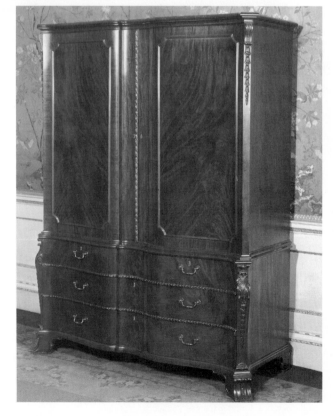

Figure 247 An English mahogany carved wardrobe from Chippendale's workshop dating from 1766. Decorative details include the bell flower motif extending from the top corner modillions, banded door fronts, and carved moldings following the serpentine shape of the lower chest. At this time, it is still common practice to fold clothes rather than hang them as is done today.
Nostell Priory, Yorkshire, UK/Bridgeman Art Library, London/New York.

with scalloped edges (evoking the edges of a pie crust) and a birdcage mechanism that enabled the table to tilt. When not in use, the flat surface of the table was converted to a vertical position and placed against the wall.

Gaming tables, as well as a variety of other tables used in dressing, writing, and dining, continued in popularity as before. Dining tables were usually understated and portable. Semicircular side tables pushed next to a square or rectangular table created extensions for numerous guests; when not in use, the side tables became console tables and were placed against the wall.

The great Chippendale bed, transformed by Chinese influence, overpowered the bedroom with its elaborately carved tester. Coordinating accessories including candle stands and mirrors complemented the great pagoda top with designs incorporating dragons and other Chinese motifs. Silk textiles with characteristic chinoiserie patterns made up the bed linens and drapery (see Color Plate 21).

Under Chippendale's direction, his cabinetmakers produced fine-quality mahogany furnishings for English country houses. Sadly, only a few remaining pieces originated from the Chippendale workshop. His later work, dating after 1760, was done for the architect and designer Robert Adam and followed more closely with the developing Neoclassical style that was influenced by the excavations of Herculaneum in 1738 and Pompeii in 1748.

Figure 248 Tilt-top tables were designed for maximum flexibility; a birdcage mechanism allowed the surface to adjust to a horizontal position at tea time and to vertical when not in use. This example of an English Chippendale-style mahogany table, circa 1750–1765, has a decorative pie-crust edge and tripod support with carved hairy-paw feet.
The Metropolitan Museum of Art, The Sylmaris Collection, Gift of George Coe Graves, 1930.

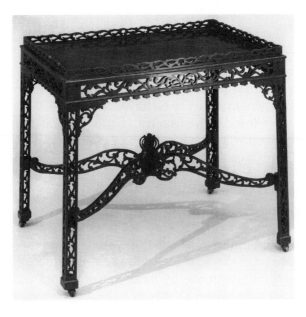

Figure 249 Chippendale-style mahogany English tea table, circa 1755–1775, has pierced carving on the gallery, apron, legs, and stretchers. Notice the casters. Height 29″, Length 33⅓″, Width 24½″.
The Metropolitan Museum of Art, The Marion E. and Leonard A. Cohn Collection, Bequest of Marion E. Cohn, 1966.

Figure 250 Card playing was a favorite pastime among all classes of society during the eighteenth century, and special tables used for this purpose were designed with folding mechanisms that allowed the table to be stored against the wall like a console table when not in use. This example, circa 1755, is in the English Chippendale style and is made from mahogany with carved acanthus leaves on the knee of the claw and ball footed cabriole legs.
The Metropolitan Museum of Art, Kennedy Fund, 1918.

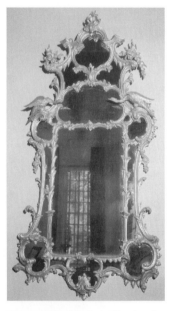

Figure 251 Made in England around 1750, the frame on this mirror clearly reflects the prevalence of Chinese styling made popular with the import–export trade between England and China. Its design parallels several of Chippendale's drawings for looking glass frames that he included in *The Gentleman and Cabinet-Maker's Director* in 1754.
Colonial Williamsburg Foundation.

Eighteenth-Century American Furniture

As discussed in the last chapter, Early Colonial furniture was intended to provide the early settlers with practical furnishings in modest living quarters. At the turn of the eighteenth century, however, colonists were becoming more prosperous in their own right. The eighteenth century was a time of immense population growth brought on by increased immigration from Europe and a thriving economy through shipping industries and the exportation of cash crops. As the modest living quarters of early colonists were replaced by much larger, multistoried homes, the demand for finer furnishings followed (see Color Plate 22).

The increasingly larger colonial homes sported wainscoted walls, painted plaster moldings, and higher ceilings. Prosperous colonists sought finer furnishings that revealed their new level of sophistication. American furniture craftsmen responded and imitated the styles popular in England, as had been done in the previous century. Although most American-made pieces lagged anywhere from ten to twenty years behind European styles, by the late seventeenth and early eighteenth centuries, local cabinetmakers introduced items based on William and Mary, Queen Anne, and Chippendale styles. Motifs and designs were slightly changed to reflect the preferences of specific geographic regions and furniture makers in Philadelphia, Baltimore, Boston, Newport, and Virginia became known for producing some of the finest examples of American-made furniture.

Not all colonists prospered in America, and there was still a need for affordable furnishings. Windsor-type chairs with splayed legs, H-stretchers, saddle seats, and spindles were used in homes of the less affluent since the furniture was made by local craftsmen and was easy to fabricate. Certain regions developed their own trademark design, whether it be a comb-back,

wheel-back, or bow-back chair. Windsor-style furnishings were popular throughout the colonies and were readily purchased by all levels of society. Several pieces were purchased for Mount Vernon by General Washington.

The Queen Anne style was more prevalent in the American colonies by 1725 and became one of the more popular styles of the Late Colonial period. Chairs, tables, and case pieces incorporated many Rococo-inspired details, including cabriole legs, serpentine curves, and scrolled pediments. The claw and ball foot was used sparingly as the pad or club foot was preferred for its simplicity and strength (see Color Plate 23).

Spoon-back chairs quickly became called fiddle-back chairs, a name adopted for the shape of the splat. While most incorporated the cabriole leg, called a *bandy* by colonists, more simplified versions kept the characteristic turned forms common to Early Colonial styles. The use of stretchers and upholstered seats was more haphazard. In more prosperous households, the fiddle-back chair followed more closely with English counterparts; it had cabriole legs as well as an upholstered seat.

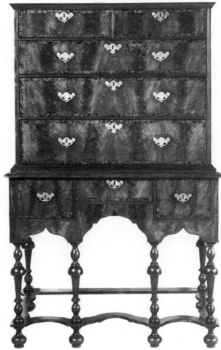

Figure 252 This highboy belonged to George Washington's mother, Mary Ball Washington, and is an excellent example of furniture made in New England between 1700 and 1730. The William and Mary style had been introduced into the American colonies as early as 1690, and its prevalence endured until about 1725 when supplanted by the emerging Queen Anne style. Each drawer front is veneered first with feathered walnut, then banded with burl.
From the collections of Henry Ford Museum & Greenfield Village.

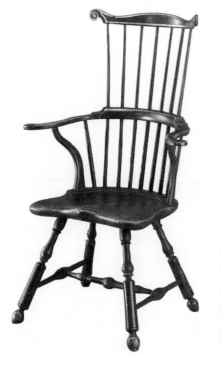

Figure 253 This armchair in the Windsor style was made in Philadelphia around 1769 and shows the more popular American comb-back design. The spindles that make up the back, the bulbous H-form stretcher, and the splayed baluster legs were turned on a lathe while the crest rail, armrail, and saddle seat were shaped. Made out of local woods such as poplar, hickory, elm, or maple, Windsor furniture was often brightly painted. This chair was once blue-green in color. Height 41 1/2", Seat Height 16 1/2", Width 17", Depth 19 1/2".
Colonial Williamsburg Foundation.

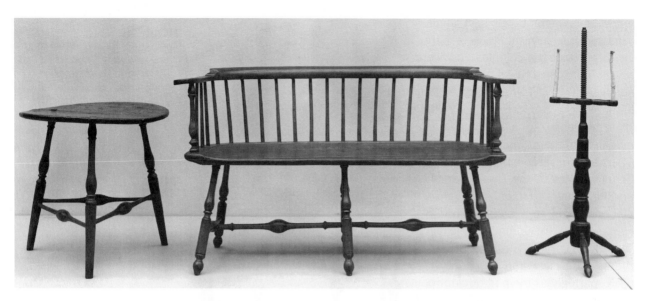

Figure 254 A collection of eighteenth-century Windsor-style furniture from Pennsylvania includes a tripod table and settee made from whitewood, maple, and ash, and a candle stand made from maple with a painted black finish. Table: Height 24″, Diameter 24½″; Settee: Height 30½″, Width 53¾″, Diameter 17″; Candle stand: Height 37½″, Width 11″.
The Metropolitan Museum of Art, Gift of Mrs. J. Insley Blair, 1947.

Case goods such as highboys, tallboys, and secretaries took on characteristics of the Queen Anne style as well. Most were quite high and nearly touched the low ceilings of American colonial homes but were impressive pieces and kept in the more public rooms for guests to admire.

Indigenous woods such as walnut, maple, and pine were used by most American furniture craftsmen; in rare cases, some items incorporated im-

Figure 255 This room setting shows reproduction Queen Anne-style furnishings, one of the more popular traditional styles adapted for the American home during the twentieth century. Note that the height of the tea table is appropriately proportioned by eighteenth-century standards.
Courtesy Kindel Furniture Company.

ported mahogany. The type of wood used, along with subtle nuances in design, help place pieces of furniture into respective regions. Philadelphia earned a reputation for producing some of the finest examples of furniture seen in the American colonies.

The disparity between the introduction of new styles in England and the time it took them to reach the American colonies lessened after the publication of Chippendale's *The Gentleman and Cabinet-Maker's Director*. Chippendale style is seen in America after copies of *The Director* made their way to the colonies within the first year of its publication. The intricate and delicate carvings indicative of the Chippendale style necessitated the use of a harder wood, and mahogany proved more suitable (see Color Plate 24).

Although all three Chippendale influences were seen in the American colonies, the more modern taste of the French Rococo prevailed as the most popular choice among the furniture maker's wealthier patrons. Cabriole legs and claw and ball feet adorned magnificently carved side chairs even though their use was diminishing in England during this time.

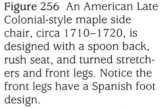

Figure 256 An American Late Colonial-style maple side chair, circa 1710–1720, is designed with a spoon back, rush seat, and turned stretchers and front legs. Notice the front legs have a Spanish foot design.
The Metropolitan Museum of Art, Gift of Mrs. Russell Sage, 1909.

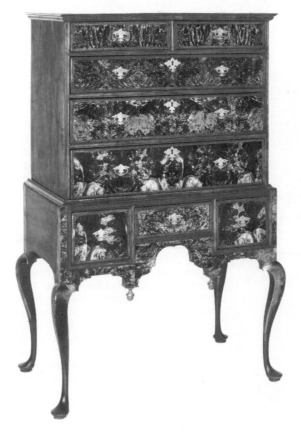

Figure 257 This highboy, circa 1730–1750 and made in Massachusetts, has a burl walnut veneer applied to the drawer fronts and apron, creating decorative patterns with its distinctive graining. Furniture designed during the American Late Colonial period followed the English Queen Anne style, as seen here with its use of the cabriole leg with pad foot, acorn pendants on the apron, and brass escutcheons. Height 60½", Width 39¼", Depth 23½".
From the collections of Henry Ford Museum & Greenfield Village.

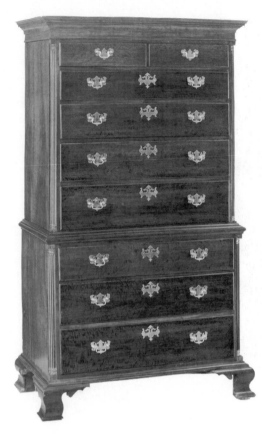

Figure 258 This chest-on-chest, or tallboy, was made in Pennsylvania and dates from around 1750–1760. Made from cherry with curly cherry drawer fronts, the piece is in three sections: it has a removable cornice, an upper chest with five full drawers and two half-width drawers, and a lower section with three graduated drawers. The shaped bracket feet, quarter columnar corners, and stepped moldings are characteristic of English Queen Anne styling but reflect the skill of the American cabinetmaker of this period. Height 80½″, Width 52½″, Depth 25¼″.
Colonial Williamsburg Foundation.

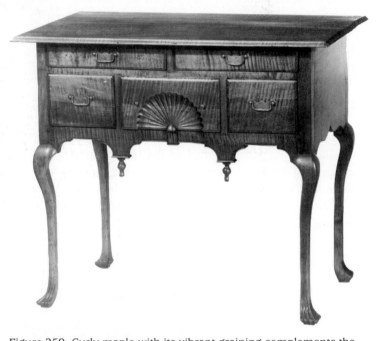

Figure 259 Curly maple with its vibrant graining complements the fine carving on this lowboy, or dressing table, dating from around 1720–1740 during the American Late Colonial Period. Possibly made in the Connecticut Valley near southwestern Massachusetts, the table incorporates significant features of English Queen Anne style. Each cabriole leg is finished with a carved Spanish foot and slight pad, the center drawer incorporates a carved fan motif, and the apron is accented with applied beading and pendants. Notice the shaped ogee arch visible on the right side. Height 31″, Width 35¼″, Depth 23⁹/₁₆″.
Courtesy Museum of Fine Arts, Boston.

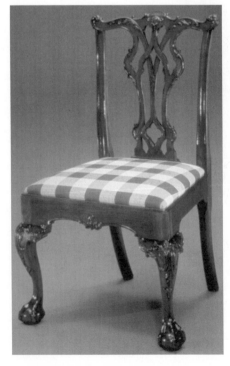

Figure 260 This is a licensed reproduction of a Chippendale side chair made in Philadelphia for Thomas and Elizabeth Edwards, circa 1760. Although the original number in the set is not known, two of the originals are in a private collection, four were purchased by H.F. DuPont from descendants of the original owners, and one was sold by Sotheby's in 1985 for $104,000. At that time, it was the highest price paid for a single side chair. The bow-shaped crest rail outlined with "C" scroll and flowering acanthus leaf carving celebrates the skill of the wood carver. The exuberance of the carving continues down the splat, apron, knee, and claw and ball feet. Width 23½″, Depth 21³/₄″, Height 38¼″.
Courtesy Kindel Furniture Company.

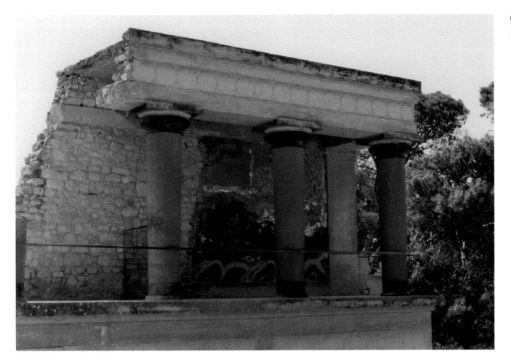

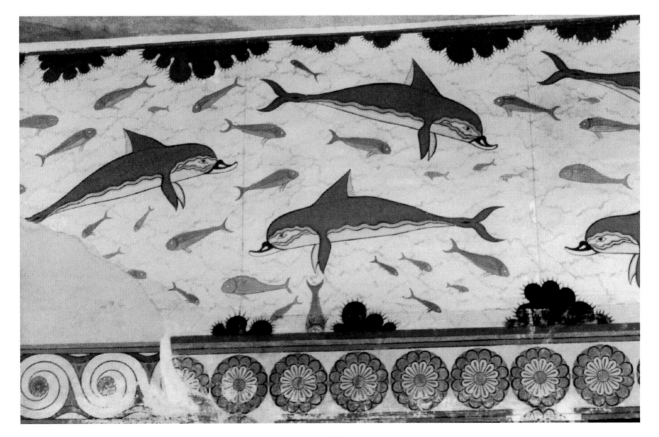

Color Plate 2 Dolphin fresco, Queen's Megaron. Knossos, Crete.

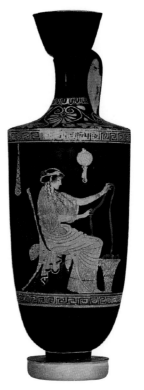

Color Plate 4 Atrium. Pompeii, Italy. Circa first century B.C.–first century A.D.

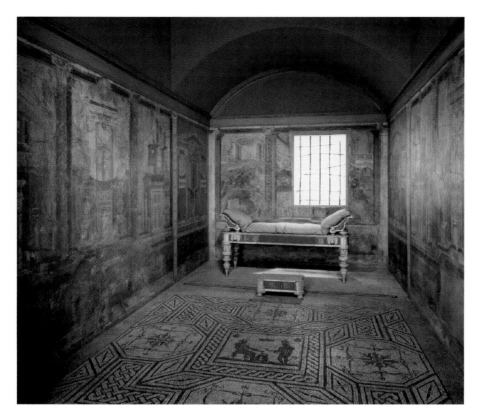

Color Plate 5 Cubiculum from Boscoreale, Roman. The Metropolitan Museum of Art, Rogers Fund, 1903. Photograph by Schecter Lee. Photograph ©1986 The Metropolitan Museum of Art.

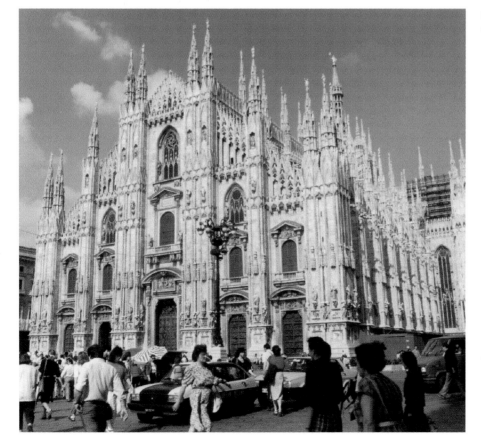

Color Plate 6 Milan Cathedral, Italy. Begun in 1386.

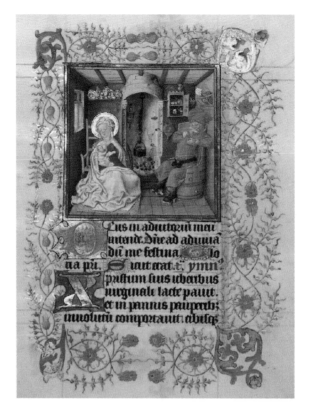

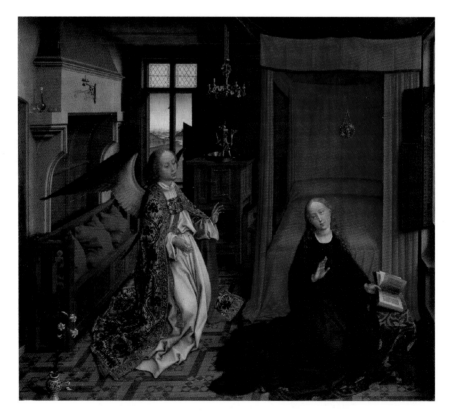

Color Plate 8 *The Annunciation* by Netherlands' painter Rogier Van der Wey-
den. Early fifteenth century.

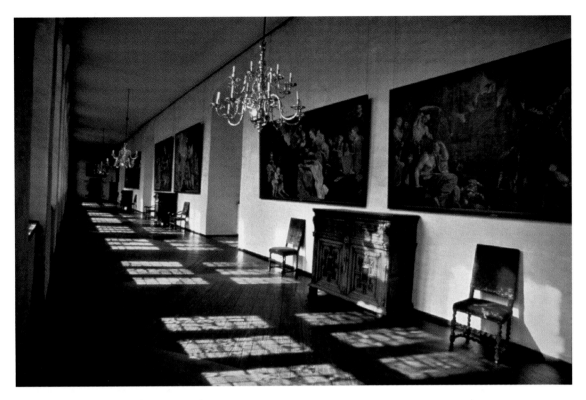

Color Plate 9 Long gallery, Copenhagen.
Image Bank, Co Rentmeester.

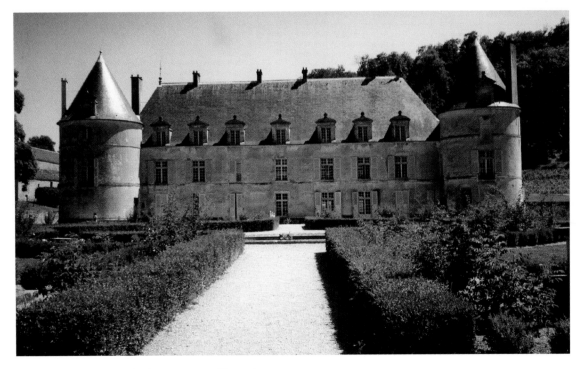

Color Plate 10 French château, circa fifteenth century.

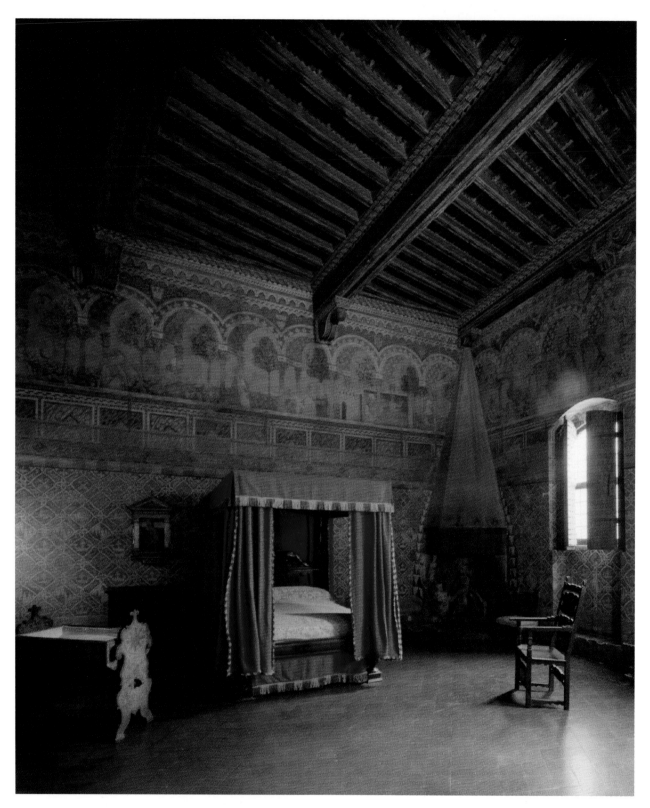

Color Plate 11 Palazzo Davanzati. Florence, Italy. Fourteenth century.
Erich Lessing/Art Resource, NY.

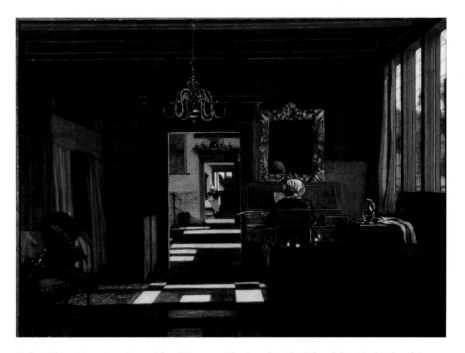

Color Plate 12 *Interior with a Woman, Playing the Clavichord*, by Netherlands'
painter Emanuel de Witte, seventeenth century.
The Netherlands Office for Fine Arts, The Hague. (loan). Museum Boijmans Van Beuningen,
Rotterdam.

Color Plate 13 Room
setting from the Early
French Baroque period.
The Image Bank, David W.
Hamilton.

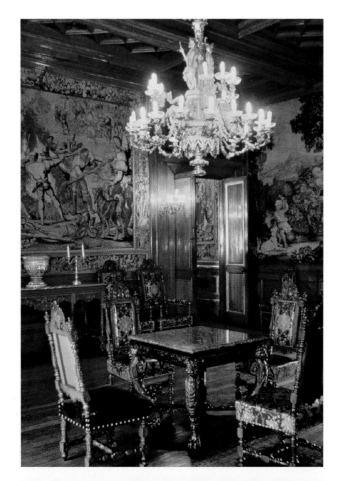

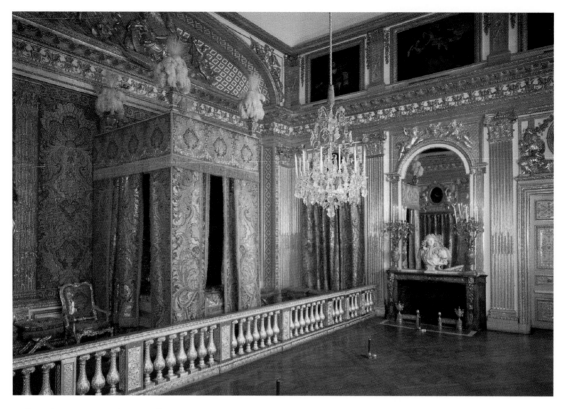

Color Plate 14 Bedroom of King Louis XIV. Versailles, France. Seventeenth century.
Giraudon/Art Resource, NY.

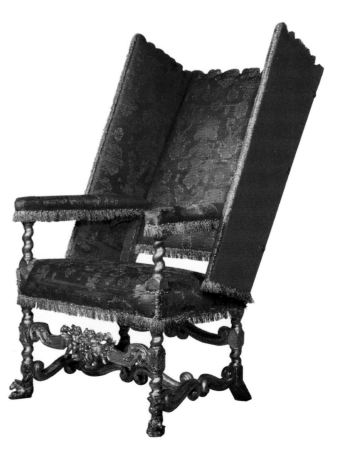

Color Plate 15 English Baroque reclining chair from
Ham House, Petersham, Surrey. 1677–1679.
Courtesy of the Trustees of the V&A, V&A Picture Library.

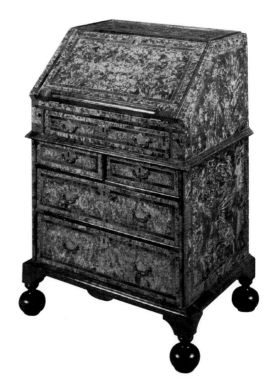

Color Plate 16 English William and Mary-style bureau, circa 1700.
Bonhams, London, UK.

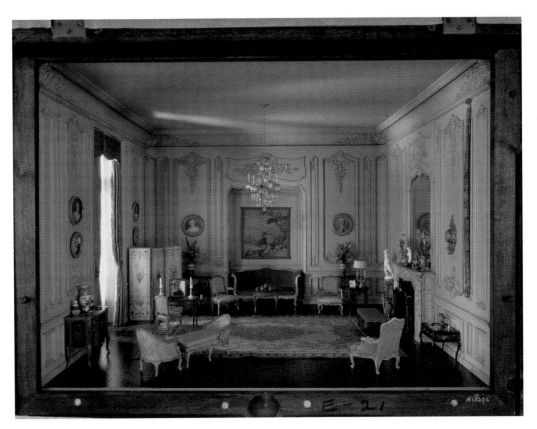

Color Plate 17 Louis XV-style boudoir room miniature reflects French Rococo period circa
1740–1760.
Workshop of Mrs. James Ward Thorne, circa 1930–1940, gift of Mrs. James Ward Thorne, 1941.1206, overall
view. Photograph by Kathleen Culbert-Aguilar, Chicago. Photograph ©1997, The Art Institute of Chicago, All
Rights Reserved.

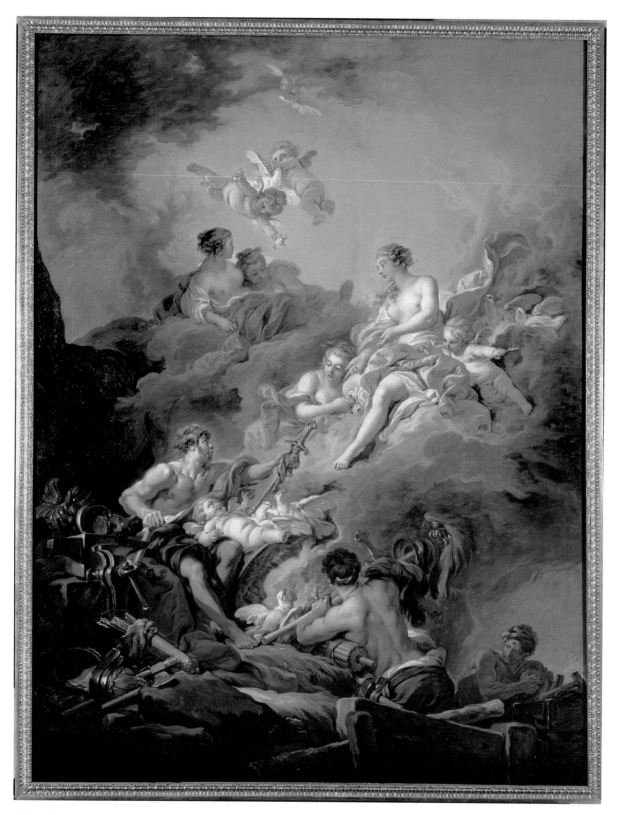

Color Plate 18 *Venus Securing Arms from Vulcan for Aeneas* by French painter François Boucher, 1769. Kimbell Art Museum, Fort Worth, Texas.

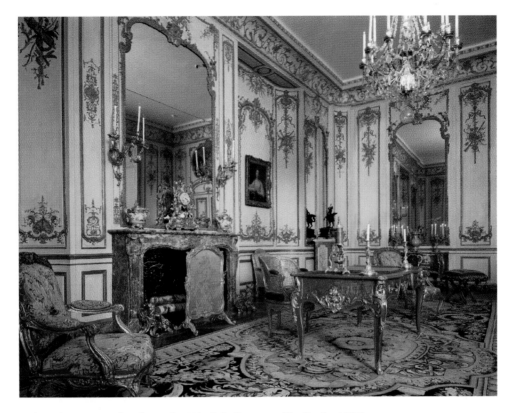

Color Plate 19 Salon from the Hôtel de Varengeville, Paris, 1735.
The Metropolitan Museum of Art, Purchase, Mr. And Mrs. Charles Wrightsman Gift, 1963. Photograph
©1995 The Metropolitan Museum of Art.

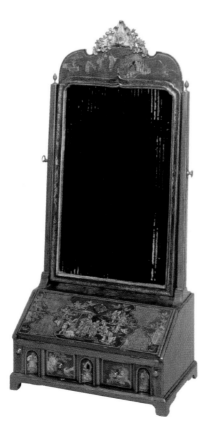

Color Plate 20 English Queen Anne-style dressing mirror.
Frank Partridge Ltd., London, UK/Bridgeman Art Library, London/New
York.

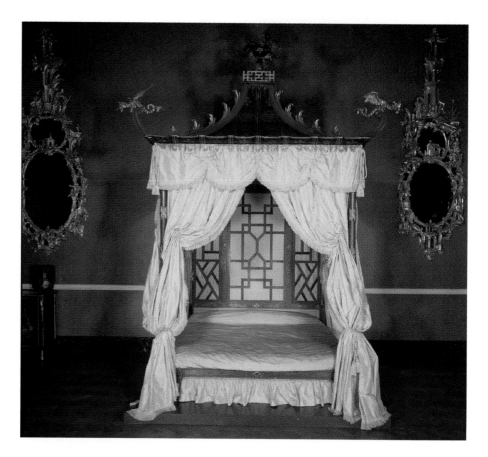

Color Plate 21 Chippendale Pagoda bed, circa 1755.
Courtesy of the Trustees of the V&A, V&A Picture Library.

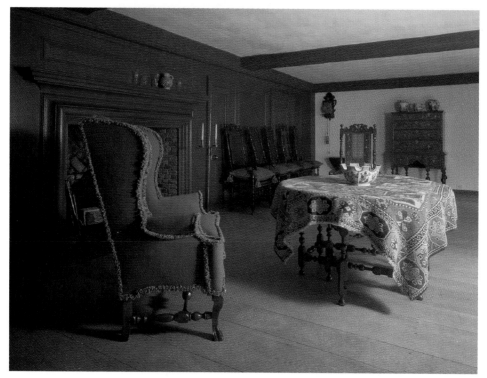

Color Plate 22 Residence of John and Sarah Wentworth, New Hampshire. Late seventeenth–early eighteenth century.
The Metropolitan Museum of Art, Sage Fund, 1926.

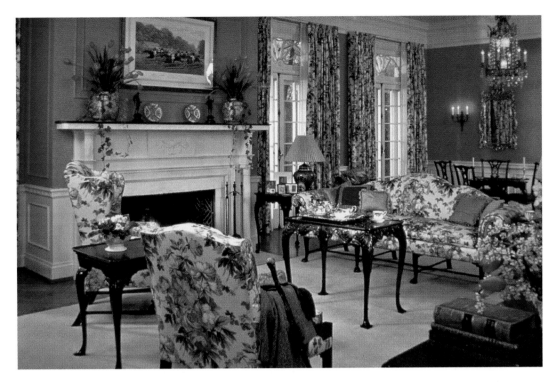

Color Plate 23 American Queen Anne-style room setting, twentieth century.
Courtesy Kindel Furniture Company.

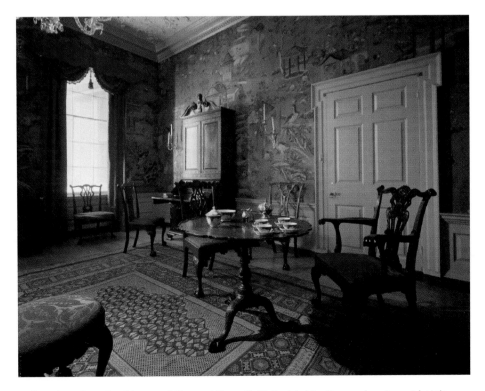

Color Plate 24 Residence of Samuel Powell. Philadelphia, Pennsylvania, mid-eigh-
teenth century.
The Metropolitan Museum of Art, Rogers Fund, 1918. Photograph ©1995 The Metropolitan
Museum of Art.

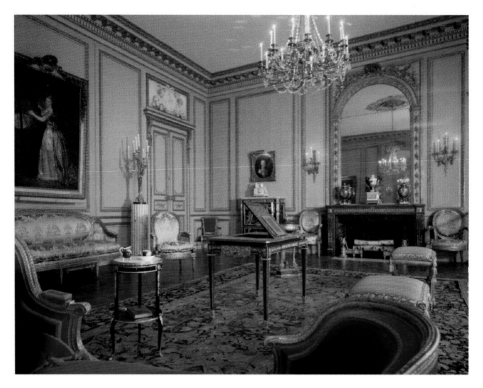

Color Plate 25 Reception room from the Hôtel de Tesse. Paris circa 1768–1772.
The Metropolitan Museum of Art, Gift of Mrs. Herbert N. Straus, 1942. Photograph ©1995 The
Metropolitan Museum of Art.

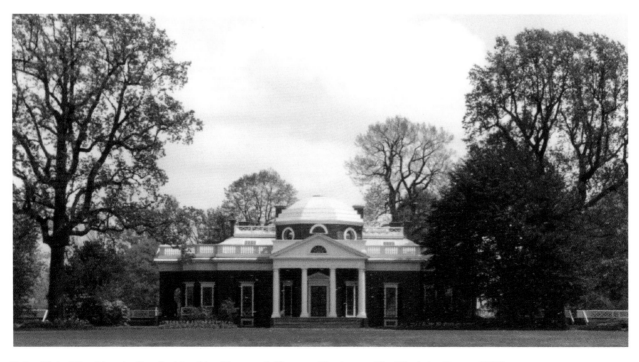

Color Plate 26 Monticello, designed by Thomas Jefferson. Charlottesville, Virginia. Begun 1770.

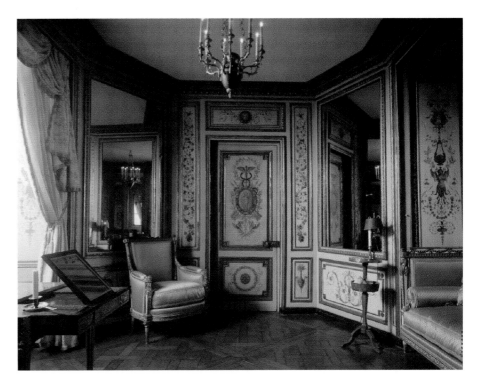

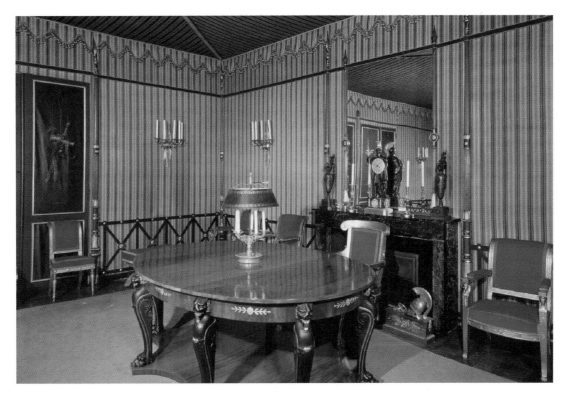

Color Plate 28 Château de Malmaison, interior view of Napoleon's council room. Designed by Percier and Fontaine, early nineteenth century.
Giraudon/Art Resource, NY.

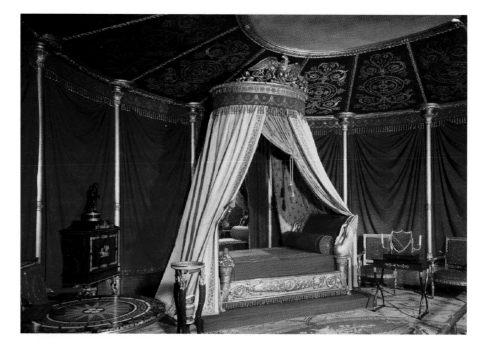

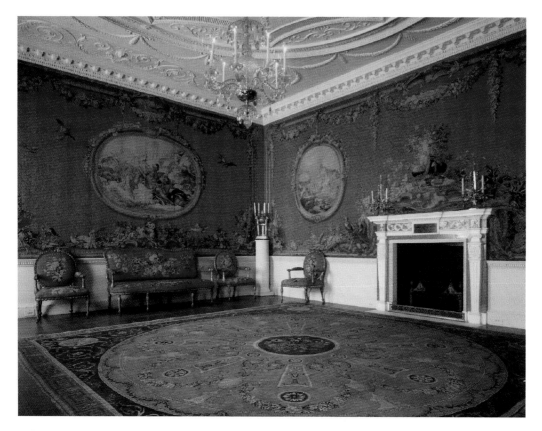

Color Plate 30 The Tapestry Room from Croome Court. Worcestershire, England. Designed by Robert Adam, François Boucher, John Mayhew, and William Ince. Mid-eighteenth century.
The Metropolitan Museum of Art, Gift of the Samuel H. Kress Foundation, 1958. Photograph ©1995 The Metropolitan Museum of Art.

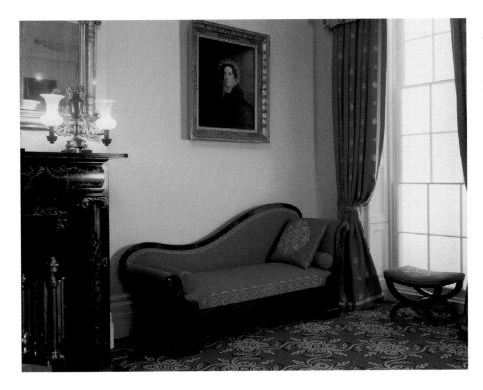

Color Plate 31 Parlor from New York City townhouse of Samuel A. Foote. Furniture by Duncan Phyfe, circa 1835. The Metropolitan Museum of Art. Photograph ©The Metropolitan Museum of Art.

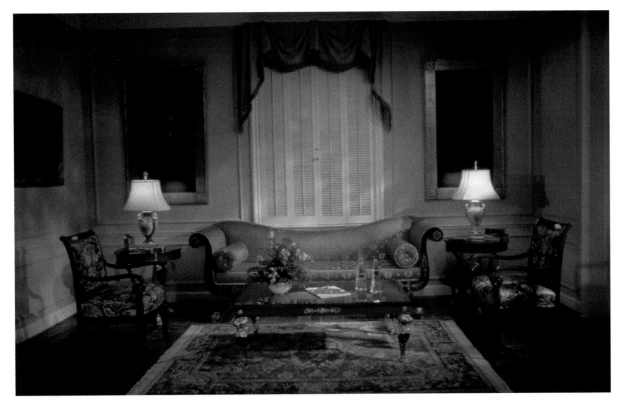

Color Plate 32 American Empire room setting, twentieth century.
Courtesy Kindel Furniture Company.

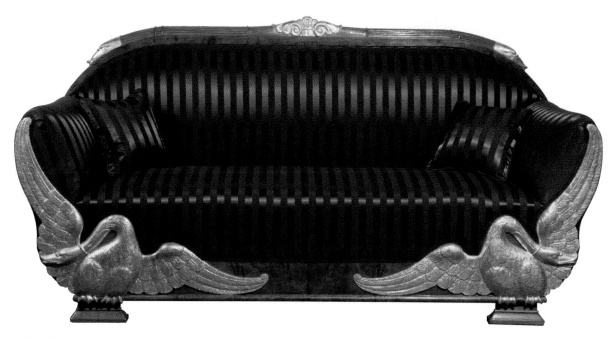

Color Plate 33 Biedermeier-style mahogany sofa from the workshop of Anton Kimbel. New York, mid-nineteenth century.
Courtesy Ritter-Antik, New York.

Color Plate 34 Chair and wallpaper by the English designer William Morris, twentieth century reproductions from circa 1870 originals.
Courtesy Sanderson.

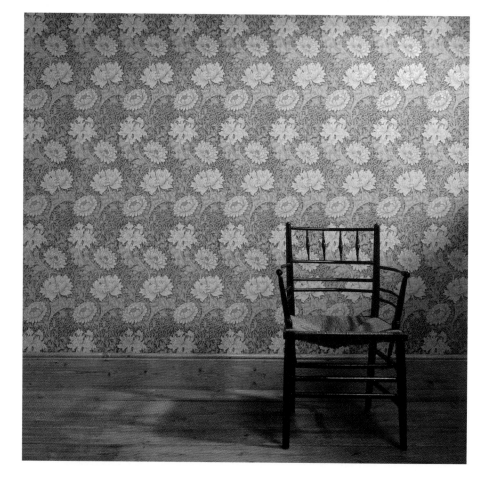

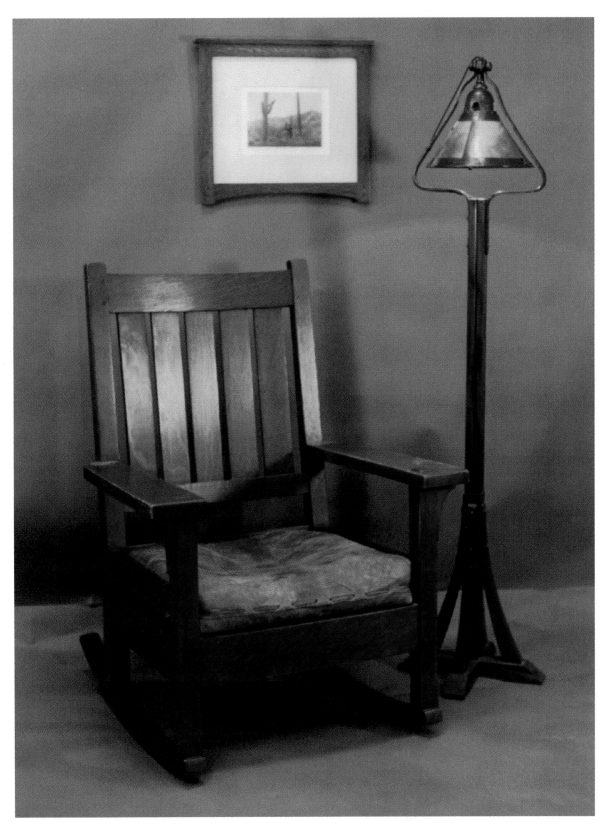

Color Plate 35 Arts and Crafts-style chair by the American designer Gustav Stickley. Early nineteenth century.
Courtesy The Mission Oak Shop, Putnam, Connecticut.

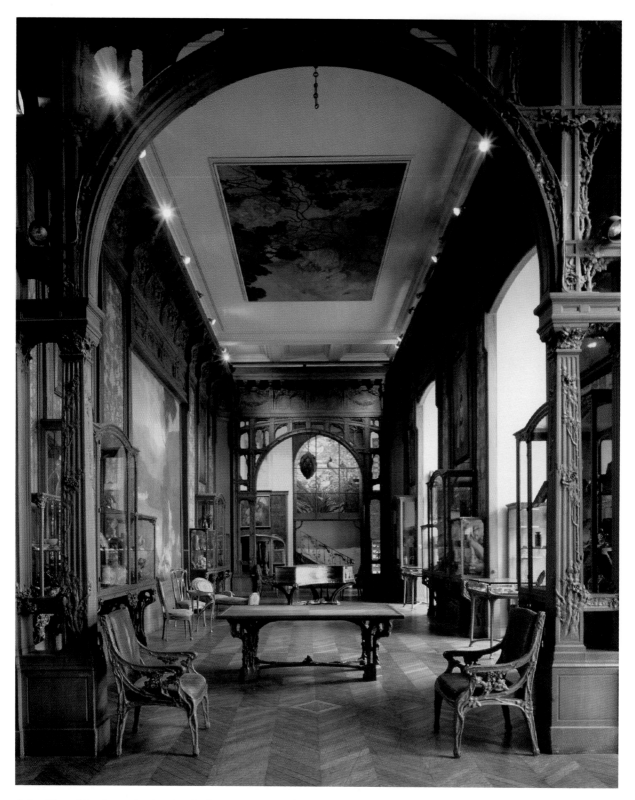

Color Plate 36 Room in the Musée des Arts Decoratifs, Paris. French Art Nouveau style, early nineteenth century.

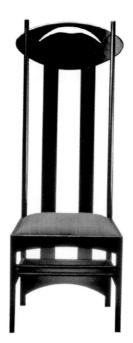

Color Plate 37 Argyle chair, by Scottish designer Charles Rennie Mackintosh, 1897. Courtesy Cassina.

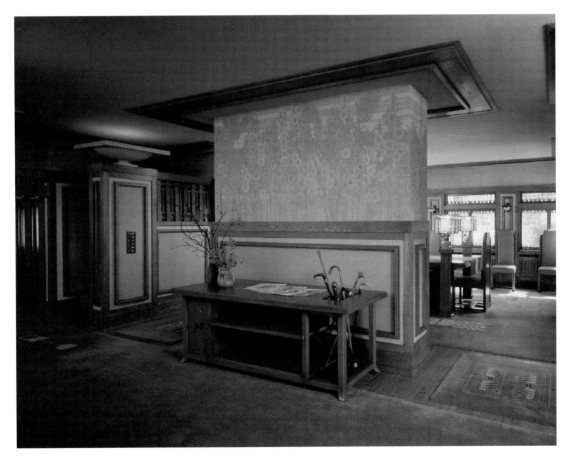

Color Plate 38 The Meyer May home, by American architect Frank Lloyd Wright. Grand Rapids, Michigan, 1908.
Courtesy Steelcase Inc., Grand Rapids, Michigan.

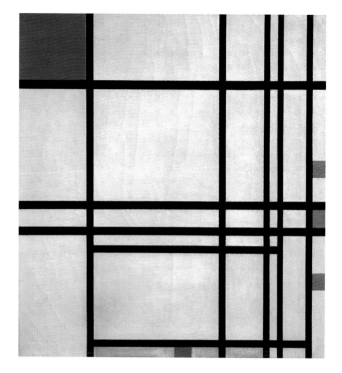

Color Plate 39 *Composition No. 8*, by Netherlands' painter Piet Mondrian. Completed between 1939 and 1942.
Kimbell Art Museum, Fort Worth, Texas.

Color Plate 40 Red Blue chair by Netherlands' architect Gerrit Rietveld, 1917.
Courtesy Cassina.

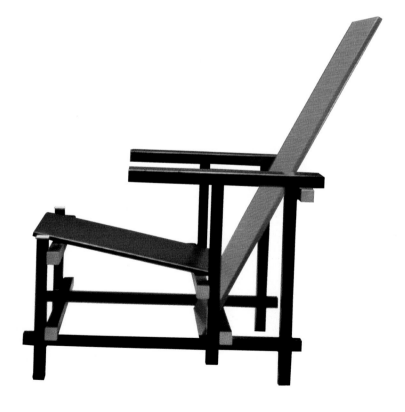

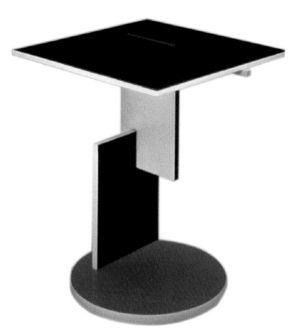

Color Plate 41 Schröeder table by Netherlands' architect Gerrit Rietveld, 1917.
Courtesy Cassina.

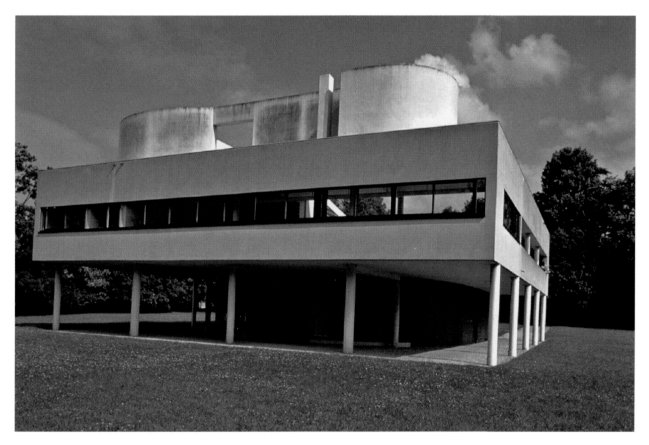

Color Plate 42 Villa Savoye, France. LeCorbusier, 1929.
Anthony Scibilia/Art Resource, NY.

Color Plate 43 *Mae West as a Surrealist Apartment*, by Spanish painter Salvador Dali, 1934–1935.

Gift of Mrs. Gilbert W. Chapman in memory of Charles B. Goodspeed, 1949.517. Photograph ©1997, The Art Institute of Chicago, All Rights Reserved. ©1998 Demart Pro Arte ®, Geneva/Artists Rights Society (ARS), New York.

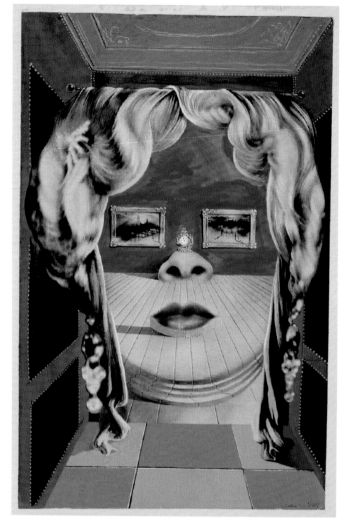

Color Plate 44 Reproduction of the Lip sofa by Green & Abbott, London, after 1936 original by Jean Michel Frank.

Royal Pavilion Libraries and Museums, Brighton.

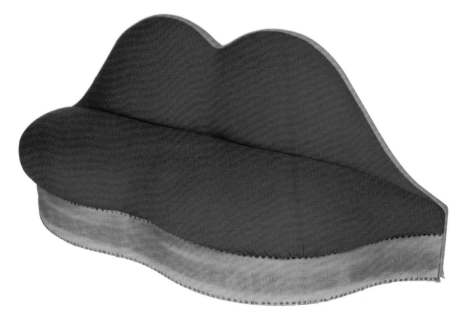

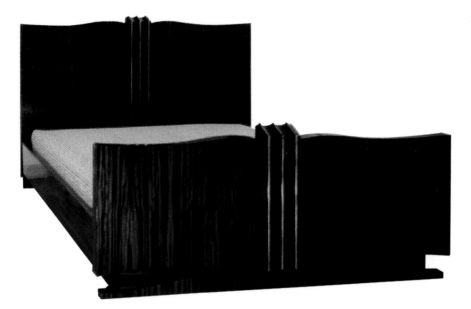

Color Plate 45 Art Deco-style bed made of macassar ebony, twentieth century.
Photos courtesy Shapes Collection, Los Angeles.

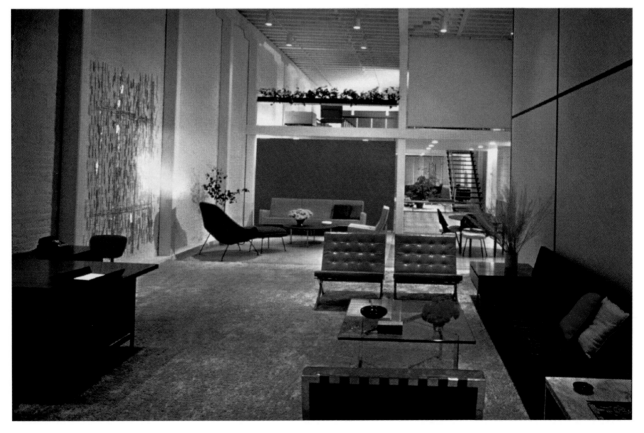

Color Plate 46 The San Francisco showroom for Knoll Associates, Inc., designed by Florence Knoll in 1956.
Courtesy Knoll.

Color Plate 47 Shell chair (RAR), by American designers Ray and Charles Eames, 1951.

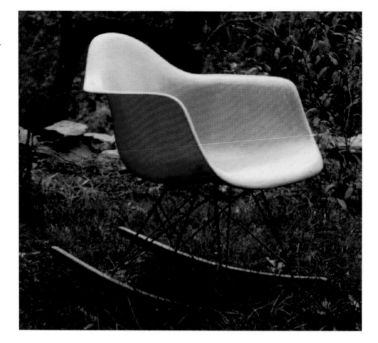

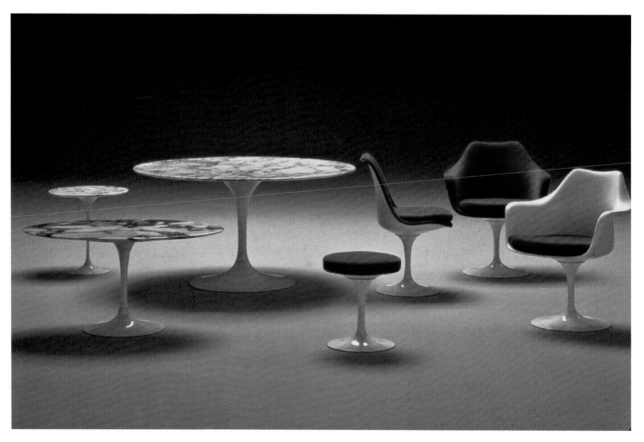

Color Plate 48 Tulip collection, designed by Eero Saarinen, 1957.
Courtesy Knoll.

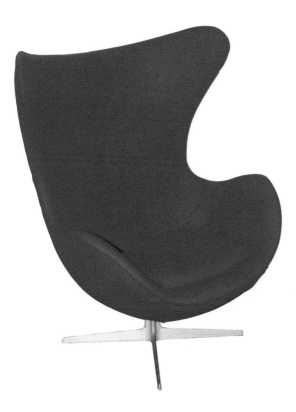

Color Plate 49 Egg chair by Scandinavian designer Arne Jacobsen, 1958.
Showroom Collection, Citi Modern, Dallas.

Color Plate 50 Mezzadro stool, by Italian designer Castiglioni, 1957.
Courtesy ICF.

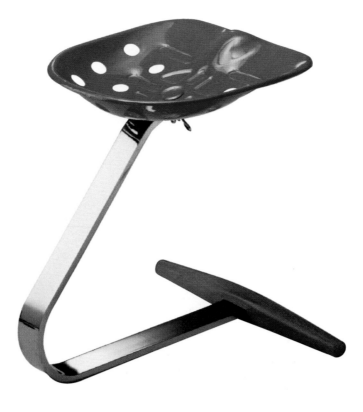

Color Plate 51 Carlton Room divider by Italian designer Ettore Sottsass, 1981. Restricted gift of the Antiquarian Society, 1984.1035. Photograph by Kathleen Culbert-Aguilar, Chicago. Photograph ©1997, The Art Institute of Chicago, All Rights Reserved.

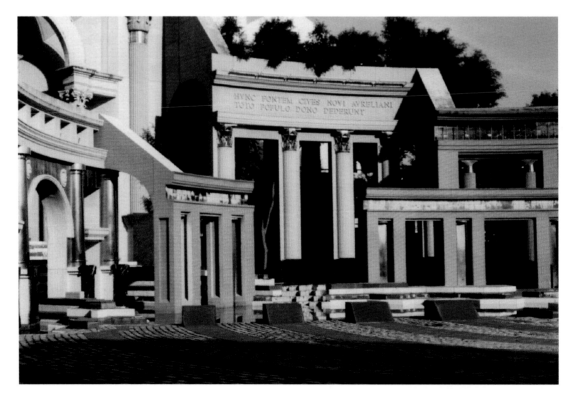

Color Plate 52 Plazza d'Italia by American architect Charles Moore. New Orleans, 1980.

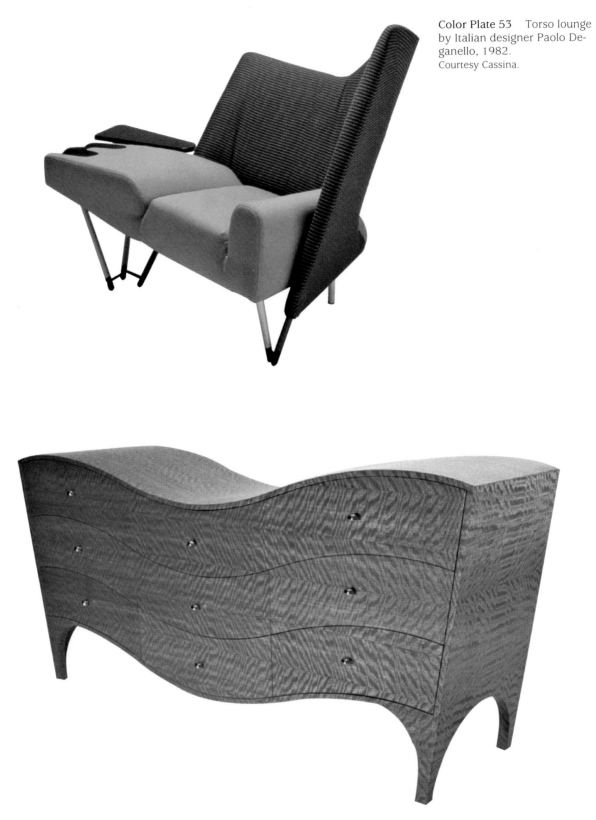

Color Plate 53 Torso lounge by Italian designer Paolo Deganello, 1982.
Courtesy Cassina.

Color Plate 54 Bedroom dresser. Designed by Robert Kornstein, 1997.
Photo courtesy Arkadia, Englewood, NJ 07631, 800.233.3281.

Color Plate 55 Lobby of the Paramount Hotel, New York City. Interior design by Philippe Starck, chaise lounge designed by Mark Newson, 1990.
Photo courtesy Starck. Reproduced by permission, Philippe Starck.

Color Plate 56 Room at the Paramount Hotel, New York City.
Courtesy Starck. Reproduced by permission, Philippe Starck.

Color Plate 57 Bodleian chair designed by American architect Robert A. M. Stern. Courtesy HBF.

Color Plate 58 Secretary by Vicente de Moltó, Geneva, Switzerland.

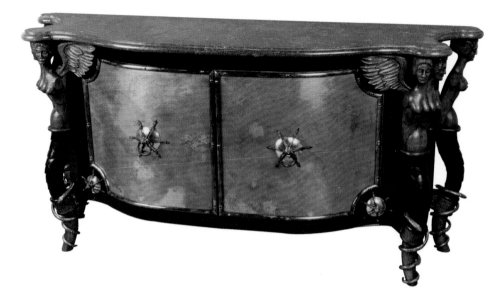

Color Plate 59 Elson Commode by designer Scott Cunningham, late twentieth century.
Photo courtesy of Scott Cunningham.

Color Plate 60 Top row:
Oak, walnut, mahogany,
bottom row: birdseye maple,
ebony, and ash veneers.

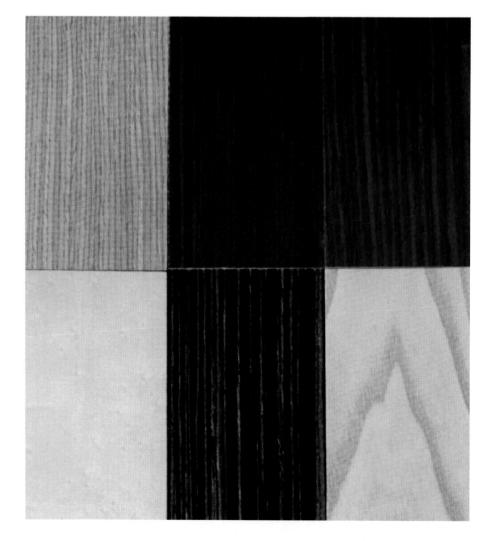

The sophisticated bombé swells of French commodes translated into exaggerated kettle shapes finished the sides of secretaries and tallboys but still maintained the essence of the Chippendale style.

Beds were of the four-poster type, often designed with an overhead canopy fitted with bed curtains. The mattress support was a network of ropes that required tightening from time to time to keep the bed from sagging.

NEOCLASSIC PERIOD

Architecture 1750–1800

A term first used in the 1880s, Neoclassicism refers to the cultural period developing during the second half of the eighteenth century and continuing through the early nineteenth century. Immediately after excavations began in 1750 at Herculaneum and Pompeii, Europeans flocked to southern Italy to witness and record the event. Significant stylistic changes ensued as numerous artifacts were removed and documented in widely published treatises on ancient Roman life.

Artists, architects, and scholars witnessed with great awe the removal of furnishings, household objects, and architectural elements that had been buried beneath tons of volcanic ash and debris for nearly 1,800 years. What seemed apparent in the discovery of these

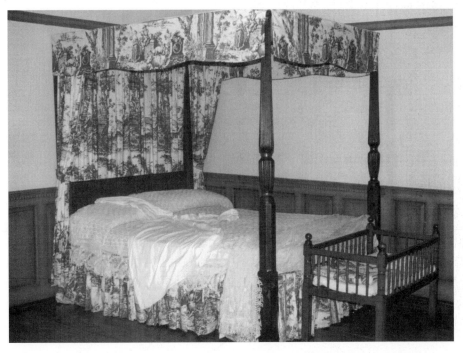

Figure 262 This four-poster rope bed with its toile de Jouy bed hangings reflects more refinement in furnishings for the eighteenth-century American home.

Figure 261 This combination desk and bookcase is attributed to cabinetmaker George Bright of Boston and dates from 1770–1775, the end of the American Late Colonial Period. Made from imported mahogany with pine structural parts, the piece reflects true Chippendale characteristics as found in the *Director*: scrolled pediment with pierced carving, dentil molding in the frieze area, mirrored doors flanked by Ionic pilasters, pierced escutcheons, bombé sides, and carved claw and ball feet. More significant American features include a brass finial in the shape of an eagle, characteristic Boston flame finials, and triple pine tree patterned drawer pulls. Height 99½″, Width 43″, Depth 24″.
Bequest of Miss Charlotte Hazen. Courtesy Museum of Fine Arts, Boston.

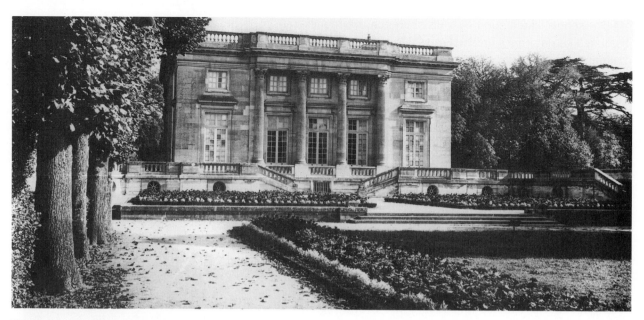

Figure 263 The Petit Trianon by architect Ange-Jacques Gabriel was built on the grounds of Versailles in France between 1762 and 1768. The design of the west façade is reminiscent of Italian Renaissance style in its strict symmetry, engaged Corinthian columns, and balustrade roof and indicative of the impending Neoclassical Period of the late eighteenth and early nineteenth centuries.
© ARCH.PHOT.PARIS, soit © CNMHS.

ancient Roman cities was that, previously, the European idea of classicism had been based on the still-standing structures of the Italian Renaissance and the writings of Palladio. Now, classicism in its purest form could be studied, modified, and incorporated into eighteenth-century living. Several books were published at this time and, with precise line drawings, documented the artifacts removed from the excavations.

Early manifestations of the Neoclassical movement were first seen in France as architects and designers had grown tired of the exaggerated intricacies of the Rococo style. In the beginning, Neoclassic elements were introduced in the design of interiors but quickly spread outward to all aspects of the structural space. A revival of the three orders of architecture—Doric, Ionic, and Corinthian—appeared in simplistic purity of use and form, singularly arranged across vast porticoes.

The Petit Trianon, built by Gabriel in 1762, exemplifies the synthesizing of Neoclassic elements on both interior and exterior. Constructed on the grounds of Versailles and built as a personal retreat for Madame de Pompadour, the basic symmetry of the Petit Trianon's façade is articulated by a central projection created by the arrangement of four engaged columns. Neoclassicism marked a return to rectilinear forms, defiantly rejecting the serpentine curves and undulations typical of the Rococo period that preceded it.

Interiors were designed using purely geometrical shapes; arcs, rectangles, and circles were incorporated into wall panels, mirror frames, and floor patterns in strict symmetrical arrangements. Ceilings, door frames, and mantlepiece moldings duplicated Roman prototypes taken from the excavations; gilted swags, urns, laurel wreaths, and egg and dart design motifs were superimposed over either white, gray, or softly tinted walls (see Color Plate 25).

Although several English architects and designers moved swiftly from Palladianism into the Neoclassic style, perhaps the most recognized was interior

designer Robert Adam (1728–1792). Adam spent time in Rome studying architectural ruins, visited Diocletian's palace in Split, and traveled to France. A few years after his return to London, in 1764, Adam published a portfolio of his engravings titled *Ruins of the Palace of the Emperor Diocletian*. This work established Adam as one of the leading "antiquarians" of the day and helped to set the standard for classic revival styles in England.

Along with his brother James and other family members, Robert Adam established a successful business as designer and architect for many wealthy Englishpeople eager to renovate their country estates. The Adam trademark consisted of ornately patterned floors balanced with walls decorated in plaster relief compressed by highly decorative ceilings. Adam's most commonly used motifs—the paterae, urns with swags, palmettes, and classical figures—dominated the overall interior scheme.

In 1761, Adam remodeled an Elizabethan country estate into a Neoclassic masterpiece. Osterly Park exemplified the nature of his talents; the grand room was laid out with a massive plasterwork ceiling, an elaborate niche fitted with classical sculptures, and large urns on pedestals. While defining the Neoclassic style, Adam captured the essence of the findings at Pompeii and Herculaneum. Adam's work became increasingly linear, and by 1770, his stylistic development advanced to a stringent adaptation of classic conventions.

In America, through the influence of Thomas Jefferson (1743–1826), Neoclassicism was adopted as the national architecture of the newly formed United States of America. Jefferson, a self-taught architect and statesman, had spent five years in Paris (1784–1789) as the United States' Minister to France. There he was surrounded by the Neoclassic movement prevalent in France at the time and was exposed to the ruins of the ancient Roman Empire.

Jefferson's own home in Charlottesville, Virginia, represented his exploration of classical elements. Monticello, begun in 1768 and remodeled in 1796, evoked a sense of Palladianism, as seen in Villa Rotonda and Chiswick House, foreshadowing Jefferson's architectural development (see Color Plate 26).

Figure 264 A drawing by English architect Robert Adam for the Great Eating Room at Shelburne House in Berkeley Square reveals the architect's penchant for Palladianism. Adam's Neoclassical designs, although interpretive, reflect the latest trend in classicism brought on by the excavations at Pompeii and Herculaneum: classical statues adorn wall-lined niches (some framed by Corinthian orders); decorative moldings accentuate the room's perimeter at the juncture of wall and ceiling; and molded door casings mimic the painted designs used by the artisans of ancient Rome. The Metropolitan Museum of Art.

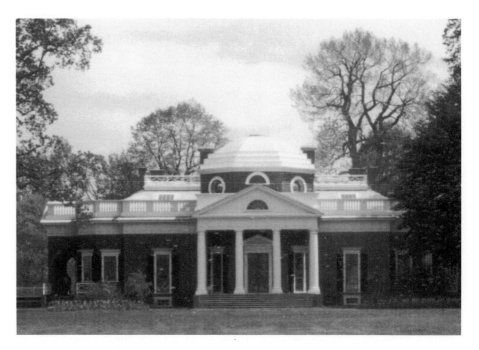

Figure 265 Monticello, Thomas Jefferson's home outside Charlottesville, Virginia, reflects his interest in the emerging Neoclassic style. With an emphasis on symmetry, the central dome and large portico anchor the projecting wings on either side.

Jefferson's mature style reflects a strict adherence to Roman and Greek classicism as seen in his designs for the State Capitol in Richmond in 1789 and the University of Virginia, which was completed in 1826. Jefferson's architectural achievements influenced the emerging American Federal style adopted by other notable American architects such as Charles Bullfinch (1763–1844) and Samuel McIntire (1757–1811).

As the century ended, architects and designers turned toward a more romanticized vision of the past. Classicism waned in popularity and was replaced by a synthesis of Gothic, Moorish, and Oriental influences. These revivalist styles represent the eclecticism of the English and American Victorian era that followed.

Neoclassic Furniture

Furniture designed in the Neoclassical style embraced the bold, straight lines of the movement as pure, geometric shape and form replaced the sinuous curves of the Rococo period. In both France and England, furniture designed during the second half of the eighteenth century reflected strong Greek and Roman influences. However, toward the turn of the nineteenth century, designs began to include Egyptian characteristics as well. The introduction of Egyptian influences resulted from Napoleonic campaigns into Egypt in 1798 and mark the division between the Early and Late Neoclassic periods.

As a whole, furniture designed in both Early and Late Neoclassic styles did not change in proportion or scale from that of the Rococo. As designs moved away from organically inspired curves toward rigid symmetry, purely geometrical shapes and idealized classical elements became the most decorative feature on chairs, tables, and case goods. Classicism based on historical fact was

Medallion block

Rosette block

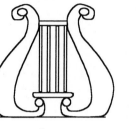

Lyre

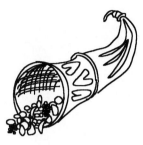

Cornucopia

Figure 266 French Early Neoclassic, Louis XVI-style design motifs.

Medallion back

Square back

Lyre back

Round tapered legs

Quadrangular leg with thimble foot

Figure 267 French Early Neoclassic, Louis XVI-style furniture forms.

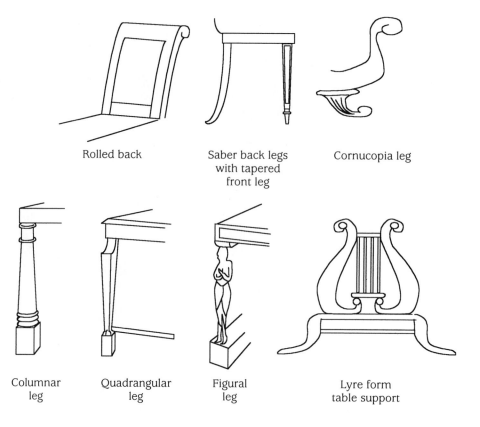

Rolled back

Saber back legs
with tapered
front leg

Cornucopia leg

Columnar
leg

Quadrangular
leg

Figural
leg

Lyre form
table support

made possible because numerous pattern books published at this time illustrated with exactness the ornamentation used by the ancient Romans. While detailed carving was still applied to most furniture items, vitruvian scrolls, guilloche patterns, urns, festoons, garlands, and diaper patterns were incorporated into marquetry work and ormolu mounts. New emphasis was placed on medallions, lyre forms, rosettes, and the cornucopia.

In adherence to Neoclassical straight lines, legs were either fashioned into fluted or reeded columns; quadrangular and tapered; or round and tapered, imitating a quiver of arrows. By 1780, most armposts were either incurvate, straight, or fashioned into slender urns. Chair backs were oval, circular, square, or rectangular while seats kept a slight curvature to the front rail. Deviances from 90-degree angles were treated with an arc or canted corners.

Early Neoclassic French Furniture 1760–1792

The interior decoration of Gabriel's Petit Trianon revealed the dissipation of the Rococo style. Interior spaces reflected his adherence to straight lines and symmetry; rooms were rectangular, and applied moldings harmonized with the angularity of the room as surface ornaments divided walls into rectangular sections. Furniture designed for the Petit Trianon was considered transitional since it intermingled the straight lines of the Neoclassic with Rococo curvilinearity.

A pure form of the Early Neoclassical style of furniture known as the Louis XVI style, or Style Louis Seize, was already being produced in the workshops

of French cabinetmakers by the time Louis XVI ascended the throne in 1774. Two celebrated cabinetmakers of the period, Jean-François Oeben (1720–1763) and Jean-Henri Riesener (1734–1806), produced some of the finest examples of French Early Neoclassic furniture in existence.

Appointed ébéniste du roi to Louis XV in 1754, Oeben joined the workshops of the Gobelins. His mastery as a cabinetmaker was revealed through skillful marquetry work depicting spectacular floral displays combined with pictorial trompe l'oeil. While in the service of the king, Oeben completed many pieces for Madame de Pompadour. Her impeccable taste and refinement along with her preference for simplistic purity accelerated the development of what would become known as the Louis XVI style.

In 1760, Oeben was commissioned to make a desk for Louis XV. Posthumously, the bureau du roi became Oeben's greatest achievement. His pupil, Riesener, not only completed the desk in 1769, but married Oeben's widow and carried on the business. In 1774, upon the coronation of King Louis XVI, Riesener became ébéniste du roi. Riesener had a prolific career, completing several works for Marie Antoinette. He survived the Revolution by producing rifle butts and, although the monarchy ended with the execution of the royal family, in 1794 the Directoire employed Riesener to remove all royal emblems from furniture of the period.

Most chairs and settees in the Louis XVI style were constructed from beech wood and painted or *parcel gilt*. Those that were left in a natural finish were made out of walnut. Soft pastel-colored upholstery fabrics consisting of brocades, damasks, silks, and taffetas covered chairs and settees, although cane and leather continued to be used as well.

Tables, commodes, consoles, and case goods were crafted using decorative veneers made from tulipwood, satinwood, ebony, and fruitwoods. Mar-

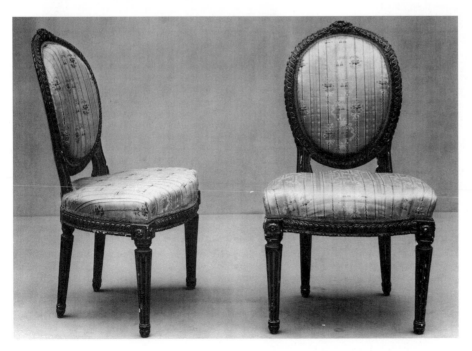

Figure 269 A pair of medallion-back French Louis XVI-style chaises, circa 1775–1802, made by Jean-Baptiste Lelarge III (1743–1802) from carved and gilt beechwood. Both chairs have round tapered and fluted legs with thimble feet and rosette blocks at the four corners of the guilloche carved seat rail. Height 35³⁄₄″, Width 20¹⁄₂″, Depth 17¹⁄₂″. The Metropolitan Museum of Art, Rogers Fund, 1923.

Figure 270 A pair of French Louis XVI-style lyre-back chaises painted gray and upholstered in red velvet.

The Metropolitan Museum of Art, Gift of J. Pierpont Morgan, 1906.

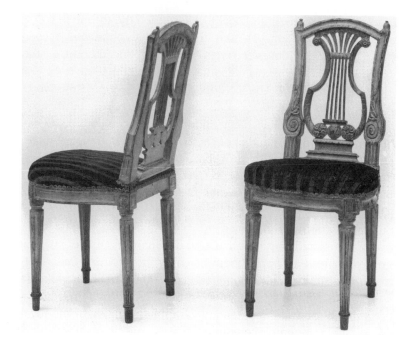

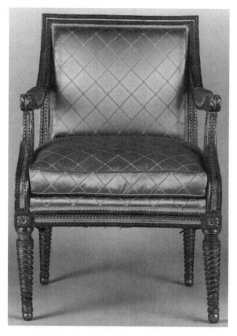

Figure 271 This French Louis XVI-style fauteuil was made from carved and gilt beechwood, circa 1775–1780, by Supice Brizard (1735–1798). Features include round tapered legs with spiral grooves, a square back, and diamond-patterned upholstery. Height 35″, Width 24″, Depth 23⅞″.

The Metropolitan Museum of Art, Gift of Mrs. Ralph K. Robertson, 1969.

Figure 272 This bergere in the French Louis XVI style was made by J. B. Claude Sene (1769–1803) and dates from between 1780 and 1790. Part of a set made for the Cabinet de Toilette of Marie Antoinette at the Chateau of St. Cloud, the chair is carved walnut with a painted and gilt finish. Height 39″, Width 27½″, Depth 25¼″.

The Metropolitan Museum of Art, Gift of Ann Payne Blumenthal, 1941.

Figure 273 An example of a French Louis XVI-style desk chair, or chaise á bureau, is upholstered in green morocco. The Metropolitan Museum of Art, Gift of J. Pierpont Morgan, 1906.

quetry work was often employed and highly decorative effects were achieved by burning the edges of the wood in hot sand or subjecting inlay to lime water acids, spirits of nitrate, or oil of sulfur for coloring. Commodes were severely rectangular in form, clearly abandoning the Rococo bombé swell. Drawers, doors, and front pieces were delineated with rectangular bands that emphasized the geometry of each piece.

The bureau took on a more rectangular appearance as well. Writing desks retained typical quadrangular or columnar legs, while ormolu patterns incorporated classical motifs. A pierced metal gallery of chased bronze was intro-

Figure 274 From the atelier of Georges Jacob, this Louis XVI-style settee has gilt wood and tapestry upholstery. Carved motifs include classically based designs such as the laurel wreath and bow and quiver details on the crest rail, acanthus leaf scrolls at the base of the armposts, and rosette blocks carved into the seat rail just above each round tapered leg.
Reproduced by the trustees of The Wallace Collection, London.

Figure 275 A French Louis XVI-style commode attributed to Jean-Henri Riesener (1734–1806) dates from around 1785–1790. The commode is decorated with ebony, chinoiserie lacquer work, and ormolu in classically inspired festoons, acanthus leaves, rosettes, and laurel wreaths. The cipher of Madame Marie Antoinette appears on the frieze. Height 39³/₄″, Width 56¹/₂″, Depth 13¹/₂″.

The Metropolitan Museum of Art, Bequest of William K. Vanderbilt, 1920.

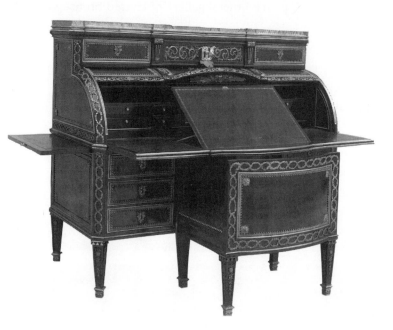

Figure 276 This eighteenth-century French Louis XVI-style mahogany and ebony bureau á cylindre has a pierced gallery top, ormolu details, and pull-out compartments.

The Metropolitan Museum of Art, Gift of Jacques Seligmann, 1919.

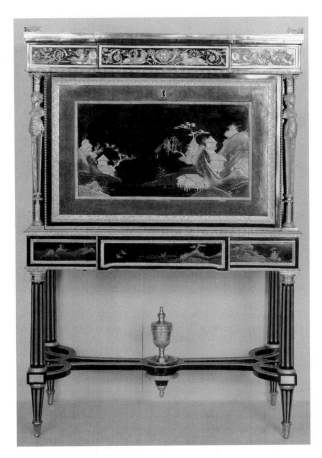

Figure 277 A secrétaire á abbatant in the French Louis XVI style, circa 1785, made by Adam Weisweiler (ca. 1778–1809) in oak veneered with black and gold Japanese lacquer combines chinoisserie panels with classical motifs. Notice the legs fashioned into columnar supports, caryatid term figures, the urn finial on the stretcher, and classical figures in the top frieze. Height 52³⁄₈″, Width 33⁷⁄₈″, Depth 16¹⁄₂″.

The Metropolitan Museum of Art, Gift of Mrs. Charles Wrightsman, 1977.

duced on Louis XVI-style furniture and is characteristically found on certain case goods and tables.

Console tables were designed to stand alone; however, several semicircular examples exist with the flat side intended to be placed against a wall. The use of a saltier stretcher is haphazard among console tables and side tables in the Louis XVI style, although most incorporate a small pierced gallery that follows the perimeter surface. Small ladies' work tables, writing tables, and toiletry tables were designed using a variety of ornamentation ranging from elaborate marquetry and parquetry patterns to chinoiseries and Sèvres plaques.

Beds were smaller in size and had headboards and footboards with canopies suspended overhead rather than hung on posts. As designers attempted to recreate the interiors of Roman villas, beds were placed lengthwise against the wall rather than perpendicular to the wall. Beds were also tucked away in alcoves, creating a sense of expansion in small rooms (see Color Plate 27).

Figure 278 An eighteenth-century French Louis XVI-style candle stand and workbox attributed to Martin Carlin has chased and gilt bronze mounts over inlaid tulip wood, boxwood, ebony, holly, and sycamore with Sèvres porcelain plaques. Notice the inlaid bell flower motif along the pedestal and tripod support. Height 31¹⁄₈″, Diameter 14⁵⁄₈″.

The Metropolitan Museum of Art, Gift of Mr. and Mrs. Charles Wrightsman, 1976.

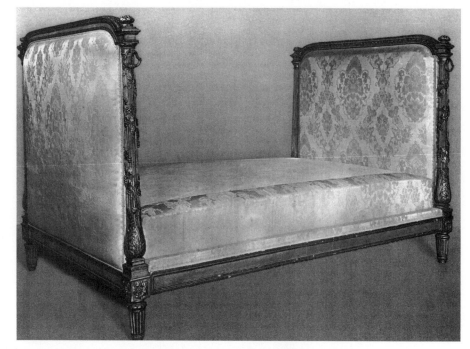

Figure 279 This French Louis XVI-style daybed from the eighteenth century is made from oak with ormolu mounts and is close in size to our modern 60-inch wide, 80-inch long queen-size bed. Height 55³⁄₄″, Width 59¹⁄₄″, Length 88″.
The Metropolitan Museum of Art, Gift of the Mary Ann Payne Foundation, Inc., 1964.

Late Neoclassic French Furniture 1793–1814

French furniture designed during the Late Neoclassical period follows two distinctive styles: the Directoire and the Empire. The Directoire represents a transitional period between the established Louis XVI style and the emerging French Empire style. Overall, Directoire-style furniture reflects a direct association with items excavated from Pompeii, although there is also a strong emphasis on Greek influences. Distinctive qualities of the Greek klismos and the Roman thronos are incorporated into the design of chairs as more attention is given to authenticity rather than interpretation. Rolled crest rails, sphinx-shaped armposts, and paw feet evoke the mood of the ancient past (see Figure 154).

The French Empire style evolved under the influential leadership of Napoleon. As the new aristocracy of a prosperous France was eager to put the trepidation of the Revolution behind it, Napoleon set the direction for a return to luxurious living with the redecoration of the Château de Malmaison. The château, owned by Napoleon's wife Josephine, was transformed by the architects

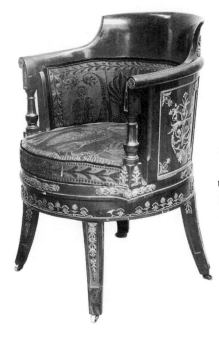

Figure 280 The French Empire style developed during the rule of Napoleon Bonaparte in the early nineteenth century. The style closely followed prototypes from the period of the Roman Empire, accelerated by the ongoing excavations at Pompeii and Herculaneum. This mahogany bergere en gondole with classically detailed ormolu mounts has a concave back reminiscent of the Roman tub chair.
The Metropolitan Museum of Art, Gift of J. Pierpont Morgan, 1907.

Charles Percier (1764–1838) and Pierre François Léonard Fontaine (1762–1853). Napoleon's campaigns into Egypt in 1798 created a new interest in Egyptian ornament and design. Percier and Fontaine combined these influences and decoration reflective of the Roman Empire with as much historical accuracy as convenient to create dramatic interior spaces (see Color Plate 28).

Interior walls were either painted with Pompeiian details, adorned with scenic papers, or draped with fabric. Pilasters and engaged columns enclosed fireplace mantels, while cornices encapsulated doors and windows. The pastel colors of the first half of the eighteenth century were replaced with rich golds,

Figure 282 A French Empire-style mahogany méridienne with cornucopia legs has a continuous back with one arm higher than the other. Notice the rolled arms, modified from the fulcrum form on a Roman lectus. Height 92 cm, Width 70 cm, Length 135 cm.

Figure 283 This portrait of Madame Récamier by Jacques Louis David painted in 1800 captures the public interest in design and culture of the Roman Empirical period. Not only is Madame Récamier dressed like a Roman aristocrat, but the stage props, an Etruscan-style torchere and a lectus-and-fulcrum-style daybed with footstool, reflect Roman inspiration as well. David has positioned Madame Récamier in repose on the daybed with her left arm supported by cylindrical pillows.

Louvre ©Photo RMN.

Figure 284 This French Empire-style toilet box, circa 1804–1814, has scenic marquetry panels on the front and sides surrounded by decorative ormolu banding. The raised lid reveals a mirror and recessed compartments fitted with an assortment of jars and other grooming implements. Notice the paw feet. Height 9³⁄₄″, Width 11¹⁄₄″, Length 16¹⁄₄″.

The Metropolitan Museum of Art, Gift of Howard H. Brown, 1930.

vibrant crimsons, deep blues, and dark greens. Fabrics emphasized motifs more characteristic of the Roman Empire: laurel wreaths, palmettes, rosettes, and medallions.

Georges Jacob (1739–1814), cabinetmaker to the royal family under King Louis XVI, survived the Revolution and went on to design furniture in both the Directoire and Empire styles. His son, François Honoré Jacob (1770–c.1841) took over the family business along with a brother and became Napoleon's most celebrated cabinetmaker. François adopted the name Jacob-Desmalter, and his workshop worked closely with Percier and Fontaine, fabricating furniture pieces for several of Napoleon's residences.

Empire-style furniture incorporated straight lines and subtle curves giving the pieces a strict formality. Carving was minimized, and less attention was given to painted or gilt surfaces as mahogany and rosewood became more prevalent. Caryatids and term figures with paw feet were reintroduced and appear on the front legs of chairs while sweeping saber legs support the back.

The méridienne, a new piece of furniture introduced in the Empire style, was a type of day bed used for lounging. With one arm raised higher than the other, the scrolled arms evoke the feeling of fulcrum supports found on the ancient Roman lectus. Similar to a méridienne, the récamier (named after the famous painting by Jacques Louis David of

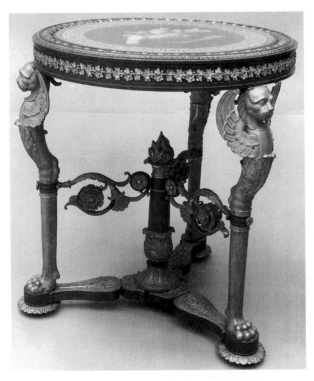

Figure 285 This tripod table dates from around 1815–1825 and represents a fine example of the French Empire style, still popular during the reign of King Louis Phillipe and the period of the Restoration. A tripod base, fashioned into paw-footed griffins, connects via stretchers to a central flame pillar. The top is made from Italian stone mosaic covered with glass.

The Metropolitan Museum of Art, Bequest of Horatio C. Kretschmar, 1912.

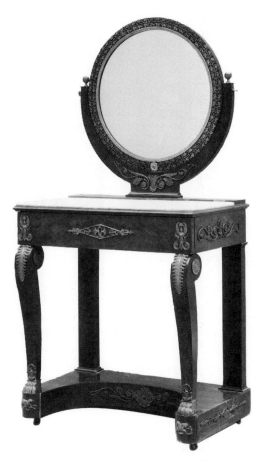

Figure 286 A mahogany dressing table, circa 1815–1830, with classically designed ormolu mounts.

The Metropolitan Museum of Art, Gift of Mrs. Frederick S. Lee, 1922.

Madame Récamier in repose) was used for reclining, although the back did not run the entire length of the seat.

Case furniture lacked the detailed carving seen in the Louis XVI style, as ormolu became the primary source of decoration on French Empire furnishings. Bronze mounts applied to mahogany veneered surfaces were fashioned into classical goddesses, laurel wreaths, olive branches, and six-point star patterns. Term figures with either caryatids, sphinxes, or pharaohs delineated the sides of secretaires, commodes, and cabinets.

Small tables had pietra dura tops with chased bronze rims and took the form of the Roman tripod with term figures or sphinxes used as the base. Larger tables were mostly round or oval and rested on columnar or other decorative supports. A variety of other tables already in use during the eighteenth century took on characteristics of the Empire style.

Empire-style beds increasingly took on the characteristics of the Roman lectus. Raised on a plinth, the bed was positioned lengthwise in the room and most were recessed into an alcove built into the wall. Those of the freestanding type often had an elaborate canopy suspended overhead (see Color Plate 29).

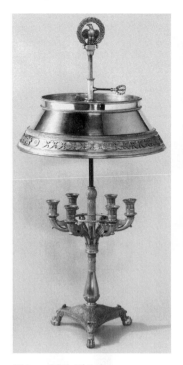

Figure 287 This bronze candelabrum, said to have been used by Napoleon Bonaparte at the château of Saint-Cloud, dates from the early nineteenth century. The shade adjusts to cover the flame as the candles melt. Notice the paw-footed tripod base and eagle insignia. Height 35½″, Shade Diameter 17⅜″.
The Metropolitan Museum of Art, Gift of J. Pierpont Morgan, 1906.

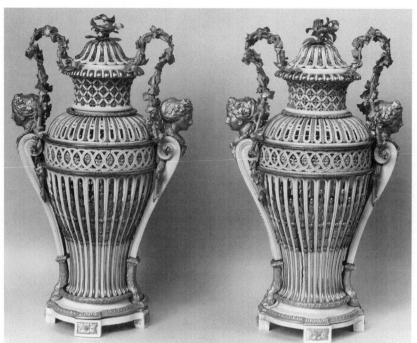

Figure 288 French vases, circa 1780–1790, possibly made by Pierre Gouthière in openwork ivory and gilt bronze. Height 14½″ with cover.
The Metropolitan Museum of Art, Bequest of George Blumenthal, 1941.

Typically Greek, Roman, or Egyptian themes were incorporated into carpets and other textiles, while lamps and vases were designed to imitate the urns, busts, and pottery pieces removed from Pompeii. These coordinated accessories harmonized with the interior furnishings and completed the interior decoration of the room.

Early Neoclassic English Furniture 1760–1805

English furniture designed during the reign of George III (r. 1760–1820) is indicative of the Neoclassic period and consists of three stylistic developments: Adam, Hepplewhite, and Sheraton. Named after the designers associated with each style, furnishings incorporated similar characteristics found in French furniture of the same period, thus unifying the designs as Neoclassical in theme.

Furniture designed and produced by Adam's workshop was specifically for the interiors he remodeled for his clients. As a style of furniture, many characteristics followed closely with the Louis XVI style already established in France, although Adam incorporated paterae, urns with swags, palmettes, and classical figures to coordinate with his most commonly used architectural motifs (see Color Plate 30).

The popularity of trade publications specifically documenting current trends in furniture design and construction increased substantially after the printing of Thomas Chippendale's *The Gentleman and Cabinet-Maker's Director* in 1754. Just as designs illustrated in the *Director* are referred to as "Chippendale" style, those that appear in *Cabinet Maker and Upholsterer's Guide* by

Wheat

Bellflower

Foliate

Paterae

Figure 289 English Early Neoclassic design motifs.

George Hepplewhite (unknown–1786) and *The Cabinet Maker and Upholsterer's Drawing Book* by Thomas Sheraton (1751–1806) are known as Hepplewhite style and Sheraton style, respectively. These two works included drawings representative of furniture in vogue for the period and perpetuated the popularity of Neoclassicism.

Information on the life of George Hepplewhite is limited. The *Cabinet Maker and Upholsterer's Guide* was actually published by Hepplewhite's widow,

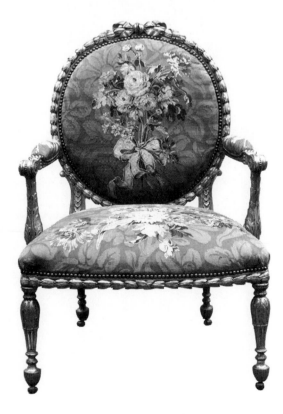

Figure 290 This eighteenth-century English Neoclassical medallion-back armchair was made by John Mayhew and William Ince from gilt fruitwood. The chair's carved designs and needlepoint upholstery harmonize with Robert Adam's Neoclassical interiors. Height 41 1/2″, Width 28 1/2″.

The Metropolitan Museum of Art, Gift of Samuel H. Kress Foundation, 1958.

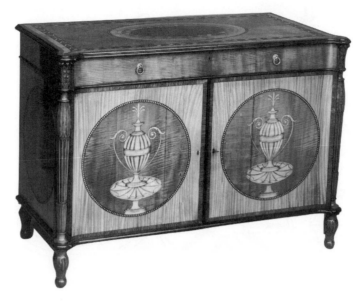

Figure 291 This English Neo-classic Adam-style commode, circa 1770–1780, is made with east Indian satinwood, harewood, pheasant wood, boxwood, sycamore, mahogany, holly, and thuya wood inlay.
The Metropolitan Museum of Art, Fletcher Fund, 1929.

Alice, in 1788. The publication included only a few original designs by Hepplewhite; the majority of the designs were based on styles made popular by the Adam brothers and other contemporary furniture designers. The furniture illustrated in the *Guide* possessed classical qualities; however, the elements were synthesized in a more simplified manner. Almost exclusively made of ma-

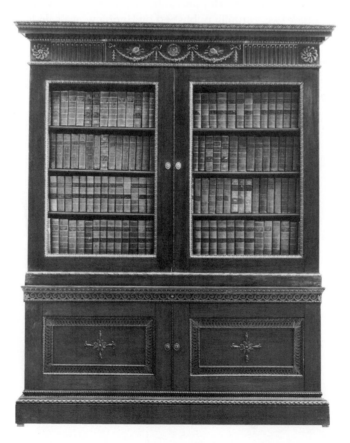

Figure 292 This English Neo-classic bookcase was designed by Robert Adam, circa 1767, and is made from pine stained to imitate mahogany. The carved and gilt decorations include thin swags, rosettes, Vitruvian scrolls, and paterae-designed door knobs. Height 95$\frac{1}{2}$″, Width 74$\frac{1}{2}$″, Depth 17$\frac{5}{8}$″.
The Metropolitan Museum of Art, Cadwalader Fund, 1917.

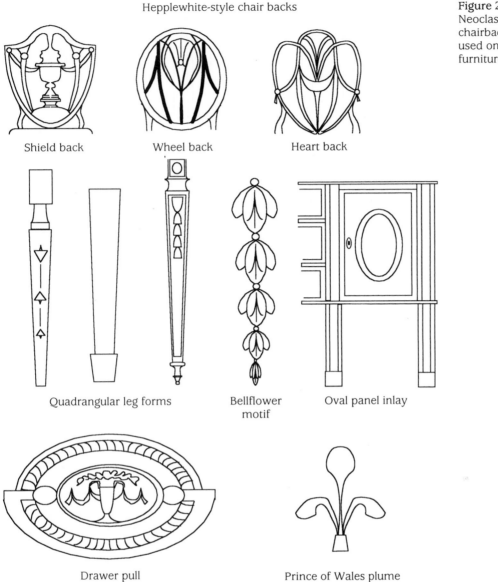

Hepplewhite-style chair backs

Shield back Wheel back Heart back

Quadrangular leg forms Bellflower motif Oval panel inlay

Drawer pull Prince of Wales plume

Figure 293 English Early Neoclassic design motifs, chairbacks, and leg forms used on Hepplewhite-style furniture.

hogany or satinwood, furniture items balanced straight lines with gentle curves and relied mostly on inlay rather than carving for ornamentation.

Identifying elements of the Hepplewhite style can be seen in the numerous chairs appearing in the *Guide*. Designed to be used either in the dining room or bedroom, chairs were all wood with either upholstered or cane seats. Backs were left open and formed distinctive shield, heart, or wheel shapes. Splats took on a variety of carved designs including wheat patterns, arcaded tracery, urns with ribbons, and the Prince of Wales plume. Stretchers, if used, were simple H-form or box-form and connected to quadrangular or round tapered front legs and saber-back legs.

Case pieces such as buffets, breakfronts, and commodes completed the suite of furniture. These pieces had little or no carving with crossbanded, oval

Figure 294 English Early Neoclassic chair backs and leg forms used on Sheraton-style furniture.

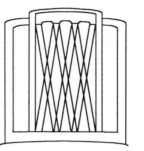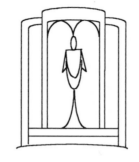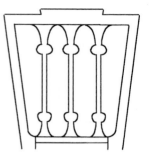

Sheraton-style chair backs

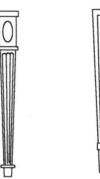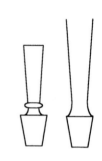

Sheraton-style quadrangular and round tapered leg forms

Spade foot forms

Figure 295 English Neoclassic shield-back chairs appeared in Hepplewhite's *Guide* published in the late eighteenth century. Made from beechwood, the painted black ground is decorated with polychrome swags, urns, ribbons, and bellflower motifs. Spade-footed quadrangular front legs, saber-back legs, and incurvate armposts are characteristic of the style. The Metropolitan Museum of Art, Rogers Fund, 1931.

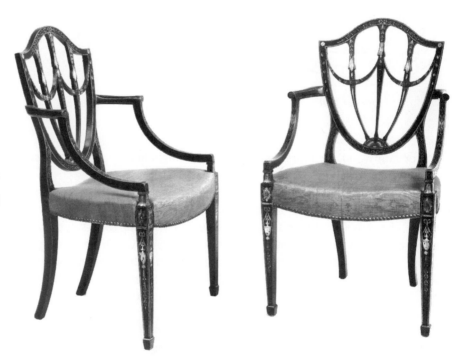

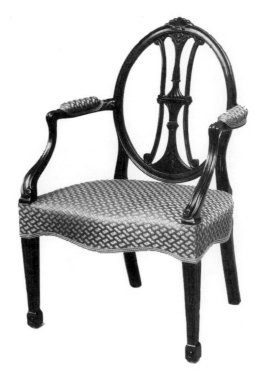

Figure 296 This circa 1780 English Neoclassic mahogany armchair in the Hepplewhite style has a medallion back, pierced splat with urn motif, incurvate armposts, and fluted quadrangular front legs. Notice the serpentine-shaped seat rail.
The Metropolitan Museum of Art, Fletcher Fund, 1929.

panels more characteristic of the Hepplewhite style. More elaborate pieces displayed detailed swags, urns, and classical figured marquetry patterns. Legs were quadrangular or round tapered and lacked stretchers.

Thomas Sheraton was a designer of furniture, although no records can prove that he actually was a cabinetmaker. *The Cabinet Maker and Upholsterer's*

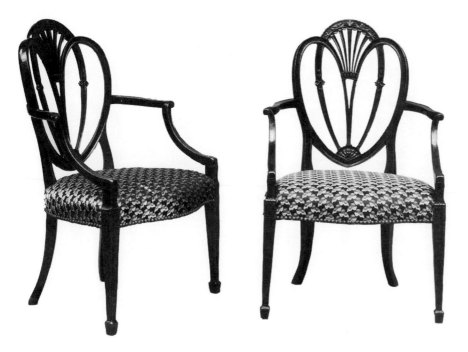

Figure 297 A pair of English Neoclassic, Hepplewhite-style mahogany armchairs with heart-shaped backs, circa 1780–1785.
The Metropolitan Museum of Art, Fletcher Fund, 1929.

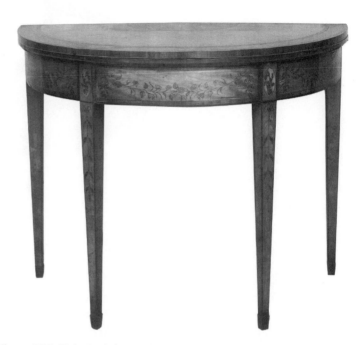

Figure 298 An English Neoclassic, Hepplewhite-style secretaire bookcase, circa 1788. Brighton Pavilion, East Sussex, UK/Bridgeman Art Library, London/New York.

Figure 299 This English Neoclassic, Hepplewhite-style card table from the late eighteenth century is made from satinwood with tulip wood and holly inlay. Note the bow front, quadrangular legs, and spade feet. The Metropolitan Museum of Art, Rogers Fund, 1912.

Figure 300 These English Neoclassic, Sheraton-style armchairs, circa 1795, differ from the majority of illustrations seen in Hepplewhite's *Guide* with their squared-off backs, baluster uprights, and round tapered front legs with thimble feet. Made from West Indian satinwood, beech, and birch, painted decorations include floral designs and paterae patterns above the front legs. Height 34½″, Width 19½″, Depth 17½″. The Metropolitan Museum of Art, Fletcher Fund, 1929.

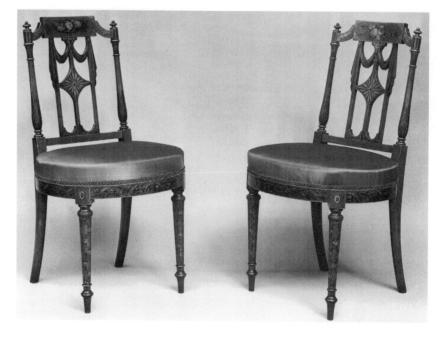

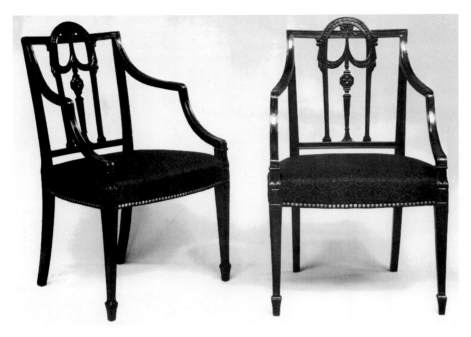

Figure 301 This pair of English Neoclassical, Sheraton-style mahogany armchairs, circa 1790–1795, have open backs with bellflower carvings on the crest rails, draped splats, and reeded designs on the armposts.
The Metropolitan Museum of Art, Fletcher Fund, 1929.

Drawing Book was published in 1791 and was widely accepted and used by cabinetmakers throughout England. Stylistically, Sheraton furniture is similar to Hepplewhite but is more angular in appearance. Straight lines and definitive arcs replace the heart-shaped and shield-shaped backs found in Hepplewhite's *Guide*. Sheraton's square-back chairs with carved trellis work, balusters, or urn-shaped splats were made mostly from mahogany or satinwood, although painted and gilded beechwood chairs were also prevalent. Incurvate arms with reeded or fluted armposts, legs, and uprights, inlaid or painted honeysuckle, pateraes, and classical swags unified pieces within Neoclassic interiors.

Included in Sheraton's *Drawing Book* were a variety of secretaries, bookcases, dressing tables, and tables. Sheraton, a noted mathematician, designed furniture employing the latest mechanical devices. Tables unfolded into library stairs, while others concealed hidden compartments activated by spring locks or cranks. A Pembroke was a small rectangular-shaped, drop-leaf table fitted with a small drawer in the frieze area. Winged sides were opened to support the leaves.

The *Drawing Book* also set the trend of incorporating porcelain plaques into English

Figure 302 An English Neoclassic, Sheraton-style mahogany dressing table, circa 1780, with boxwood inlay. Shown opened, a raised top reveals interior fitted compartments, a mirror, and reversed-hinged drawers that open out to the sides.
The Metropolitan Museum of Art, Gift of John L. Cadwalader, 1911.

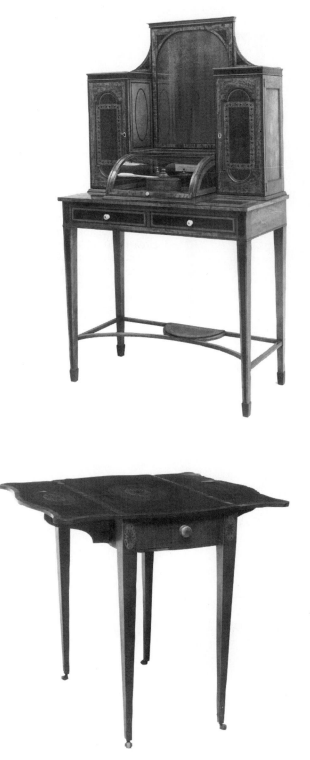

Figure 303 This English Neoclassic, Sheraton-style mahogany dressing table has a top unit with mirror, side cabinets, and a glass-enclosed sliding compartment. Its tablelike base is fitted with drawers and has quadrangular legs with spade feet. Notice the decoration is created through the use of contrasting woods rather than carvings. Height 58″, Width 32¾″.
The Metropolitan Museum of Art, Rogers Fund, 1919.

Figure 305 A dumb waiter was used in the dining room for the host to serve from while seated at the head of the table. This two-tiered, Sheraton-style mahogany dumb waiter has a pierced gallery running the edge of the top tier and fitted compartments to hold a variety of food items for serving. Notice the reeded pedestal support, tripod base, and casters.
Mallet & Son Antiques Ltd., London, UK/Bridgeman Art Library, London/New York.

Figure 304 A small, drop-leaf table used for light meals was called a Pembroke table. This example in the English Neoclassic Sheraton style dates from around 1775–1800 and is made from sycamore and mahogany. Notice the casters.
The Metropolitan Museum of Art, Gift of Mrs. Russell Sage, 1909.

furniture designs. This fashion had been popular in France since the early Rococo period, but was not adopted by the English until the success of Josiah Wedgwood (1730–1795). Wedgwood's factory produced *jasperware*, a type of pottery recognized today as pale blue with white relief classical figures. Although the pale blue is the most popular, Wedgwood also produced these cameo effects in other colors including black, green, and lavender.

Late Neoclassic English Furniture 1810–1830

The Regency style in England of the early nineteenth century parallels the Empire style introduced in France by Percier and Fontaine. This second phase of Neoclassicism identified more closely with the classical past and incorporated many of the same characteristics found on furniture items excavated from Pompeii: saber legs, concave crest rails, volute arms, and paw feet. Unlike the French Empire style, the treatment of line and proportion on English Regency-style furnishings is more austere, often appearing too heavy and cumbersome.

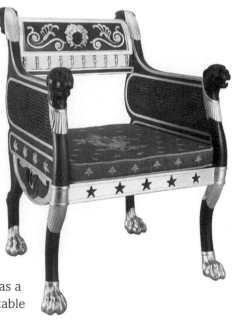

The sofa table or library table, a new piece of furniture introduced in the Regency style, was a large, rectangular table with drop leaves positioned at each of the short ends. Usually supported with trestle legs, this table was designed to be placed behind the sofa or to be used as a reading table. Another type of new table

Figure 307 The Regency style of the English Late Neoclassic Period followed closely with the current trend for combining Greek-, Roman-, and Egyptian-influenced designs. This armchair is made from ebony, has carved details, and gilding. Notice the large paw feet, panther armposts, and Roman mask detail on the backrest.

Courtesy of the Board of Trustees of the V&A.

Figure 308 An English, Late Neoclassic Regency-style mahogany library table, circa 1810, shown here with extended leaves has lyre-form supports, an inlaid top, classical figures on the drawer fronts, and allover gilt designs. Height 71.9 cm, Length 150.1 cm, Depth 58.4 cm with leaves extended.

was a large mahogany pedestal type with a tripod base, with either a circular or rectangular top. This acted as a center table or console table and was often plain and undecorated, giving more attention to the accessories placed on top. Accessories included large floral arrangements in vases, candelabrums, and porcelains.

Continuing in the nineteenth century, English interior design shifted toward a more eclectic synthesis of historicism. While Neoclassicism was one of the more popular movements of the period, other designers began introducing Gothic, Turkish, and Oriental influences into their work. Thomas Hope (1770–1831) was instrumental in presenting a collection of designs based on the assimilation of divergent cultures in his 1807 publication, *Household Furniture and Interior Decoration*. His travels and studies in Egypt, Greece, and Italy are reflected in drawings of furniture, accessories, and architectural details that

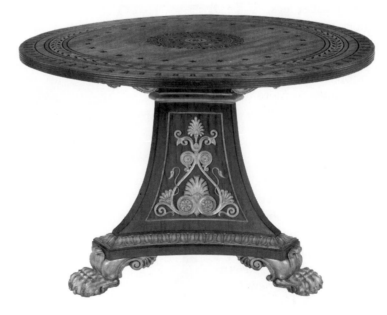

Figure 309 A pedestal table, circa 1810, by English architect and designer Thomas Hope (1769–1831). Designed in the Regency style, the table is made from mahogany with ebony and metal inlays, giltbronze mounts, surface gilding, and large paw feet. Height 72.4 cm, Diameter 106.7 cm × 105.4 cm.

imitate the qualities and characteristics of each culture. As a practicing designer, Hope's completed works covered Egyptian, Hindu, Roman, Greek, Chinese, and Turkish themes. As the century progressed, more attention was given to the creative reinterpretation the past rather than its duplication. This led to the numerous revivalist styles popular throughout most of the Victorian era.

Furniture of the American Federal, 1785–1820, and American Empire, 1810–1830, Periods

The preeminence of the Neoclassic period reached the colonies soon after the end of the American Revolution. As an independent nation under the newly established United States of America, Americans were eager to return to the more prosperous days before the war. Although there was a short period of economic depression, the young country quickly recovered, resuming its shipping industries along the eastern seaboard. With an increase in commerce, more people came to the United States in search of their own fortunes. With money to spend, homes of the Federal period were more palatial than ever. Because more money was spent on furnishing the "public" rooms of the house—the entry, sitting room, and dining room—the owners' sense of refinement and good taste was reflected to their guests.

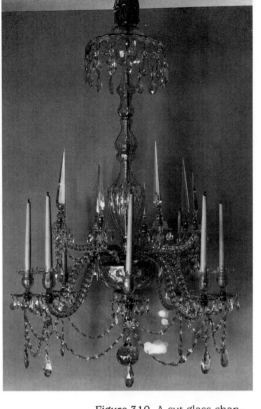

Figure 310 A cut glass chandelier, circa 1775–1780, from England captures and reflects light with its multitude of prisms and beaded swags. Height 46″.
The Metropolitan Museum of Art, Rogers Fund, 1924.

Furniture of the American Federal period closely followed the Hepplewhite and Sheraton styles popular in England, although importing furniture items made by English cabinetmakers was considered a violation of national pride. American furniture makers captured the simplicity of Neoclassic styling as illustrated in Hepplewhite's *Guide*, and Sheraton's *Drawing Book* into graceful, well-proportioned chairs, settees, and case goods. The new style exemplified the confidence of the new republic as patriotic themes replaced more traditional ones; the American eagle appeared frequently as a decorative motif.

The lolling chair was unique to American colonial homes of the Federal Period. Sturdy in its construction, square tapered legs usually reinforced with stretchers supported a tall upholstered back and an upholstered seat. The name lolling was given to the chair in the same context as today's easy chair—it induced relaxation. Over the centuries, a more popular name was used to identify this eighteenth-century chair: the Martha Washington.

Case goods included the popular secretaries, sideboards, and utility tables of the day, although there were new additions to these. An increase in the number of ladies writing tables and bureaus emphasized the growing acceptance of educated women in society from all social classes. Sideboards were more popular in American households because Federal-style homes designated separate rooms for dining. Used as a server during the meal, the sideboard was designed with drawers and cabinets for storage of plates, cutlery, and linens.

One of the leading craftsmen of fine carvings for furnishings and interior millwork during the American Federal period was Samuel McIntire (1757–1811)

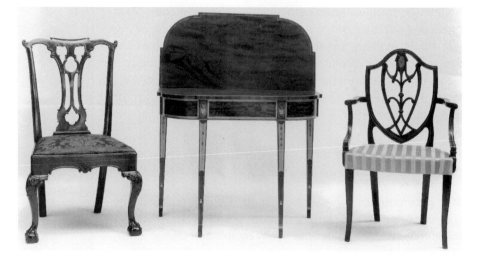

Figure 311 American furniture of the Late Colonial style includes a Chippendale-influenced mahogany side chair from Philadelphia, circa 1770–1780, and Federal-style card table and shield-back chair, both circa 1790–1795 and made from mahogany and satinwood.

The Metropolitan Museum of Art, Gift of George Coe Graves, 1931.

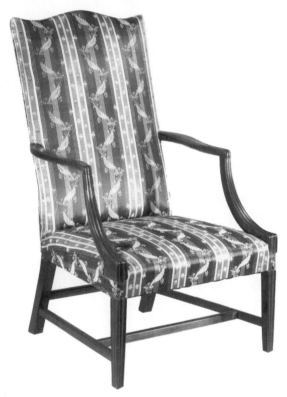

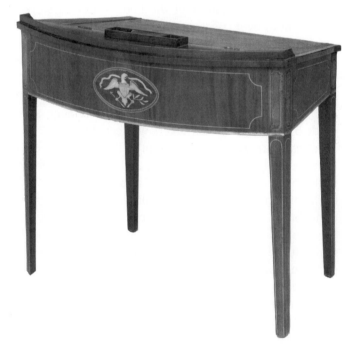

Figure 312 Furniture from the American Federal Period resembles the Hepplewhite and Sheraton styles popular in England during the Early Neoclassic Period. This particular style of upholstered armchair became known as the "Martha Washington" and dates from between 1795 and 1810. Height $42\frac{1}{2}''$, Width 26″, Depth $21\frac{1}{2}''$.

Bequest of Miss Hannah Marcy Edwards for the Juliana Cheney Edwards Collection. Courtesy Museum of Fine Arts, Boston.

Figure 313 This speaker's desk dates from 1797 and was made by John Shaw for the president of the Senate in the Maryland State House. The eagle became a symbol to the United States' freedom from England and is inlaid on the curved back panel of the desk in satinwood and holly. The tapered legs, cross-banding, and geometric panels used on this desk are all characteristics of the American Federal Period. Height $32\frac{3}{4}''$, Width $36\frac{1}{4}''$, Depth 23″.

Gift of Mr. and Mrs. Robert B. Choate. Courtesy Museum of Fine Arts, Boston.

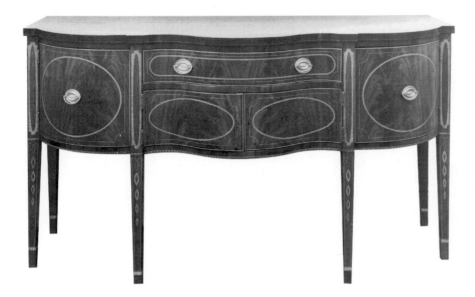

Figure 314 This mahogany sideboard made in Baltimore dates from 1775–1800 and is a fine example of the American Federal style. The bail hardware and oval cross-banding on drawer and door fronts along with quadrangular legs are characteristics documented in Hepplewhite's *The Cabinet Maker and Upholsterer's Guide*.

Museum of Art, Rhode Island School of Design. Gift of Charles L. Pendleton.

from Salem, Massachusetts. An architect known for his exquisite carving and exceptional skill, McIntire produced carvings for bedsteads and case goods, balustrades, mantels, and cornices for windows and doors in some of the finest homes in Salem and Boston.

Just as Windsor-style furniture satisfied the needs of the less affluent with quality furnishings at affordable prices, Lambert Hitchcock (d. 1852) produced

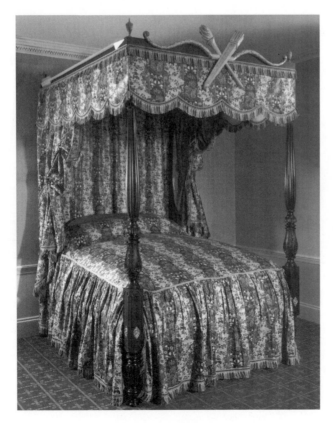

Figure 315 The carving on this four-poster bed is attributed to Samuel McIntire of Salem, Massachusetts. However, the account ledgers of John Doggett of Roxbury, Massachusetts, who gilt the bow, quiver, and torch on the cornice, confirms that the cornice was carved by William Lemon, also of Salem. Carved details on the front posts include acanthus leaves, reeding, gadrooning, and lyre forms; all characteristic of McIntire's classical repertoire. Height 87³⁄₈″, Width 67¹⁄₂″, Depth 81³⁄₄″.

Gift of Martha C. Codman. Courtesy Museum of Fine Arts, Boston.

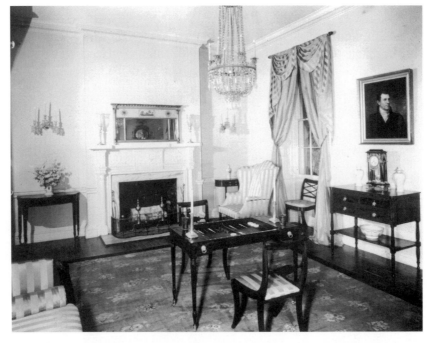

Figure 316 The "L. Hitchcock, Hitchcocksville, Conn. Warranted" stenciled on the back seat rail of this chair authenticates its origin from the Hitchcock factory. Made between 1825 and 1835, the rounded crest rail on this example is consistent with early examples of Hitchcock-style chairs. This chair has decorative gold stenciling on a black ground in fruit and leaf motifs on the back slat, feathered arrows on the uprights, and an anthemion motif on the front seat rail. Gold banding accentuates the ring turning on the front legs, stretcher, uprights, front seat rail, and crest rail. This is one of a pair. Height 34″, Width 17″, Depth 18″.
From the collections of Henry Ford Museum & Greenfield Village.

Figure 317 Furnishings shown in this photograph date from between 1810 and 1820 and reflect the American Empire style. The game table in the center of the room was made by the Frenchman, Charles-Honoré Lannuier, who worked in New York from 1803 to 1819. Remaining pieces are believed to be from the workshop of Duncan Phyfe, although they are not documented. The card table to the left of the fireplace has carved Prince-of-Wales feathers and turned and reeded legs. Notice the ladies work table designed to hold needlework placed next to the wing chair in the corner. The server located to the right of the window has turned and reeded legs, a characteristic form used by New York cabinet-makers. The klismos-style chairs exemplify the renewed interest in Grecian designs and resemble other chairs attributed to Phyfe. The glass chandelier and Aubusson rug are European imports. Card table Height 29¼″; Work table Height 31½″; Game table Height 29¼″. This photograph of the Benkard Memorial Parlor was on view at the Museum of the City of New York from 1934 to 1992.
©Museum of the City of New York.

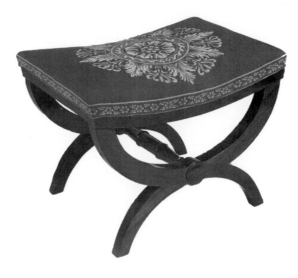

Figure 318 From the work-shop of Duncan Phyfe, this curule-form mahogany veneer bench is one of a pair made between 1837 and 1838 in the American Empire style. Height 15½″, Width 20¾″, Depth 15½″.
The Metropolitan Museum of Art, Purchase, L.E. Katzenbach Foundation Gift, 1966.

some of the finest examples of American country chairs from his factory in Connecticut. Known as the Hitchcock chair, distinctive Sheraton styling was combined with turned legs and stretchers, a rush seat, and beautifully stenciled fruits and flowers. Widely imitated, the chair was a popular favorite seen in many homes throughout New England.

The transformation of furniture designed in the American Federal style into that of the American Empire style overlaps significantly as one style simply did not replace the other. Through the work of New York cabinetmaker Duncan Phyfe (1768–1854), who combined Sheraton-influenced designs with French Empire styling, the American Empire period was well received by the public. American Empire furnishings took on a distinctive Grecian appearance as Federal-style homes were replaced by the emerging Greek Revival style. Phyfe was able to sustain a successful business as a cabinetmaker producing furniture for New York's elite (see Color Plates 31 and 32).

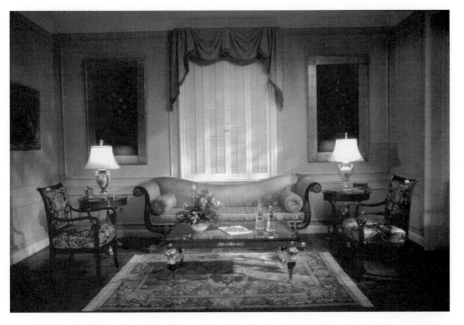

Figure 319 A twentieth-century adaptation of the American Empire period. The Neoclassical chairs and sofa fit well within the modern traditional interior. Once an accessory item in the nineteenth century, the Grecian urns have been translated into lamps, while a scaled-down tea table serves as a coffee table.
Courtesy Kindel Furniture Company

THE 19TH CENTURY

POLITICAL AND ECONOMIC CONDITIONS

At the close of the eighteenth century, Western culture faced enormous change as the Industrial Revolution replaced political revolution and gave power to those who capitalized on the manufacturing of goods. As society became less dependent on agriculture and more focused on industrialization, inventive entrepreneurs earned substantial profits and accumulated wealth. These self-made millionaires mingled with birth-right aristocrats and monarchs in political and social circles.

Industrialization displaced the tenant farmer and urbanism encroached on the agrarian society as more people moved to the city to become a source of cheap labor for factory owners. Soon, new employment opportunities opened for educated middle-class workers who could handle the quantity of paperwork necessary to fill customer orders, direct the shipping of goods, and supervise the labor force. This increasing population of white-collar, middle-class workers sought a better standard of living for themselves and their families.

The urban environment also changed as more people moved into the city. The townhouse replaced the country villa and offered middle-class families a comfortable home, appropriately scaled to fit within a small narrow plot of land. The newly emerging middle-class consumer wanted a more commodious lifestyle, often sacrificing good taste and quality for machine-made goods that imitated hand-made items. The lower cost associated with these mechanized goods appealed to the restricted budgets of the white-collar working class.

BIEDERMEIER STYLE

The Biedermeier style of furniture, popularized in Austria and Germany, offered middle-class consumers the form and style of French Empire but it lacked the handmade quality found in fine cabinetmaking. Based on a popular cartoon charac-

ter printed in German newspapers, the word itself as translated into English is descriptive enough: *bieder*, meaning commonplace or plain, attached to the surname, *meier*. Mr. Biedermeier represented all that was uncouth about this emerging middle-class gentleman; he was uncultured, brash, and lacked good taste.

The furniture was introduced to the market through the factory and workshop of Josef Danhauser (1780–1829). Born in Vienna and trained as a painter, in 1807 Danhauser began producing home accessory items and by 1814 had expanded the workshop to produce furniture. His workshop offered customers an array of carpets, glassware, and textiles for the beautification of their home. The Biedermeier style appealed to the urbane, working middle class striving to keep up appearances.

This style of interior decoration and furniture reflected an interest in French Empire and English Late Neoclassic styling; however, it was designed to be practical and functional in smaller interiors. Detailed ornamentation was often sacrificed for painted designs and applied carvings, while local woods—mainly maple, birch, and fruitwoods such as pear and cherry—were used in the construction processes. Unlike the Late Neoclassic period, finer woods were seldom used for furniture. Instead, pear wood was stained black to imitate ebony, while cherry and maple replaced mahogany and satinwood, respectively.

The construction reflected the skill of the local craftsmen. Workers employed in the factories and workshops were not cabinetmakers, but semiskilled craftsmen who learned how to work with faster production methods. Stan-

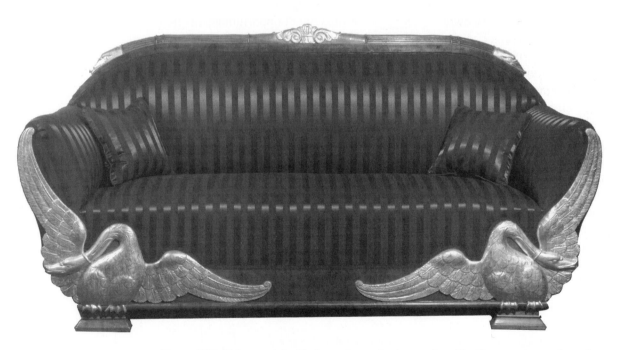

Figure 320 This exquisite Biedermeier mahogany sofa with gilt swans came from the workshop of Anton Kimbel in New York and dates from the mid-nineteenth century. Anton's father, Wilhelm Kimbel, was one of the leading Biedermeier cabinetmakers of the period.
Courtesy Ritter-Antik, New York.

dardized patterns for chair, cabinet, settee, and table designs were used and items were often held together with glues instead of traditional joinery. Biedermeier furnishings personified the middle class, bourgeois gentleman's good taste; they were practical, comfortable, and inexpensive. As the style gained in popularity, finer examples of Biedermeier furniture with excellent quality, materials, and craftsmanship were made for wealthier clients. Most are of Russian, French, Scandinavian, or American origin (see Color Plate 33).

While most embraced these cheap imitations, a small circle of elitists reviled the shoddy, machine-produced goods. In England, social critic John Ruskin (1819–1900) feared that the machine took away the dignity of the craftsman. His concerns were shared by many others during the nineteenth century, and the debate between handiwork and machine fabrication would not be resolved until the next century.

NINETEENTH-CENTURY ARCHITECTURE AND DESIGN

Stylistically, the mood of architecture and design during the first half of the century shifted to a nostalgic reinterpretation of the past. Perhaps derived from the intense interest in classicism brought on by the eighteenth-century rediscovery and excavation of Pompeii and Herculaneum, early nineteenth-century architecture reflected a semblance of the Gothic, Italian Renaissance, and Greek styles with inventive interpretations. Many architects continued to build upon established traditional structural systems incorporating a plethora of visual references to the past in an attempt to create new buildings that looked

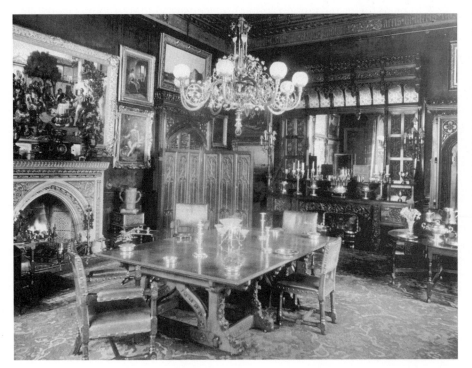

Figure 321 The dining room at Abney Hall, designed in 1857 by A. W. N. Pugin (1812–1852), characterizes the Neo-Gothic style. Pugin, like many other architects working in Victorian England, believed that the Industrial Revolution and machine-made goods took away from the integrity of the craftsworker. Gothic revivalist styling emerged as an attempt to restore the handicraft of the Medieval craftsman and established the basis for William Morris and the Arts and Crafts movement.
RCHME, ©Crown Copyright.

Figure 322 This is an American Victorian cabinet in the "Elizabethan" revivalist style. The split spindles, arcaded front, and bulbous-form legs evoke the spirit of English Renaissance designs with a truly nineteenth-century interpretation.
Private Collection, Mr. & Mrs. Richard Whitlock II.

"old." Academically trained architects in England, France, and America approached their subjects with enthusiastic vigor. These revivalist styles and the prior eclecticizing of period ornamentation dominated the urban environment during the first half of the nineteenth century.

In England and America, the Victorian style categorically identifies this period in time. Named after the sixty-four-year reign of England's Queen Victoria (1819–1901), the Victorian style of design is noted for its literal references to historical style and its emphasis on immoderate ornamentalizing. The Victorian architectural style and coordinated interior exhibited ornamental detail on virtually every surface plane. Fancy millwork complemented the eaves, porch, and door frames on the outside structure only to be repeated on the interior hallways, stairwells, and door casements. The Victorian interior pullulated with superfluous ornament. Textiles, wallpapers, carpets, and table coverings with intricate floral patterns created a sense of excitement within dark and dramatic architectural interiors.

Heavily draped windows concealed the inner sanctum of the home from the outside, offering the inhabitant an escape from the pressures of living in an industrialized world. Rooms were filled to capacity with bric-a-brac scattered about on whatnot shelves and in curios. Porcelain bouquets, ceramic birds, and small animals fashioned from molded glass conveyed the presence of nature while an accumulation of these objects reflected the owner's pride in material possessions and indicated his economic achievements.

Adding to the visual tantalization of the senses, cluttered rooms were filled with large-scale furniture upholstered in rich colored velvets ornamented with fringe. These tufted furnishings expressed the essential character of the Victorian style: heavy, cumbersome, and overstuffed.

Figure 323 The heavy, overstuffed tufted upholstery and fringe seen on the récamier and rounder shown here from the mid-nineteenth century are characteristic of Victorian-style furniture. The design of the rounder reflects the strict moral character of the Victorian era; its design prohibits courting couples from bodily contact and enables the chaperone to hear all conversations.
Courtesy of the Board of Trustees of the V&A.

EXPERIMENTATION WITH MATERIALS

Increased mechanization and inventive new processes for furniture making allowed middle-class consumers to purchase inexpensive imitations of superior quality goods. Papier mâché proved to be a suitable material for making furniture and accessory items at reasonable prices that evoked fine marquetry inlays produced by eighteenth-century ebénistes.

As new processes were developed in furniture fabrication, furniture designers were quick to file patents claiming exclusivity of production rights. Trained as a master cabinetmaker, Michael Thonet (1796–1871) established a workshop in his native Germany in 1819 where he produced fine furniture. By 1830, he abandoned his skill in marquetry and joinery to experiment with new methods and materials of construction. He first attempted to developed a type of plywood—several layers of wood laminated together with glue—that could be forced into molds that would bend the wood using steam and pressure. Thonet made a series of chairs out of laminated bentwood and exhibited them publicly in 1841. The chairs caught the attention of the Chancellor of Austria who encouraged Thonet to move to Vienna. Heeding the Chancellor's advice, Thonet left for Austria where he opened his own company and patented the steam bending process.

A commission to furnish the Lichtenstein Palace prompted Thonet to experiment with other materials. Realizing that laminated wood splintered too easily during the bending process, he substituted solid beech wood. By comparison, the natural lightness and elasticity of beech wood enabled the wood to conform to the molds without breaking. Further success ensued after Thonet's bentwood furniture was included in the Great Exhibition held in London in 1851. This event, similar to the modern concept of a world's fair, introduced the general public to the latest technologies and inventions of the century. Thonet's furniture exemplified the capabilities of machine production, although by modern standards a great deal of handwork was still required.

Figure 324 This mid-nineteenth century Victorian balloon-back settee is made from papier mâché and has inlaid mother of pearl foliate and botanical designs. Notice the Rococo-inspired cabriole legs, armposts, and shaped seat rail.
Courtesy of the Board of Trustees of the V&A.

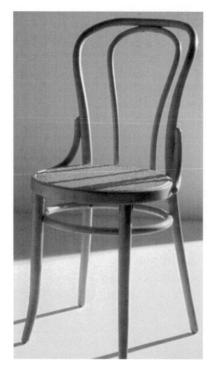

Figure 325 Designed for mass production in the 1860s, Michael Thonet's Café chair is the most recognized piece of bentwood furniture and is still in production today. The chair's bentwood features made it easy to produce and assemble by nineteenth-century standards; the chairs were crated and shipped worldwide from factories throughout Europe.
Courtesy Thonet Industries.

With applied steam and pressure, beech wood strips were clamped onto iron forms that shaped them into curvilinear pieces to be used on legs, seats, backs, stretchers, and arms. Handwork was still necessary to assemble frames and weave the cane for seats and backs.

In 1853, Michael Thonet and his five sons established their manufacturing facility in Czechoslovakia and worked under the name Gebruder Thonet. With factories and showrooms in Europe and America, Thonet offered a variety of furniture items and accessories made from bentwood. The success of the company is attributed to Thonet's assembly-line production methods; a high volume of goods was produced daily thereby keeping the cost within the reach of most household budgets. By the end of the century and with twenty-six branch facilities, Thonet produced 15,000 pieces of furniture per day with nearly fifty million chairs sold.

Thonet was not alone in his experimentation with lamination processes or mechanization. John Henry Belter (1795–1863/65), a German born and trained cabinetmaker working in New York City, perfected the process for laminating

Figure 326 Steam and pressure was used to form the sinuous curves on this bentwood rocker designed by Thonet in the late nineteenth century.
Courtesy Thonet Industries.

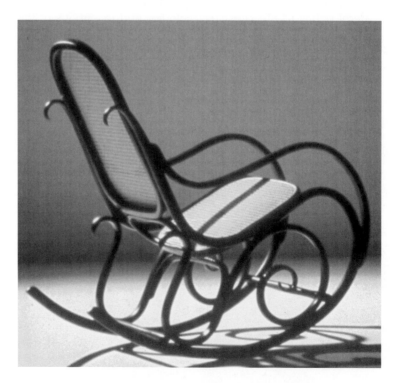

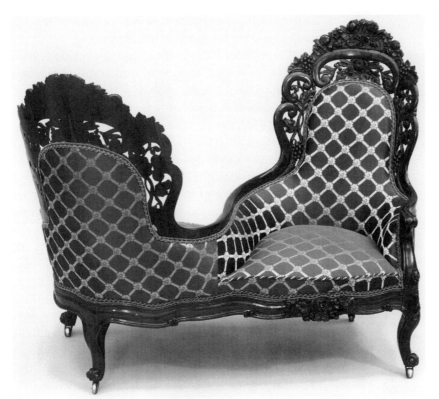

Figure 327 This love seat in the American Victorian style was designed around 1855 by John Henry Belter. A reflection of the strict moral character for the period, the unusual design of this particular loveseat, called a tête-à-tête, kept courting couples from touching. Belter revolutionized the furniture industry with his patented laminating process. Laminated rosewood was pressed into molds to give it shape, then the front was machine-carved. The back of each piece of furniture was left without ornamentation, as seen in this photograph. Height 44½″, Width 52″, Depth 43″.
The Metropolitan Museum of Art, Gift of Mrs. Charles Reginald Leonard, 1957, in memory of Edgar Welch Leonard, Robert Jarvis Leonard, and Charles Reginald Leonard.

wood. Belter built up several layers of wood, each layer cross-grained and glued in place. He then subjected the wood to steam and pressure until the layers conformed to a mold giving shape to Rococo-style cabriole legs and serpentine curves. Carved bouquets, vines, and fruit patterns were both hand and machine carved onto the surface, leaving the backside flat. The finished frame was then upholstered and tufted, characteristic of Victorian style.

INDUSTRIALIZATION VERSUS CRAFTSMANSHIP

The 1851 Great Exhibition held in the Crystal Palace in London marked the turning point for architectural design during the second half of the nineteenth century. With 900,000 square feet of exhibition space, the building itself reflected the advancements made in structural engineering and building materials. Designed and built exclusively out of iron and plate glass, the Crystal Palace became an icon of the Industrial Revolution and brought notoriety to its architect, Sir Joseph Paxton (1803–1865). Paxton's only work to this point had been in landscape design and the building of greenhouses for his most important patron, Queen Victoria.

The Victorian era was transformed. The building of the Crystal Palace foreshadowed the development of modern twentieth-century architecture in its use of iron and glass as the primary building materials. During the second half of the nineteenth century, the debate between industrialization and

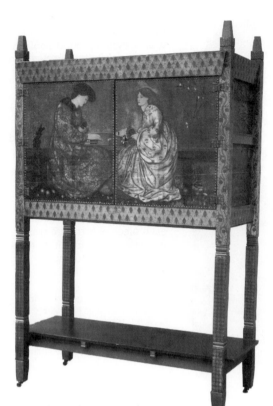

Figure 328 This Arts and Crafts-style cabinet designed by William Morris during the second half of the nineteenth century has door panels painted by Pre-Raphaelite artist Edward Burne-Jones. The Arts and Crafts style incorporated many characteristics of the Medieval period, as seen here with the exterior use of hinges.
The Metropolitan Museum of Art, Rogers Fund, 1926.

Figure 329 Turned beechwood spindles and a rush seat are the basic components for this simple but functional armchair created by Morris & Company around 1870. The chair is set against hand blocked wallpaper in the "Chrysanthemum" pattern designed by William Morris and printed by Sanderson. Sanderson has been printing Morris's wallpaper designs since 1864.
Courtesy Sanderson.

craftsmanship heightened as proponents of the machine challenged the existence of the artisan.

Rallying to the cause of the craftsman was William Morris (1834–1896), the initiator of the Arts and Crafts style that lasted from the mid-1850s to about 1900. Red House, built in 1859, was a collaboration between Morris, architect Philip Webb (1831–1915), and Pre-Raphaelite painters Dante Gabriel Rossetti (1828–1882) and Sir Edward Burne-Jones (1833–1898) and their associate, Ford Mattox Brown (1821–1893). Concerned with workmanship, their designs reflected the spirit of the Medieval age in both appearance and construction, maintaining the quality of hand-crafted furnishings. Red House was built using indigenous materials on both the exterior and interior, contributing to the articulation and cohesiveness of the total spatial experience (see Color Plate 34).

The Morris firm designed wallpapers and fabrics as well as furniture which completed a unified interior theme. Morris's statement, "Have nothing in your house which you do not know to be useful or believe to be beautiful," summarized his belief that a house should only have in it what was necessary for daily life. His philosophy was in direct opposition to the style of the day, which seemed to reflect a fear of empty spaces through the accumulation of clutter more typical in earlier Victorian interiors.

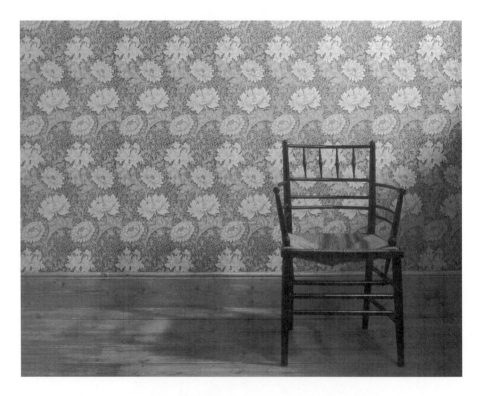

Figure 330 This is a typical example of a Morris Chair named after William Morris who designed a nineteenth-century version of the modern-day recliner. Solidly constructed out of oak with baluster-turned armposts and both straight and shaped slats, coil springs are used to support a loose cushion seat.

Figure 331 This detail of the Morris chair reveals how the angle of the back changes with each position of the wooden rod.

Morris's anti-industrial philosophies were not supported by his contemporaries and led others to produce machine-made items that looked hand-made. Charles F. A. Voysey (1857–1941) realized that the machine was an integral part of modern society and therefore should be utilized to its fullest potential. While Morris wanted to do away with the mechanization of furniture production, Voysey saw industrialization as the brain child for future development. Voysey's furniture designs and interiors, like Morris's were based on the theory of the elimination of unnecessary ornament.

The Arts and Crafts tradition made an impact on American furniture designer Gustav Stickley (1858–1942). Stickley and his four brothers manufactured Victorian-style furniture from 1880 to mid-1890 in their factory in Grand

Figure 332 An Arts and Crafts-style oak desk by Charles Voysey dating from 1896 has large, oversized brass hinges and a pierced brass pastoral scene.
Courtesy of the Board of Trustees of the V&A.

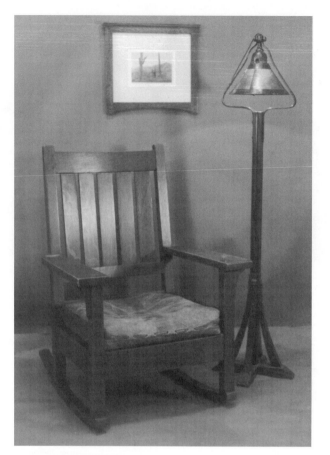

Figure 333 This original Gustav Stickley chair made from quarter-sawn white oak has a beautiful flaked-grain pattern. An aged patina was achieved by subjecting the wood to ammonia fumes while a hand-rubbed finish gave the piece its luster. The lamp and chair reflect an Arts and Crafts style known in America as the Mission style.
Courtesy The Mission Oak Shop, Putnam, Connecticut.

Rapids, Michigan. Gustav separated from his brothers in 1895 to establish his own workshop in upstate New York where he could more fully develop his ideas.

Three years later, in 1898, Stickley traveled to Europe and the British Isles where he exposed himself to the well-established styles of the Arts and Crafts movement. While in England and Scotland, Stickley took a strong interest in work completed by Charles Voysey and the philosophies of William Morris. Taken in by the uncomplicated simplicity of Arts and Crafts designs and Morris's interest in hand-crafted quality, Stickley returned to America and began to develop his style of functional and simplistic furniture (see Color Plate 35).

The 1900 debut of Stickley's trade magazine, *The Craftsman*, introduced Americans to his carefully designed houses and interiors that emphasized clean lines, plaster walls, and exposed beams. Like Morris, Stickley wanted to coordinate the interior with the exterior. *The Craftsman* provided scaled house plans that set the architectural background for his furniture designs. The magazine clearly helped to establish the American Arts and Crafts style, more commonly referred to as the Mission style or Mission Oak style, names derived from its semblance to ecclesiastical furniture found in southwestern missions. The popularity of the American Arts and Crafts style extended into the twentieth century. A 1908 Sears and Roebuck catalog featured "Mission"

Figure 334 In the late 1980s, original Stickley furnishings brought sums well over $100,000 at auction prompting the L. & J. G. Stickley, Inc. furniture company to reissue designs from old catalogues. Shown here are the more popular Stickley styles available to a new generation of American Arts & Crafts appreciators.
Courtesy L. & J. G. Stickley, Inc.

furniture for purchase, as by this time there were several companies imitating Stickley's work.

To discourage Americans from buying lesser quality goods, Stickley, a proponent of handmade furniture, published catalogs of his furniture styles. He encouraged do-it-yourselfers by printing detailed drawings of furniture that could be easily made and supplied kits of leather and other finishing materials to complete the construction. Stickley criticized and rebuked his imitators, including his two brothers, Leopold and John George, who had established their own manufacturing facility in Fayetteville, New York. Unfortunately, Gustav's workshop went bankrupt in 1916 and he joined the workshop of L. & J. G. Stickley.

THE SHAKERS

One of the first architecture and furniture styles to go against ornamentation and excessive decoration was not attributed to a particular architect or designer, but evolved from a strong religious sect of

Figure 335 By the turn of the twentieth century, this American Mission-style chair was one of the more popular chair designs produced in the workshops of L. & J. G. Stickley.

Figure 336 A room used by the children of Hancock Shaker village for their studies reveals the simplistic but functional desk, cupboard, and chair designs. The Shaker rail with intermittent pegs can be found in all interior rooms, creating a convenient place to hang a multitude of objects.
Hancock Shaker Village, Pittsfield, Massachusetts.

people known as the Shakers. The Shakers' founder, Anne Lee (1736–1784), grew up working in a textile factory in Manchester, England. Like most factory workers, Anne began working as a young girl. She received no formal education but learned how to be a productive worker and to seek comfort in Christianity. Through her involvement with the Quaker religious order and because she suffered through an abusive marriage, Anne formulated her own religious philosophy based on celibacy and confession. In 1774, she left England with a small group of followers and went to America to seek religious freedom.

Many members of the group did not know the hardships they would face. Upon arrival, the Shakers established themselves in upstate New York where they assembled provisions and built shelter, establishing a self-sufficient and isolated community. The future of the sect depended on converts, and soon Shaker missionaries set out to find them. By the turn of the nineteenth century, Shaker communities had expanded into New England, Ohio, and Kentucky.

Like the first American colonists, the Shakers built temporary shelters until permanent structures could be erected. Shaker religious philosophy emphasized the second coming of Christ and prepared its followers for the millennium. All buildings and furnishings were designed for function and perpetuity. Shaker meeting houses, dormitories, shop houses, and barns still stand after nearly 200 years as reminders of a religious sect that has long since disappeared.

Most of the Shaker communities were self-supporting, but they required capital to purchase farming equipment and supplies. To raise money, they made rugs, boxes, brooms, baskets, and furniture that were sold publicly. The

Figure 337 While the Shakers designed and crafted their own furnishings for communal use, after the Civil War the Mount Lebanon village turned chair making into a thriving business. People of the "world" eagerly purchased the chairs that had a reputation for strength and durability. Earlier versions were often painted or stained in red, blue, or green while later examples were either painted or stained black or left in a natural finish. Seats were made from either interwoven cloth strips in contrasting colors or woven rush. Hancock Shaker Village, Pittsfield, Massachusetts.

furniture, like the architecture, reflected a rational approach to design. Simplistic in style with clean lines and without unnecessary ornamentation, the Shaker style was the antithesis of eclectic Victorian style.

The most significant furniture item made for public sale by the Shakers was the chair. A variety of local woods were used for the construction of the chair frame; however, oak was more commonly used when available. Workshops complete with foot-powered lathes and hand drills produced a few variations of the basic style: turned uprights, legs, and stretchers with back slats and woven cloth seats. While the chairs made for sale were often stained red, blue, or green, chairs made exclusively for Shaker property buildings were left in natural coloring.

The workshops also supplied communal furniture—beds, clothes presses, tables, desks, and cabinets—although most storage units were built directly into the walls. The tidy appearance of the room and the Shakers' devotion to cleanliness led to the implementation of the Shaker rail—a narrow rail attached to the wall above head height following the perimeter of the room. At regular intervals, small pegs were inserted into the rail that allowed for the hanging of household items, including the ladder-back chairs. This proved

highly efficient as a means of storage, as well as lifting the furniture off of the floor while it was swept and mopped clean every evening.

The Shaker style of design reflected the efforts of devoted craftsmen who diligently sought to produce goods that were functional rather than being designed for luxury and exuberance. Today, many people find beauty in the furniture's restrained elegance. At auction, Shaker furniture began to break records during the 1980s and 1990s. A Shaker rocker taken from a community in New Hampshire sold for $37,400, setting a world record for furniture of its kind.

ART NOUVEAU STYLE

One last effort to freshen the atmosphere of cultural change in Victorian taste occurred during the last decade of the nineteenth century. However difficult it is to place the many design trends developing at the fin de siècle into one neatly defined category, for the sake of clarification specific thematic characteristics unify these trends into the classification of the Art Nouveau style. Sometimes referred to as a period of influence rather than a specific stylistic trend, Art Nouveau, a conglomeration of several movements within the auspices of the style, attempted to revive ornate beauty while bridging the gap between handicraft and machine fabrication.

From as early as 1890, characteristic traits of this movement developed nearly simultaneously throughout Europe. Of its regional components—Jugendstil in Germany, Modernismo in Spain, Secession in Austria, and Stile Floreale in Italy—a consistent thread connected and unified these individual movements into the "new art" of Art Nouveau.

Clearly resisting historical reiteration that culminated into the confusion of Victorian eclecticism, architects and designers created less literal interpretations of past style. Instead, the majority abstracted the beauty inherent in nature, introducing sweeping lines and whiplash curves through organic forms and free-flowing botanicals (see Color Plate 36).

Figure 338 A walnut armchair designed by the Spanish Art Nouveau architect Antonio Gaudi (1852–1926) dates from around 1902–1904. Notice how Gaudi interprets characteristics of the Rococo period into pseudo-cabriole front legs with scroll feet and C-scroll armrests. Height 38″, Width 25½″, Depth 20″.
The Metropolitan Museum of Art, Purchase, Joseph H. Hazen Foundation, Inc., Gift.

One of the earliest applications of the term Art Nouveau is traced to Frenchman Samuel (documented also as Siegfried) Bing (1838–1905). The opening of his innovative Salon de l'art Nouveau in Paris in 1895 was motivated by his recent visit to America. There he witnessed a fresh and almost naive integration of the decorative arts, unrestricted by national heritage. Bing was particularly interested in the workshop of Louis Comfort Tiffany (1848–1933). Tiffany & Company, established by Louis's father, had organized furniture makers, glassblowers, silversmiths, and ceramists into one workshop where they all strove to achieve a cohesive stylistic direction based on organic form.

Figure 339 A bronze table lamp by American designer Louis Comfort Tiffany with a colorful leaded glass shade became popular during the Art Nouveau movement of the late nineteenth and early twentieth centuries. Base Height 26¼″, Base Diameter 14″, Height of Shade 14⅝″, Diameter of Shade 18½″.
The Metropolitan Museum of Art, Gift of Hugh Grant, 1974.

Figure 340 This hanging cabinet by French designer Emile Gallé (1846–1904) dates from the early twentieth century and is made from birch, rosewood veneer, and various other woods used in the marquetry designs. Nature-inspired motifs capture the spirit of the Art Nouveau style with asymmetrical vine patterns, botanicals, and butterfly designs. Height 40″, Width 48″, Depth 12″.
The Metropolitan Museum of Art, Anonymous Gift, 1982.

Figure 341 This Art Nouveau-style dressing table made by Louis Majorelle (1859–1926), circa 1900–1910, is made from Honduras mahogany and Macassar ebony with gilt bronze drawer handles and door knobs, mirrored glass, marble top, and ceramic basin. The asymmetrical design remains a prominent feature of the Art Nouveau style, along with growing vine patterns. Height 86⅜″, Width 45¼″, Depth 25⅝″.
The Metropolitan Museum of Art, Gift of The Sydney and Frances Lewis Foundation, 1979.

Figure 342 Many scholars credit the architect Victor Horta with establishing the Art Nouveau style in Europe with designs such as this one for the Van Eetvelde House. Built in 1895 in Brussels, Belgium, this view of the salon shows the interrelatedness between architectural detail—both structural and ornamental—and interior furnishings. Straight and sturdy columns rise toward the ceiling then dissolve into thin, sinuous wisps of iron. The fluidity of these lines is repeated in the stained glass of the skylight, the magnificent grille work on railings and banisters, and the central rug design. The botanical theme of the Art Nouveau style is most prominent in the design of the glass lamp shades clearly visible on the right column the foreground. Photograph Courtesy The Museum of Modern Art, New York.

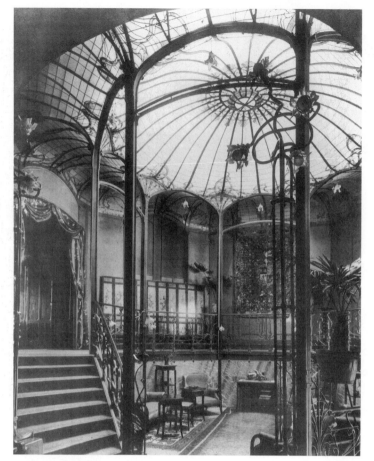

Figure 343 A side chair designed by French designer Edward Colonna in 1899 shows Art Nouveau styling in the vine-patterned carving appearing on the chair back, legs, and seat rail. The Metropolitan Museum of Art, Edward C. Moore, Jr., Gift, 1926.

With the Salon de l'art Nouveau, Bing sought to establish a gallery where his invited talented designers from France, Belgium, and America (including Tiffany) worked together to create rooms filled with coordinated furnishings and decorative accessories. His attempt to unify all the craftsmen into one collective and cohesive body of artists foreshadowed modern ideology.

At the same time, Belgian architect Victor Horta (1861–1947) completed the Eetvelde House, a masterpiece of Art Nouveau architecture. Just as the Crystal Palace prompted architectural change during the second half of the nineteenth century, the newly completed Eiffel Tower in Paris challenged modern engineering achievements. Perhaps influenced by the Eiffel Tower, Horta concealed the overt function of the iron support column in its ornateness. Reduced to thin, delicate supports, his structural columns terminated into sweeping arches while banisters, iron grilles, and door gates were shaped into harmonizing vine patterns.

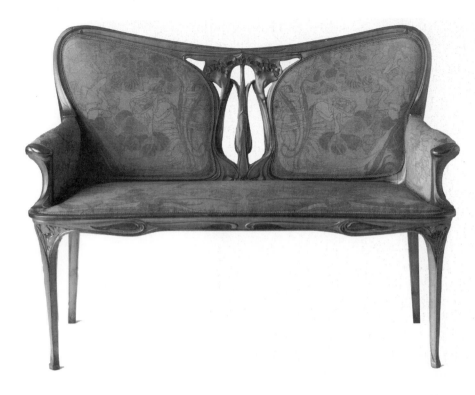

Figure 344 Georges De Feurre captures the delicate beauty of the Art Nouveau style with this settee designed for the 1900 Paris Exhibition. Richly carved details on the legs, seat rail, arm supports, and back complement the flowing vine and botanical patterns of the upholstery.

Courtesy Kunstindustrimuseum, Museum of Decorative Arts Copenhagen, Denmark. Photo: Woldbye.

Although there are other fine examples of Art Nouveau architecture spread across Europe and into America, the style itself was more popular in the decorative arts. Complex interiors emphasized exaggerated organic forms that were repeated in furnishings, textiles, art, and accessories. What originally began as a movement to produce a new style of design antithetical to austere Victorian historicism became a movement steeped in elaborate ornamentation.

Bing assembled three superb artists to complete the Pavilion of Art Nouveau for the Paris Exhibition of 1900: Edward Colonna, Eugène Gaillard, and Georges de Feure. Six rooms were decorated in the height of Art Nouveau style incorporating whiplash curves, organic plant forms, and swirling vine patterns into every possible combination of elements.

The pavilion and the high style of Art Nouveau isolated the middle-class consumer. While most of the Art Nouveau designers believed in modernization, the intricacies of the style and the fine quality of craftsmanship inhibited its mass production. Since these furnishings were not within the financial reach of the middle class, posters, prints, vases, tea services, and textiles manufactured with the essence of whiplash curves, botanical patterns, and organically inspired motifs were more widespread.

The movement that intended to bridge the gap between machine-made and hand-crafted furnishings only widened it. Handmade goods, as Morris dis-

Figure 345 An Art Nouveau-style vase by French designer Emile Gallé (1846–1904) dates from around 1875–1900. Hexagonal in shape, the glass is enameled and gilt with botanical designs. Height 11⅝".

The Metropolitan Museum of Art, Gift of Gertrude Moira Flanagan, 1972.

Figure 346 This pen drawing, *Salome with the Head of John the Baptist*, by Aubrey Beardsley dates from 1892 and is reflective of art and design in the Art Nouveau style. Here, Beardsley uses fluid, sweeping lines to depict humans, stylized botanicals, and sinuous vine patterns that circulate throughout the composition.
Gallatin Beardsley Collection. Manuscript Division. Department of Rare Books and Special Collections. Princeton University Library.

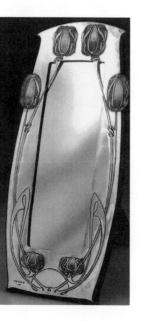

Figure 347 Here, the English designer Archibald Knox (1864–1933) translates free-flowing stem and petal patterns found in nature into typical Art Nouveau styling on this stand-up mirror designed for sale through Liberty and Company. The frame of the mirror is made from wood, silver, and enamel, and is dated 1902. Height 18³⁄₄″, Width 8⁷⁄₈″, Depth ¹⁄₂″.
Virginia Museum of Fine Arts, Richmond, VA. Gift of Sydney and Frances Lewis. Photo: Katherine Wetzel. ©1997 Virginia Museum of Fine Arts.

covered earlier, kept costs beyond the reach of the middle class. Art Nouveau had suffered the same fate as Morris's Arts and Crafts movement: demise through elitism.

Belgian painter, architect, and designer Henry van der Velde (1863–1957) realized that the hand craftedness of furniture ensured high quality yet isolated all but the wealthy patron who could afford its cost. In his workshop in Brussels, he employed craftsmen that produced furniture using assembly-line methods, although each piece was hand-made.

Van der Velde supported complete unity in design and feared that mass production of household goods with Art Nouveau inspired designs would be perceived out of context. After moving to Germany in 1900, van der Velde, along with Hermann Muthesius (1861–1927), helped to organize the Werkbund

in 1907. The purpose of the Werkbund was to bridge the gap between art and industry by improving "professional work through the cooperation of art, industry and the crafts." With the establishment of the Werkbund, Jugendstil and Secessionist designers shifted toward a more rectilinear interpretation of the Art Nouveau style. Consequently, as the nineteenth century closed the "art and industry" philosophies of the Werkbund became the root of twentieth-century modernism.

Figure 348 This satinwood cabinet with inlaid ivory and ebony details by German designer Patriz Huber was manufactured by W. Kummel in 1902. Indicative of the German Art Nouveau movement known as Jugenstil, the cabinet is more geometrical in its design and less fluid. Height 226.5 cm, Width 97.5 cm, Depth 79.5 cm.
Courtesy Museum of Fine Arts, Boston. Bequest of the Estate of Mrs. Gertrude T. Taft, Gift of Mrs. Frederick T. Bradbury and Gift of Mr. S. Paul Boochever, by exchange.

THE 20TH CENTURY

EARLY MODERN

The modern cultural movement has been praised for its assimilation of the new technology that impacted the world nearing the turn of the twentieth century. Modern culture embraced the development of electricity, telephone communication, and rapid transportation made possible by railroads and automobiles. At this time, architects discovered that the Neoclassical, Neo-Gothic, and Victorian styles of architecture popularized throughout most of the nineteenth century no longer fit into this new industrial age of enlightenment.

For the first time, materials such as steel, glass, and reinforced concrete were put to innovative uses by modern architects in both industrial and residential designs. These architects expressed form in their own individual ways using these new materials without regard to historical element or context. Adolf Loos (1870–1933), the Viennese architect, wrote: "To find beauty in form instead of making it depend on ornament is the goal towards which humanity is aspiring." This statement typifies the efforts of early modern architects whose historical exclusionism introduced unadorned, minimilistic structures. The design of modern furniture evolved from the need for a new style equally reflective of the technological advances made at the turn of the twentieth century.

In the beginning, most modern furniture was designed adhering to strict geometrical formulas that made machine fabrication more effective. Soon, machine aesthetics prevailed over the distinctive curvilinear styles of the Art Nouveau movement and the excessive scrolls and curlicues seen in Victorian designs.

Charles Rennie Mackintosh (1868–1928), a Scottish designer, worked as an architect in the late nineteenth and early twentieth centuries during the height of the Art Nouveau style. While studying at the Glasgow School of Art, Mackintosh met his future wife, Margaret MacDonald (1864–1933), who worked with him in the design studio and on several architectural projects. In 1894, Mackintosh began designing furniture. His styles were sleek and vertical, emphasizing a front elevation that expressed geometrical negative spaces (see Color Plate 37).

After Mackintosh won a design competition in 1897 for work on the Glasgow School of Art building, design commissions followed. The Hill House, 1902, and the Willow Tea room, 1904, introduced to modern culture a shock-

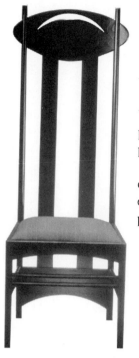

Figure 349 Charles Rennie Mackintosh designed the Argyle Chair in 1897 for his and Margaret MacDonald's apartment in Glasgow. Made from oak, the chair has a black stain finish consistent with other Mackintosh chairs. The tall back and unadorned surface treatment attests to the Modern spirit in furniture design. Height 53⅞", Width 19", Depth 18⅜".
Courtesy Cassina.

ingly stark minimalism that would be developed further by leaders of the Bauhaus in Germany during the 1920s. Several of these commissions were carried out through the collaborative efforts of Mackintosh, Margaret MacDonald, her sister Frances (1873–1921), and her sister's husband Herbert MacNair (all students at the school). Together they completed architectural designs that unified the design process from the inside out.

In a manner that embodied the spirit of an uncomplicated, simplified interior, "the four" designed china and tableware, textiles, carpets, and murals. The popular whiplash curves and organically inspired motifs of the Art Nouveau style appeared as delicate accents to the harsh rectilinearity of the architecture. Their chosen color palette was light and bright, lifting the dark veil of the Victorian era. Furniture was stained in a dark brown or dark green that contrasted with creamy white interior walls.

Figure 350 Mackintosh's entrance hall of Hill House, completed in 1905, was shockingly modern for its time. Contrasting light and dark values combined with a minimalistic approach to furniture design and decoration relieved the Victorian clutter of the nineteenth century. The strong linear patterns created with wall and ceiling details are carried through to the furniture in the use of the recurring grid motif.
Crown Copyright: Royal Commission on the Ancient and Historical Monuments of Scotland.

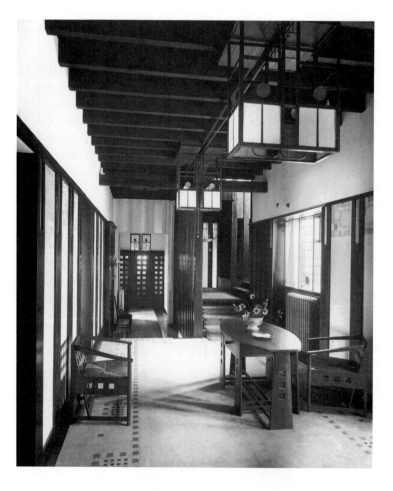

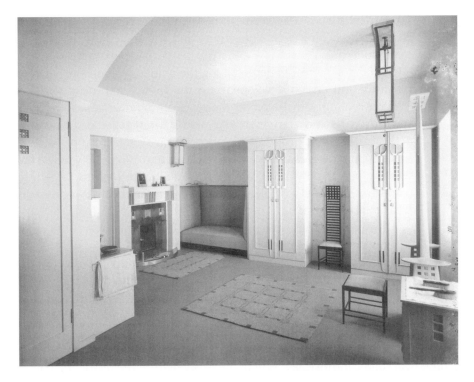

Figure 351 The bedroom of Hill House by Mackintosh is equally stark in its appearance. Built-in alcoves keep the furniture carefully placed, while providing space for built-in closets, a rare feature for the time. Notice that the textiles, fireplace mantel, closet doors, and furniture incorporate the grid pattern. A Mackintosh Hill House chair designed in 1907 is visible in the central alcove. Hill House chair: Height 55.1″, Width 16.1″, Depth 14.2″.
Crown Copyright: Royal Commission on the Ancient and Historical Monuments of Scotland.

All the while, the team's work was not in great demand by the general public and, after winning a few more competitions, Mackintosh and "the four" faded into obscurity until resurrected by modern enthusiasts. In 1975, Italian manufacturer Cassina began reproducing the Mackintosh furniture line.

The Viennese designer Josef Hoffmann (1870–1956) came under the influence of Mackintosh after the two met in 1903. Hoffmann broke from the Art Nouveau tradition to explore a more rectangular style employing severe geo-

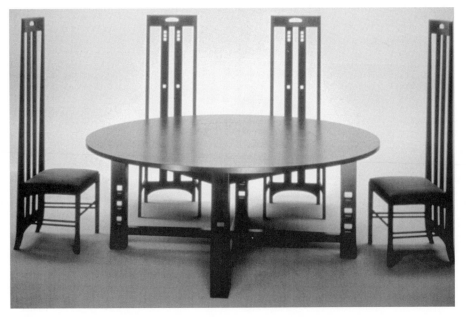

Figure 352 The table was designed by Mackintosh circa 1900 for the Glasgow School of Art. Grouped with the Ingram chair collection, Mackintosh's repeated use of the grid motif is evident in the legs of the table and the back of the chairs. The straightness of the back requires the sitter to be erect. Chairs measure 59¼″ high, 18½″ wide.
Courtesy Cassina.

metrical shapes. His work synthesized the progressive attitudes of an encroaching twentieth century and anticipated the strictness of modern art.

Hoffmann's interest in perpetuating the unified relationship between architecture and design developed into the formulation of the Wiener Werkstätte. Along with Koloman Moser, Hoffmann organized a workshop of artisans and craftsmen who would work together to produce goods in the more progressive modern spirit. A factory of workers hand-crafted designs that were appreciated and afforded by only a few wealthy patrons. By 1932, a dwindling supply of patrons forced the workshop to close as workers could no longer compete against increased mechanization.

In America, the work of Frank Lloyd Wright (1869–1959) introduced a new style of design comparable in theory to the simplistic purity of Mackintosh. Wright studied engineering from 1885 to 1887 at the University of Wisconsin then worked for the "father" of the modern skyscraper, Louis Sullivan, from 1888 until 1893. Subsequently in 1896, Wright opened his own architectural practice and began designing residences.

Wright's structures emphasized the horizontal plane expressed as geometrical solids. Intrinsically, Wright broke away from the restricting bulk of the Victorian style and chose to articulate the contradiction of form and materials: mass opposed void spaces, smooth poured concrete contrasted with the harsher textural qualities of brick and mortar, and light values visually advanced from darkened backgrounds. Unlike Mackintosh whose flat spatial relationships were best appreciated from a two-dimensional perspective, Wright's architecture leaped into three-dimensional space emphasizing a contradiction between mass and void.

In 1909, Wright completed a landmark structure for the Robie family of Oak Park, Illinois. The Robie House epitomized Wright's interest in the horizontal plane and the dichotomy of mass and void. The house was designed

Figure 353 Josef Hoffmann designed this side chair in 1907. Contemporary for its time, the black finish and lack of ornamentation led the way for the modern movement. Height 29.5″, Width 18.5″, Depth 17.7″.
Courtesy Thonet Industries.

Figure 354 Frank Lloyd Wright's Robie House captures the geometric nature of his designs as horizontal planes intersect at right angles. The furniture designed by Wright for this house included several built-ins as well as freestanding pieces that were criticized for being too uncomfortable.

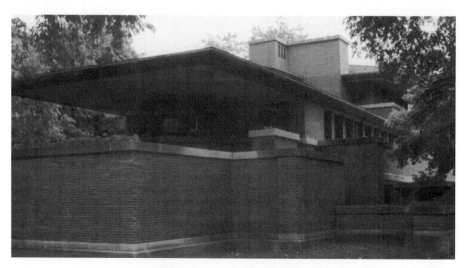

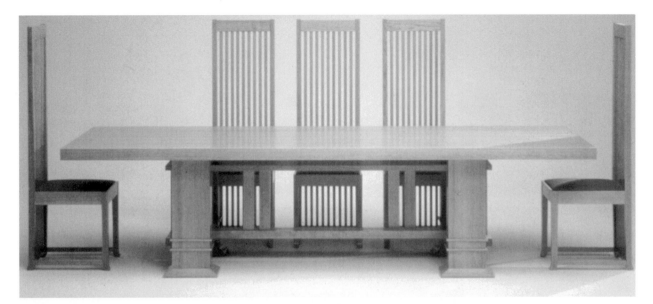

Figure 355 Frank Lloyd Wright's dining room chairs in the Robie House are grouped around the Allen table designed for another client in 1917. Notice again the strict verticality of the chair back. Similar to Mackintosh, Wright favored oak but chose to keep its natural finish rather than applying a dark stain. The honey-colored oak blended harmoniously with the earth tones Wright used on the interior decoration of his houses.
Courtesy Cassina.

with a flat roof cantilevered beyond the supporting walls. This house initiated Wright's "prairie style" and set the stylistic direction for future projects.

The Robie house, severely contemporary for its time, demanded interior furnishings equally modern in design. Wright complied by creating a unified environment that included specially designed furniture, textiles, carpets, lighting fixtures, and beveled glass windows.

The unique open-plan interior of the Robie house enabled Wright to use a system of built-ins and carefully placed chairs and tables that ingeniously separated space with minimal walls or room dividers. Tall-backed chairs created a visual screen around the dining table and separated the eating area from the living area.

Wright went on to build many more residential and commercial structures, each carefully orchestrated from the inside out (see Color Plate 38). Creating a sense of harmony and balance, for the most part Wright's furniture reflected his fascination with geometrical shapes and angular forms. Wright's furniture and textile designs were explicitly connected to the structures he built. His furniture, often criticized for being too heavy and cumbersome, was not intended to be mass produced and sold to the general public. Today, reproductions of Wright's furniture, textiles, and tableware are available to a new generation of appreciators through licensed manufacturers.

Although these early works by Wright introduced modernism into the American vernacular, it was The Armory Show of 1913 held in New York City

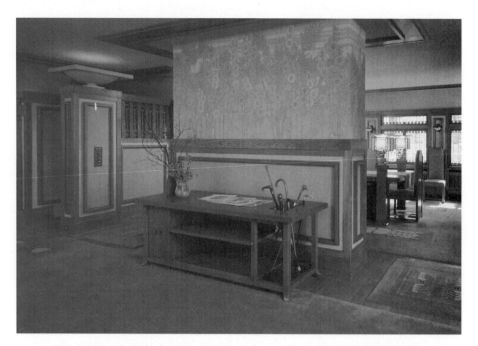

Figure 356 Wright designed this Prairie-style house located in Grand Rapids for the Meyer May family in 1908. Consistent with the characteristics found in Wright's other Prairie designs, low walls and freestanding partitions act as dividers within an open-plan interior. The golden oak millwork stands out against a background of warm ochres as Wright's selective layering of contrasting colors and materials emphasizes the horizontal. All of the home's furnishings, including the textiles, mural design, carpets, light fixtures, furniture, and stained glass windows, were carefully executed by craftsworkers according to Wright's drawings and specifications.
Courtesy Steelcase Inc., Grand Rapids, Michigan.

Figure 357 The Midway chair designed for the Midway Gardens in 1917 was made out of metal, a material usually used in office furniture. Here Wright has created a functional chair employing the lively arrangement of the circle and triangle.
Courtesy Cassina.

that brought modern art and modernism to the American public's attention. The exhibition was highly controversial for its time. Works by European artists representing styles from Impressionism to Expressionism and Cubism shocked an incognizant American public. Even though The Armory Show was not readily accepted by the general public, it validated American artists' curiosity about modernism and freed them to seek alternative forms of expression.

Avant Garde Influences

In analyzing the extremity of modern architecture and the achievements of pioneer designers, it is important to recognize the unquestionable influence of the European avant garde art community. As early as 1906, European Cubist painters represented the world as a collage of forms reduced to simplified geometrical shapes that shattered the traditional laws of spatial order. Through the accomplishments of Pablo Picasso and Georges Braque, other European painters sought to purify form and remove art from the context of traditionalism.

By 1917, European architects excelled in removing architecture from traditionally based revivalist design. Instead, they initiated a purely geometrical style of design based on the principles of Cubism. Structural innovations,

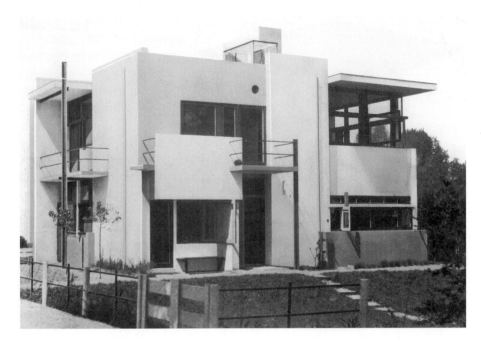

Figure 358 The Schröder House in Utrecht, The Netherlands, designed by Gerrit Rietveld in 1924 is considered to be the purest expression of De Stijl architecture. Rietveld emphasizes the cubist nature of the structure by using projecting cantilevers, balconies, and flat rectangular planes to create interesting areas of mass and void. The color palette is restricted to the white surface treatment of the concrete accented by red, yellow, blue, and black steel on columns, window and door frames, and railings.
Photograph Courtesy The Museum of Modern Art, New York.

specifically the use of non-load-bearing walls resulting from the employment of industrially engineered materials such as steel and reinforced concrete, enabled the fragmentation of interior space.

Dubbed "International Style" by architect Philip Johnson, this style of design is identified through its ability to escape regional vernacular by adhering to geometrical form and avoiding applied ornamentation. The architects introduced a rational approach to design, emphasizing international unity that crossed cultural boundaries.

In 1917 under the direction of Theo van Doesburg (1883–1931), a Dutch artist-architect, the De Stijl movement began as a collaboration between painter Piet Mondrian (1872–1944) and architect Gerrit Rietveld (1888–1964). The group adopted specific design characteristics that embodied the De Stijl movement: extensive use of the geometric plane; exclusive use of primary hues, black, and white; and an arrangement based on asymmetrical spatial relationships (see Color Plate 39).

Analogous to the work of Frank Lloyd Wright, De Stijl architects incorporated engineering innovations and new technological advances available in building construction into their work. They designed without historical expressiveness and created imaginative structures that required equally inventive interior furnishings.

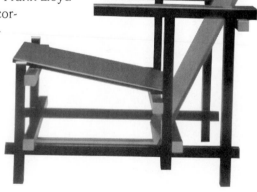

Figure 359 Gerrit Rietveld designed the Red Blue chair in 1917 for the Schröeder House. Written accounts describing the interior of the Schröeder House explain how Rietveld created a three-dimensional study of a Mondrian painting using the Red Blue chair. Placed on a black painted square section of the floor, the red, blue, and yellow planes appeared to float in space as the chair's black supporting framework visually blended in with the background. Height 34.6″, Width 26.2″, Depth 32.6″.
Courtesy Cassina.

Figure 360 The table for the Schröeder House complements the Red Blue chair in its use of primary hues, black, and white. The interconnecting planes reflect the intensity of the exterior architecture. Height 23.6″, Width 20.3″, Depth 19.6″.
Courtesy Cassina.

In 1924, Rietveld received a commission that gave him complete creative freedom to design a residence unifying both architectural structure and interior space. The Schröder House, still considered a milestone achievement in modern design, allowed Rietveld to fully explore the theories of the De Stijl movement. The house made famous his 1918 design for the Rood Blauwe (Red Blue) chair (see Color Plates 40 and 41).

Rietveld's furniture became three dimensional sculptures expressing basic De Stijl principles. Rietveld continued to design after the completion of the Schröder house, adapting his designs to children's toys and furniture. Although Rietveld was trained in custom joinery and had learned the skill of cabinetmaking at eleven years of age, he was a proponent of mass production. Convinced that machine fabrication was the only affordable way to reach the masses, his designs were finally produced by the Netherlands-based Mertz and Company in the 1930s.

Soon after the establishment of the De Stijl movement in Holland, architect Walter Gropius (1883–1969) instituted the Bauhaus in Germany in 1919. The Bauhaus became the first school to recognize the importance of training artists and craftsmen to design products for mass production. Until its doors were closed in 1933 by the National Socialist Party, the Bauhaus led the way for an avant garde style of teaching emphasizing a cooperative effort between artist, craftsman, and machine. At first, students of the Bauhaus were trained in the

Figure 361 The severity of the International Style of architecture can be seen in the Walter Gropius Residence located in Lincoln, Massachusetts. Narrow ribbon windows on the first and second level positioned at head height allow for maximum privacy in the bedrooms. The entry is concealed behind glass block while a spiral staircase leads up to an outdoor terrace.

art of painting and sculpture. Eventually, industrial arts and home product design—textiles, tableware, wall covering, lighting, and furniture—were introduced into the curriculum.

Trained under the guidance of "master craftsman" instructors, student apprentices were encouraged to experiment with the materials of construction before working through the problems of design. This clearly expressed the working philosophy of Gropius, and "Form follows function" became the motto of the Bauhaus.

Gropius and his colleagues believed it was important for the student to understand how the materials of construction functioned relative to the design process. One of the most influential products to come out of the Bauhaus was a chromium-plated tubular steel chair designed by Marcel Breuer (1902–1981).

In 1920, Breuer came to the Bauhaus as a student in the cabinetmaking shop. There he was introduced to the cubical angularity of the De Stijl movement, specifically the work of Gerrit Rietveld. Breuer's first chairs were constructed entirely out of flat planes of wood. Soon after, he designed a chair that had an open wood frame with stretched canvas providing the structural support for seat and back. Breuer discovered that the stretched canvas supported the body without heavy upholstery and it was quite comfortable.

After additional experimentation with various other materials, Breuer encountered something unique in the design of the bicycle he rode to the workshop. As he studied the bicycle, he noticed the frame was strong yet lightweight due to its tubular steel construction. Breuer also noticed that the curvilinear shape of the handlebar was created by bending the bar of tubular steel. He reasoned that this same process could be adapted to the design and manufacture of furniture. Breuer quickly arranged for tubular steel bars to be

Figure 362 Marcel Breuer designed the Cesca chair in 1928 using natural materials of beechwood and cane integrated with sleek tubular steel. The cantilevered design revolutionized modern furniture and machine-produced furniture. Side chair: Height 30.5", Width 18.5", Depth 22".
Courtesy Thonet Industries.

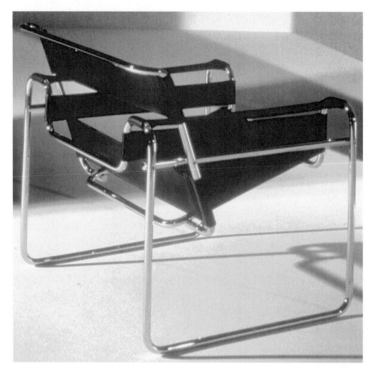

Figure 363 Marcel Breuer designed this chair in 1925 for his friend and Bauhaus colleague, Wassily Kandinsky. The chair's tubular steel construction with leather strapping instead of upholstery gave the design a modern theme and emphasized machine aesthetics. Height 28.3", Width 31.1", Depth 27.5". Courtesy Thonet Industries.

Figure 364 The steel frame on this chair designed by Mies van der Rohe with its graceful, sweeping curves supports leather webbing which holds tufted cushions that form the seat and back. Height 29½", Width 29½", Depth 29½". The Mies van der Rohe Collection, Barcelona chair, Courtesy of Knoll.

sent to his workshop, and finally, in 1925, the first chair made from bent tubular steel was introduced.

Breuer's contributions to furniture design were not realized right away since the chair was too expensive to manufacture until proper tube bending equipment could be developed. Breuer's furniture designs and his famed Cesca chair were eventually manufactured by Thonet.

Following the lead of Breuer and Dutch designer Mart Stam (1899–1986), who in 1924 introduced a cantilevered chair made from jointed tubular steel parts, several other designers developed furniture made from bent tubular steel. Before long, chromium steel replaced wood as the dominant material in furniture construction.

In 1928, a department of architecture was added to the Bauhaus curriculum. Ludwig Mies van der Rohe (1886–1969), a longtime acquaintance of Walter Gropius, became Director of Architecture at the Bauhaus from 1930–1933. Mies quickly introduced his own theories on architectural design that emphasized glass curtain walls supported by a steel skeletal frame.

When asked to design a pavilion for the 1929 World's Fair held in Barcelona, Mies complied by building a spec-

tacular glass and steel structure known as the German Pavilion. The glass curtain walls were void of ornamentation and illustrated Mies's design philosophy, "Less is more." His achievements in International Style architecture advanced the cause of modernism and set forth a new direction in residential design.

The significance of the Pavilion led to the popularity of a chair designed by Mies specifically for its interior. The Barcelona chair quickly became a modern furniture classic even though its construction was not conducive to mass production due to a complicated design that required special welding. Mies continued to design significant architectural structures and complemented their interiors with coordinating furnishings, including several versions of cantilevered tubular steel chairs. His complete line of furniture is currently reproduced through Knoll and is seen as an icon of the twentieth century.

Charles Jeanneret-Gris, nom de plume LeCorbusier (1887–1965), a native-born Swiss, was another advocate of modern design. Even though most of his training was from a local art school, at age seventeen he designed his first house. In 1907, he took a grand tour of Europe and the Middle East where he sketched numerous ancient monuments. During these travels, he met Josef Hoffmann who exposed him to the work of the Wiener Werkstätte.

Over the next four years, LeCorbusier worked as an apprentice in the architectural firms of August Perret and Peter Behrens. As a leading proponent of modern architecture, Behrens collected European publications of Frank Lloyd Wright's work and kept them in his atelier. Here, LeCorbusier was first exposed to Wright's design philosophies. It was also in the studio of Behrens

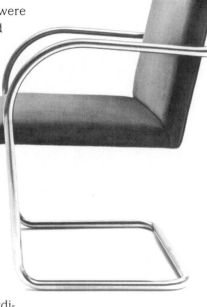

Figure 365 Mies van der Rohe designed the Brno chair for his Tugendhat house, an all-glass house built in Brno, Czechoslovakia, in 1930. The cantilevered base is made from stainless steel and supports an upholstered seat and back. Like many other Bauhaus furniture designs, the chair did not go into mass production until after the war. The Brno chair was added to the Knoll collection in 1960. Height 31", Width 23", Depth 23". Courtesy of Knoll.

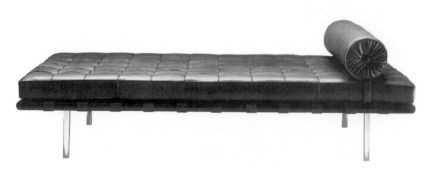

Figure 366 Mies van der Rohe's design for this couch maintains many of the characteristics from his Barcelona stool and chair collection, specifically steel, leather webbing, and tufted leather cushion. Mies designed this piece in 1930 for his close friend Philip Johnson. Height 24.4", Width 38.2", Depth 77". The Mies van der Rohe Collection, Courtesy of Knoll.

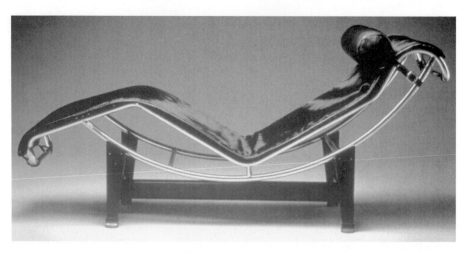

Figure 367 In 1929, LeCorbusier and Charlotte Perriand exhibited their newly designed furniture collection at the Salon d'Automne in Paris. Their efforts to treat the function of the supporting frame separate from the body of each piece, along with their use of tubular steel, are characteristic of their unique style of design. The back on this chaise longue designed in 1927 adjusts from an upright to reclined position by simply moving the arc-shaped frame along its detached base. Width 22.2″, Length 63″, Adjustable Height.
Courtesy Cassina.

where LeCorbusier met two other apprentices, Walter Gropius and Ludwig Mies van der Rohe.

In 1917, LeCorbusier relocated to Paris and began his own practice. After legally changing his name to LeCorbusier in 1920, he began to write extensively on modern design while developing a style of architecture that was truly purist in nature. Encompassing the avant garde theories of Cubism, his forms were reduced to geometrical solids emphasizing a machine aesthetic that supported the use of reinforced concrete and steel. LeCorbusier's claim that "the house is a machine for living in" summarized his more rational approach to design.

The 1925 Paris Exposition Des Arts Décoratifs et Industriels, the first of a series of expositions that continued through 1937, introduced furniture and decorative arts designed for mass production. LeCorbusier's Pavilion de l'Esprit

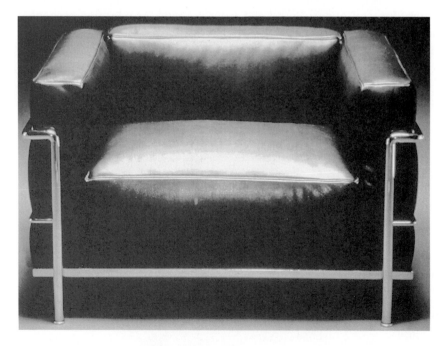

Figure 368 LeCorbusier and Perriand's Grand Comfort chair (available in two sizes with a matching settee) is manufactured with a separate steel frame that holds cushions in place to form the seat, back, and sides. Width 39″, Height 24.4″, Depth 28.7″.
Courtesy Cassina.

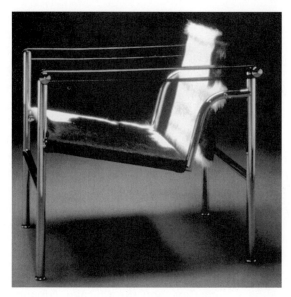

Figure 369 The seat and back of LeCorbusier and Perriand's sling chair are suspended from the steel frame that support it. Height 25.2″, Width 23.6″, Depth 25.5″. Courtesy Cassina.

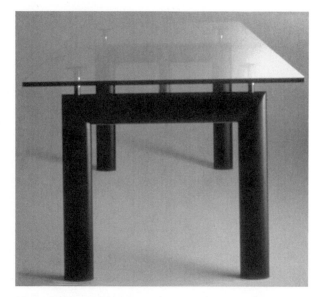

Figure 370 LeCorbusier and Perriand's plate glass table top appears to float above the frame as it is supported on slender adjustable posts. Height 27.1″, Width 88.6″, Depth 33.4″. Courtesy Cassina.

Nouveau showed attendees the architectural possibilities of mechanization and standardization. His method of using uniform measurements for doors, windows, and walls revolutionized residential construction.

The completion of Villa Savoye (see Color Plate 42) in 1929 introduced LeCorbusier-designed furniture that fit within the context of his architecture. The furniture satisfied both comfort and function, but was small in scale since LeCorbusier chose to emphasize the architecture of the interior space. He viewed furniture as sculpture—artwork that completed the overall integrity of the architecture. Along with LeCorbusier-designed tapestries, paintings, and sculptures, his furniture became accessory items. LeCorbusier preferred that the clients live in the space rather than among furniture.

The steel supports on chairs and tables mocked the pilotis used to elevate Villa Savoye's main living area above the ground. LeCorbusier treated the furniture support mechanism and body of the piece as separate entities, each depending on the other to function.

Tubular steel, black leather, and pony hide were basic materials used by LeCorbusier in furniture construction. Cushioned black leather or stretched pony hide kept the body from coming into direct contact with the supporting framework, thus eliminating discomfort to the sitter.

Art Deco and Art Moderne

The effects of the modern architectural movement continued to dominate European design throughout the 1920s and 1930s. Coupled with Cubist, Fauvist, and Futurist artists of the avant garde, industrial designers delighted a rising so-

Figure 371 Raymond Hood took first place in the design competition for the building of the Chicago Tribune Tower completed in 1922. At the time, U.S. architects struggled with the concept of the skyscraper and the emerging modern style. Still steeped in historicism, Hood's design incorporates Gothic detailing seen in the buttressing on the first setback of the ziggurated top. A few years later, Hood captured the essential qualities of Art Deco ziggurated skyscrapers, without historical rhetoric, in his imposing Rockefeller Center in New York.

cial class of aesthete elitists eager to commission works for the sole purpose of proclaiming an understanding and appreciation of ultra-modern art and design.

As the appreciation of modernity became fashionable, remarkable cultural change took place. Often referred to as the Jazz Age, popular culture of the 1920s embraced change like no other decade in history. Music, dance, clothing, and hairstyles resonated with modernization exemplified by Erté's graphic illustrations for *Harper's Bazaar* magazine.

Buildings such as the Chrysler, Empire State, and Rockefeller Center in New York City, and the Chicago Tribune in Chicago incorporated Aztec, Gothic, Egyptian, or primitive African designs into ziggurated façades. The sleekness of the industrial age manifested through these engineering achievements influenced both the Art Deco and Art Moderne styles.

Significant contributions to modern design were made through the Metropolitan Museum of Art in New York City. The American Industrial Art Exhibition held annually from 1917–1940 introduced the sleek styling of a streamlined age of industrial glamour. The name Art Moderne exemplified the marriage of art and industry into aesthetically designed objects that lacked the industrial harshness of earlier modern designs.

Figure 372 Macassar ebony, ivory, silvered bronze, and snakeskin combine to create this spectacular desk designed by Emile-Jacques Ruhlmann around 1925–1927. Ruhlmann's use of exotic materials such as these kept his work out of the assembly lines and in the households of wealthy patrons. Height 28½″, Width 53″, Depth 28½″.
Virginia Museum of Fine Arts, Richmond, VA. Gift of Sydney and Frances Lewis. Photo: Katherine Wetzel. ©1997 Virginia Museum of Fine Arts.

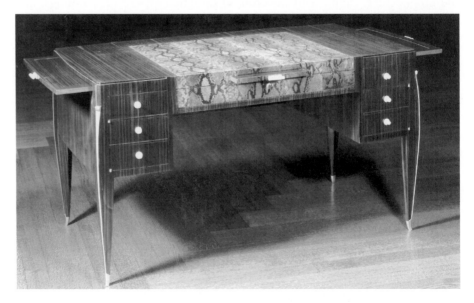

The harder edges of ziggurated façades and sharp angles were softened by incorporating a series of circles and arcs into glossy interiors accentuated with lacquered furniture. An increased use of bakelite, a hard plastic that was easily formed into a variety of shapes and sizes, made streamlined industrial products and cheap decorative objects more affordable to the general public.

The 1925 Paris Exposition Des Arts Décoratifs et Industriels expressed the new style of Art Deco, evolving from a culmination of machine aesthetics coupled with lavish ornamentation and rich color to whimsical interpretations of space and form. A special pavilion was devoted to the outrageously exotic furnishings of Jacques-Emile Ruhlmann (1879–1933) who revived the opulence of cabinetwork unequaled since the French Baroque period in the seventeenth century. The Art Deco style of the 1920s emphasized exotic woods and high quality craftsmanship (see Color Plate 45).

Figure 373 A side chair made from elm burl emphasizes the contemporary lines and exotic woods typical of the 1920s Art Deco style. This chair dates from the late twentieth century. Height 33″ Width 19½″ Depth 16″, Seat Height 17″.
Photos courtesy Shapes Collection, Los Angeles.

Figure 374 An Art Deco-style bed made of Macassar ebony. Height 48″, Width 72″, Length 84″, Footboard Height 34″.
Courtesy Shapes Collection, Los Angeles.

Figure 375 A console table made of wrought iron with marble top and base evokes the spirit of the Art Deco style and the essence of E. Brandt. Height 36″, Width 22″, Length 62″.
Courtesy Shapes Collection, Los Angeles.

Similarly, René Lalique (1860–1945) contributed to the advancement of the decorative arts. His creations in crystal evoked the feeling of the Art Deco style and embodied central themes seen in the graphic illustrations of Erté.

The designer-turned-architect Eileen Gray (1879–1976) successfully combined the more decorative Art Deco styling with Bauhaus machine aesthetics and LeCorbusier industrialism. Often overlooked, but nonetheless important, Gray made significant contributions to the field of design. After studying drawing and learning the craft of Japanese lacquerwork in London, she left for Paris in 1902 to further develop her interest in lacquering techniques. While in Paris, Gray was trained in this ancient art by the Japanese cabinetmaker and lacquerworker, Sugawara.

She began her career as a designer of exotic lacquered screens for wealthy Parisian patrons. These designs were so successful that, in 1922, Gray opened

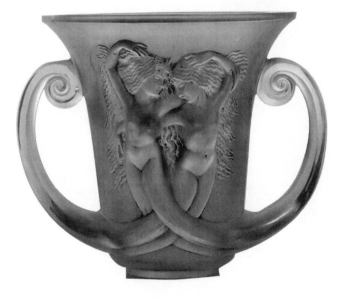

Figure 376 French designer René Lalique earned a reputation for designs in fine crystal. This vase was made by pressing the glass into a patterned mold. Lalique crystal is still in production today.
The Metropolitan Museum of Art, Gift of Edward G. Moore, Jr., 1936.

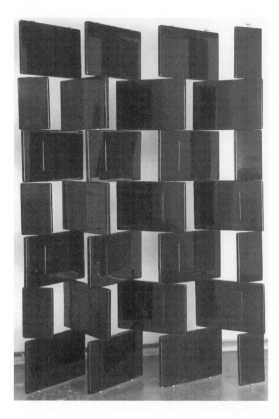

Figure 377 A lacquered screen designed by Eileen Gray in 1922 with pivoting panels captures the sleekness of the Modern movement. Height 67.2", Width 59.8".
Courtesy of the Board of Trustees of the V&A.

her own workshop and gallery to produce and sell her collection. During this time, Gray expanded the content of her work to include wood furniture, lamps, mirrors, and hand-woven textiles.

These early works depict a definitive Art Deco styling exemplified through the use of shiny finishes, bright colors, and exotic materials—rich inlays of ivory, colored enamels, and ebony. After Gray saw the work of LeCorbusier in

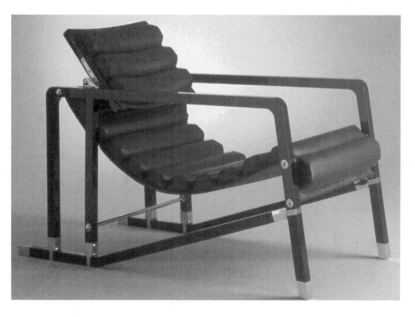

Figure 378 The Transat chair designed and patented by Eileen Gray and Jean Badovici in 1927 has a lacquered wood frame with leather upholstery. Notice the adjustable headrest. Height 30.5", Width 22.2", Depth 42.1".
Courtesy Luminaire and Architects, SRL.

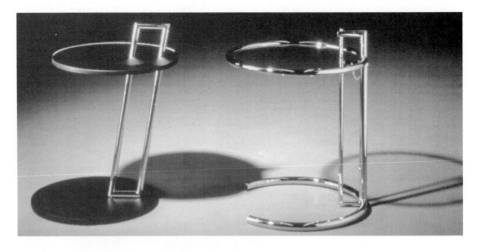

Figure 379 Cantilevered tubular steel frames support wood and glass tops on these side tables designed by Eileen Gray between 1925 and 1928. Courtesy Luminaire and Architects, SRL.

1922 at a Parisian exhibition, her designs evolved to reflect the theories of LeCorbusier, the Bauhaus, and the De Stijl movement.

In 1926, Gray received a commission to design and build a house on the Côte d'Azur in France. From 1926 until 1929, Gray and her partner, Jean Badovici, devoted most of their time and attention to the Maison E.1027. Designing every last detail from the outside structure to the interior, Gray created chromium steel and glass furniture that transformed the Art Deco designer into one epitomizing the International Style.

The Art Deco style gained in popularity throughout the 1920s, and by the end of the decade had reached its pinnacle in America and Europe.

Jean Michel Frank, a leading French designer working in the Art Moderne style, captured the playfulness of Surrealism in his work on the Mae West room (see Color Plate 43). Marrying art with industry, Frank created overstuffed furnishings immortalized by his famous lip sofa (see Color Plate 44) and lipstick chair.

Figure 380 This armchair designed by Jean Michel Frank is reflective of Art Deco styling with its arched back and rounded arms. Height 37″, Width 32⅝″, Depth 31½″. Courtesy Palazzetti.

FURNITURE OF THE POST-WAR PERIOD

While architects and furniture designers in Europe and America in the 1920s and 1930s became increasingly fascinated with industrialization and man-made materials, designers of the Scandinavian countries (Denmark, Sweden, and Norway) and Finland looked to their own natural resources for inspiration. Combining mechanized fabrication with hand-finished detailing, these designers used teak, birch, and maple to replace tubular steel in furniture production. The warmth and natural coloring of the bentwood coupled with natural fiber textiles used on cushions and upholstery softened the contours of modern furniture design.

One of the most recognized modern furniture designers was Alvar Aalto (1898–1976) from Finland. His process for bending plywood—which he patented in 1933—led to the design of his famous stacking stool and lounge chair. Aalto and his wife Aino Marsio formed the Artek company to fabricate Aalto's unique and influential creations. Original Aalto furniture is still produced by the Artek company following his exact specifications for production that include both mechanical and hand-finishing processes.

Figure 381 Alvar Aalto designed the stacking stool around 1933–1935. Made of beechwood, the stool is lightweight yet sturdy in its construction. Height 18½", Diameter 15".
Courtesy Palazzetti.

Aalto's accomplishments with bending laminated woods inspired Marcel Breuer to create his own version of an organically designed chaise lounge in 1935. After Aalto's stacking stool was exhibited at the New York World's Fair in 1939, Scandinavian design gained significant popularity in America. The natural lightness of materials and the economy of line led Americans to popularize this contemporary style throughout the next decade. Also noteworthy is Aalto's influence on American designer Charles Eames. Eames introduced his rendition of a molded plywood chair in 1940.

The decade of the 1920s is historically known as the "Jazz Age," but the slogan for the 1930s became "Brother can you spare a dime?" Although the Great Depression started in America with the crash of the New York Stock Market, economic ramifications were worldwide. The number of unemployed reached record numbers in America and abroad.

In America, economic recovery came about slowly, encouraged by government intervention that boosted manufacturing and development through

Figure 382 This molded plywood chair was developed for the Paimio Sanatorium by Alvar Aalto between 1930 and 1933 and is still in production today. Although the chair is constructed entirely from wood, the rounded contoured seat and back make it comfortable to sit in. Height 25.2", Width 23.6", Depth 31.5".
Courtesy ICF.

the Works Progress Administration. The New Deal implemented by President Franklin Roosevelt gave Americans the necessary means to support economic recovery and boost American manufacturing.

While Americans dealt with the Great Depression, independent European countries cautiously watched the activities of the National Socialist Party. In the Spring of 1933 under Adolf Hitler's leadership, the Nazi Party held supreme power in Germany. Before the year ended, concentration camps began filling up with resisters and persecuted Jews. Those who could leave the country did so, many fleeing to England and the United States.

As previously mentioned, the doors to the Bauhaus closed in 1933 by orders of the National Socialist Party. Afterward, many faculty members and students left Germany for England and America. Walter Gropius, who had left as director of the Bauhaus in 1928, went to England in 1934, worked there briefly, then moved to the United States in 1937 accompanied by Marcel Breuer. Both became professors at Harvard University with Gropius eventually becoming Director of the School of Architecture. The two combined their architectural talents and built several homes in New England. Their work in residential design brought Bauhaus styling to the American vernacular. While Breuer went on to establish his own architectural practice in New York, Gropius remained in Cambridge and formed The Architects Collaborative in 1945.

Open-plan dwellings catered to changing American lifestyles brought on by the economic Depression of the 1930s. Lack of work forced many Americans from their home towns in search of employment. Consequently, temporary living quarters in rooming houses and small apartments kept household furnishings to basic essentials. This change in American culture inspired the need for easily transported, lightweight furniture produced using sophisticated technology. Mass-produced furniture fit more appropriately into the budgets of American families. Almost prophetic in a lecture given at the Technical University in Delft in 1931, Breuer commented,

> A few simple objects are enough, when these are good, multi-use, and capable of variation. We avoid thus the slavish pouring of our needs into countless commodities that complicate our daily lives instead of simplifying them and making them easier.

Ludwig Mies van der Rohe arrived in America a year after Gropius and Breuer. He settled in Chicago and became the Director of Architecture at the Armour Institute (renamed the Illinois Institute of Technology) where he contributed to the design of many campus buildings. Eventually, Mies left Chicago to become Director of Architecture at Massachusetts Institute of Technology in Cambridge.

German forces under Hitler's command invaded Poland in 1939, officially marking the beginning of World War II. The war accelerated over the next two years, engulfing all of Europe, Great Britain, parts of Russia, Greece, the Pacific Islands, and North Africa. Extensive bombing raids made by both Allied and Axis powers caused considerable damage to human life and property. In Great Britain, the government stepped in and established an emergency relief fund for bombing victims. Those left without home furnishings could purchase new items through a catalog of basic utilitarian furniture regulated by the Board of

Trade. Utility furniture was the only style of furniture produced in Great Britain during the 1940s, as the manufacture of wartime equipment took precedence over furniture production.

America had not yet entered the war in 1940, and therefore was not limited in resources and there were no government-imposed manufacturing restrictions. In an attempt to promote creative development in America, the Museum of Modern Art in New York sponsored a competition with the central theme "Organic Design in Home Furnishings." Furniture, textile, and lighting designers were encouraged to send in entries; the winning entrants were promised manufacturing contracts to produce the designs. Distribution of the work was to be handled through the twelve department and furniture stores co-sponsoring the exhibition.

Charles Eames (1907–1978) and Eero Saarinen (1910–1961) won the prize for furniture design with a living room entry that combined modular furniture units with an informal grouping of chairs around a low, round table. The entry had fulfilled the intent of the competition. Eames and Saarinen created organically designed home furnishings offering modern conveniences for the new American lifestyle. The working partnership of Eames and Saarinen was short lived; however, their accomplishments changed American design for the next two decades. Their furniture revolutionized the American living room by reducing the bulk of heavy upholstered goods that cluttered newer small houses.

St. Louis-born Eames studied architecture at Washington University and worked for a local architect after graduation. He worked privately until 1937 when hired by Eliel Saarinen (1873–1950) to head up the Experimental Design department at the Cranbrook Academy of Art. It was here that Eames met Eliel's son, Eero. Eero came to the United States with his family in 1923 after his father won second place in the design competition for the Chicago Tribune Tower. He attended art school in Paris before returning to the United States to study architecture at Yale University. Upon graduation, Eero earned a scholarship enabling him to travel throughout Europe for two years; he returned in 1936 to teach at the Cranbrook Academy of Art.

Although Eames and Saarinen won the Museum of Modern Art design competition, American involvement in World War II delayed the production of their work. The winners of the competition had to wait until after the war before their impact on American design could be realized.

On December 7, 1941, Pearl Harbor was bombed by the Japanese. As the United States declared war the next day, American manufacture of consumer goods virtually shut down and geared up for military production. The government placed restrictions on manufacturing that limited the use of raw materials including timber and metal. Instead of refrigerators, automobiles, and washing machines, metal was used to manufacture bombs, tanks, and munitions. America was brought out of the Depression through an increase in government spending on the war.

Since raw materials were scarce during the war, experimentation with new and recyclable materials led to significant discoveries that not only benefited the production of military equipment, but home furnishings as well. Plywood, laminated cross-grained layers of thin wood, produced a lightweight but durable substitute for solid lumber. Eames and his wife Ray spent the war years mak-

ing wooden leg splints for the Navy. As they experimented with molding plywood to make the splints, they continued to perfect the winning chair design. The chair was designed with a separate seat, back, leg, and supporting frame out of molded plywood. Once formed, the seat and back attached to the plywood support frame with galvanized rubber disks, which Eames added as shock absorbers, between the molded plywood and the frame.

The war finally ended in 1945. By 1946, the Museum of Modern Art exhibited new furniture designed by Charles Eames in a show of the same title. Herman Miller, Inc. a major furniture manufacturing company based in Zeeland, Michigan, purchased the production rights from Eames and went on to manufacture all of Eames's designs.

In 1948, Eames introduced another version of the molded plywood chair. Aluminum was substituted for the molded plywood of the support frame and leg in the previous design. Both versions were easily manufactured through assembly-line production and provided comfort to the newfound American consumer. Eames's molded plywood chairs became an icon of American popular culture of the 1940s and 1950s.

At the end of World War II, veterans returned to home towns across America eager to secure civilian work and start families. Money earned from military service coupled with available mortgage financing enabled a newly emerging middle class to purchase the American dream—a new home. Tract homes built in the early 1950s offered returning veterans affordable housing. Soon, suburban America grew out of developer-planned communities.

The California style or ranch style home exemplified the quintessential American tract home. Designed and built with a sense of economy, these homes featured flat roofs, a carport, and a patio for outside entertaining. Generally, the homes had two or three bedrooms with one or two bathrooms, prefabricated kitchen components, and a combined living and dining space. The more informal living and dining space opened onto the patio through sliding glass doors. This created a more casual atmosphere that allowed for flexibility in indoor and outdoor entertaining.

The furniture had to be flexible. Modular furniture fit well into the interior scheme because of its adaptability; storage units, bookshelves, and cabinets could be modified by restacking or reconfiguring the arrangement. The furniture designed by Eames and Saarinen was well suited to this environment.

Another leading figure in the perpetuation of modern design in the post-war era was Florence Schust (b. 1917).

Schust met Eames and Saarinen while she was an architectural student at the Cranbrook Academy of Art. She later studied at the Illinois Institute of Technology under the leadership of Mies van der Rohe. After her marriage to the German furniture designer Hans Knoll (1914–1955), the husband and

Figure 383 This molded plywood chair designed by Charles and Ray Eames and manufactured through Herman Miller, Inc., captured the American post-war market. The chair was designed in two versions: the LCW (lounge chair wood) shown here and the DCW (dining chair wood). Notice the galvanized rubber disks positioned between the frame, back, and seat. Height 26.8″, Width 22″, Depth 25.9″.

Courtesy of Herman Miller Inc., Zeeland, MI 49464. Photograph by Phil Schaafsma.

wife team formed Knoll Associates, Inc., in 1946 (see Color Plate 46). Their goal was to merge furniture and textile design into one complete manufacturing package, promoting a collection of interior products designed by Florence and others. At this time, Knoll signed on some of the leading furniture designers of the twentieth century, including Eero Saarinen and Mies van der Rohe.

Knoll signed on another designer affiliated with the Cranbrook Academy of Art, Harry Bertoia (1915–1978). Bertoia began his career as a student at Cranbrook and eventually became a member of the faculty. Early experimentation with designing furniture resulted in Eames-inspired molded plywood types; however, Bertoia's interest had previously been in metal sculpting. He quickly abandoned wood and returned to working with metal. Bertoia's ability to sculpt and mold metal greatly influenced his future as a designer of furniture. He commented that when "it came to rod or wire, whether bent or straight, I seemed to find myself at home. It was logical to make an attempt by utilizing the wire." In 1952, Knoll introduced the Bertoia collection of wire chairs. Bertoia analyzed the connection between sculpture and furniture. He summarized this ability to translate one concept into the other in describing the wire chairs: "Chairs are studies in space, form, and metal too. If you look at these chairs, you will find that they are mostly made of air, just like sculpture. Space passes right through them."

Figure 384 A detail of the galvanized rubber disks used by Eames between the seat and supporting frame.

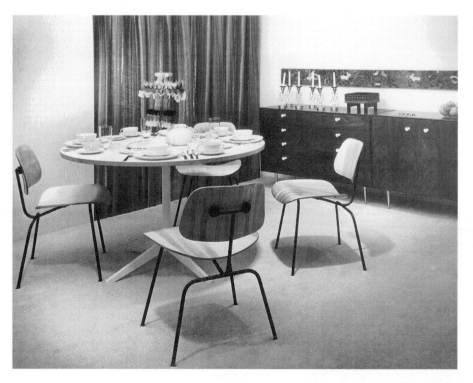

Figure 385 The DCM (dining chair metal), shown here in a photograph taken in 1953, was made from laminated zebra wood supported by a metal frame and metal legs. The Eames's trademark galvanized rubber disks are visible on the chair in the foreground. Reducing the legs to thin metal supports on chairs, table, and sideboard gives the room its uncluttered appearance.

Courtesy of Herman Miller Inc., Zeeland, MI 49464. Photograph by Dale Rooks.

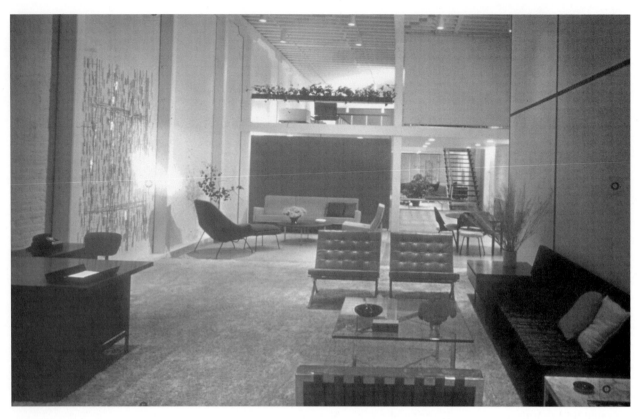

Saarinen's furniture designs were also manufactured through Knoll Associates, Inc.; he was paid royalties on each item sold. Compared to Eames's designs, Saarinen's were equally organic in form but he chose to work with different materials. Like Bertoia, Saarinen's experimentation with molded plywood was brief; he chose instead to work with plastics.

In 1946, Saarinen introduced a chair made from a press-formed plastic shell supported by a steel structural framework. Instead of traditional upholstery, the plastic shell was made more comfortable for the sitter with a covering of foam rubber (another new material developed during the war) encased between the plastic shell and woven fabric. This reduced the weight of the chair by nearly one-half compared to a chair made with traditional upholstery methods. As Florence Knoll sat in the chair, she appropriately named it the Womb chair because of

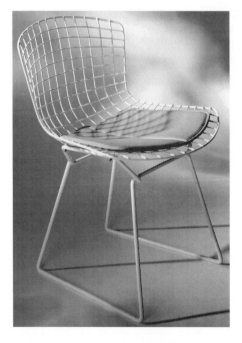

its comfort. The body of the chair raised on slender steel legs expresses Saarinen's disgust with the cluttering of architectural spaces with unnecessary elements. In a speech given to the Society of Industrial Designers, he explained himself: "The undercarriage of chairs and tables in a typical interior makes an ugly, confusing, unrestful world. I wanted to clean up the slum of legs."

In 1951, Eames introduced a shell-type chair made out of thermoset resin-reinforced glass fibers. The seat unit was formed out of this colored fiberglass-reinforced plastic and shaped so the seat, back, and sides were one continuous piece. The plastic seat shell was supported by a thin steel framework of legs that was held in place by characteristic galvanized rubber disks (see Color Plate 47).

Eames continued to design furniture throughout the 1950s, expanding into the commercial market by introducing tandem seating for airport terminals. Herman Miller Inc. continued to sell Eames-designed plastic shell chairs and the molded plywood chairs, along with molded plywood coffee tables, stools, and screens for the residential market. In 1956, Eames added another design to his collection: a lounge chair and an ottoman. This chair came to encapsulate the achievements of molded plywood and was the perfect chair for a new American pastime, TV watching.

First thought to be an invention that would not amount to much, television became increasingly popular during the 1950s when the price of a set was within reach of the typical middle-class family. A radio could be anywhere in the room, with family members reading a book, sewing, or working a jigsaw

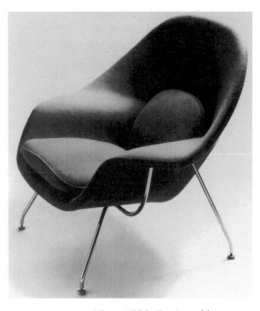

Figure 388 Designed by Saarinen in 1946, this chair was given the name "Womb" chair by Florence Knoll who quickly attested to its comfort. The chair utilized two new post-war materials in its fabrication process: plastic and foam rubber. Traditional upholstery methods that had depended on coils and stuffing for support and comfort were replaced with the Womb chair's molded plastic shell layered with foam rubber and covered with a wool fabric. Courtesy of Knoll.

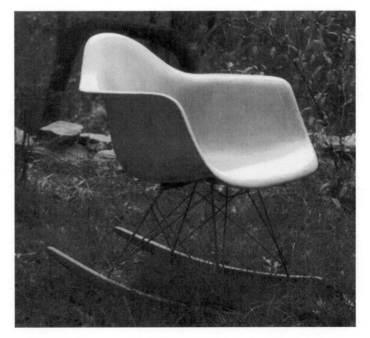

Figure 389 The 1951 Eames Shell chair is made of molded fiberglass with aluminum supports on rockers. Private Collection, Photo courtesy Laura Rafferty.

Figure 390 The Eames lounge chair and ottoman made from molded rosewood plywood has tufted leather upholstery and an aluminum frame. Galvanized rubber disks (visible on headrest and back) are still employed, connecting the frame to headrest, back, and seat. Lounge: Height 31.5", Width 32.3", Depth 33.4". Ottoman: Height 17.3", Width 25.9", Depth 20.8".
Courtesy of Herman Miller Inc., Zeeland, MI 49464. Photograph by Earl Woods.

Figure 391 The Tulip collection of chairs, shown here with circular tables, was designed by Saarinen and introduced through Knoll in 1957. Saarinen emphasized slender aluminum pedestals that appear to effortlessly support the mass of the structure in the design of both marble table and fiberglass-coated plastic shell chairs. Although pedestal tables date back to Egyptian times, Saarinen's Tulip chair was the first to utilize a pedestal base.
Courtesy of Knoll.

puzzle. The radio provided hours of entertainment and news as long as the listener was within earshot. A television set, however, was something that had to be watched. This new invention quickly altered the arrangement of the family living room. Now the furniture was arranged to face the TV set. American lifestyles changed from formal sit-down meals to quick TV dinners and a more relaxed, casual existence.

Charles Eames and Eero Saarinen continued their contracts with Herman Miller and Knoll, respectively. Each designer considered comfort and functional flexibility as a key factor in successful designs. While Eames chose to work in plywood, Saarinen preferred to work with man-made materials and approached the structural aspects of furniture similarly to his architectural de-

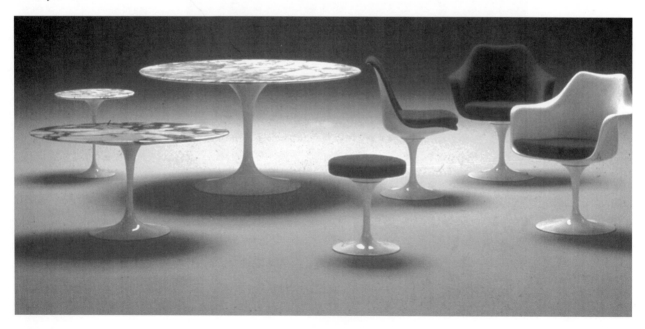

Figure 392 The interior of the TWA terminal at JFK Airport in New York built in 1962 reveals the organic nature of Eero Saarinen's architectural designs and captures the essence of his furniture designs through sweeping lines and biomorphic shapes.

signs. Recalling the Womb chair, slim steel legs seemed to effortlessly support the upholstered molded shell, giving the design a sense of weightlessness. When the Tulip collection, introduced in 1957, was combined with Saarinen-designed tables, it created a similar feeling of lightness, as if the mass was suspended in space (see Color Plate 48).

The organically shaped seats supported by slender legs or pedestals compare with Saarinen's architectural designs for two airport terminals: the TWA terminal at JFK Airport in New York and Dulles Airport serving Washington, D.C. (both airports completed the year after his death). The biomorphic interior of the TWA terminal and the gravity defying sloped concrete roof of Dulles reflect a common attitude of the 1950s—a fascination with futuristic design.

Most Americans were eager to put World War II behind them, but the Cold War was an ever-present reminder of living in the atomic age. By 1957, scien-

Figure 393 Eero Saarinen's design for Dulles Airport reveals the core of his gravity-defying structural designs. The original terminal, designed in 1961–1962, was constructed using slender columns that seem to effortlessly support the roof as they penetrate through the massive concrete. Saarinen applies this visual dichotomy to his furniture designs as already seen with the Tulip chair, Womb chair, and Saarinen tables.

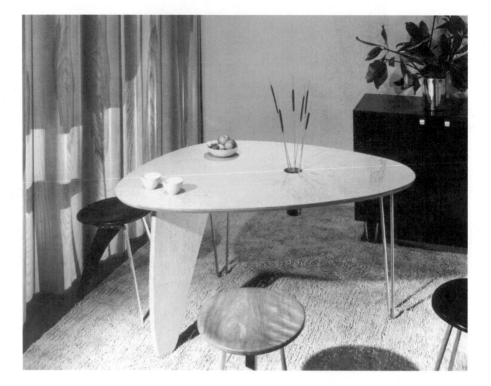

Figure 394 This interior setting from 1949 shows Noguchi-designed table and stools, an Eames molded plywood screen (left), and a sideboard by George Nelson. Noguchi's use of amorphic shapes set the direction for the futuristic-looking design trends of the 1950s.

Courtesy of Herman Miller Inc., Zeeland, MI 49464. Photograph by Herman Miller.

tific research and development propelled human beings toward space with the Russian launch of Sputnik, the first satellite. The design industry produced goods that exemplified this fascination with speed and space travel. Soon, space-age designs took over; boomerang patterns, space-ship-inspired architecture, and futuristic automobiles reflected this latest look of modernism. Streamlined products with push-button controls gave the appearance of gliding through space. Popular culture was enthralled with the possibilities of living on the moon.

Figure 395 Noguchi's biomorphic-shaped sofa and ottoman are shown grouped around a circular coffee table in this photograph taken in 1949. Features such as the conical legs, boomerang shapes, and armless sofa set a contemporary tone for furniture designs of the 1950s.

Courtesy of Herman Miller Inc., Zeeland, MI 49464.

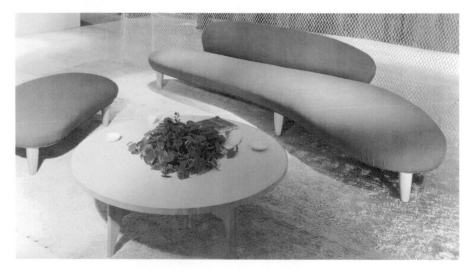

American-born Isamu Noguchi (1904–1988) was one of the first designers to translate this science fiction attitude into futuristic furnishings for the home. Bizarre biomorphic-shaped sofas and tables were considered too extreme when first introduced in the late 1940s and were not mass produced until the 1950s. Other designers followed Noguchi's lead. Noguchi worked as a freelance designer selling work to both Herman Miller and Knoll (see Color Plate 49).

Eventually, both the Herman Miller Company and Knoll focused more on the manufacture of office and commercial furniture and discontinued many of their post-war production designs. As the next decade unfolded, these icons of contemporary design were replaced with new furniture designed for a rapidly changing consumer-based American culture. Only recently have the classics of modern furniture been reintroduced to an enthusiastic public, eager to own an "original."

Figure 396 Scandinavian designer Arne Jacobsen exaggerates organic forms derived from nature to create interesting, yet comfortable sculptural furnishings. His Egg chair designed in 1958 has a molded fiberglass shell layered with foam and fabric and is supported by an aluminum base.
Showroom Collection, Citi Modern, Dallas.

Figure 397 Verner Panton, an associate of Jacobsen, has his own vision of what futuristic design should be in the "space age." The Cone chair, designed in 1959, anticipates the mood of 1960s Pop art.
Showroom Collection, Citi Modern, Dallas.

CONTEMPORARY FURNITURE

In 1957, when the USSR launched Sputnik, the world's fascination with outer space quickly became reality. What was considered to be science fiction in the 1950s quickly became science in the 1960s. American President John F. Kennedy felt that the future lay in space; thus, the United States began a race to the moon against the Russians. Now more than ever, the dream that humans could someday walk on the moon meant that life on earth also would change.

In anticipation of this new way of life, the late 1950s and early 1960s experienced drastic change in design trends once more. The organic designs that enveloped the early 1940s took on an entirely new direction. As humans ventured beyond the earth's atmosphere, buildings began to look like space stations and space ships. The geodesic dome, inspired by architect and industrial designer Buckminster Fuller, hinted at what a space colony might look like. Circular, biomorphic shapes supplemented the angularity of the 1950s. Adaptable housing, inspired by the prefabricated mobile home, was more conducive to a temporary lifestyle and was well suited to change. Prefabrication was considered the wave of the future.

Figure 398 The futuristic appeal of housing projects like this one, designed for the 1967 Montreal Expo by Moshe Safdie and Associates, is in the prefabrication of building materials that are easily installed on site and functioning within days of assembly. Each module is made from precast concrete at a factory, shipped to the site, and arranged as stackable units.
Courtesy ©Jerry Spearman/Moshe Safdie and Associates.

With the emergence of the youth culture, the 1960s experienced progressive change inspired by the pop art movement begun in New York and London. Soon, the design of almost everything had to have a gimmick, evoke fantasy, or reflect space-age technologies. If it were going to be popular, it would have to be different (see Color Plate 50). An emphasis on the temporary here-and-now dominated everything from housing design to furniture to clothing. Culture was something that was used to change—rapid change that evoked a sense of the disposable aspects of daily life.

What was here today most often was gone tomorrow, and popular culture capitalized on the disposable consumerism that dominated American life. Emphasis was placed on the chair or adaptable seating unit, and round, organically shaped modules manufactured out of plastic materials prevailed.

An easier lifestyle centered on a seemingly younger generation—one that never saw the Great Depression or suffered through the rationing of World War II. More and more goods were available and at lower prices, thanks to sophisticated manufacturing processes and the wonder material, plastic. Soon, cheap goods replaced well-built, more expensive ones. The generation grew up on the belief that once used up, throw it out. Furniture became more disposable as well. Buy a plastic chair, use it, and when it no longer performs, throw it out with the plastic milk cartons.

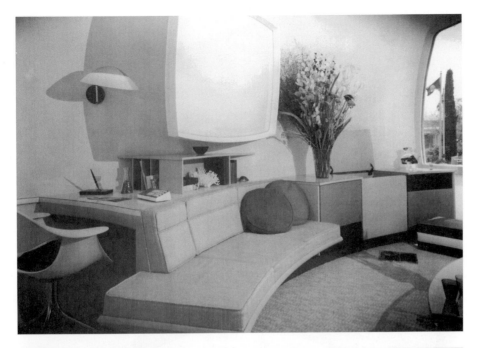

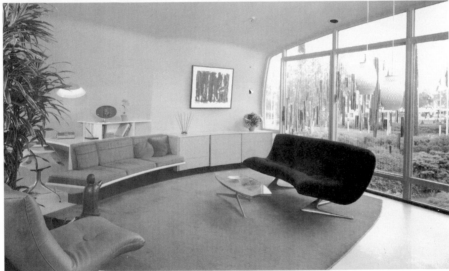

Figure 399 Researchers, engineers, and designers from the Monsanto Company and the Massachusetts Institute of Technology joined forces to study the long-term potential for using plastics in building construction. After four years of study, in 1957 Monsanto opened the doors to the Plastics House of the Future,™ a one-story house built entirely from molded plastics. The futuristic architectural structure boasted rounded corners and flowing curves, full-wall glass windows, and four cantilevered wings. These photographs show the almost capsule-like formation of the living room wing, with built-in furnishings that maximize interior space. Original 1957 interior furnishings were updated twice to reflect the latest in home fashions during the 10-year period the house stood. Shown here are two views of the same room: the large screen television was added to the interior during remodeling in 1960; the other view is from 1964. Rooms were furnished with items manufactured by Heywood-Wakefield and Herman Miller, with lighting designed by Noguchi.

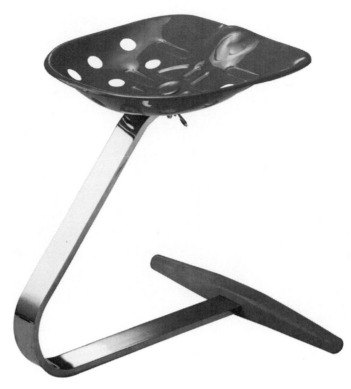

Figure 400 The Mezzadro stool, or tractor seat stool, was designed in 1957 by Italian designer Castiglioni. Re-released in 1971, the stool's design captures the spirit of the Pop art movement that endured for almost two decades.
Courtesy ICF.

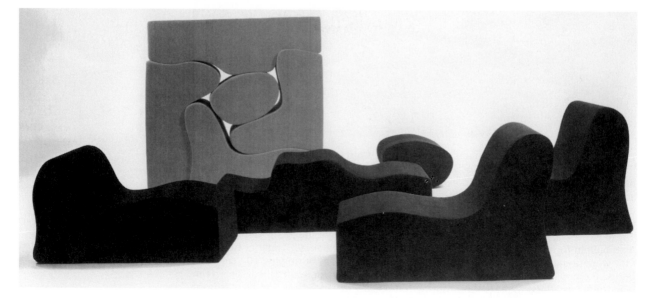

Figure 401 Roberto Sebastian Matta developed the stackable living room in 1966. The Malitte Lounge collection is made out of lightweight, polyurethane foam blocks covered with stretched wool fabric.
Courtesy of Knoll.

Figure 402 The Sacco seat by Italian designers Gatti, Paolini, and Teodoro was originally designed in 1969. Known today as the beanbag chair, its design endures as small polystrene balls encased in a vinyl or leather sack conform to any position of the body. Height 68 cm, Width 80 cm, Depth 70 cm.
Courtesy ICF.

Figure 403 Finnish designer Eero Aarnio designed the first "globe" chair in 1967. This adaptation, called the "pod" settee by Lee West Manufacturing of California, dates from 1970–1971 and was available as either a one- or two-seater with optional stereo speakers. Its design incorporates futuristic fantasy capitalizing on popular culture's fascination with the space race to the moon realized in 1969.
Showroom Collection, Citi Modern, Dallas.

Soon the younger generation, who questioned everything that had been established by the previous generation, found themselves living in a society that felt that life was disposable, too. Increasing American involvement in the conflict in Vietnam gave this younger generation a platform on which to rebel.

As the Vietnam conflict ended, the 1970s saw a return to a more stabilized, secure society. In the 1960s, the world was considered disposable; when things got too polluted, too used up, there was always the belief that mankind would find a new existence somewhere else. The Greenpeace movement, however, had given people a new outlook on their world, one that emphasized the fact that when things on earth did get too polluted, or used up, there would be nothing to sustain life here on earth. Consequently, human existence would cease.

A renewed interest in crafts, traditional materials, and processes followed. Colors of the earth based on the celadons of plant life, umbers of the soil, and other colors of nature became popular. Designers began to look to the past for their inspiration. Natural materials once again became the chosen element for furniture designers. More emphasis was placed on individual creativity rather than culturally mandated genres.

There was a dualism in the 1970s of taste and style. As the computer age influenced the functioning of everyday life, some designers reinterpreted the sleekness of industrialized materials of the Bauhaus era, while others sought a back-to-basics approach. A diversity of design characteristics resulted, with

Figure 404 The Lloyds of London building built by Richard Rodgers punctuates the London skyline with its stainless steel and industrial-like qualities.

Figure 405 Synthesizing the characteristics of Saarinen's Tulip collection and retaining the influence of Bertoia's sculptural use of metal, Warren Platner emphasized the industrial qualities of bent wire in his chair and table collection designed for the TWA grill at JFK airport in 1970.
Courtesy of Knoll.

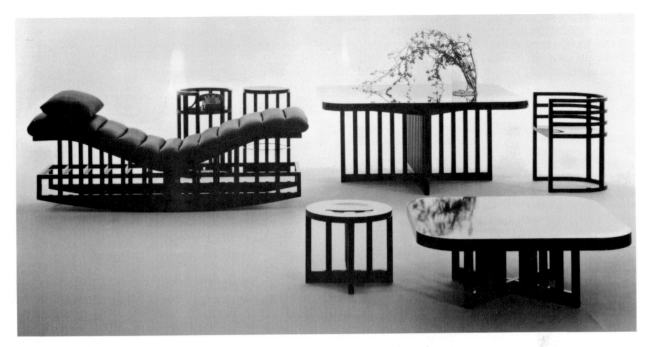

Figure 406 Richard Meier designed this collection of chairs, tables, and chaise lounge in 1982. The hand-rubbed, black stained maple finish and sculptural, geometric form evoke the spirit of the early modern designers, Mackintosh and Hoffmann.
Courtesy of Knoll.

each designer choosing what aspect suited him or her best: high-tech design based on the advances of an automated world or historically based retrospective styling.

The high-tech style of design set the direction both architecturally and in interior design. Objects that normally were used in factories or in an industrial setting were now used in the home: dome lighting, galvanized steel, and rubber flooring. Glass block made a comeback, creating interesting walls that accentuated the sleekness of fabricated materials. Nothing was sentimental or suggested anything prior to the extreme modernism seen in the early twentieth century.

POSTMODERN MOVEMENT

As the decade of the 1980s began, it seemed that design enthusiastically embraced every new emerging style. Ettore Sottsass led a group of young designers in what was known as the Memphis style. Loosely based on an interest in popular punk culture, the Memphis movement became the latest "shock" to the design industry. Charged with imagination and emotion, Memphis designers challenged the way in which materials were used. There existed a contradiction between high style and high tech, as the rationale of traditional wood furniture was transformed into that of wood and plastic laminate (see Color Plate 51).

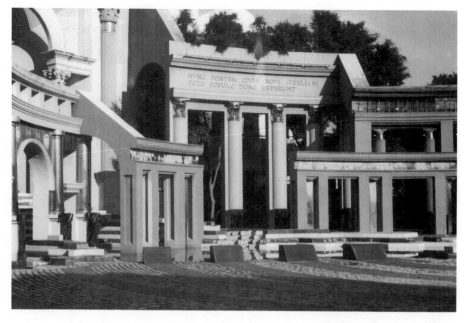

Figure 407 The Piazza d'Italia designed by Charles Moore for the City of New Orleans to commemorate its Italian ethnic population exemplifies one aspect of early Postmodern architecture. Moore completed this project in 1980 when Postmodernism was just beginning to emerge in the American vernacular. His approach to the modernization of historical elements in architecture includes highly stylized steel classical columns and capitals accentuated at night with bands of neon tubing.

Our understanding of the preservation of the earth and the basic human needs of society led to a more responsible approach to urbanization. The resulting movement, equivocally labeled Postmodern, turned toward a romantic and often sentimental interpretation of the past (see Color Plate 52). Robert Venturi (b. 1925), a leading proponent of Postmodernism, interpreted the past in his bold collection of chairs for Knoll based on eighteenth-century examples.

The work of French furniture designer turned architect Philippe Starck (b. 1949) incorporates cutting-edge styling with a retrospective interpretation of Art Moderne.

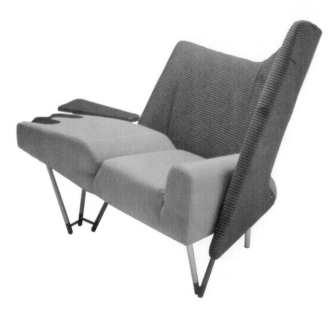

Figure 408 Designed in 1982 by the Italian designer Paolo Deganello, the Torso lounge reflects the nostalgic 1950s with soft boomerang contours supported by slender stick legs. The collection also includes a chair and settee. Width 57″, Height 45.6″, Depth 41.7″.
Courtesy Cassina.

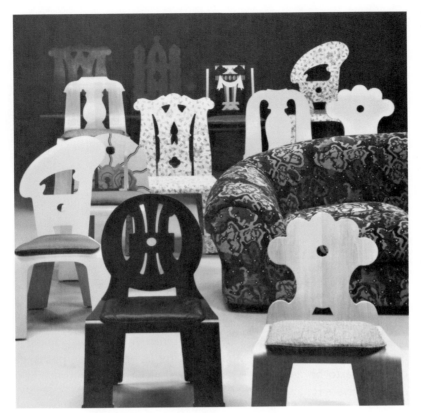

Figure 409 Architect Robert Venturi, one of the founding fathers of the American Postmodern movement, takes a novel approach to revitalizing historicism and decoration by designing a collection of chairs that parody earlier prototypes. Designed in 1979 and introduced through Knoll in 1984, his collection captures the form of Rococo, Neoclassic, Gothic, Art Deco, and Art Nouveau styling using twentieth-century materials and technology. Each chair is constructed from molded plywood covered with colorful, decorative laminates.
Courtesy of Knoll.

Figure 410 The Piazza Collection of furniture designed by Steve Kokinis in 1997 was inspired by great architecture of the past and present and captures the more whimsical side of the Postmodern movement. Landmarks include the Chrysler Building, Notre Dame Cathedral, and Philip Johnson's Sony Building.
Courtesy CIT Designs, California.

Figure 411 A bedroom dresser designed by Robert Kornstein in 1997 made from satinwood combines traditional craftsmanship and materials with artistic expression of form. Length 80″, Height 36″, Depth 20″.
Photo courtesy Arkadia, Englewood, NJ 07631, 800.223.3281.

Just as the nearing of the twentieth century impressed upon society what the future might bring, designers in the nineteenth century looked to the past for inspiration and stability. Modernism, for all practical purposes, gave artists the license to be as creative as possible, embracing culture that welcomed change, diversity, and individualism.

Figure 412 Philippe Starck combined the elegance of 1930s Deco styling with surprising interior details to create an interesting gathering place in the lobby of the Paramount Hotel in New York. A stainless chaise lounge designed by Australian designer Mark Newson accentuates Starck's tapering staircase and angled glass handrail.
Photo Courtesy Starck. Photo reproduced by permission.

Figure 416 The Bodleian chair, with its exaggerated volute arms, sweeping saber legs, and rolled back, takes a twentieth-century retrospective look at the Late Neo-classic Regency style. Designed by the architect Robert A. M. Stern.
Courtesy HBF.

Now, after a century of progress and rapid change, present-day designers are equipped with the realization that anything is possible and obtainable. No longer restricted by the mandates of a patron, whether public or private, the designer works with the freedom of an artist, creating for the sake of creation. As young designers looked inward for answers, practicality and function no longer hindered the creative mind. As society moves into the twenty-first century, and with a growing acceptance of multiculturalism, design no longer has restrictions or boundaries, as an individual's personal taste is reflective of the freedom to choose.

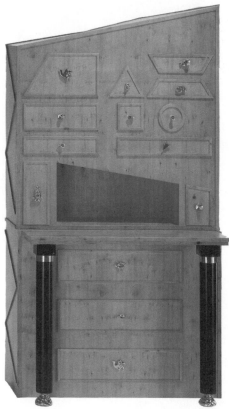

Figure 417 This contemporary secretary designed by Vicente de Moltó and made of yew offers a contemporary twist on the French Empire and Biedermeier styles of the nineteenth century.
Photo Courtesy Moltó, Geneva, Switzerland.

PART III
FURNITURE TECHNOLOGY

FURNITURE DESIGN AND CONSTRUCTION

THE ERGONOMICS OF DESIGN

Ergonomically and anthropometrically designed furniture can be traced back to the Egyptian period when the first raking-back chair was introduced in the palaces of the pharaohs. Ergonomics, a scientific approach to design, is based on the relationship between humans and their environment. In furniture design, the relationship is based on the function of the object and how the body responds to it.

The Egyptian chair with a raking back aligned the sitter in a more appropriate, somewhat reclined position, rather than a vertical, upright manner. The seat height was designed according to the physiological length between knee and foot so the feet would not dangle in midair. Remember, in Greek and Roman times, some chairs were equipped with a foot stool.

Ergonomically designed furniture takes into consideration the seat depth, back height, and seat-to-back tilt ratios as well as how adaptable the chair is to a change in the body's position. The tilt of the back and pitch of the seat are important factors. In designing most general-purpose chairs, the seat and back are kept perpendicular to one another. When the seat is pitched 5 degrees off the horizontal plane, the back is automatically tilted. Would this be comfortable?

By increasing the angle between the seat and the back from 90 degrees to 105 degrees, the seated person is made more comfortable since pressure is relieved from the tuberosities and distributed to the back. Keeping the back to seat angle at 105 degrees, the designer can vary the pitch of the seat off its horizontal plane from the standard 5 degrees to 15 degrees, ideal for an easy chair or recliner. Leaving the pitch at 0 degrees or in a direct horizontal position is seen in the design of a stool or a drafting chair where it is necessary to lean forward. Designing special-needs furniture obviously deviates from these formulas.

Obviously, different chairs are designed for different tasks, thereby requiring different solutions. An office desk chair will be designed differently from a chair for reading and so on. The main function of a chair, whether for office workers or for relaxing and reading, is to provide support for the lumbar area of the back. The designers of the Queen Anne spoon-back chair noticed

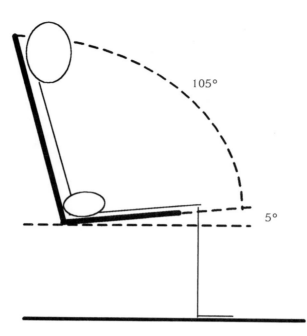

Figure 418 A general-purpose chair is designed with a seat-to-back ratio of 105 degrees, while the seat is pitched 5 degrees off of the horizontal plane.

105°

5°

that a seated person does not have a straight and vertical spine, nor a straight and slanted one; it is curved.

The spinal column is an undulating shape: shoulder blades out, lumbar in, buttocks out. Another concern for the seated person is the weight distribution of the body. The posterior ischial tuberosities maintain the body's balance and take the shock of the entire weight of the body bearing down on the seat. The depth of the seat must be correctly adjusted to the body's seated position because of the sensitive areas behind the knees. Blood circulation can be cut off

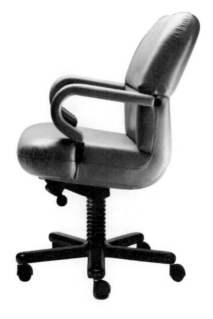

Figure 419 Designed by Niels Diffrient in 1979, this executive chair's ergonomic design uses a seat-to-back tilt ratio of 105 degrees and a seat pitch of 5 degrees off the horizontal plane. Notice the undulating shape of the back fits the curvature of the spine, providing extra support to the lumbar region. A five-star base insures the chair's stability while moving on casters.
Courtesy of Knoll.

Figure 420 Study this drawing of a Queen Anne side chair. Based on the information provided on ergonomics, how did the designer of the Queen Anne chair alter the seat-to-back tilt ratio and seat pitch to accommodate the seated body? Consider the shape of the "spoon" back. How does the design of this chair differ from chairs designed before the eighteenth century?

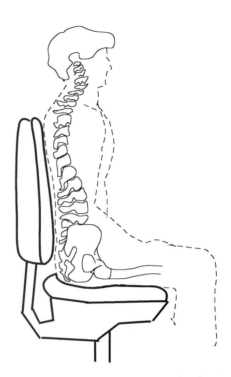

Figure 421 In this drawing, notice how the design of the chair fits the natural undulation of the spinal column. The pitch of the seat relieves pressure from the tuberosities and distributes more weight to the back. While providing enough support to stabilize the body, the seat depth is calculated to alleviate pressure from the back of the knee.

if there is too much pressure on this area. Also, if the seat is too short, the body becomes cantilevered without proper support and may lose its balance.

How do furniture designers know the correct proportional relationship between chair and sitter? The science of anthropometrics studies the measurement of the human body. The Greek's philosophy of "man is the measure of all things" came to life with Leonardo da Vinci's studies of anatomy. The proportional relationship between head and hand, hand and foot, and foot to overall body height was illustrated in his well-publicized drawing of the man in the square/circle.

Designers study anthropometric data to determine how high a chair seat should be from the floor, the placement of the armrest above the seat, and the width of chair seat. An incorrect system of figuring these calculations would be to base the dimensions on an "average" size. Instead, the designer should concentrate on the "normal"-sized individual.

The normal sizes are determined by decades of studies recording the measurements of a cross-section of individuals from various countries and in specific age groups. Once the information is compiled, a figure is determined reflecting the percentage of the population that fits these measurements. For

example, if 95 percent of the adult male population has a shoulder breadth of 19 inches and only 5 percent of the population has a breadth of 17 inches, then the average size of 18 inches would not be a successful compromise. If so, then only 5 percent of the adult male population could sit comfortably (or fit) in a wing chair that had a breadth of 18 inches, while 95 percent of the population would be eliminated. The designer should study anthropometric data for the larger percentile range of the population rather than working from averages.

By designing a wing chair 20 inches in breadth, it satisfies a functional requirement for 95 percent of adult males and accommodates a larger percentage of the population. When the data for women are included, again this becomes a concern of the furniture designer. Do you compromise? If so, how? Study the following diagrams to determine what is considered industry standard for seat height, width, depth, etc.

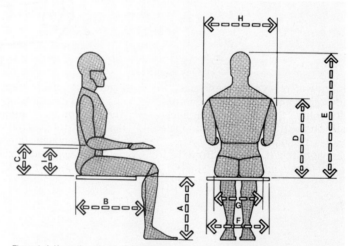

Figure 4–4. Key anthropometric dimensions required for chair design.

Figure 422 These diagrams are keyed to the chart below and reflect the more important measurements considered by designers in the manufacture of furniture. Review the information presented in this chapter regarding the meaning of the percentile ranking system; it is better to design for 95 percent of the population than for only 5 percent.

Diagram and chart from *Human Dimensions & Interior Spaces*. Copyright ©1979 by Julius Panero and Martin Zelnik by arrangement with The Whitney Library of Design, an imprint of Watson-Guptill Publications, a division of BPI Communications, Inc.

	MEN				WOMEN			
	Percentile				Percentile			
	5		95		5		95	
MEASUREMENT	in	cm	in	cm	in	cm	in	cm
A Popliteal Height	15.5	39.4	19.3	49.0	14.0	35.6	17.5	44.5
B Buttock-Popliteal Length	17.3	43.9	21.6	54.9	17.0	43.2	21.0	53.3
C Elbow Rest Height	7.4	18.8	11.6	29.5	7.1	18.0	11.0	27.9
D Shoulder Height	21.0	53.3	25.0	63.5	18.0	45.7	25.0	63.5
E Sitting Height Normal	31.6	80.3	36.6	93.0	29.6	75.2	34.7	88.1
F Elbow-to-Elbow Breadth	13.7	34.8	19.9	50.5	12.3	31.2	19.3	49.0
G Hip Breadth	12.2	31.0	15.9	40.4	12.3	31.2	17.1	43.4
H Shoulder Breadth	17.0	43.2	19.0	48.3	13.0	33.0	19.0	48.3
I Lumbar Height	See Note.							

Note: No published anthropometric studies concerning lumbar height can be located. A British study [H-D. Darcus and A.G.M. Weddel, *British Medical Bulletin* 5 (1947), pp. 31–37], however, gives a 90 percent range of 8 to 12 in, or 20.3 to 30.5 cm, for British men. Diffrient (*Humanscale 1/2/3*) indicates that the center of forward curvature of the lumbar region for adults is located about 9 to 10 in, or 22.9 to 25.4 cm, above the compressed seat cushion.

Chart 4–1. Selected body dimensions, taken from Tables 2 and 3 of Part B, useful in the design of seating. Little detailed published data are available with regard to lumbar heights. Estimates, however, vary from a range of 8 to 12 in, or 20.3 to 30.5 cm, and 9 to 10 in, or 22.9 to 25.4 cm.

WOODS

There are two types of woods from which furniture and millwork are constructed. Hardwoods derived from deciduous trees supply the best types of wood for furniture construction because of their strength. Deciduous trees have a broad leaf and typically drop their leaves in the winter. Softwoods, taken from coniferous trees having needles or cones, are sometimes used in furniture construction. These woods, however, are less durable than hardwoods.

Oak, walnut, cherry, and mahogany are only a few examples of hardwoods used in furniture construction, and as history records, were most commonly used by cabinetmakers for centuries. Softwoods, like pine, were used by English and American furniture makers as the body material, covered with a finer walnut or mahogany veneer. The differences between hardwoods and softwoods reflect the density of the physical makeup of the wood. Since wood is from a natural, living substance, it is important to realize the material's strengths and limitations. Both types of wood will warp and crack over time.

Woods are chosen for their different characteristics. Some are more conducive to stain finishes, while others require painted finishes due to the grain patterns. The most important aspect of using wood, whether for furniture construction or millwork construction, is the curing process it goes through. When most timber is cut, it dries briefly at the lumberyard before it is sent to the kiln.

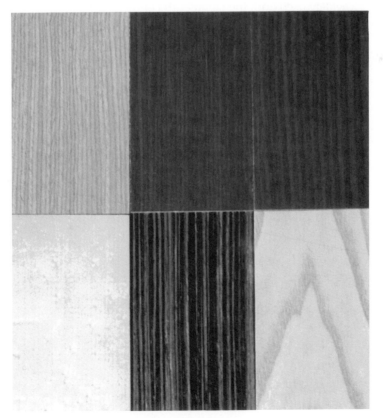

Figure 423 These samples show the coloring and grain of the more common woods used in the construction of furniture. From left to right on the charts: plain sliced oak, walnut, mahogany, birdseye maple, ebony, and ash.
Samples courtesy of Ven Tec, Ltd.

It would take a piece of wood five years to dry completely using air-drying methods. Instead, lumber mills use kilns to dry the wood, some reaching a temperature between 110–180 degrees. This is necessary to remove the moisture from the wood, which, over time, causes the lumber to warp or crack. The moisture content of cured wood usually ranges from 6 to 11 percent.

Kiln-drying methods also kill any diseases or insects embedded in the wood, as well as drying resins commonly found in most trees. The drying process is important since it helps prevent warping. Wood constantly expands and contracts, resulting in large and small fissures known as cracks and checks, respectively.

Whether hardwood or softwood, the physical makeup of the tree determines how responsive the material will be in fabrication. A cross-section of a tree reveals various layers from the bark to the center. The cambium layer is just under the surface of the bark and is made of new growth cells. The next layer, sapwood, distributes water to the roots and is a soft wood with light coloring. Moving toward the center, the heartwood is the hardest core of the tree. Heartwood is darker in color than sapwood since these cells have matured, creating compact deposits. When using pine or other coniferous wood in construction, heartwood is most desirable since it is denser and more durable. Often, trade names given to wood products allude to the differences in coloration of wood taken from the same species. White birch is sapwood, whereas red birch is the heartwood. The pith is the very center of the tree and is not used in the construction of furniture.

The veneering of wood dates back to Egyptian times, even though it was not widely used until the eighteenth century. Veneering is a process of removing layers from the log or branch of the tree in thin sheets, then applying these layers to the surface of another material with glue. A *flitch* is bought and sold based on its appearance and quality of graining. Size, figuring, color, and naturally occurring marks can make the veneer more or less desirable, depending on the overall characteristics.

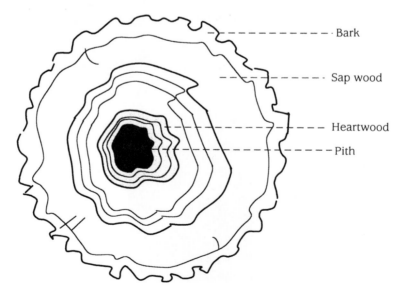

Bark

Sap wood

Heartwood

Pith

Figure 424 This cross-section indicates the various growth cycles of a tree trunk from the bark to the pith. Only the sapwood and heartwood are used in furniture construction.

PART III • FURNITURE TECHNOLOGY

Naturally occurring marks such as graining depend on the wood's growth over time. Graining is the pattern caused by growth rings developing over the life of the tree and reflects the composition of the wood fibers. Figuring refers to the depth or three-dimensional appearance of the grain and depends on the contrast between light and dark values. Contrast occurs when the tree experiences natural deviations from a normal growth cycle. For example, if a tree suffers through a drought, the grain of the wood is permanently altered.

Character marks such as worm holes, branch knots, injuries to the bark, or mineral deposits can bring added beauty to the veneer. To illustrate, burl walnut is taken from a tree that has suffered injuries or bruising to the bark during the growth cycle. Mending of the injured bark takes place, creating small spirals of contrasting grains. In many cases, injuries to the tree are often manmade, forcing a burl effect. Other irregularities, such as knot holes, can create interesting effects as seen in knotty pine used in the construction of country furniture or panel products.

Another contributing factor to the character of a veneer is from what part of the tree the flitch is cut. Crotch mahogany, a desirable veneer for its irregular grain pattern, is cut from the intersection of two branches. Also, different methods of removing the layers of wood from the trunk or branch can emphasize character marks, graining, and figuring. Likewise, various veneer matching processes such as book match, slip match, and diamond match are commonly used to enhance the wood's decorative qualities.

When matching the veneer's grain and figuring, the book match produces the most symmetrical pattern. Slip matching creates the visual effect that the grain and figure continue, while the diamond match radiates the grain around a center point. End matching produces a similar effect to slip matching since the veneers are placed end to end and side to side. Random matching is often done where the continuity or symmetry of the match does not matter, like the inside or on the back of a case piece.

The most economical way of removing layers from the tree is the plain sawn method. By cutting the log in a straight path from top to bottom, resulting grain patterns emphasize more separation between figuring. This method also produces wider veneer strips.

Quarter sawing produces the straightest grain since the log is first quartered then sliced; however, this process yields smaller veneer widths. Quarter-sawn veneers give the appearance of cathedral or peaked figuring with a flaking effect. Frank Lloyd Wright preferred this trait as most of his furniture was constructed from quarter-sawn oak.

Rift cuts are similar to quarter sawn; however, cuts made into the quartered log are cut like slices of a pie. This results in even widths and cuts down on the flaking produced with a direct quarter-sawn process.

The rotary method basically shaves the wood from the log as it is turned. This method often results in uneven grain patterns, making matching more difficult. However, since the entire log is cut, one continuous veneer sheet is possible. Half-round slicing is a method of cutting the log into halves first, then rotary slicing from the half log. The veneer's graining has a visual appearance between that produced by rotary and plain slicing.

Figure 425 Table of veneer-matching processes.

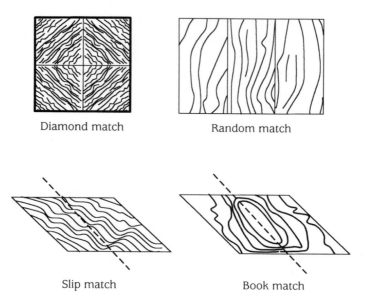

Diamond match

Random match

Slip match

Book match

Different woods are more conducive to yielding larger or smaller net footage depending on the species. Lengths of veneer sheets can range from 9 to 12 feet, also depending on the species. The thickness of veneer sheets can be anywhere from 1/28 to 1/42 inch thick with 1/32 inch most commonly used for furniture veneering. Flexwood is cut at 1/100 inch and is used as wall paneling that requires the flexibility necessary to be formed around curves.

Veneers are laid onto a core material with either urea or melamine resins (moisture resistant) and are aesthetically pattern matched. Cores are usually solid wood, plywood, or particle board. Particle board, once thought to be in-

Rotary cut

Half round

Plain slice

Quarter sawn

Rift cut

Figure 426 Methods for removing veneers from a log. Each cutting process results in different grain patterns.

ferior, proves to be much stronger and more durable than solid core or plywood. Since particle board is composed of a fusion of wood chips and glues, it is less likely to warp or crack. Particle board is available in low, medium, and high densities and should be selected for its strength according to its appropriate application.

Veneers are adhered to the core material using pressure and adhesives. The veneer is placed over the core in cross-banded patterns, or at 90 degree angles to the direction of wood grains. This gives the veneer and the piece of wood more stability against warping, cracking, or checking which may cause separation. As one layer expands in one direction, the other expands opposite, thereby providing more stability to the piece.

A distinction is made between the face veneer and the back veneer. Whenever a veneer is applied over a core material, careful consideration is made to the final appearance of the furniture item. A case piece should be constructed with the most decorative grain and figured veneer panels on the front and sides of the piece. The back, which is usually placed against a wall, often will have a less expensive piece of veneer. Types of woods, sizes, and defect ratings are supplied in *Architectural Woodwork Quality Standards* as Grades I, II, and III. Grade I has a higher quality of veneer selection based on color and graining, whereas grade III has no matching requirements.

Figure 427 Quality furniture is completed with a hand-applied stain to enhance the natural color of the wood. The quantity of stain used and the length of time it remains on the wood is critical to achieving even coloring. Here, a skilled artisan carefully applies and wipes the stain on this Rococo reproduction side chair.
Courtesy Kindel Furniture Company.

FINISHES

The use of finishes on woods also dates back to Egyptian times. Modern applications of stains bring out the beauty of the grain and accentuate the wood's natural color. Stains, enamels, oils, lacquers, and varnishes are used to treat woods. Each has a distinctive purpose and resulting finish. Stains are usually transparent, tinted with color, and dissolved in either a chemical solvent or water. Solvent stains are used most often because they dry more quickly than water-based stains.

Paints and enamels are usually opaque and require that the wood be sealed before application. Kiltz is often applied to the exposed wood, then painted. A finishing seal is added to protect the painted surface, guarding against nicks and scratches. Shellac, lacquer, and varnish create an indelible finish over the stained or painted wood surface. Most are polyurethane based and will not yellow over time.

Toners, wash coats, and wiping stains can create interesting visual effects such as distressing or white washing. Faux finishes have become popular once again, creating marbleized patterns, white-washed woods, and crackle finishes that provide alternatives to regular stained or painted finishes.

CONSTRUCTION TECHNIQUES

Joints

In addition to the type of wood and core material used, the quality of a piece of furniture also depends on its method of construction. Custom joinery techniques used to hold the piece of furniture together can be more expensive to produce and purchase. Nevertheless, these items will last much longer than an inferior item and not need to be replaced as quickly.

Deciding which joint to use in furniture construction depends on the type of furniture, how it is to be used, and, in many cases, the wholesale price. It is more expensive to use traditional joinery methods and the final price point for the finished piece will be determined by the quality of construction.

Figure 428 These drawings include plan views and extruded views of specific types of joints and show how the joints are used to secure pieces of wood. The *tongue and groove* joins two pieces with the tongue form fitted to the groove. *Mortise and tenon* joints are used most often when attaching two pieces of wood at right angles. A *dado* is used to attach two pieces of wood in a perpendicular arrangement. *Dowels* are separate cylindrical pieces of wood that are fitted into recessed holes on the wood to be joined. These are often reinforced with glue. *Finger joints* are used to attach two pieces of wood end to end. These joints help to extend the length of wood segments. Minimum joint visibility is obtained by using a wood filler and painting. *Rabbeted joints* are used to create a flush overlapping of two pieces of wood. Examples of these can be found on shutter or cabinet doors. A *butt joint* is secured with glue or sometimes screws. Extra reinforcement is obtained with the insertion of a corner block. *Dovetail joints* are commonly used on drawers and create a durable bond between two pieces of wood that does not need additional gluing.

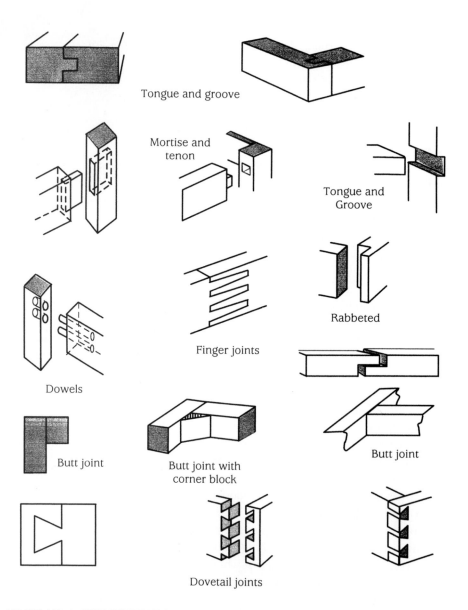

Tongue and groove

Mortise and tenon

Tongue and Groove

Dowels

Finger joints

Rabbeted

Butt joint

Butt joint with corner block

Butt joint

Dovetail joints

Frames

All wood furniture is made from the frame up. Upholstered goods depend on the frame to set the design style and provide a foundation for building up the layers of materials required in the upholstering process. The frame is created from several supporting members or elements that strengthen the frame and determine the furniture's design. Seats, legs, backs, arms, and wings serve an ergonomic purpose and can be enhanced depending on the upholstery foundation.

Open frames are commonly used for upholstery since the open cavity allows for the platform of springs for seats and padding for the back and arms. Exposed frames are only partly upholstered. Slip frames are exposed wood with an independent piece that is upholstered and attached separately to the supporting frame. Open frames can be made from metal, plastic, or wood.

Wooden frames should be made from kiln-dried, straight-grained woods that are free of knots and selected based on the desired furniture finish. Stained wood, used in the construction of exposed frames, must have a visible grain pattern. Cut widths of 1 1/8 to 1 1/2 inches are common and most manufacturers will use poplar or maple, although oak is desirable.

Leg construction and its attachment to the furniture frame are equally important in determining quality. Better-grade furniture manufacturers will fabricate the front legs into the seat rail, while the rear legs are incorporated into the uprights or stiles. This reduces the chance of breakage and stabilizes the overall frame.

Figure 429 A craftsman hand carves an arm that will be attached to the rear seat rail of the settee shown in the background. This second arm completes the frame support for a rolled arm that will be upholstered to finish the design.
Courtesy Chestnut Hill, East Berlin, Pennsylvania.

Figure 430 Construction of an open-frame chair determines the character of the finished piece. This frame is held together using custom joinery; dowels and mortise and tenons are hand cut and reinforced with a strengthening glue.
Courtesy Chestnut Hill, East Berlin, Pennsylvania.

Figure 431 This wood carver is finishing a decorative detail on the knee of a cabriole leg. In quality furniture construction, a more secure support is created when the leg and seat rail are carved from one piece of wood.
Courtesy Kindel Furniture Company.

Upholstery

In traditional upholstery methods, webbing made from wooden slats, jute, metal, polypropylene, or rubber provides the support for coil springs that shape the contour of seats and backs. Since the introduction of coil springs in the mid-eighteenth century, various other types have been introduced and used in the construction of upholstered furniture. Using coil springs requires either a four-way or eight-way, hand-tied process. Hand tying the springs secures the loose edge of the wire, keeping it from puncturing through the upholstery fabric. The tying process also determines the contour of the unit, depending on how tight the coil is tied. The firmness of the support is connected to the gauge of wire used along with the size, type of coil, and number of coils used. After the coils are set, burlap is stretched over the springs and the unit is ready for the stuffing.

While traditional conical or cylindrical coil springs are still common, the modern zigzag spring offers a faster method of providing the supporting foundation for upholstery. Today, many manufacturers use zigzag springs because they do not need to be tied and can be quickly stapled to the frame and covered with layers of stuffing and padding.

Loose stuffing materials can be made from animal hair (dating back to the Renaissance), natural fibers such as moss (typically found in furniture con-

structed in the South), down and feathers (90 to 10 percent blend is desirable since down has a tendency to flatten; feathers are more resilient); or man-made dacron fibers. Compact stuffing such as foam rubber (introduced in the 1940s), rubberized hair formed into cushions, or polyfoam (higher density foam is used for the seats, whereas lighter density foam is used for the arms) are used more often in today's upholstered goods. Once the stuffing is in place,

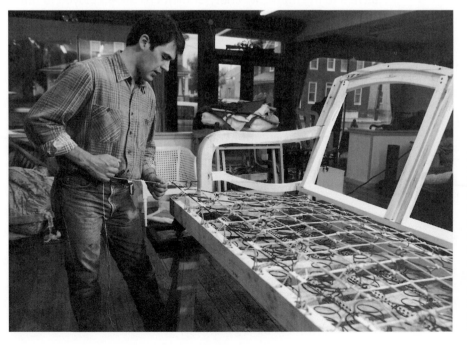

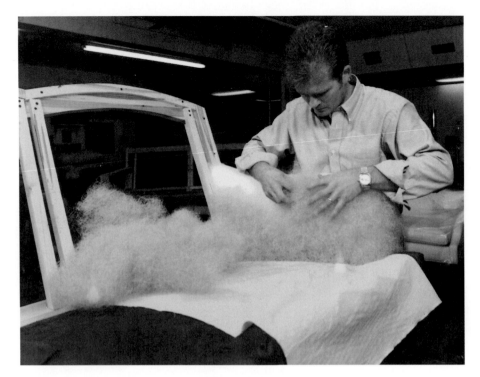

Figure 434 Stuffing material is applied over burlap-covered springs or, in this case, the framework of an armrest to soften the upholstery's foundation.
Courtesy Chestnut Hill, East Berlin, Pennsylvania.

Figure 435 The final upholstered chair is covered with decorative fabric and finished with self-welted trim.
Courtesy Chestnut Hill, East Berlin, Pennsylvania.

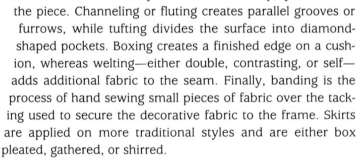

a felted pad, either cotton or polyester, is placed over the stuffing and the piece is then covered with muslin.

This muslin cover prepares the piece to receive the decorative fabric and helps to protect it from unnecessary wear. The muslin keeps the decorative fabric from rubbing on the support materials. After the covering fabric is attached to the frame, a variety of methods are employed to finish the piece. Channeling or fluting creates parallel grooves or furrows, while tufting divides the surface into diamond-shaped pockets. Boxing creates a finished edge on a cushion, whereas welting—either double, contrasting, or self—adds additional fabric to the seam. Finally, banding is the process of hand sewing small pieces of fabric over the tacking used to secure the decorative fabric to the frame. Skirts are applied on more traditional styles and are either box pleated, gathered, or shirred.

Decking is used on the underside of loose seat cushions or over springs to conceal the inner workings of the upholstery. Decking may be made from an inferior material or the same decorative fabric. Self-decked cushions, although more expensive due to increased fabric costs, allow the flexibility of "turning over" the seat cushions, maintaining more even wear. Other concealing materials are added to the bottom of the unit. An inferior, lightweight fabric similar to what is found on a box-spring mattress is stapled to the underside of the upholstered good, keeping dust away from the inner springs.

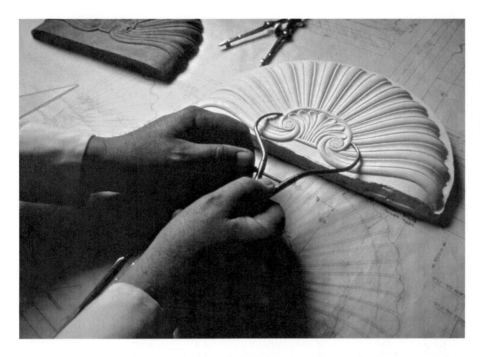

Figure 436 Scaled drawings of antique furniture details are used to create templates necessary in the construction of quality reproduction furniture. The template is checked against drawings for accuracy before the wood carver begins his work.
Courtesy Kindel Furniture Company.

While upholstery refers to the construction of a piece of furniture from the frame up, the process of recovering a piece of furniture pertains to the replacement of the decorative fabric. Fabrics used as decorative coverings are chosen for their durability. It is important to consider the wear and use of a piece of furniture and select a finishing fabric accordingly. A good rule of thumb is to know the thread count—the tighter the weave of individually colored threads, the greater the fabric wear. Good-quality upholstered furniture should exhibit a uniform pattern match of fabrics, especially on the backs in case the furniture is not placed against the wall.

Figure 437 This shell motif was hand carved by a highly skilled craftsman following scaled drawings and using templates created from museum-quality furniture items. Strict control measures determine the correctness of the reproduction as each piece is checked against drawings for accuracy.
Courtesy Kindel Furniture Company.

Figure 438 Wood carving tools remain virtually unchanged since the Middle Ages. While the tools are still a part of our modern culture, the necessary skills to create fine specimens of carved furniture are not. Long, arduous apprenticeships as well as extensive training in European schools have enabled artisans to carry on the tradition.

Figure 439 This trained wood carver puts the finishing touches on a claw-and-ball-footed cabriole leg.
Courtesy Kindel Furniture Company.

In addition to upholstered furniture, case good construction should be examined closely to determine its quality. From outside appearances, check the veneer match of the piece from the front and side. There should be an even match and consistent coloring. If the front of the case piece has glass doors, the veneer used on the inside back should also show careful selection and match to insure the overall unity of design. The inside of the cabinet should reflect the same quality as the outside. Glass doors should be secured inside the case piece as well as on the outside and the glass should be beveled or sturdy enough not to rattle when opening or closing the door. Glass shelves should be a standard 3/8-inch thick or more and easily glide in and out from the stabilizers that support them.

A trained artisan can use drawings and templates to execute precisely detailed carvings using tools that remain unchanged since the Medieval period. Check for a sharpness to the carving. This will determine whether the ornamentation was actually carved or created from a mold. There is an obvious difference in wholesale pricing, as quality constructed pieces will never use plaster or melamine casts.

When examining the joinery, the best indication of quality is to remove a drawer. If the drawers are held together with dovetail joints then, more than likely, the remainder of the piece will be constructed using custom joinery. While the drawer is removed, check the body of the piece to see if dust covers are included between the drawer openings. As the drawer is put back into the piece, check the ease of the slide. A drawer should fit tight, but not stick. This could be a sign of warpage or improper construction. Again, a good rule of thumb is to compare wholesale price points as a lower-quality case good will be less expensive.

Figure 440 A side view of this case piece reveals the dovetails used to join the drawers. The presence of dovetail joints is one indication of quality construction.
Courtesy Kindel Furniture Company.

GLOSSARY

Alabaster A natural stone of translucent, creamy white coloring suitable for carving decorative accessories such as lamps and vases. Also used in windows before glass panes.

Ambry An English wardrobe or cabinet.

Amphora A Greek egg-shaped vase designed with a long neck and side handles used to store liquids.

Apron Decorative skirting attached to the underside of a seat rail, tabletop, or case piece.

Architectonic Having architectural characteristics. In furniture design, architectonic features such as the cornice and frieze, columns, pilasters, and modillions are used.

Armario A large Spanish case piece used to store articles of clothing.

Armoire A case piece originating in the medieval period used to store arms and suits of armour. Also a wardrobe cabinet.

Armoire à deux corps Literally translated from the French, "armoire of two bodies" refers to a case piece designed in two sections used to store articles of clothing and miscellaneous household goods.

Baldachin An Italian term describing an architectural canopy supported solely by columns.

Baluster A turned form used as a furniture support and in the construction of railings. The baluster is commonly formed in the shape of an elongated vase, but not exclusively.

Banded banding A narrow border in a contrasting veneer that follows the perimeter of table tops, drawer fronts, and cabinet doors.

Bandy An American term used to describe a cabriole leg. Bandy refers to a shape that is bent or curved.

Bergère A French upholstered armchair with closed-in sides.

Bergère en gondole A French upholstered armchair having curved sides that meet to form the back.

Block front A façade treatment on case furniture whereby the center vertical structure is recessed between its two sides.

Bombé A French term describing the gentle curve or swell applied to the front and/or sides of furniture case pieces. The use of the bombé is typically found on furniture of the Rococo period.

Bonheur du jour Literally translated from the French, "good hour of the day" refers to a small desk with a compartment top used by ladies in their daily correspondences.

Bonnet top A singularly arched pediment used on the top of case pieces, also referred to as a "hooded top." A double bonnet or double hood refers to the presence of two arched pediments.

Boulle work A type of marquetry named after the cabinetmaker who introduced it, using tortoise shell and silver or brass.

Bracketed knee Makes the transition between the top of a cabriole leg and the front and side rails on a chair or case piece.

Breakfront Case furniture having recessed and projecting sections on its facade.

Brocade A textile (originally silk) used as an upholstery fabric having fluid foliate and arabesque patterns woven into the fabric in contrasting values or colors.

Bureau à caissons latéraux Literally translated from the French, "desk with lateral compartments" refers to a desk with drawers.

Bureau à cylindre Literally translated from the French, "desk with cylinder" refers to a roll top desk.

Bureau à dos d'âne Literally translated from the French, "desk with a donkey back" refers to a ladies writing table designed with a curved storage compartment.

Bureau du roi Literally translated from the French, "desk of the king" refers to roll top desks designed for the French monarchs.

Bureau plat Literally translated from the French, "flat desk" refers to a writing table. Some bureau plats were fitted with drawers on both sides and used from either side.

Buttress An exterior architectural support for a wall designed to alleviate outward thrust created by the compression of the roof.

Cabriole A leg formed to resemble the stylized front leg of a capering animal. The cabriole leg with its distinctive knee form is a strong characteristic of the Rococo period.

Canapé A French sofa or settee.

Caquetoire A derivative of the French word caqueter meaning, "to chatter" refers to a conversation chair.

Cartoon A preliminary drawing or sketch used as a pattern for paintings, tapestries, or carpet designs.

Carving The process of cutting into the surface material either wholly or in part to create pattern or texture.

Case good/case piece Any furniture used for storage including bookcases, bureaus, chests, china cabinets, and armoires.

Certosina The Italian term used to describe light colored wood, bone, or ivory inlaid against a dark background.

Chaise longue Literally translated from the French, "long chair" refers to a chair with an extended seat used for lounging.

Chasing/chased The process of cutting, embossing, or incising metal to create design or pattern.

Chiffonier A French chest of drawers.

Chinoiserie A French term describing design motifs possessing distinctive Chinese styling.

Chinz A textile of woven cotton having a printed pattern or design.

Continuous stretcher Connecting members between all legs of a chair or case piece used to strengthen the construction of the frame.

Crest rail The top horizontal member on a chair frame, also referred to as the top rail.

Crockets Ornamental finials resembling the foliate patterns found on handles of medieval swords. Architectural embellishments on a Gothic cathedral.

Crossbanded/crossbanding Banding inlayed at a 90° angle to the grain.

Curule Having an X-form base.

Dais A raised platform or base.

Damask A textile with flatly woven monochromatic floral designs.

Dantesca An upholstered Italian armchair having a short back, open sides, and an X-form base. Dantesca is also referred to as a Dante chair named for the fourteenth century Italian poet.

Double cove A term used to describe the contoured seat on an Egyptian chair or stool. Also called a dipped seat.

Dowels Cylindrical pegs used to join two pieces of wood. Each receiving member has a drilled hole with a combined depth of the length of the dowel. Glue or epoxy is often used to strengthen the joint.

Dressoir A French sideboard or dresser. Originally the dressoir was placed in the great hall of a medieval castle and used for storage and display.

Drop seat A shaped upholstered seat designed to rest securely within the framework of the seat rail. The seat was easily removed for seasonal recovering. Also referred to as a slip seat.

Drum A cylindrical architectural support for a dome. In furniture, any decorative or supporting cylindrical form that resembles this.

Façade In architecture, the face of a building: usually the main entrance or side bearing architectural significance.

Farthingale chair An upholstered, box-form English side chair. The chair accommodated fashionable sixteenth century ladies wearing hooped skirts called farthingales.

Fauteuil A French upholstered armchair with open sides.

Finial An upright, decorative object formed in a variety of shapes.

Flitch The series of veneer cuts taken in sequence from a log.

Fluted/fluting Concave cut parallel grooves used as a decorative surface treatment. The process of fluting originated from Greek architecture; column shafts were decorated with this treatment.

Frailero A Spanish box-form armchair typically used in monasteries (the name is a derivative of friar). Most chairs of this type had a stretched leather seat and back tacked to a wooden frame. The chair could be folded lengthwise and carried from room to room.

Fulcrum A scroll shaped object placed at one or both ends of a Roman lectus and used as a headrest or armrest.

Gable The pitch or slope of a roof, pediment, or wall. Also the slope or pitch of the top of a chest or other piece of furniture.

Gilding The process of applying gold leaf to a prepared surface such as wood or plaster.

Gilt furniture Furniture that has gold leaf applied to its surface.

Goose-neck arm A crook-shaped arm support imitating the neck of a goose.

Guilloche A decorative motif of interlocking circles with or without further embellishments.

Hieroglyph/hieroglyphics An ancient Egyptian form of writing using pictures or symbols to represent words or thoughts.

Hypostyle In architecture, interior columns that support the roof in an Egyptian building.

Impluvium The recessed area located directly under the atrium of a Roman house used to collect rainwater.

Impost block In architecture, a wedge-shaped block placed between the capital and that which it supports.

Inlay In furniture it is the process of imbedding a variety of materials including contrasting woods, bone, ivory, metal, and/or semiprecious stones into the wood's surface to create a decorative effect.

In situ In its original location.

Insula A Roman dwelling containing several units or apartments.

Intarsia The Italian term for inlay.

Japanning/japanned A paint and varnish process that imitates oriental lacquer work.

Jasperware A hard biscuit ware pottery popularized by Wedgwood in the eighteenth century.

Kline A Greek reclining couch or bed.

Klismos A Greek side chair having a concave back and saber legs.

Krater A Greek two-handled piece of pottery used as a mixing bowl.

Kylix A Greek drinking cup, with or without handles.

Ladder-back chair A chair with horizontal back slats resembling the rungs of a ladder.

Lectus A Roman reclining couch or bed.

Manchette The French term used to describe a small upholstered arm pad attached to the armrest.

Marquetry A decorative treatment whereby colored woods, ivory, mother of pearl, metal, or tortoiseshell is inlayed into a veneered surface.

Megaron A large rectangular room used by the Minoans and Mycenaeans for ceremonial or religious purposes.

Mensa A small Roman table.

Modillion An architectural bracket located under the cornice. Also, a decorative motif used on furniture.

Mortise and tenon A type of joint consisting of peg and hole configuration. The projecting member (tenon) from one piece of wood is fitted into the cavity (mortise) of another.

Mosaic A decorative wall or floor covering created by placing small pieces of colored stone, glass, or tile in a mortar or cement ground.

Mudéjar A style of ornament based on a combination of Spanish Christian and Moorish influenced designs.

Objets d'art Literally translated from the French, "art object" refers to any small art object.

Papelera A small Spanish cabinet with fitted compartments or drawers used for the storage of important papers and writing implements.

Parcel gilt Gilding applied to specific parts of a carved or flat design.

Pargework Ornamental ceiling details in plaster or stucco relief.

Pendant An ornamental knob that hangs vertically.

Pietra dura Literally translated from the Italian, "hard stone" refers to colored marble mosaic.

Pilaster A squared column, usually positioned against a flat surface.

Plinth A small block placed at the base of a column, pilaster, or pedestal.

Puente A Spanish arcaded stand used to support a vargueño.

Quatrefoil A design motif with four lobes or foils originally used as ornamentation on Gothic cathedrals.

Raking back A chair with a slant back.

Refectory A room used for dining.

Romayne A medallion-enclosed portrait resembling Roman coins.

Runner A horizontal connecting member used between the legs of a chair or case piece to strengthen its construction. Unlike a stretcher, the runner rests on the floor.

Rush In furniture, a type of grass used to make chair seats.

Sarcophagus/sarcophagi (plural) A coffin made from a variety of materials including stone and wood.

Savonarola An Italian Renaissance chair constructed from multiple wooden staves in an X-form configuration that collapses lengthwise for easy mobility.

Seat rail The horizontal member on a chair, sofa, or settee frame that forms the seat.

Secretary/secretaire A tall fall front writing desk with storage compartments above and drawers below.

Sedia An Italian Renaissance box form upholstered armchair.

Sgabello An Italian Renaissance wooden chair designed with two trestle supports, an octagonal seat, and inverted triangular back.

Shoe A small disk attached to the bottom of a scrolled foot.

Sillón de caderas, sillón de tijera A Spanish Renaissance armchair with an X-form base.

Singerie The French term describing design motifs depicting frolicking monkeys.

Slat A wide, horizontal wooden member used in furniture construction. Slats can be decorative or plain.

Slip seat A shaped upholstered seat designed to rest securely within the framework of the seat rail. The seat was easily removed for seasonal recovering. Also referred to as a drop seat.

Spindle An elongated turned member in a variety of shapes used as decoration in millwork and on furniture. Split spindles are cut lengthwise, the flat side affixed to the surface of case pieces for decoration.

Splat back A wide, vertical wooden member used as a back support on chairs or settees. Splats can be decorative or plain.

Splayed Legs or trestle supports designed with an outward slant.

Spoon-back chair A chair with a shaped splat that follows the curvature of the spine.

Stretcher A horizontal connecting member used between the legs of a chair or case piece to strengthen its construction. Unlike runners, stretchers do not touch the floor.

Strut A connecting member from the seat to the stretcher providing additional structural support.

Table á ouvrage A French work table.

Tabouret A French stool.

Tapestry A woven textile with the decorative pattern or design worked into the looming process.

Taracea Spanish inlay work using contrasting woods, bone, ivory, metal, and/or other semiprecious materials for decorative effect.

Tesserae Small pieces of colored stone, glass, or tile used in mosaics.

Toile de Jouy A printed cotton textile made in Jouy, France popularized during the eighteenth and nineteenth centuries.

Top rail The top horizontal member on a chair frame, also referred to as the crest rail.

Trabeated In architecture, post and lintel construction whereby horizontal beams are supported by vertical posts.

Tracery In architecture, decorative stone mullions used in windows such as those that hold the stained glass in a Gothic cathedral. In furniture, a decorative carving that imitates this cut stone work. Pierced tracery is a decorative cut-through carving.

Trefoil A design motif with three lobes or foils originally used as ornament on Gothic cathedrals.

Trestle A type of support used on chairs and tables in the place of traditional legs.

Trompe l'oeil Literally translated from the French, "fool the eye" refers to a type of illusionistic painting giving the appearance of three dimensions.

Turkey work A handmade textile made to simulate the appearance of an oriental rug.

Turning/turned A process used to shape to a block of wood into a uniform, cylindrical design. First, a wooden block is securely fastened to a lathe. As the lathe rotates the block, a cutting implement is moved in a forward and backward motion giving the wood its shape.

Unguents Perfumed ointments, lotions, or salves used by the ancient Egyptians.

Vargueño A Spanish drop-front writing cabinet.

Vernis Martin A term describing a type of varnish used on French furniture of the eighteenth century named for the cabinetmaker who developed it.

Wainscot/wainscoting The lower half portion of a wall covered with wood paneling or anything that resembles this treatment.

Wainscot chair A chair having a solid wood paneled back introduced during the Renaissance period.

Webbing Latticed leather, jute, burlap, rubber, or metal used as a support for upholstery, whether coil springs or loose cushions.

METHODOLOGY AND WORKS CONSULTED

Primary data used in the preparation of this book was gathered from curatorial staff members, docents, and photographic archival information during extended visits to many of the museums referenced herein, and supplemented through study trips to England, France, Greece, and Italy. The following is a list of sources consulted in the verification of supplementary historical facts.

Adam, Peter. *Eileen Gray, Architect Designer*. New York: Harry N. Abrams, 1987.

Aronson, Joseph. *The Book of Furniture and Decoration: Period and Modern*. New York: Crown Publishers, 1941.

Aronson, Joseph. *The Encyclopedia of Furniture*. New York: Crown Publishers, Inc., 1965.

Baker, H. S. *Furniture in the Ancient World: Origins and Evolution, 3100–475 B.C.* New York: Macmillan, 1965.

Boardman, John, *Greek Art*. London: Thames and Hudson, Ltd., 1985.

Boethius, Axel. *Etruscan and Early Roman Architecture*. New York: Penguin Books, 1978.

Boger, Louise Ade, and H. Batterson Boger. *Dictionary of Antiques and the Decorative Arts*. New York: Charles Schribner's Sons, 1967.

Bowman, John S. *American Furniture*. New York: Crescent Books, 1995.

Capart, Jean. *Egyptian Art: Introductory Studies*. Freeport: Ayer Company Publishers, 1971.

Carter, Howard, and A. C. Mace. *The Tomb of Tutankhamun*. New York: Cooper Square Publishers, Inc., 1963.

Clark, Thomas D., and F. Gerald Ham. *Pleasant Hill and Its Shakers*. Harrodsburg: Pleasant Hill Press, 1983.

DeCenival, Jean-Louis. *Living Architecture: Egyptian*. New York: Grosset and Dunlap, 1964.

Duncan, Alastair. *Art Deco Furniture*. New York: Holt Rinehart & Winston, 1984.

Fitzgerald, Oscar P. *Three Centuries of American Furniture*. New York: Gramercy Publishing Co., 1982.

Franklin, Fay, ed. *History's Timeline*. London: Grisewood & Dempsey Ltd., 1981.

Giedion, S. *The Beginnings of Architecture*. Princeton: Princeton University Press, 1964.

Gilbert, Katherine Stoddert, Joan K. Holt, and Sara Hudson, eds. *Treasures of Tutankhamun*. New York: Ballantine Books, 1977.

Gloag, John. *A Social History of Furniture Design*. New York: Crown Publishers, Inc., 1960.

Greer, Thomas H. *A Brief History of the Western World*. New York: Harcourt Brace Jovanovich, Inc., 1982.

Halsey, R. T. H., and Elizabeth Tower. *The Homes of Our Ancestors*. New York: Doubleday, Page & Company, 1925.

Hamlin, A. D. F. *A History of Ornament: Ancient and Medieval*. New York: The Century Co., 1916.

Hecker, Stefan, and Christian F. Fuller. *Eileen Gray*. Barcelona: Gustavo Gili, 1993.

Honour, Hugh. *Cabinet Makers and Furniture Designers*. New York: G. P. Putnam's Sons, 1969.

Hood, Sinclair. *The Arts in Prehistoric Greece*. New York: Penguin Books, 1978.

Julier, Guy. *Encyclopaedia of 20th Century Design and Designers*. London: Thames and Hudson, Ltd., 1993.

Katz, Laslo. *The Art of Woodworking and Furniture Appreciation*. New York: P. F. C. Publishing Co., Inc., 1970.

Kjellberg, Ernest, and Gösta Säflund. *Greek and Roman Art: 3000 B.C. to A.D. 550*. New York: Thomas Y. Crowell Company, 1968.

Kostof, Spiro. *A History of Architecture: Settings and Rituals*. New York: Oxford University Press, 1985.

Larabee, Eric, and Vignelli Massimo. *Knoll Design*. New York: Harry N. Abrams, Inc., Publishers, 1989.

Lees-Milne, James. *English Country Houses: Baroque 1685–1715*. Woodbridge: Antique Collector's Club, 1986.

McCorquodale, Charles. *The History of the Interior*. New York: The Vendome Press, 1983.

Mellaart, James. *Catal Huyuk: A Neolithic Town in Anatolia*. New York: McGraw-Hill, 1967.

Michailidou, Anna. *Knossos: A Complete Guide to the Palace of Minos*. Athens: Ekdotike Athenon S. A., 1989.

Nash, Ernest. *Roman Towns*. New York: J. J. Augustin Publisher, 1944.

Nims, Charles F. *Thebes of the Pharaohs: Pattern for Every City.* New York: Stein & Day Publishers, 1965.

Noyes, Eliot F. *Organic Design in Home Furnishings.* New York: The Museum of Modern Art, 1969.

Raimondi, Giuseppe. *Italian Living Design: Three Decades of Interior Decoration 1960–1990.* London: Tauris, 1990.

Riley, Noel. *World Furniture.* 1990.

Ritcher, Gisela, and Marie Augusta. *The Furniture of the Greeks, Etruscans, and Romans.* London: Phaidon Press, 1966.

Sanders, N. K. *Prehistoric Art in Europe.* Baltimore: Penguin Books, 1968.

Silverman, Debora L. *Art Nouveau in Fin de Siècle France: Politics, Psychology, and Style.* Los Angeles: University of California Press, 1989.

Smith, William Stevenson. *The Art and Architecture of Ancient Egypt.* New York: Penguin Books, 1965.

Speltz, Alexander. *Styles of Ornament.* New York: Dover Publications, 1940.

Stone, Dominic R. *The Art of Biedermeier: Viennese Art and Design 1815–1845.* London: Quintet Publishing Limited, 1990.

Wanscher, Ole. *The Art of Furniture: 5000 Years of Furniture & Interiors.* New York: Reinhold Publishing Corp., 1966.

Wilk, Christopher. *Marcel Breuer Furniture and Interiors.* New York: The Museum of Modern Art, 1981.

Woldering, Irmagard. *The Art of Egypt: The Time of the Pharaohs.* Translated by Ann E. Keys. New York: Greystone Press, 1963.

Wood, Margaret. *The English Mediaeval House.* London: Bracken Books, 1983.

INDEX